Contents

Supporters' Statements 6
Director's Foreword 7
Acknowledgements 8

Van Dyck in Britain 10
Karen Hearn

Van Dyck, the Royal Image and the Caroline Court 14
Kevin Sharpe

Fashioning the Modern Self: Clothing, cavaliers and identity in van Dyck's London 24
Christopher Breward

Painting in England before van Dyck: His first visit in 1620–1 and its aftermath 38

Van Dyck's Return to England: Royal portraits 64

Other Patrons and Sitters 84

Self-portraits and Life 132

Van Dyck's London Studio 152

Van Dyck's Impact during the Seventeenth Century 170

Van Dyck's Continuing Influence 204

Notes to Essays 238
Select Bibliography 240
Exhibited Works 242
Loans from The National Trust and Other Properties Open to the Public 247
Lenders and Credits 249
Index 250

Supporters' Statements

Just as a portrait by van Dyck of Charles I conveys a direct sense both of the monarch's personality and of his presence, this exhibition will open our eyes to more than the extraordinary talent of the artist alone. Through van Dyck's vision and through the access that he gives us, we gain an insight into who his sitters really were and what seventeenth-century Britain was like.

Making art accessible and meaningful to people of all ages is one of the goals of the Annenberg Foundation. We congratulate Tate Britain on the opening of this wonderful exhibition. We applaud your efforts to present shows such as this one and so we are pleased to work in partnership with American Patrons of Tate to promote educational exchange between Tate Britain and American students and scholars.

Wallis Annenberg
Vice President and Trustee, The Annenberg Foundation

The charity Tate Members was founded in 1958 specifically to support the work of Tate; it has proved one of the most successful schemes of its kind. Last financial year Members gave over £5 million in direct funding to Tate.

We hope that many of you who read this catalogue and enjoy the exhibition will join us in supporting Tate's vision.

Francine Stock
Chair, Tate Members

Van Dyck & Britain

Van Dyck & Britain

Edited by Karen Hearn

Historical consultant Kevin Sharpe

With contributions by
Tabitha Barber
Tim Batchelor
Christopher Breward
Christopher Brown
Diana Dethloff
Emilie Gordenker
Catharine MacLeod
Susan North
Kevin Sharpe
Susan Sloman
Simon Turner
Robert Upstone

Tate Publishing

Supported by Wallis Annenberg and
the Annenberg Foundation through
the American Patrons of Tate, and by
Tate Members – to mark fifty years
supporting Tate

First published 2009 by order of the Tate Trustees
by Tate Publishing, a division of
Tate Enterprises Ltd, Millbank, London SW1P 4RG
www.tate.org.uk/publishing

on the occasion of the exhibition
Van Dyck & Britain
Tate Britain, London
18 February–17 May 2009

© Tate 2009

A catalogue record for this book is available from the
British Library

ISBN 978 1 85437 795 1 (hbk)
ISBN 978 1 85437 858 3 (pbk)

Distributed in the United States and Canada by
Harry N. Abrams, Inc., New York

Library of Congress Control Number: 2008938614

Designed by Atelier

Lithography and printing by Engelhardt und Bauer
in Karlsruhe, Germany

Mixed Sources
Product group from well-managed
forests and other controlled sources
www.fsc.org Cert no. SGS-COC-003186
© 1996 Forest Stewardship Council
FSC

Front cover: Anthony van Dyck, *Lucy Percy, Countess
of Carlisle* 1637 (no.43, detail)
pp.36–7: Anthony van Dyck, *Thomas Killigrew and
another Gentleman* 1638 (no.47, detail)
pp.236–7: Anthony van Dyck, *Charles I and Henrietta
Maria and their two eldest children ('The Greate Peece')*
1632 (no.17, detail)

Measurements of artworks are given in centimetres,
height before width

Contributors

Tabitha Barber (TB), Curator, Seventeenth
and Eighteenth Century British Art, Tate

Tim Batchelor (TJB), Assistant Curator, Tate

Christopher Breward, Acting Head of Research,
Victoria and Albert Museum, London

Christopher Brown (CB), Director, The Ashmolean
Museum, University of Oxford

Diana Dethloff (DD), specialist in seventeenth-
century British painting, University College London

Emilie Gordenker (EG), Director of the
Mauritshuis, The Hague

Karen Hearn (KH), Curator, Sixteenth and
Seventeenth Century British Art, Tate

Catharine MacLeod (CM), Curator of Seventeenth-
Century Portraits, National Portrait Gallery, London

Susan North (SN), Curator, Victoria and Albert
Museum, London

Kevin Sharpe, Professor of Renaissance Studies
at Queen Mary, University of London

Susan Sloman (SS), specialist in the eighteenth
century

Simon Turner (ST), specialist in seventeenth-
century prints

Robert Upstone (RU), Curator, Modern British Art,
Tate

Director's Foreword

Sir Anthony van Dyck was the most profoundly influential of that succession of European-born artists who were to work in England (in some instances quite briefly) and so notably nurture its artistic growth from the sixteenth to the eighteenth centuries – amongst them Holbein, Rubens, Lely and Canaletto. Van Dyck's creation for his patron Charles I of a number of memorable images of seemingly impregnable kingship could, of course, have been rendered irrelevant by the crisis of the Civil War and indeed by the temporary abolition of the monarchy itself. But his pictorial influence – an elevated form of portraiture drawn ultimately from Titian and Veronese – was to continue undiminished through the Restoration and confidently on into the eighteenth and nineteenth centuries, and even beyond. His style and patterns of portraiture were imitated and adapted era by era, continuing to provide a model to convey social elegance and aristocratic sophistication. This exhibition explores the nature and range of van Dyck's work in relation to the tides of taste, politics and patronage in his day, and to the course of British art more generally, incorporating the work of no fewer than thirty-one other artists in so doing.

The exhibition was conceived and curated by Tate's Karen Hearn (previously the curator of our landmark exhibition of 1995, *Dynasties: Painting in Tudor and Jacobean England 1530–1630*) with great skill and commitment. She has been closely supported by assistant curator Tim Batchelor, Professor Kevin Sharpe, chair of Renaissance Studies at Queen Mary College, University of London, and a team of other authors including Professor Christopher Breward of the Victoria and Albert Museum. The V&A's own *Baroque 1620–1800: Style in the Age of Magnificence* exhibition, co-curated by Tate's Head of Research, Professor Nigel Llewellyn, forms a thrilling counterpart to our own show, together providing a sharp and varied focus on seventeenth-century culture for London's public, who will be able to enjoy it as part of Baroque '09, a year of events celebrating Baroque music and culture. Meanwhile Tate's acquisition last year of Rubens's *The Apotheosis of James I*, his multiple sketch for the Banqueting House ceiling, Whitehall, c.1628–30, and our interest in forming research partnerships with scholars at York, Queen Mary, London, and other universities in the study of later seventeenth-century British art, promise to draw further and welcome attention to a still under-studied but exceptionally rich area of art history.

Her Majesty the Queen has graciously lent ten works to the exhibition from the Royal Collection, and the National Trust, our partners in presenting the project, a further eight. To them and to the many generous additional lenders to the exhibition from the UK, Europe and the USA we extend our grateful thanks. We are also indebted to Wallis Annenberg and the Annenberg Foundation for their support of the project in tandem with our ever loyal supporters, Tate Members.

Stephen Deuchar
Director, Tate Britain

Acknowledgements

Producing an exhibition that comprises such diverse material, and within such a short period of time, has placed considerable demands on everyone involved, and there are many people to thank. First of all, I would like to thank all the lenders to the exhibition, both those who are named and those who have chosen to remain anonymous; also all those who have made the loans possible.

I would also like to thank the exhibition's historical consultant, Kevin Sharpe, and all the other contributors to the catalogue: Tabitha Barber, Tim Batchelor, Christopher Breward, Christopher Brown, Diana Dethloff, Emilie Gordenker, Catharine MacLeod, Susan North, Simon Turner and Robert Upstone. I am grateful to the participants in the preparatory round-table discussion on van Dyck and his work in Britain in October 2007, which was coordinated by Nigel Llewellyn. I would particularly like to thank Helen Culver Smith, who was an exceptionally efficient and resourceful intern.

Within Tate, I wish to thank the super-efficient Tim Batchelor, as well as Gerry Alabone, Anne Beckwith Smith, Gillian Buttimer, Rica Jones, Cathy Putz, Jennifer Batchelor, Stephen Deuchar, Jess Gormley, Judith Nesbitt, Andy Shiel and Tate photographers Dave Clarke, Andy Dunkley, Marcella Leith, Marcus Leith and Rod Tidman. In the Tate Publishing catalogue team, I am extremely grateful to Nicola Bion, Emma Woodiwiss, Deborah Metherell, Johanna Stephenson, and designers Paola Faoro and Quentin Newark at Atelier. For the realisation of the Tate Britain exhibition, I should like to thank David Ellis of Why Not Associates, Michael Falzon of M.C. Designers and Alan Farlie of RFK Architects.

Special thanks are due to the staff of the Heinz Archive and Library at the National Portrait Gallery – an outstanding resource for all who study early British portraiture – and to CODART, based at The Hague, via whose meetings I was able to develop various van Dyck ideas and connections.

Tate is grateful to the following donors who have, over the last decade, enabled it to acquire the works catalogued here as nos. 13, 49, 50 and 103: the National Heritage Memorial Fund, Tate Members, The Art Fund, Monument Trust, Manny and Brigitta Davidson and the Family, Danny Katz, The Michael Marks Charitable Trust, Sir Harry and Lady Djanogly, The Basil Samuel Charitable Trust, The Flow Foundation, The Stanley Family Foundation, David and Susan Gradel through The Art Fund, Christopher Ondaatje, the late Alice Cooper Creed and the Tate Patrons.

The following are warmly thanked for their assistance on the exhibition and catalogue: Derek Adlam, David Adshead, the late Ian Arnison, Karen Ashworth, Sir Jack Baer, Katharine Baetjer, Patricia L. Baker, Andrew Barclay, Clare Baxter, Nancy Bell, Ben van Beneden, Peter Black, Rhea Blok, Susan Bracken, Barbara Bryant, Laura Chapman, Michael Clarke, Michael Daley, Petra Dvorakova, David Edmond, Elizabeth Einberg, Florence Evans, Oliver Fairclough, Rupert Featherstone, Susan Foister, Claire and Richard Gapper, Richard and Jonathan

Green, Miriam Grice, Robin Harcourt Williams, Robert Harding, Robert Holden, Laura Houliston, Maurice Howard, Gareth Hughes, Lynn Hulse, Amelia Jackson, David Jaffé, Jes Kaines, Alastair Laing, Sandra de László, Adrian Le Harivel, Walter Liedtke, Jill McNaught-Davis, David McNeff, Gregory Martin, James Miller, Ann Mitchell, Cathal Moore, Susan Morris, John Morton Morris, J.P. Vander Motten, John Murdoch, Charles Noble, Sheila O'Connell, Barbara O'Connor, Michael P. Parker, Paul Petzold, Cathy Power, Sir William Proby, the late 8th Earl of Radnor, Timothy Raylor, Janice Reading, Elizaveta Renne, Aileen Ribeiro, Kate Rigby, The Hon Lady Roberts, Mark Roberts, John Martin Robinson, Malcolm Rogers, Martin Royalton-Kisch, Francis Russell, Nicolas Sainte Fare Garnot, Mary Sandys, Scott Schaefer, Jennifer Scott, David Scrase, Lisa Shakespeare, Desmond Shawe-Taylor, Claire Skinner, Lindsay Stainton, Nicholas Stogdon, Rebecca Wallace, Adam White, Gareth Williams and Jeremy Wood.

My greatest debt is to the late Sir Oliver Millar, whose many decades of research on van Dyck, and particularly on the artist's British career, culminated in his magisterial 'Van Dyck in England'– Section IV of the authoritative catalogue raisonné of the artist's paintings, published in 2004. He not only set the very highest standards of scholarship: I would like also to pay tribute to his generosity and kindness. Although he did not live to make a contribution to the exhibition, or to see it, it is hoped that it would have met with his approval.

Karen Hearn

Van Dyck in Britain

Karen Hearn

Van Dyck's shadow looms large over portraiture in Britain: his impact has been overwhelming, not only within his lifetime, but right up to the First World War. As portraiture has always been the form of painting that the British have held in the highest regard, van Dyck's influence has been of outstanding importance.

The amount of time that he spent in Britain was, in fact, comparatively short: five months over the winter of 1620–1, just under two years from mid-June 1632 to early 1634, and then most of the rest of his career from March 1635 until his death in London in 1641. Even then, much of his final year was spent visiting the Southern Netherlands (where he was seeking opportunities for commissions following Rubens's death in May 1640), France (hoping to win the commission to decorate the Grande Galerie at the Louvre) and the Northern Netherlands; he returned, seriously ill, to die in London on 9 December 1641 – the day on which his only legitimate child, Justina, was baptised.[1] Nevertheless, many subsequent commentators have regarded van Dyck as an 'English' painter, and his portraits as a model to which later painters aspired and which subsequent clients and patrons desired to see emulated and re-created in contemporary terms. In recent years our knowledge and understanding of van Dyck's entire career, including his work in Britain, have been greatly advanced by major exhibitions and publications.[2]

Van Dyck was born in Antwerp on 22 March 1599, the seventh of twelve children of a silk merchant, Frans van Dijck, whose own father, also a silk merchant, had trained as an artist. Van Dyck was a precociously talented child, and around the age of ten was apprenticed to Hendrick van Balen (c.1575–1632), a painter of small narrative (often religious) pictures. Van Dyck's earliest dated work is thought to be a portrait of an old man, inscribed 1613.[3] He set up his own workshop in Antwerp around 1615, although also at this time or shortly afterwards he joined the most dynamic studio in Antwerp, that of Peter Paul Rubens (1577–1640), where his skills seem soon to have been widely recognised. He achieved the status of Master of the Guild of St Luke (the artists' guild) in Antwerp in February 1618, although by now he had already received commissions in his own right for a number of religious paintings.

In October 1620 van Dyck arrived in London for the first time. Here he painted at least two of his surviving paintings (nos 6 and 7), and evidently made the acquaintance of some of the most significant connoisseurs and collectors of art (many of whom, like George Villiers, subsequently 1st Duke of Buckingham, also enjoyed political power), the people who were or would become the leading patrons, collectors and artistic arbiters in Britain during the first half of the seventeenth century. In their collections van Dyck saw some of the finest examples of Northern European and Italian art.

Briefly back in Flanders, he then moved to Italy where he settled for a time in Genoa, the most important centre for Flemish artists in Italy. Here he worked for some of the great aristocratic families, and his range of portraiture expanded to include the grand full-length format. He also travelled to Rome and Venice, and south to work in Palermo. By the end of 1627 he was back in Antwerp, where he gained some significant religious commissions and produced some of his very finest portraits, both of wealthy merchants and of aristocrats. Rubens was abroad between September 1628 and March 1630, and in his absence van Dyck became painter to the Regent, Archduchess Isabella Clara Eugenia, and thus one of the leading portrait painters in the Southern Netherlands.[4]

He returned to London in 1632 in order to hand over to Charles I a number of royal portraits. On 5 July that year he was knighted at St James's Palace and

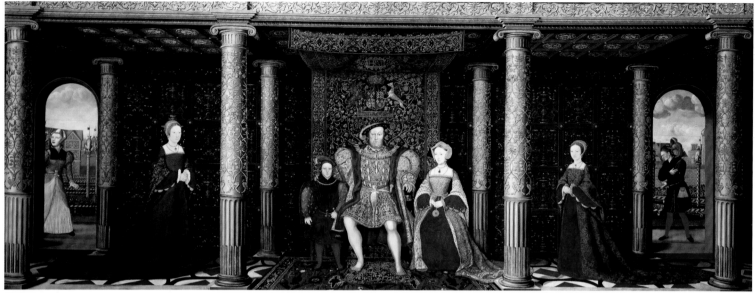

Fig.1
British School
The Family of Henry VIII c.1545
Oil on canvas
169.5 x 356.9
Her Majesty The Queen (The Royal Collection Trust)

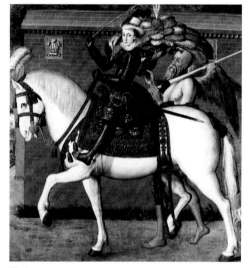

Fig.2
Robert Peake
Prince Henry on Horseback with the figure of Time c.1612
Oil on canvas
231 x 219.5
The Trustees of Parham House

appointed 'principalle Paynter in Ordinary to their Majesties'.[5] As Charles I's official painter, van Dyck was now expected to settle in London. A property on the riverside in Blackfriars was soon made available to him.

The works he produced in England are distinct from those he painted elsewhere. The brushwork is generally less visible, with flesh areas rendered particularly smoothly; the facial expressions are depicted with greater simplicity and clarity; and the textiles are often presented as plainer, broad areas of colour. He had used the full-length format previously in Italy, and in London, where he found that it was already popular, he brought to it a sense of drama and movement.[6]

The complex issue of the numerous replicas, versions and copies of his paintings that have survived is critical in any consideration of van Dyck's British career. He followed both Netherlandish – and indeed English – precedent in employing assistants in his studio to help him to complete the immense number of works required by his clients (see pp.153–5 below). It has been estimated that his studio in Britain produced perhaps as many as four hundred portraits in seven and a half years, an average of at least one a week.[7] It is clear that Daniel Mytens similarly ran a substantial studio in London, just as in previous decades Marcus Gheeraerts II and Robert Peake had done and as John de Critz would continue to do. No evidence has survived as to how any of these artists organised their studios, although documents relating to a group of works commissioned from van Dyck's studio by Thomas Wentworth indicate that replicas, not by the hand of Sir Anthony himself, could be ordered simultaneously – the cost in this case was £20 for a half-length and £30 for a full-length.[8] At this time van Dyck was charging between £50 and £60 for a standard full-length portrait, £30 for a half-length and £20 for a head-and-shoulders portrait.[9] Moreover, while a portrait was still in van Dyck's studio a miniaturist might also be organised to make small-scale copies of the head alone. Thus rather than commissioning a single, unique work of art, a client could be offered a full range of options (like a modern-day formal portrait photographer). As a result, the question of which surviving version of a portrait may be thought to have primacy has been, and may always be, a vexed one, especially when many may have suffered various types of damage over the intervening nearly four hundred years as a result of being kept in harmful ambient

conditions, cut down, or altered by overpainting.

The works by van Dyck featured in these pages are believed to be largely by his own hand, to be fine examples of their type and to be in good condition, although there will always be debate over these questions. The numerous surviving copies of his works that were made either in his lifetime or afterwards attest to the importance and power of his images, both for those who already owned them and for others who wished to do so. It should be remembered, however, that later owners often prized past portraits because of the historical celebrity or personal significance of the *sitter*, rather than for the identity of the artist.

There is no question that van Dyck brought a wholly new approach to British art, yet, as with his Genoese work, he also responded to the established artistic conventions he encountered locally and adapted them in his own paintings. He was both genuinely innovatory and at the same time delivering something of an illusion of originality. For example, in the 'Greate Peece' (no.17), the royal family group that he painted for Charles I in 1632, it has been observed that he was tackling a subject similar to *The Family of Henry VIII*, painted by an unknown artist almost a century earlier (see fig.1).[10] Here, indeed, he transformed the portrayal of a group of people who were royal – part of a dynasty – and yet also a family.[11] Similarly, his enormous equestrian portrait depicting Charles I in armour (fig.7, p.18), in sharp profile in an echo of the royal image on the Great Seals of successive English kings, also had another, more recent prototype in Robert Peake's massive portrait of Charles's late elder brother, Henry, on horseback, hauling along the naked figure of Time (fig.2).[12] His celebrated full-length portrait of Henrietta Maria in a riding habit, with the diminutive Sir Jeffrey Hudson (fig.8, p.20), was to a considerable extent a re-working of a form of portrait previously originated by Daniel Mytens (compare Mytens's large painting of *Charles I and Henrietta Maria Departing for the Chase*, fig.3).[13] Van Dyck was also happy to borrow from a more modest artist like Cornelius Johnson: his portraits of *Lucius Cary, Lord Falkland* (no.45) and the young Charles Cavendish (1620–43) of c.1637 (Chatsworth, Derbyshire)[14] echo one of Johnson's standard formats, seen for example in his head-and-shoulders portrait of *Sir Thomas Hanmer* (no.16).

Even the double-portrait format that van Dyck pioneered was not completely unprecedented in Britain, as demonstrated by the regional *Cholmondeley Ladies* of about 1610, perhaps the work of a painter based in Chester; the exact relationship between the two sitters – who are portrayed side by side, with their respective infants – is uncertain.[15]

It is clear nevertheless that van Dyck's synthesis of Antwerp baroque and Italian influences with many of the formats and elements already popular in British early seventeenth-century portraiture produced a type of representation that met with the overwhelming approval of King Charles I and of the majority of his court, as well as van Dyck's other, less illustrious sitters. It is this success and the extraordinary and long-lasting influence of this inventive artist, his pictorial strategies and enormous importance in the history of British painting, that are explored in these pages.

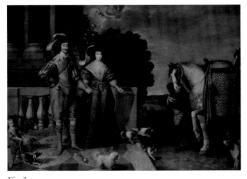

Fig.3
Daniel Mytens
Charles I and Henrietta Maria Departing for the Chase c.1630–2
Oil on canvas
282 x 377.3
Her Majesty The Queen (The Royal Collection Trust)

Van Dyck in Britain

Van Dyck, the Royal Image and the Caroline Court

Kevin Sharpe

The relationship between artist and patron, especially in the past, is often difficult to determine. Did a powerful patron, a prince or magnate, not only commission a portrait but also provide a clear brief for the canvas – pose, dress, accessories, and, indeed, its meaning? Or did the great artists, whose skills were in demand among emperors and kings, exercise a large measure of independence even in executing royal portraits? Was the representation of authority, or as we might put it today, the brand image, more the work of the ruler or the artist? It is tempting to suggest as a generalisation that the most powerful royal images in our history have emerged from a peculiarly symbiotic relationship between sovereign and painter. In the case of Charles I and van Dyck it appears certainly to be the case not only that the two formed a special relationship, but that the relationship transformed as well as expressed both of them. In van Dyck's hands Charles I, the former faltering prince and young king awkwardly depicted by Daniel Mytens, became the epitome of a majesty founded on natural authority and innate virtue. Under the patronage of Charles and his courtiers in England, van Dyck, departing from his earlier oeuvre, became almost entirely a portraitist – and a portraitist who effected a revolution in royal and aristocratic portraiture. In order to understand the importance of the relationship between king and artist, we must briefly consider them separately, and before van Dyck came to work for Charles in 1632.

Van Dyck had been a star pupil in Antwerp of Peter Paul Rubens. In 1629 Charles I had commissioned Rubens to paint scenes of the apotheosis of his father, James I, to decorate the ceiling of the Banqueting House at Whitehall, the showpiece of Stuart palace architecture.[1] Van Dyck had briefly visited England during James's reign, apparently at the invitation of Viscount Purbeck, brother of the king's favourite, George Villiers, Duke of Buckingham, and he probably painted canvases for Buckingham.[2] He received a royal pension, but apparently executed no portrait for the king and left after three months. Over the course of the next decade in Italy and Flanders van Dyck painted principally religious subjects, including several canvases of the Crucifixion and Lamentation and images of saints, as well as portraits of cardinals, doges and grandees. Before he left the Low Countries for England in 1632 he was still widely known as an artist of sacred works, although his work as a portraitist was growing in quantity and recognition and he was working for the courts at Brussels and the Hague. In the Protestant England of Charles I, however, this was to change. Although van Dyck executed a few mythological and historical canvases, and planned others, in the seven and a half years he sojourned in England – apart from a brief return to Antwerp and to biblical subjects in 1634–5 – he became principally a portraitist, producing some four hundred portraits for royal and aristocratic patrons.[3] It was not only the move to a Protestant country that influenced van Dyck's career and work. In England the artist came this time to work for a ruler who had a sophisticated appreciation of the arts and a firm belief in their role in government.

Charles I was the first real connoisseur king to occupy the English throne; he also had a philosophy of rule and a powerful sense of the role of the arts in the representation and exercise of kingship. His father, James I, had insistently argued for the divine origins and sacred nature of regal authority in a large number of treatises, collected in his folio *Works* of 1616.[4] Although Charles also believed in the Divine Right of Kings, his reign saw a marked shift in personal and political style. Less inclined to words than his father, Charles preferred to assert his majesty and his claim to divine authority by other means, visual and ceremonial.[5] In Spain, to which he had travelled in 1623 to court a bride, he had been particularly impressed

Van Dyck, the Royal Image and the Caroline Court

Fig.4
Inigo Jones
Salmacida Spolia
Scene 1: A Storm and a Tempest
Pen and brown ink
19.2 x 30.9
Devonshire Collection, Chatsworth

Fig.5
Inigo Jones
Salmacida Spolia
Scene 2: A Peaceful Country
Pen and brown ink
29.7 x 41.3
Devonshire Collection, Chatsworth

by Titian's portraits of the sixteenth-century Habsburg rulers hanging in the Escorial and other royal palaces, and had begun to collect the artist's work.[6] Furthermore, possibly encouraged after 1625 by his young French bride, Henrietta Maria, Charles devoted a great deal of time and attention to court masques, entertainments of music, dance and drama, as representations of his rule. Where James had never performed in masques – and on some occasions had displayed a lack of patience with them – Charles and his queen regularly performed and rehearsed them and staged them for each other. The overarching theme of the Caroline masques was the transformation from chaos to order with the arrival on the stage of the king – or queen. Since the royal actors did not speak, that transformation was effected by action, dance and changes in scenery: from scenes of darkness or storm to scenes of light and serene skies (figs.4, 5). An essential secondary theme was that of love. Charles I and Henrietta Maria represented their love as Platonic and chaste, a triumph of virtue and self-regulation over base appetites.[7] Since self-regulation was a principal virtue that equipped men for rule, such a representation depicted the monarch as the perfect Platonic king, qualified to govern by virtue as much as by lineage. The royal marriage was also represented on the stage as a model of government: joined as one, the king and queen, the 'Carlomaria' as one masque described them, ruled by love and example rather than by force.[8] Their union, it was argued, promised a loving relationship between a virtuous couple, and between them and their subjects who were led to virtue by them. In the words of one masque:

> All that are harsh, all that are rude,
> Are by your harmony subdued;
> Yet so into obedience wrought,
> As if not forced to it, but taught.[9]

Just as he changed the nature of Anglican worship to a more ceremonial and visual experience which expressed his personal form of piety, so Charles altered court rituals and ceremonies to reinforce his image as a sacred, virtuous king.[10] He brought in a new archbishop and ministers, putting aside the leading masque writer of the previous reign, Ben Jonson (1572–1637), to give more scope to the architect Inigo Jones (1573–1652) and his collaborators to represent visually his philosophy of rule. He was also, after some years, to dismiss Daniel Mytens, the 'picture drawer' who had continued in his employ since his father's reign and who had executed early portraits of the new king and his bride to send abroad. Indeed, Mytens seems to have fallen from royal favour within weeks of the arrival in England of the artist who was his nemesis, Anthony van Dyck.

The circumstances that brought van Dyck to London are not known. Charles I probably met the artist when he visited London in 1620, and the fact that in March 1630 the king seems to have purchased van Dyck's *Rinaldo and Armida* 1628–9 (fig.22, p.65) suggests that he had followed van Dyck's career.[11] What is striking is the speed with which Charles immediately lavished favour on the new arrival. Van Dyck, who landed on 2 April 1632, was knighted in July and the following year given a pension and the gift of a gold chain, and a house was sought for him. In 1633 the artist returned to Brussels; by March 1635 he was not only back in London, but a permanent residence in Blackfriars had been provided for him at royal expense; in April the king had a special staircase down to the Thames constructed in order to facilitate his visits to van Dyck's studio. As well as scores

of commissions for portraits, the royal favour continued unabated. Unlike so many unlucky servants of the Stuarts, van Dyck had his pension paid and the arrears were even made up in the midst of the serious financial difficulties faced by the Crown during preparations to fight the Scots in 1638. Charles's admiration for the artist was evidently reciprocated. It seems likely that van Dyck had not initially intended to stay in England but was persuaded to do so. In his *Self-portrait with a Sunflower* (fig.6), van Dyck advertised himself as 'Principal Painter in Ordinary to their Majesties': the artist wears a gold chain, probably that given to him by the king in 1633, and the sunflower is a symbol of devotion (and an allusion to the sun of regality).[12] The relationship between king and artist was clearly one of mutual admiration. Indeed, over seven years van Dyck revolutionised not only the arts of royal portraiture, but also, by transferring a royal philosophy on to canvas, the arts of royal leadership.

Van Dyck came to England at the height of his powers and with no little sense of his talent and reputation. Evidently he could be difficult, even when dealing with the great. The Cardinal Infante Ferdinand described him as capricious and irrational, and he had refused to finish some works of his former master, Rubens, preferring to repaint the subjects *ab initio*.[13] In England, even with the aid of several studio assistants, his output indicates that his workload was almost incredible; but van Dyck not only developed an affinity with his new country – to which (although he had entertained hopes of working in France) he returned to die – he adjusted his art to his English circumstances and particularly to the values of the Caroline court. We know little of his own values and intellectual development: we do know that he befriended the connoisseur and collector Thomas Howard, Earl of Arundel (1585–1646), and that he admired the treatise on art *De Pictura Veterum* (*On the Painting of the Ancients*) penned by Arundel's client and librarian Franciscus Junius (1545–1602).[14] Both Arundel and Junius professed a neo-Stoic belief in the moral force of the arts to inculcate virtue and it may be that van Dyck, who on his first visit to England had painted a classic depiction of neo-Stoic self-regulation, *The Continence of Scipio* (no.6), had a wider sympathy with that philosophy which was fashionable in the Low Countries in the early seventeenth century.[15] What we can say with more confidence is that, as well as appreciating Charles I's taste (van Dyck borrowed from and imported several references from Charles's beloved Titian, and even owned some of his works[16]), the artist appears to have understood the king's philosophy of rule and to have experienced the court masques in which it was represented.[17] It was arguably that understanding which cemented the relationship of king and artist and informed van Dyck's transformation of English royal portraiture.

It has rightly been observed that in his English portraits, unlike his earlier work, van Dyck often depicted sitters outdoors, including royal ones, and his compositions draw the viewer's gaze to the landscape beyond the figure(s). While in some cases the scenery can be identified, in most the landscapes are imagined. Like van Dyck's skies, many appear to owe a debt (which still needs full elucidation) to masque scenery and the ideological role performed by Inigo Jones's landscapes in masques. In placing his aristocratic subjects, and especially his royal sitters, in idealised pastoral surroundings and against serene skies, van Dyck not only underlined the poise and self-control of the sitter; he connected personal virtue and self-restraint with wider public values and social order. It was van Dyck's embrace of royal values, furthermore, that influenced other changes both in his own style and in that of the evolving English royal portrait.

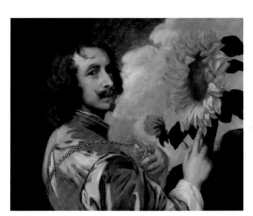

Fig.6
Anthony van Dyck
Self-portrait with a Sunflower 1633
Oil on canvas
58.4 x 73
Private collection

Van Dyck, the Royal Image and the Caroline Court

One innovation in England that was likely to have expressed both Charles I's and van Dyck's interest was the equestrian portrait. Van Dyck had executed equestrian portraits in Italy[18] and Antwerp[19] and may have painted the picture of Charles V now in the Uffizi.[20] In England, the equestrian portrait was 'almost unprecedented in … [painted] royal iconography', the most recent example being Robert Peake's of Prince Henry (at Parham Park; fig.2, p.12).[21] Charles may have wished to be represented as his elder brother Henry's martial successor in his two equestrian portraits by van Dyck; but van Dyck's *Charles I on Horseback* (fig.7) owes a more direct debt to Titian's image of *The Emperor Charles V at Mühlberg* (1547; Prado, Madrid), which Charles would have seen in Madrid. Furthermore, van Dyck's portrait expressed a philosophy very much at the core of Charles's values: in contemporary courtesy literature, mastery of a great horse was a symbol of the mastery of wild nature, of the passions, a virtue essential for aristocrats (the word aristocrat literally means 'the most virtuous') and princes.[22] Charles had been praised for his capacity to tame his horses 'with no bits' and to control 'their natural and brutish fierceness'.[23] It is this natural authority of the self-disciplined ruler that van Dyck presents in *Charles I on Horseback*. The king's left hand only lightly touches the reins of the vast dun charger which he rides at the trot with relaxed ease, against the backdrop of a tranquil sky and a peaceful landscape pacified by beneficent rule. Although the king wears his sword, his greatest strength is his virtue.

Van Dyck's other, probably earlier, equestrian portrait of Charles with the riding master M. de St Antoine (no.21) was probably painted in 1633 for the Gallery at St James's Palace, which was filled with portraits of mounted emperors by Giulio Romano and Titian. It is the image of a British *imperator*, an image of triumph. But again we might discern that the triumph is of virtue as much of as arms: as Charles rides through the arch (an ancient symbol of triumph) his equerry can only gaze upwards in awed admiration of the king, who turns his white horse with effortless skill: the pupil is here the true master because, as the masque *The Triumph of Peace* asserted the same year, he has mastered his passions.[24] We may discern, too, in the arch and in St Antoine's gaze, allusions to the sacred and Christic nature of kingship in which James I had tutored his son, showing Charles as one come to lead and redeem his people as the embodiment of faith as well as of virtue.[25]

It is in the context of van Dyck's two equestrian portraits that we might helpfully consider his depiction of Charles in the hunting field (fig.21, p.65). Though the canvas gestures to the portrait of Charles's mother, Queen Anne of Denmark (1617; Royal Collection), by Paul van Somer (c.1577–1621) and to Robert Peake's of Prince Henry (no.1), it is the differences and the innovation in van Dyck's work that are striking. Though he is painted in hunting costume, nothing in Charles's pose (unlike Prince Henry's) suggests strenuous activity. The king turns away from the horse behind him, and from the attendants whose busy activity highlights his calm tranquillity. While Charles's groom works to settle the beast, the horse bows its head in obeisance towards the king, who effortlessly commands the natural world. The composition of the canvas highlights his authority: he stands elevated on a grassy ledge, as one who commands naturally; his left elbow in foreshortening draws our gaze to his face, yet at the same time secures his command of space and of the viewer. Again there is a suggestion of a sacred dimension. Van Dyck may have taken the horse with its lowered head and the groom from Titian's *Adoration of the Kings* (probably the version now in the

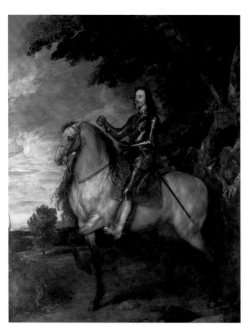

Fig.7
Anthony van Dyck
Charles I on Horseback c.1637–8
Oil on canvas
367 x 292.1
The National Gallery, London

Cleveland Museum of Art, of about 1556),[26] and so gestured to Charles as a Christ figure. But what is most innovative about this image – and characteristic of van Dyck's portraits of Charles – is absence: the absence of the regalia or escutcheons that usually signified royalty. Charles the man is king because he literally embodies authority and naturally commands. We see here the monarch's two bodies, personal and political, made one, the personalisation of power in paint.[27]

Love, marriage and family were central to Charles I's representation, not only as the traditional signs of dynasty, fertility and patriarchal authority, but also as the manifestations of neo-Stoical values of self-restraint and a neoplatonic philosophy of love and authority. Although Holbein and others had depicted Henry VIII and members of the Tudor royal family in dynastic canvases, van Dyck effected a revolution in the portrayal of the royal marriage and family. The influence here seems very much to have come from the patron: as Oliver Millar wrote, 'The double portrait, the relaxed conversation piece between relations … had appeared very seldom in van Dyck's work before he went to London'.[28] It was quite probably van Dyck's first double portrait for Charles that secured his ascendancy over Daniel Mytens. In around 1631 Charles had commissioned Mytens to paint a double portrait of himself and Henrietta Maria, holding between them a laurel wreath, an attribute of Apollo and Daphne (fig.24, p.71). The canvas did not please the king, who put it in store and commissioned van Dyck, soon after his arrival in 1632, to paint another version (fig.26, p.71). Since van Dyck's portrait, displayed prominently above the chimney at Somerset House, clearly pleased the king, its variations deserve attention as an early indication of the meeting of minds between artist and patron. Whereas in the Mytens version Charles and Henrietta Maria stand, somewhat stiffly, in an interior beneath red drapery, van Dyck positions them on either side of drawn green curtains opening to a vista of landscape and sky. The changed setting throws light on the silver slashing of the king's sleeves and on the queen's gown, which now has ribbons matching her husband's carnation suit. The matching colours symbolise their harmony and love, as do their (repositioned) hands, encircling the laurel to suggest victory over the baser passions. More than Mytens' portrait, van Dyck's is a public and political proclamation: not only did he add the regalia behind the king to connect a private love and marriage to that wider union between the monarch and his people; the laurel wreath placed exactly in front of the open vista suggests a relationship between personal and public commitments and values. Van Dyck's work not only stylistically improved the original version; he also made it a proclamation of the king and queen.

During his early months in England van Dyck was commissioned by Charles to paint at least nine 'pictures of our royal self and most dearest consort', for which payment was ordered in May 1633.[29] In some portraits the queen gestures to her pregnancy, holding her hands or a rose to her stomach.[30] Such portraits underline the fertility of the Stuart dynasty (note the crown placed on a plane with the rose and queen's womb: Gemäldegalerie, Dresden, and private collection, New York) after centuries of childless monarchs and disputed successions; but they do more. The rose, a symbol of Venus, was also associated with the Virgin Mary (Henrietta Maria's name was often anglicised as Mary in panegyrics). So once again it is chaste love and purity that are being depicted.

It would appear that this is also the conceit of van Dyck's most beautiful portrayal of Henrietta: that of the queen with her dwarf, Jeffrey Hudson (fig.8, p.20).[31] Mytens had earlier executed full-lengths of the queen with Hudson (fig.3,

Van Dyck, the Royal Image and the Caroline Court

p.13), but again van Dyck reworks and repaints the scene. The column and crown placed behind the queen signify authority and regality, and the orange tree on the ledge behind her right arm probably represents chastity and purity, the fruit in Dutch art being sometimes an attribute of the Virgin. The monkey tethered to Hudson's left arm was a familiar symbol of the senses and the baser nature of man. Henrietta Maria's gentle but firm right hand on the monkey asserts her control over such base appetites, her virtue and gentle regimen. While this canvas has been described as a 'lighthearted' allegory of the conquest of beauty over the passions, the crown and column invite us to read it like masque, as a representation of regality.[32] Indeed, a late van Dyck work, *Cupid and Psyche* (no.29), one of the artist's few mythological works in England, probably painted for the decoration of the Queen's Cabinet at Greenwich, captures the philosophy of the masques. For Cupid and Psyche represented divine love and earthly desire and their union not only represented the perfect platonic love but, in John Milton's words in his 1634 masque *Comus*, from it

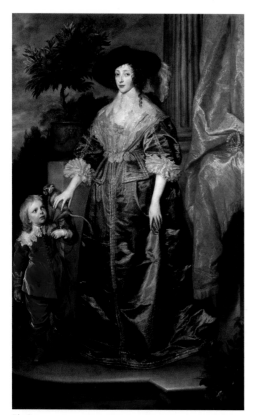

> Two blissful twins are to be born
> Youth and Joy[33]

Henrietta Maria was pregnant almost every year from 1629 and she gave birth to five children who were all still alive in 1640. Arguably van Dyck's portraits of the royal children were his most original contribution to the image of the monarchy; certainly his portraits of them convey an intimacy and tenderness greater than any to be found in his earlier family portraits executed in Antwerp and Italy. Charles's early commission of a family portrait within weeks of van Dyck's arrival, the large dimensions, and his description of the 'Greate Peece' (no.17) depicting himself, Henrietta Maria, Prince Charles and Princess Mary, suggest the importance of this painting, displayed prominently in the Long Gallery at Whitehall.

After five years of marriage, two children, born within two years of each other, demonstrated the fecundity of the young queen and the security of succession. But van Dyck's composition is no mere formal dynastic proclamation. Quite unlike earlier family portraits, the arrangement emphasised the loving relationship linking the sitters. Henrietta Maria, holding the infant princess, looks not outwards to the viewer but adoringly towards her husband, the loving paterfamilias. On her right Charles is seated with, between them, two dogs, traditional emblems of fidelity. The king's right arm reaches behind the figure of his son and heir, Prince Charles, who rests both his hands on his father's leg. Touch, gesture and gaze unite the group in domestic intimacy. But the representation is not only domestic: since Aristotle the family had been widely described as a 'little commonwealth' and kings were frequently referred to as fathers of their subjects. The 'Greate Peece' encourages the viewer to make that connection by leading the eye to the orb, sceptre and crown on the table behind the prince, to the paper in the king's hand – a reminder of business – to the column behind the king and, most of all, the vista opening in the background, with Westminster Hall and the Parliament House discernible. The love of the domestic family thus also represents the love and affection felt by the king for his people, and his loving, well-ordered family becomes a model of his beneficent rule.

Though he painted no other comparable family portrait, van Dyck produced three others of the royal children over the next five years. The last of these,

showing the five royal children, was painted for Whitehall in 1637 (fig.23, p.66). In this canvas Prince Charles stands facing the viewer, his siblings placed two on either side of him, his brother James's crimson sleeve echoing the colour of his own silk suit, connecting the male heirs. At the centre of the composition, young Charles places his left hand lightly on the head of a large mastiff, a symbol, like the horse, of wild nature, here governed by the reason and innate authority which a virtuous prince possesses, even at such an early age. Although Charles I, the father and monarch, does not appear in person, he is in many respects the subject of this painting: the sire of progeny and the father of the commonweal who has schooled his son in self-discipline in preparation for good government. In the background, to which the viewer's eye is led, the tranquil pastoral landscape and the dish of rich fruits with grapes signify the benefits of good, virtuous rule at a time when Charles I and his courtiers spoke of the happiness of England's halcyon days.[34]

The year 1637 marked the end of the Caroline peace and the beginning of the troubles that were to explode in civil war across the British Isles. The Scots resisted Charles I's new Prayer Book and, after the failure of negotiation, the king prepared for war. The shift from a leadership based on virtuous example and love to that of a martial prince asserting his sovereignty presented challenges, to say the least, to the poets and panegyrists who sang the king's and queen's praises.[35] In the case of paintings, it is notable that van Dyck's later portraits of both Charles I and his son showed them in armour. That of Charles I now in the Hermitage, St Petersburg, figures the king beside a table with an imperial crown and plumed helmet on it, and a gauntlet lying on the ground behind. Charles bears a sword at his left side, his left hand lightly resting on the hilt while in his right he grasps a baton of command.[36] What has been described as the 'oddity' of the right-hand gauntlet may indicate the challenge laid down to the rebellious Scots: to be ruled by the baton of peaceful regimen, as it were in the one hand, rather than the sword, in the other.[37] Whatever the possibilities, the idealised world of love and harmony forged by virtue and self-regulation had manifestly come to an end. Where only a couple of years earlier the young prince's hand resting on a mastiff signalled his future promise as heir to his father's philosophy of government, in one of the portraits of 1638–40 (no.23), which clearly draws from his figure in the *Five Eldest Children*, he appears in an interior setting and armoured, his left hand resting on a plumed helmet and his right holding a pistol.[38] The late portraits indicate that the future of Stuart rule – indeed, the future of the country – would be determined by arms. In 1640, as Charles went north to fight the Scots, van Dyck left for France in the hope of securing a prestigious commission there; he returned to die just before the onset of the Civil War in England.

In order to understand, indeed to appreciate, van Dyck's English work, the relationship between the artist and the king needs to be considered, and Charles I's aesthetic and political philosophy examined. The symbiosis of monarch and artist produced an entirely new type of royal image in England, with royal authority represented as psychological as well as philosophical, and no longer simply signified by the accoutrements of regality. Van Dyck, we might say, addressed the tensions in the theory of the king's two bodies (so well examined in Shakespeare's history plays) and rendered the personal and political bodies of the king as one.

Any assessment of van Dyck's royal portraits must obviously confront the fact that political events developed in ways quite contrary to Charles's philosophy of order and authority. Even before the outbreak of the Civil War in 1642, rather than the harmony represented in masque and on canvas, Caroline aristocrats and

Van Dyck, the Royal Image and the Caroline Court

courtiers were divided into rival factions by religious and ideological differences. The success of Charles I's royal image is too complex to be evaluated here;[39] but it is helpful to see the paintings, like the masques, not as simple statements of royal values but as part of the means of inculcating them, of persuading men and women to follow them. In that rhetorical process, van Dyck's non-royal portraits are important sources for the historian, complicating as they do the simple stories of emerging parties. What is striking about van Dyck's oeuvre is that he was patronised by not only future Royalists and those who clearly shared the king's religious and political values, but also by peers and gentlemen who were regarded as champions of Puritanism, or whose constitutional and political views were far removed from Charles's ideas of sacred kingship.[40] The 4th Earl of Pembroke (no.44), a major patron of the artist, and the Earl of Warwick (no.35), for example, were regarded as supporters of the Puritans and of godly clergy. Philip, Lord Wharton, commissioned van Dyck for numerous family portraits for his new long gallery (see p.88). Wharton was an ardent Parliamentarian who during the Civil War became a member of the Westminster Assembly of Divines, which met to restructure the Church of England and to establish a Presbyterian settlement; he also helped create the New Model Army which, under Cromwell, defeated the Royalist forces.

Since some historians of politics and culture have suggested a growing divide in taste between royal sympathisers and opponents, it is interesting that van Dyck's portraits of future Parliamentarians reveal no obvious stylistic differences from those of future Royalists. Although unquestionably depicted by van Dyck as a man of action, Warwick, not much a courtier during Charles's reign, stands in front of rich drapery, his armour behind him as he appears in fashionable and opulent courtly dress. As for William, Lord Russell, although on the outbreak of Civil War he accepted a commission in the Parliamentary Horse, his portrait image in sumptuous scarlet made him appear 'a quintessential Cavalier' (fig.29, p.86).[41] The pursuit of fashion, of course, has often overridden different ideological preferences; but in early Stuart England religious preferences were often expressed – and seen to be expressed – in external appearances, of dress as well as church interiors and furniture. If, on van Dyck's canvases, Catholic, Anglican and Puritan sitters do not appear very different – the one ironic exception being the intensely and almost uniquely austere portrait of Charles's archbishop, William Laud (no.41) – such images served to minimise those differences. The king himself appears to have sought to the end to unite his courtiers behind his authority. In his last masque, *Salmacida Spolia*, written by William Davenant and staged by Inigo Jones, Charles, as Head of the Church of England, and Henrietta Maria, his Catholic queen, (unusually) presented the entertainment together. The theme was reconciliation, both with the Scots and between the contending factions at court. At the close of this masque the revels were danced by leading courtiers of opposing religious and political views (critics of Charles like the Earls of Bedford and Pembroke and Lords Paget and Russell, as well as loyalists such as the Duke and Duchess of Lennox, and scions of the Howard family), as though to persuade the nobles to suppress their differences for the higher virtues and values embodied by mask. It is tempting in some ways to see van Dyck's portraits as similarly underplaying differences, as representing and even forging a courtly community of men (and women) who shared values. In nearly all his portraits, the air of natural command and authority of the sitter is striking, be he a member of the royal family like Lennox (no.31), a minister like Wentworth (no.42)[42] or Pembroke

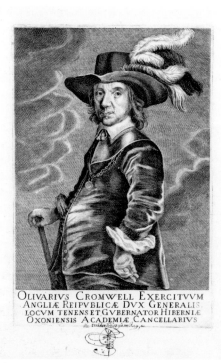

Fig.9
Unknown artist
Oliver Cromwell
Engraving
The British Museum, London

(no.44), a writer such as Sir John Suckling (c.1637; Frick Collection, New York) – or even the artist himself (nos.5, 65, 67). (As for the female portraits, nearly all are characterised by chaste beauty, purity and the command of the passions.[43]) Whatever the divisions between sitters, and the evolution of van Dyck's style during his period in England, the strong affinity between so many of these canvases makes them invaluable records of their age, as well as some of the greatest portraits of all time.

Van Dyck was enormously well regarded, not only by the English monarchy (Henrietta Maria wrote to Jean Druy, Abbot of the Park Abbey near Louvain, about the artist's excellent service[44]) and the aristocracy. There was a demand for countless repetitions and copies (some close to, some distant from the master's hand) for the houses of minor nobility and perhaps even for public buildings. Miniatures and engravings enabled images, particularly of the king and the royal family, to be widely circulated. Van Dyck's portraits were seen to be so powerfully evocative of authority that, although the Commonwealth regime ordered the royal collection to be sold, even Oliver Cromwell, who helped to bring Charles to the scaffold, directly appropriated poses, gestures and conceits from specific van Dyck royal portraits for his own image as Lord Protector (fig.9). At the Restoration, Sir Peter Lely, who first came to England from the Netherlands in 1641, executed portraits of Charles II, his mistresses and courtiers, very much in the style of van Dyck, as did, in some measure, Sir Godfrey Kneller (1646–1723) for William III, to whom he became principal painter in 1691.

Van Dyck's influence on English portraiture, on the work of Sir Joshua Reynolds (nos.118, 128), Thomas Gainsborough (nos.125, 126) and John Singer Sargent (nos.131, 132), lasted well into the twentieth century and is even discernible in some celebrity images in the more modern genre of photography. Van Dyck was, in later times, emulated and appropriated for his ability to render psychological insight into, and the natural command of, his sitters – as Charles I himself apparently ordered inscribed on the artist's tomb, van Dyck 'gave immortality to many'.[45] If the works of his English heirs and successors never quite live up to the brilliance of the original, that may be because van Dyck's achievement, his revolutionising of the English portrait, was not merely a matter of technical accomplishment but the product also of a cultural and political moment and milieu – and arguably of a philosophy – that were shattered on the battlefields of the English Civil War soon after the artist's death.

Fashioning the Modern Self: Clothing, cavaliers and identity in van Dyck's London

Christopher Breward

Blesse us! Why here's a thing as like a man
As Nature to our fancie fashion can.
Beshrew me, but he has a pretty face,
And wears his Rapier with indifferent grace.
Makes a neat congie, dances well and swears:
And wears his Mistresses pendant in his eares;
Has a neate foote as ever kist the ground,
His shoes and roses cost at least five pound.
Those hose have not a peere, for by relation,
They're cut a moneth at least since the last fashion.
He knows two Ladies that will vow there's none
At Court, a man of parts, but he alone.
And yet this fop, scarce ever learn'd to know
The mixture of the disjoyn'd Christ-crosse vow.
Strip off his rages, and the poore thing is then
The just contempt of understanding men.[1]

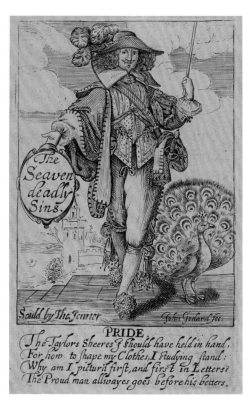

Fig.10
John Goddard
'Pride' from 'The Seven Deadly Sins' c.1629
Engraving
The British Museum, London

In his *A description of the Round-head and the Rattlehead* of 1642, an unidentified London pamphleteer provided this vivid account of the dress and demeanour of a 'rattleheaded' cavalier. Published in the year after van Dyck died in his house on the Thames and that the royal family finally departed from Whitehall, his sharply observed dissection of this effeminate courtier's attempt to clothe a spiritual hollowness in modish trappings illustrates the moral currency invested in sartorial matters at a moment of unique tension in the capital's social, economic and political history. Though the extravagance of courtly and metropolitan male (and female) dress had long provided a target for London's satirists and balladeers, the particular characteristics of its form that evolved through the 1620s and 1630s offered perhaps the most enduring template of elegantly poised worldly vanity. The graceful fall of the rapier, the single pearl earring, the expensive silk shoes and hose, and the pretty face (undoubtedly framed with luxuriant locks of long hair) described above, together with their parallel but more flattering depiction in many of van Dyck's portraits, produced a compelling image of aristocratic hauteur that set the highly fraught subject of courtly fashionability firmly in the contemporary consciousness. It is an image made more eloquent by our romanticised knowledge of its subsequent destruction in the 1640s. As Oliver Millar suggested in the catalogue to a previous Tate exhibition, of painting of the age of Charles I, "'In growing and enlarging times, Arts are commonly drowned in Action". The effect of the Civil Wars was to destroy the brittle fabric of the civilisation of the Caroline court'.[2] This essay looks to explain the material and visual context in which the 'brittle fabric' of fashion so described was produced and deployed, particularly on the bodies of men. It argues for a reading of van Dyck's London paintings that locates the seductive sheen of his sitters' dress in the varied spaces of their urban milieu – a milieu in which the combined management of body, image and identity held a powerful potential to reflect and inform both momentous change and more stable traditions.

Beautiful and magnificent: City of sticks and bricke – and cloth

When van Dyck first arrived in London in October 1620, at the invitation of John Villiers, Viscount Purbeck, and half-brother of the old king's favourite, the

Fashioning the Modern Self: Clothing, cavaliers and identity in van Dyck's London

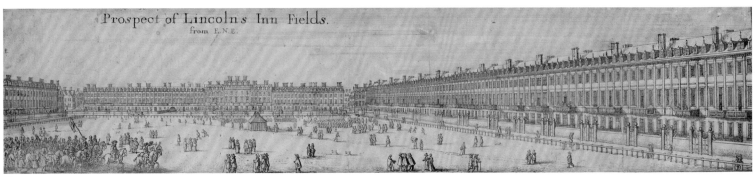

Fig. 11
Wenceslaus Hollar
Prospect of Lincoln's Inn Fields c.1641
Etching
85 x 389
The British Museum, London

Marquess of Buckingham, he would have found a city in the throes of rapid expansion. Pushing inexorably outwards from the old city walls, new suburban developments were spreading the capital's boundaries at a rate to rival Naples and Paris, the only other European centres whose scale exceeded that of what was swiftly becoming a new English version of classical Rome. As James I famously proclaimed, justifying his illegal selling of licences to build superior property developments:

> As it was said of the first Emperor of Rome that he had found the city of Rome of Brick and left it of marble, so Wee, whom God hath honoured to be the first of Britaine, might be able to say in some proportion, that we had found our Cities and suburbs of London of sticks, and left them of bricke, being a material farre more durable, safe from fire and beautiful and magnificent.[3]

By the time van Dyck returned in 1632 for permanent lodgings in Blackfriars and Eltham and a knighthood as 'principalle Paynter in ordinary to their Majesties' Charles and Henrietta Maria, the building projects initiated by James and given the seal of a more artistic approval by his son had matured, setting the ground-plan for the subsequent growth of a world city that by the end of the century could claim to be the largest and most vibrant in Christendom. The palatial transformation of the Strand, the laying out of Leicester Square and Covent Garden and the development of Lincoln's Inn Fields, under the speculative leadership of men like the earls of Salisbury and Bedford, were radically altering the nature of the urban landscape.

Behind the neat façades of the rebuilt districts and in the teeming medieval streets which still constituted great swathes of Westminster and the City, demographic and economic trends also played their part in re-fashioning London as the modern centre of cosmopolitan style in which the talents of a man like van Dyck could flourish. In the first half of the seventeenth century the population of the capital grew from 200,000 to 375,000, accounting for around 7 per cent of the nation. Many of these residents were provincial and international migrants seeking work or training as apprentices in the Guilds or legal students at the Inns. More affluent members of the gentry and aristocracy also came and went with increasing frequency, in time with the newly established social season.[4] All were in need of accommodation, sustenance, clothing, equipment and entertainment and, inevitably, their needs brought with them the overcrowding, poverty, disease, disorder, pollution and barely controlled sprawl that both marked London as a monstrous dystopia and ensured the sense of edgy pride and excitement that today would be associated with the concept of contemporary city living. Little wonder that the courtier Peter Heylin should protest in the 1630s that London

is grown at last too big for the Kingdom' and that 'Great towns in the body of the State are like the spleen … in the body natural; the monstrous growth of which impoverisheth all the rest of the Members … And in the end cracked … by its own fullness, not only sends unwholsom fumes and vapours unto the head and heavy pangs unto the heart, but draws a consumption on itself.[5]

The consumption of luxury and fashionable goods was in fact the fire that powered the life of the city – its heat drawing on the fuel of industrial and craft production and international trade. Economic historian A.L. Beier provides an insight into the varied commercial ecology of just one West End parish, St Dunstan's, in the late sixteenth and early seventeenth centuries, noting an unmatched

> clustering of professional men and auxillary trades … over half [its] occupations involved some form of manufacturing … building, 6 per cent; clothing, 22 per cent; leather, 12 per cent; and metal, 10 per cent, with tailors, shoemakers and cutlers especially numerous. If … the gentry led the new trends towards conspicuous consumption, the producers of luxury goods were likely to be located close to this profitable market [which] clearly stimulated a large service sector. Even excluding servants per se, it accounted for 10 per cent of positions in St Dunstan's in the West, including two musicians and a tombmaker, which was roughly twice the level for other [outlying] parishes.[6]

A study of thirty-four houses occupying one plot on the Strand in the early 1600s reveals a similar pattern of intensive activity revolving around the making and selling of fashionable commodities. These accommodated 'two saddlers, two shoemakers, two cutlers and two chandlers, a sempster, goldsmith, tailor, spectacle maker, confectioner, apothecary and a milliner'.[7]

Besides drawing on local production, London's growth and prominence as an international centre of fashion in the period also benefited from shifting patterns of foreign trade. The Far Eastern activities of the newly established East India Company accounted for 5 per cent of imports, including pepper, cloves, nutmeg and other spices, 'raw silks, calico, indigo and saltpetre for gunpowder'. From the 1620s contact with the New World brought tobacco in increasing quantities.[8] Further luxuries, such as sugar, citrus fruit and wine joined the silk stockings, lace collars, Venetian glasses, watches and coaches that together were becoming staples rather than rarities on the wealthy Londoner's shopping list. It is no surprise that the new specialised shops of the capital stretched to the provision of 'everything from imitation flowers fashioned of animal horn to trained falcons'.[9] Home-produced rather than imported products were also constantly being introduced, as the incorporation of new companies for watchmakers, spectacle makers and gunmakers in the 1630s attests, and particular groups of immigrants, such as the Dutch of East Southwark, made a sizeable contribution to the birth of 'specialised industries such as … felt and hat-making, dyeing and textile manufacture'. In Bow, the Dutchman Cornellius Drebbel discovered and produced a brilliant scarlet dye, which during the 1630s found immediate favour amongst London's fashion-hungry cognoscenti.[10]

What is significant in all of this innovation is the degree to which cloth, clothing and the fitting up of the body, especially the male body (with everything from timepieces to guns), played such a prominent role in London's rising fortunes.

Fashioning the Modern Self: Clothing, cavaliers and identity in van Dyck's London

On the eve of Civil War in 1640, 'textiles amounted to some 87 per cent of ... total [exports from London], about half of which consisted of the lighter ... New Draperies ... The [traditional] broadcloth industry was languishing, and these ... bays, says and frisadoes provided a vital new element' both to local wardrobes and to the international reputation of the city as a source of new fashions.[11] As historian Stephen Porter attests, 'most English cloth passed through London and much of it was finished there. Indeed, clothing was the capital's largest single industry, occupying one fifth of its workforce ... Cloth valued at roughly £1,150,000 was exported from London in 1640, three quarters of the national total, and that was a poor trading year'.[12]

There is little doubt that, at the top end, much of the material product of London's fashion trade and manufacture found its way into the wardrobes of those attached to the court – those, indeed, who sat for van Dyck – and the potential market here was enormous. While the sixteenth-century court of Elizabeth I supported a household of around 1,000 and that of Queen Anne in the early eighteenth century around 950, at its height in the early 1630s, Porter estimates that a Caroline court of 2,600 members cost just over £250,000 each year to maintain and 'represented one of the largest communities in England, bigger than all but the largest provincial town'.[13] The symbiotic relationship between host city and court, forged via conspicuous consumption, 'had thus given rise to a fashionable urban society larger and far more complex than either could have supported alone'. As Malcolm Smuts observes,

> Van Dyck's portraits sold for between £30 and £50, less than some courtiers spent on a suit of clothes ... These sums were not small, but they appear almost insignificant compared with the thousands of pounds great courtiers spent annually on jewels, clothing, gambling and lavish banquets ... [A] courtier's wardrobe might cost more to maintain than an orchestra, and a single evening of entertaining in the grand style or a few hours at cards more than a room full of art treasures and the gratitude of a dozen poets.[14]

Alongside metropolitan renewal, the stuff of dress was a serious matter indeed, more serious even (or at least more intrinsically valuable) than its visual representation on canvas.

Fashion at court

As Kevin Sharpe has argued, the Palace of Whitehall had played a central role in disseminating an idea of monarchy based on visual magnificence and sartorial display since the reign of Henry VIII. This role naturally encouraged an effect whereby the court emerged as the prime model of virtuous fashionability for the nation – attracting increasing numbers of qualified individuals to enrol in its functions and sending news of its personalities, ceremonies and festivals out to the provinces. By the 1620s and the accession of Charles I, the duty of the courtier had crystallised to include the presentation of 'an idea of that which is possible; to pursue in his own life decorum, discretion and self-regulation that he might represent the possibility of human self-perfection'.[15] Following a period in which the idea of a morally progressive concept of courtly magnificence had been somewhat sullied by the general loucheness of James I and his entourage, a renewed emphasis on order through regulated ritual and the careful manipulation of

splendid objects and imagery was swiftly reimposed by the new Caroline regime. Sharpe positions the glorious self-presentation of Charles and his courtiers, recorded and promoted through van Dyck's innovative portrait techniques, as

> the most powerful and perhaps last manifestation of the Renaissance belief in the didactic power of images.... [In] their capturing of the very essence of nobility ... their richness of dress never becomes indulgence; the record of their office never a blatant boast; their pose is one of 'psychic balance' rather than swagger. The subjects appear ... natural, themselves ... because they have command of their own unruly appetites and so have fulfilled their highest nature.[16]

Fashion historian Susan Vincent describes the way in which this conscious self-fashioning was promoted through the circulation of conduct books such as Castiglione's *The Courtier* (1528), Thomas Elyot's *The Governor* (1531) and Giovanni Della Casa's *Galateo* (c.1551–4), characterising its theatrical execution as a constant play between notions of disguise or masking and revelation.

> Thus one's appearance and outward behaviour could affect viewers and, to a certain extent, manipulate their responses. But presenting a self conscious model like this ... could run extremely close to deceit ... For the cultivated exterior was not a 'true' mirroring of internal reality. Conduct books recommended the reader to appear better than he was: more knowledgeable, more skilled, wittier, more urbane.[17]

Such closely regulated fictions extended across all aspects of the court of Charles I, finding an apotheosis in the culture of the masque, whose sumptuous neoplatonic imagery formed a principal tool of royal propaganda. As Sharpe argues,

> it was a political ideology that the masques performed at Whitehall communicated to those ... in positions of authority who might translate [their] ideals into practice within their own sphere of influence.... In an era of non-bureaucratic government, in a realm that lacked a standing army, in a system of patronage, the communication of ideas and principles was a principal art of politics. The highest mysteries of cosmic harmony, and their inter-relation with the government of the commonwealth and the regulation of the self, were the politics of Caroline art.[18]

This tension between self-promotion and regulation found strong echoes in the manipulation of the courtier's wardrobe. From the top downwards the careful management of dress formed a prime political duty. In the first decade of Charles's reign expenditure on the royal wardrobe doubled from £13,000 per annum to over £27,000 (due in part to the needs of the queen), and whilst an investigation of abuses in the late 1620s curbed excessive consumption, an attention to detail and propriety still dictated the maintenance of an appropriate level of regal display. Regality, for the king, tended towards an expensively produced restraint – where a combination of softly dulled and shimmering surfaces, muted tones and fine complementary trimmings formed a decorous and finely worked whole. In this espousal of a sober gravitas in dress he echoed the advice of Henry Peacham, whose conduct book *The Compleat Gentleman* of 1622 offered the emperor Charles V's

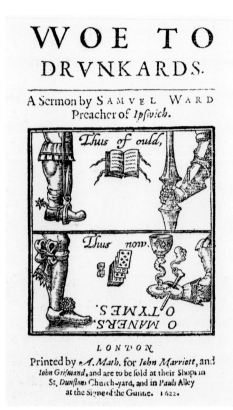

practice of appearing 'as plaine as any ordinary gentleman' as a model for emulation.[19] The shift towards subtlety in colour and cut, away from the overt magnificence that had been achieved through surface decoration in the sixteenth and early seventeenth centuries, did not simply indicate a decline in conspicuous consumption. Instead it heralded a more finely coded set of sartorial rules.

George Kirke, Charles's Gentleman of the Robes, recorded details of the making, materials and price of the king's garments during the early 1630s which underscore the theme of increasing subtlety. In 1631 he patronised London tradesmen, including Patrick Black the master tailor, George Garret the woollen draper, Robert Austen the mercer and Walter Eldred the silkman, for the furnishing of items such as a 'suit and cloak of black colour watered taffeta laced with small satin laces. Doublet cut thick in panes lines with taffeta and edged with bone laces. Cloak laced with satin lace and lined and cut with open taffeta. £44 14s 06d'. Around thirty suits ranging in price from £27 to £117 were ordered each year, alongside a handful of riding coats and cloaks, spectacular 'masquing apparel' in 'white … with silver spangles', and a wide range of accessories including hats, hatbands, boots, shoes, swords, nightcaps, gloves, girdles, slippers, silk hose, garters and Holland drawers. Most evocative, however, are the careful notations of textile shades, whose variety reflects the fecundity and sophistication of the contemporary London retail landscape and the important role played by colour in communicating allegorical meaning.[20] The palette extended through beaver, willow, sage, grass and sea green, carnation, rose, dove, sand, straw, primrose, peach, sky, cinnamon, deer, musk and honey.[21]

The exquisite finish of the fashionable courtly image of the 1630s is also discernible in a doublet and breeches and a Flemish lace collar held by the Victoria and Albert Museum.[22] The suit, in stamped and pinked white satin (where the fabric was first dampened and then treated with a heated tool and sharp awl to produce the delicate lozenge and petal pattern that mimicked the treatment of leather in bookbinding), lined with linen and buckram and trimmed with braid and silk ribbon, accords well with Susan Vincent's characterisation of dress in the early part of Charles's reign, when 'individual details no longer obtruded onto the eye, and parts of an ensemble were pressed into service for the good of the whole'. Similarly, the Flemish linen bobbin lace with its thirteen deeply scalloped edges decorated in alternating designs of potted flowers, double-tailed mermaids, eagles and crowns was designed to drape lightly and fluidly across the shoulders, heightening the shining mass of satin beneath. Vincent rightly observes that 'the typical Caroline portrait emphasises the play of light sliding on its surface. In a stock pose the subject furthers this effect by lightly grasping the abundant and satiny billows'.[23]

Beyond the newly refined material details of everyday elite dress, mention of reflective surfaces and stock poses also suggests two further innovations associated with the courtly culture of Whitehall and frequently represented in van Dyck's work. The first was the reinvention of the chivalric tradition, whereby the martial heroism of the Accession Day tilts, the annual festivities which had been such a feature of the Jacobean court and the circle of Charles's elder brother Prince Henry, were replaced by a more nuanced, subversive and almost anti-chivalric attitude, promoted by the retinue of the Duke of Buckingham and quickly taken up by groups of young aristocratic men on the fringes of the court. An investigation of the Privy Council in the mid-1620s

revealed the existence of at least three such societies of knights and gentry, meeting in alehouses in the verge of the Court, as burlesques of the chivalric orders of knighthood. They took mock oaths mixed with a number of other ridiculous toys … as having a Prince whom they call Ottoman, wearing of blue and yellow ribands … [and] having certain nicknames.[24]

Kevin Sharpe and Peter Lake point to the pro-Spanish, anti-Puritan tendencies of these sects, whose mock-heroics parodied the patriotic call-to-arms of anti-popish polemicists. Arguably their antics were little more than adolescent posturing, rather like succeeding instances of subcultural dandyism, and had little significance beyond metropolitan coteries.[25] However, it is significant that both political positions drew heavily on the symbolism of the defunct tournament with its heraldry and armour – and engaged both positively and negatively with the trappings of courtly dress. The title page of a 1622 Puritan sermon, *Woe to Drunkards*,

> employs the chivalric iconography of the tournament to contrast an idealised warlike (and by implication moral) past with a foppish and degenerate present. The gauntleted fist grasping the tournament lance is contrasted with the emblems of the contemporary vices of gambling, tobacco and the cockatrice – cup of the literally demon drink; the soldier's boot with the effeminate courtier's shoe.[26]

At the heart of court culture, a second refinement of the visual and political language of knighthood resulted in the promotion of the Order of the Garter as 'the cynosure of the Caroline reformation of chivalry'. From April 1626, all Knights of the Garter were ordered to wear the escutcheon of the Cross of St George embroidered on their cloaks and riding habits 'at all times … and in all places and assemblies'. The 'sacrilised aspect of the Order was further stressed when Charles ordered that the escutcheon … be surrounded with an aureole of silver rays in imitation of the insignia of the French order of the Knights of the Holy Spirit'.[27] Mention of embroidery by John Shipley costing £115 on thirty-seven taffeta, satin, chamblett and cloth cloaks for the Order of the Garter in Kirke's Royal Wardrobe accounts of 1631 attests to the widespread adoption of the cult, while van Dyck's 1633 portrait of James Stuart, Duke of Richmond and Lennox, and its preparatory drawing (probably commissioned on the occasion of James Stuart's election to the Order in April of the same year), capture its dramatic visual impact.[28]

Charles himself was painted in the regalia of the Order on several occasions, and the 1632 van Dyck image (the 'Greate Peece', no.17) of the king with Henrietta Maria and their two eldest children with the sweep of the Thames behind them, completed for the Long Gallery at Whitehall, is 'a bravura display of technical skills' deployed in the detail of 'the delicate lace-edged ruff and collar, the glitter of the silver braid and aglets on the doublet, the decorative cuts on the pinkish-lilac lining to the cloak, the shine on the slightly wrinkled silk stockings, and the shoes of punched white leather with spiky shoe roses'.[29] But it is the 1633 van Dyck equestrian portrait of Charles with his French riding-master and equerry, the Seigneur de Saint Antoine, that most effectively captures the radical redefinitions of knighthood emanating outwards from the court. Clad in 'English tournament armour made at Greenwich between c.1610 and 1620 … the King [is

Fashioning the Modern Self: Clothing, cavaliers and identity in van Dyck's London

revealed] as one who has proved himself in the lists ... made explicit by the lance-rest fixed conspicuously to the right-side of the breast-plate'. Here 'the context of iconographical reference is classical; yet it remains one which is nevertheless emphatically chivalric: an image of the King as former tournament-knight, as "St George himself", the champion of the Caroline peace'.[30] Beyond the court, in the streets and stews, taverns and theatres of 1630s London, the figure of the cavalier made a similar play with the practices of self-fashioning, extending Sharpe and Lake's insistence that 'the diversity of Caroline chivalry bears witness ... to an eclectic tradition which offered a variety of role models and a plurality of values'.[31] As the final section of this essay demonstrates, such parallels and pluralities find traces both on the fantastical surfaces of van Dyck's canvases and in the work of his contemporaries, and amongst the bodies of the city's broader population.

Cavaliers, bodies, gestures

While conduct books described ideals in courtly behaviour, popular satirical literatures, associated with the more variegated life of the city streets, also depicted a series of fashionable characters. Historian Margaret Pelling demonstrates how such stereotyping, with its stress on appearances, was a direct result 'of the anxieties caused by social mobility and urban excess ... Many writers signified their intention of adapting the fashionable bauble of the looking-glass to serious purposes: metaphorically, they held up a mirror to reflect deformity'. The deformity in question was often of a moral and sexual nature, and found its most vivid manifestation in the peculiarities of contemporary dress. Echoing the dual function of court dress as a vehicle of conspicuous display and self-regulation, Pelling suggests that

> refinements introduced into the town dress of the wealthier classes pointed to the same desire to combine ostentation with concealment. It seems reasonable to connect this with a high incidence of, and even increased sensitivity to, defect ... caused by disease in the context of a crowded society ... The pre-eminence of the face was stressed by many styles of the period, notably ruffs. Small looking-glasses were attached to the costume like fobs. It is not surprising to find that masks were also worn ... by both sexes.... By a similar desire and fulfilment, men's hair became longer and women's hair more visible, just when it seemed that the likelihood of hair-loss by disease was at its greatest.[32]

Though the tracing of material connections between historical physiology and dress is necessarily a speculative affair, art historians have drawn similar links between the physical conditions of urban life and their representation in the visual culture of the 1630s and 1640s. Richard Godfrey makes just such a case in his description of Wenceslaus Hollar's etching of a fashionable female figure symbolising 'Summer' in his *Four Seasons* of 1644:

> a woman is seen in profile, stirring the air with a fan in her left hand. Her complexion is protected by a beautifully etched veil. The view beyond shows St James's Park ... the Banqueting House and old St Paul's Cathedral. The luscious landscape and serene clear sky may not be entirely fanciful. The curse of the London atmosphere was sea-coal, brought from Newcastle. In 1644, however, Newcastle was besieged and could not export ... John Evelyn

notes in 'Fumifugium' that, as a consequence, London had a bounteous summer, with rich summer foliage and an unusual abundance of fruit.[33]

So, besides plague and venereal disease, we might also consider the degree to which pollution informed the dressing habits of seventeenth-century Londoners. But beyond conjecture, what is clear is the extent to which the urban milieu generated a number of real and imagined concerns focused around the subject of fashionability.

The stresses and confusions of city life were no less fraught within the confines of the Court itself, whose heterogeneity gave rise to numerous overlapping factions. 'Catholics and Puritans, Hispanophiles and Francophiles, the pacific and the belligerent, English and Scots' all lived in close proximity, leading historians to cast doubt on the existence of any serious cultural divisions between the worlds of the court and the city in the 1630s that might have given rise to later demarcations between the styles of the Roundhead and Cavalier. What is clear, however, is that the characterisation 'Cavalier' was current in both courtly and metropolitan spheres during van Dyck's time in London; its meaning, though lacking explicitly partisan political significance, certainly carried with it concerns about appropriate modes of masculinity and an engagement with the fashionable life. The future parliamentarian Robert Rich, 2nd Earl of Warwick, was painted by van Dyck in 1634 resplendent in a crimson cloak and breeches, gold and silver-worked doublet, and pink stockings with silver rosetted shoes; hardly the image of the sober Puritan (itself a construction that bears little relation to the actual clothing choices of those following 'puritan' religious and moral precepts). Indeed, the Venetian Ambassador's description of Warwick, defender of liberty and enterprising supporter of protestant colonies in Massachusetts and the West Indies, as 'that cavalier' clearly referred more to the gallantry and sartorial brio evidenced in the portrait than it did to any sympathy for the kingship of Charles I.[34]

Literary historian Thomas Corns has provided a useful lineage for the term, working back from its powerful role as a damaging stereotype in the 1640s. Corn draws on the rich satirical descriptions of pamphleteers, such as 'a spoof account of a Cavalier Parliament' where the assembled Royalists 'are made to admit that they are "old beaten souldiers of Bacchus" recognisable by "the manner of our Periwigs, the length of our curled or crisped hair, by the pearle or ribbins at the eares," by the "nicety and curiosity of the habit," by the "gingling of the coach-wheel rowled spurs," and by "the French troubled straddling of the legs"'. Such constructions, Corns argues, 'reactivate an established pejorative image of the professional soldiery available well before the spiral into open warfare' and develop 'the ancient … tradition of anti-court writing, which represented the monarch's courtiers as ruthless, foppish, esurient, and lecherous'.[35] What is significant here is the insistence on the trappings of violence as an important component of the cavalier mode, a violence that sits in exquisite juxtaposition with the supposed effeminacy of long hair, rich textiles and jewellery, and often finds its way into contemporary portraits through the ostentatious display of armour and weaponry: 'spurred riding boots, buff coat, and the identifying officer's sash.'[36]

In aristocratic circles the cult of violence was seen both as 'a legitimate means of preserving vested interests and maintaining social pre-eminence'. It manifested itself through 'the personal violence of duels and assaults' and the execution of 'political violence' at court, and it had strong links to the vicious 'honour code' that still prevailed in mainland Europe. As Caroline Hibberd suggests, 'although England was not at war abroad save for a few years in the first half of the

Fig.13
Wenceslaus Hollar
'Summer' from 'The Four Seasons' 1643–4
Etching
The British Museum, London

Fashioning the Modern Self: Clothing, cavaliers and identity in van Dyck's London

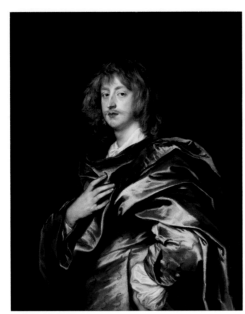

Fig.14
Anthony Van Dyck
George, Lord Digby, later 2nd Earl of Bristol c.1638
Oil on canvas
103.2 x 83.2
Dulwich Picture Gallery, London

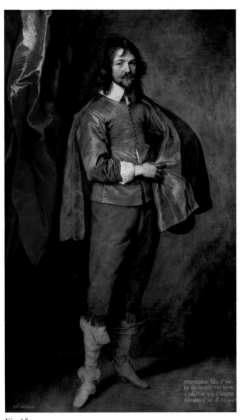

Fig.15
Anthony van Dyck
Portrait of Arthur Goodwin, MP c.1639
Oil on canvas
219.1 x 130.8
Devonshire Collection, Chatsworth

seventeenth century, and although relatively few Englishmen served for extended periods in foreign armies, large numbers of young gentlemen combined travel abroad with … a desultory experience in warfare'. Hibberd offers up the example of Lord Herbert of Cherbury, who in 1616 spent time in the Low Countries, and 'since there was no campaigning that year contrary to his hopes and expectations, [he] satisfied himself with lesser activities, horsemanship, chess playing, making love, and meanwhile raised a troop of horse for service in Saxony'.[37] By the 1630s such posturing even carried global connotations, for as John Carpenter notes in his study of the representation of young Japanese noblemen in decorative arts of the Kan'ei era (1624–44), men of the sword across the world were often depicted as 'picnickers, philanderers and poseurs', their elegant Kabuki-derived stances twisting the weight of their bodies around the tensile curve of a sword. This masquerading he compares to Daniel Mytens' 1629 portrait of the 1st Duke of Hamilton, which 'despite [the] emblems of a man of action … conveys the impression of an effete soldier manqué'.[38]

Van Dyck's portraits of men of the Caroline elite, from the gloriously disdainful Lords John and Bernard Stuart in their brilliant gold, silver and sky-blue satin silks to the more pensive George Digby, Earl of Bristol, and the MP Arthur Goodwin (figs.14, 15) in their muted soft rose and ochre cloaks, all of the later 1630s, present the same combination of confident swagger and knowing sensuality. All make conscious play of gesture, thrusting an elbow into the picture space while the hand rests gently on the hip, as if in deliberate reference to the 1616 Italian text on deportment by Bonifacio, *L'arte de Cenni*. In this the writer 'devotes a fascinating section to the elbow and the arm akimbo, which he describes as giving the impression of strength', as if those adopting the pose were pushing 'their way through crowds'. By the mid-1640s, not surprisingly, such overt courtly posturing seemed entirely out of place and time. Now in the context of parliamentarian London, the thrust of an elbow drew entirely negative commentary. John Bulwer's *Chironomia* of 1644 advises that 'to let the arms agambo … and to rest the turned-in back of the hand upon the side is an action of pride and ostentation, unbeseeming the hand of an orator'.[39]

Alongside the politics of gesture, the style of hair most associated with the image of the cavalier also drew the ire of Puritan moralists through the 1630s, 1640s and 1650s. Cultural historian Will Fisher describes a whole series of sermons and broadsides that

concentrated on men's hair and chastised them for nourishing long locks. In Edward Reynolds's 'the Sinfulnesse of Sinne' (preached at Lincoln's Inn), he insists that 'long hair' on men is 'condemned by the dictate of Nature and right reason.' He cites Saint Augustine as an authority on the subject, noting that 'he hath written three whole chapters against this sinful custome … whiche he saith is expressly against the precept of the Apostle.'

More humorous critiques also focused on the fashion, one anonymous one advising '"The long-haired Gallants of these times" … to … "Go … to the Barber's, go, and bid them your hairy Bushes mow./ God in a Bush did once appear,/ But there is nothing of him here"'. And Samuel Rowlands' satirical pamphlet *Earth's Vanity* of 1632 also 'ironically asserts [that] "Your Gallant is no man unless his hair be of the woman's fashion, dangling and waving over his shoulders"'.[40]

That condemnation of long hair was not reserved for the rich and powerful

is also suggested by the constant and generally unsuccessful attempts of the London Guilds to curb fashionable excesses amongst their apprentices. Paul Griffiths relates how 'numerous acts, watches, wards and committees' were set up in the first four decades of the seventeenth century 'to force uniformity in dress on the youth of London'. The last committee before the Civil War sat 'in November 1638 to "advise and consider" the dangerous freedom claimed by apprentices in their extravagant clothes … and discussed a suitable curb on the "libertie [taken] in wearing of long hair'. Griffiths continues: 'It was vital to differentiate sex roles at an early stage, so that young men could be adequately prepared to employ and govern others.' Furthermore,

> magistrates and moralists associated fine clothes [and an 'unnatural' concern with appearances] with wayward promiscuous youth. The hunger for fashion to parade in the bachelor's social round also produced young spendthrifts and pilferers … Worse still, these examples of inordinate pride upset social order, including age-relations. The public demonstration of social order was not only an issue of choreographed rituals like processions … individual appearance, especially clothing and hairstyles, was also subject to the critical gaze.[41]

Van Dyck's images of fashionable masculinity record, then, not just the sartorial predelictions of a doomed elite; they also speak of a more universal concern, one that in the coming century would continue to define the political economy of England in different but significantly linked ways. Kevin Sharpe and Stephen Zwicker have argued recently for a contingent understanding of 'Fashion' in the period that extends from Renaissance scholars' understanding of a 'material and psychological moment' in the sixteenth century, characterised by the term 'self-fashioning', to the 'moment' in the early eighteenth century when 'commodity culture, no longer the privilege of an aristocratic elite, democratised the opportunities for self-presentation'. The 'theatrum mundi', they suggest, 'was one of the oldest metaphors of social and political representation, a figure brilliantly extended throughout Renaissance political and literary discourse. But for the Augustans the metaphor of theatricality diffused into common social discourse, and even social practice. Like the donning of dress, the adoption of personae and performance of roles were characteristic … of the social theatre'. In the 1630s, as this essay has proposed, styles of masculinity tested and performed in the court and in the wider fashion culture of London, bridged these two positions. For in the mid-seventeenth century, as in the eighteenth and twenty-first, 'fashion and role, seemingly vehicles for self-expression, are also the instruments for the social inscribing of the self: social role and persona in the end fabricate personality. The creation of the self, we might discern, is a process of interiorizing all the instability and incoherence of society and state'.[42] Van Dyck, it would seem, had an intuitive understanding of the manner in which the drama of fashionable dress could be deployed to represent these profound complexities at a moment of extreme social and political flux.

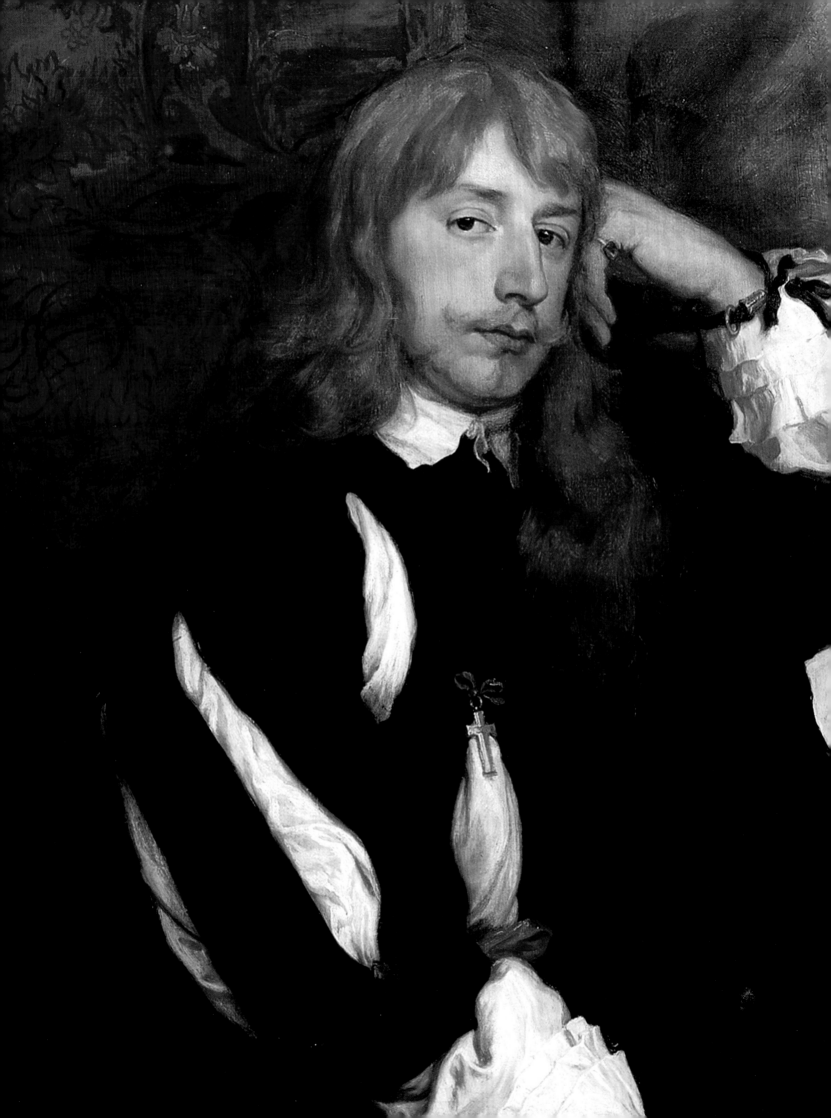

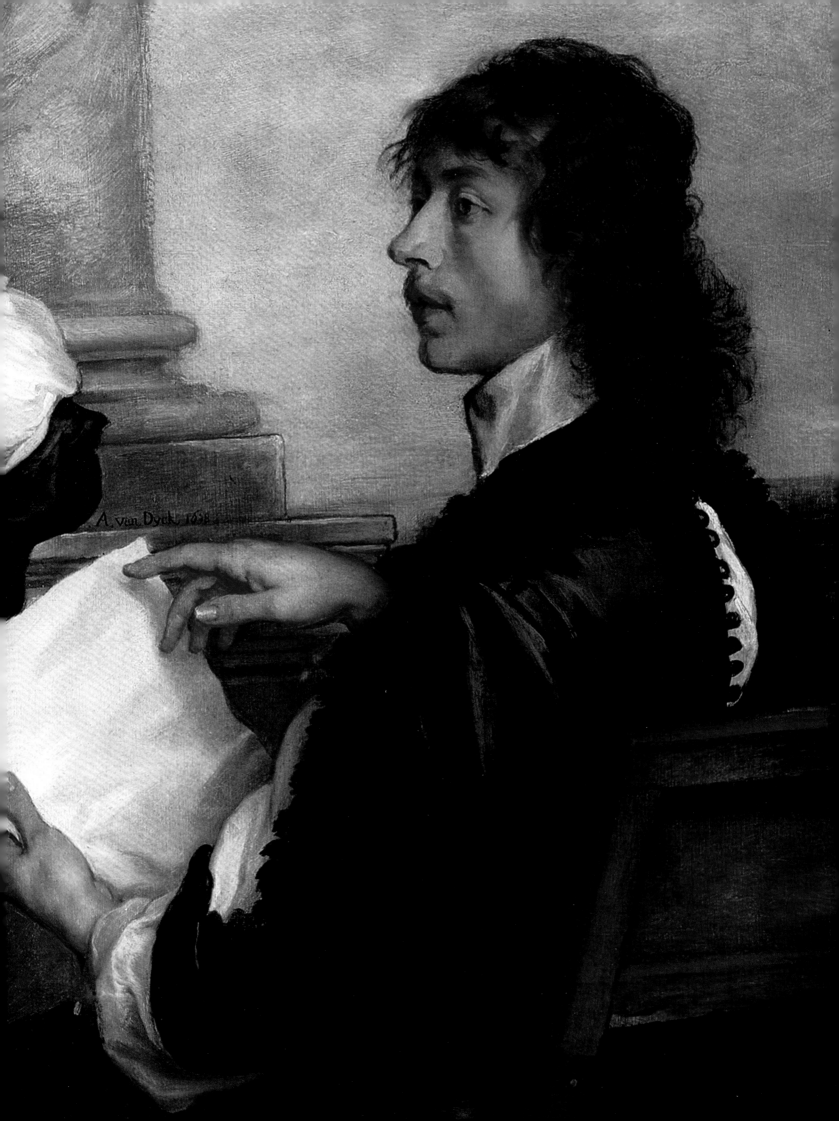

Painting in England before van Dyck: His first visit in 1620–1 and its aftermath

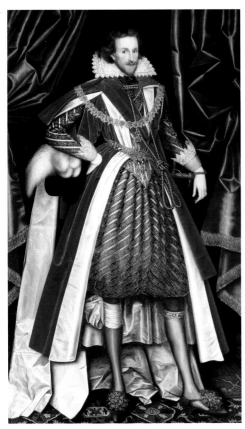

Fig.16
Attributed to William Larkin
Portrait of Philip Herbert, Earl of Montgomery, later 4th Earl
of Pembroke c.1615
Oil on canvas
213.5 x 125.5
From the private collection of Lord Braybrooke, on display
at Audley End House, Essex

Following the death of Elizabeth I in 1603 the Scottish king, James VI, became James I of England. The two separate nations became uneasily united. Unlike Elizabeth, James was married and had children. As a result, royal portraiture no longer meant the image of a lone female. Although James I showed only occasional interest in having his own portrait painted, individual portraits were now commissioned of his queen, Anne of Denmark, and of his eldest surviving children – his heir, Henry, Prince of Wales (who was to die young in 1612), Prince Charles (the future King Charles I) and Princess Elizabeth (later, briefly, Queen of Bohemia).

Early seventeenth-century London was a large, expanding melting pot with a significant population of religious and economic migrants from the Continent. Many trades were transformed by the influx of newcomers, which caused much anxiety to English craftspeople, who attempted various protectionist measures in retaliation. Incomers who worked for the court, like van Dyck, were generally exempt from these restrictions.[1]

Little is known about the lives and careers of painters who practised in Britain during this period.[2] They worked in a comparatively linear, non-naturalistic style. The leading painters to the court and the nobility – John de Critz I (c.1551/2–1642), Marcus Gheeraerts II (1561/2–1636) and the miniaturist Isaac Oliver (c.1560/5–1617) – were the London-raised offspring of migrant incomer craftspeople. In 1605 de Critz was appointed Serjeant-Painter to James I, and in 1606 he was paid for full-length portraits of the king, the queen and Prince Henry to be sent as gifts to other rulers overseas. Numerous similar portraits of James survive from this period – full-lengths, half-lengths and head-and-shoulders – evidently based on a restricted number of prototypes. De Critz clearly ran a large London studio which produced these images, although no specific details of this are known; it was probably located at Holborn Conduit, within the City of London. He officially remained Royal Serjeant-Painter until his death in 1642, although Charles I apparently used him and his team for decorative and restoration work alone. Gheeraerts, born in Bruges and brought to Britain as a child by his painter father, had been the principal court portraitist during the final decade of Elizabeth I's reign.[3] James's queen, Anne, employed him for her portrait images; Gheeraerts may also have collaborated with de Critz, who was his brother-in-law. Anne commissioned her portraits in miniature from Oliver, who was also related by marriage to Gheeraerts.

The leading English-born artists included Robert Peake (c.1551–1619), who became principal painter to James's heir, Prince Henry (see nos.1 and 2), and was a close neighbour of de Critz. Another painter who gained court patronage was William Larkin (c.1580–1619). Meanwhile, in the field of portrait miniatures, Elizabeth I's official miniaturist Nicholas Hilliard (1547–1619) continued to work in this role under James I.[4] The deaths in 1619 of these three English artists left the market open for a number of incoming Netherlanders.

From about 1616 onwards a handful of migrant painters from the northern Netherlands came over to work for the royal family and leading courtiers. They produced sober, serious images of their elite clients. Paul van Somer, born in Antwerp, arrived in London in 1616 and became the favoured image-maker, initially for Queen Anne and then for James I himself. He quickly supplanted de Critz and Gheeraerts in royal favour, before his early death in the winter of 1621/2. The most prolific, and long-staying, of this migrant group of portrait painters was Daniel Mytens, who was born in Delft in about 1590, worked at The Hague, and

Painting in England before van Dyck: His first visit and its aftermath, 1620–1

came to London in the summer of 1618. He was soon working for the discerning 14th Earl and Countess of Arundel and in 1621 painted James I (see no.3), who granted him an annual royal pension in 1624.

This was the artistic community in the London to which van Dyck came late in the reign of James I. Reports of his remarkable ability had preceded him. The Countess of Arundel had sat to Rubens in Antwerp for her portrait in the summer of 1620, and her secretary Francesco Vercellini had reported in a letter back to her husband the earl that '… Van Deick is still with Signor Ribins, and his works are hardly less esteemed than those of his master'. The circumstances of van Dyck's first arrival in London are not entirely clear, but he was there by late October 1620.[5] In February 1621 he was paid £100 for having performed some 'speciall service' for James I; the following month he returned to Antwerp.[6] Only a handful of works painted during this first visit survive, including a cutting-edge portrait of the leading aristocratic art patron and collector Arundel (no.7). Already a patron of Daniel Mytens, Arundel was the most active of a number of English collectors of works of art, including Italian paintings. Van Dyck was able to study these collections in the London residences of Arundel and other more politically active courtiers (see no.11).[7]

By November 1621 van Dyck had arrived in Italy, where he worked successively in Rome, Venice, Palermo and Genoa. While in Italy he made portraits of travelling Britons, including Sir Robert and Lady Shirley (nos.9 and 10). He returned to Antwerp by mid-1627 (see nos.14, 15), having acquired a number of Italian paintings which he was later to bring with him to England.

Meanwhile, painters and patrons in London had noted van Dyck's work. Recognising his impact on court clients with avant-garde taste, local painters incorporated elements of his Flemish baroque manner in their own portraits. The clearest example of this is Mytens's portrait of Philip Herbert, later 4th Earl of Pembroke, which is manifestly based upon van Dyck's seated portrait of Lord Arundel (see nos.7 and 8).

In 1625 James I died. He was succeeded by his son Charles I, a keen enthusiast of Italian painting, particularly from Venice. On his visit to the court of the Spanish king Philip IV in 1623, Charles had seen how art could be used to create and enhance the image of a monarch.[8] By now an informed interest in art had become a marker of elite status. Many leading court figures had become serious collectors, acquiring works of art from abroad and encouraging artists from overseas to come to London.

At his succession in 1625 Charles I appointed Mytens his 'picture-drawer' for life, and from then on regular payments were made to him for portraits for official use (see no.12). During the 1620s Mytens portrayed many of the principal figures at court. In some cases these images survive in multiple versions, indicating that he must have run a studio with associates and assistants. During the 1620s various other Netherlandish artists (including those who were not portrait specialists) came over to work in London, aware that there was a new market for art production there. Some, such as Claude de Jongh (c.1600–1663), Gerrit van Honthorst (c.1590–1656) and Hendrik Pot (c.1580–1657), came for brief visits but others remained for longer periods. From June 1629 until March 1630 van Dyck's master, Peter Paul Rubens himself, was present in London as a diplomatic envoy for the Archduchess Isabella, the ruler of the southern Netherlands, and her nephew Philip IV of Spain (see no.13). During this visit it seems finally to have been agreed that Rubens would produce the nine great

canvases that comprise the still extant ceiling of the new Banqueting House at Whitehall Palace. The ceiling was an immense baroque celebration of the achievements of the late James I. The canvases were completed in Antwerp by August 1634.

The London-born Cornelius Johnson forged a career in London during the 1620s and 1630s. In 1632 (the year in which van Dyck returned to Britain) Johnson was appointed 'picture-drawer' to the king, although in the event he seems to have received few royal commissions.[9]

Notes
1 Susan Foister, 'Foreigners at court: Holbein, Van Dyck and the Painter-Stainers Company', in Howarth 1993, pp.32–50; Edmond 1978–80.
2 Hearn 1995, p.171.
3 Hearn 2002.
4 Edmond 1978–80; Hearn 2005.
5 See David Howarth, 'The Arrival of Van Dyck in England', Burlington Magazine, vol.132, 1990, pp.709–10. Lord Purbeck, the eldest brother of George Villiers, later Duke of Buckingham was reported to have brought van Dyck over to England.
6 Ibid. On 28 February Arundel testified that van Dyck had been given a passport to travel abroad for eight months.
7 See Chaney 2003, pp.1–124.
8 Alexander Samson (ed.), The Spanish Match: Prince Charles's Journey to Madrid, 1623, Aldershot and Burlington, VT, 2006.
9 Hearn in Roding 2003, pp.113–29.

1

Robert Peake (c.1551–1619)
Henry, Prince of Wales, and Sir John Harington in the Hunting Field 1603
Oil on canvas
201.9 x 147.3
The Metropolitan Museum of Art, New York, Purchase, Joseph Pulitzer Bequest, 1944

Prince Henry Frederick (1594–1612) was the eldest son of James VI of Scotland, who became James I of England following the death of Elizabeth I in 1603. Henry would have inherited the British throne had he not died of typhoid fever in November 1612. He was keenly interested in sport, including hunting, and in military and naval activity, and considerable hopes were invested in him by the Protestant pro-war faction at James's court.[1] A severe Protestant, austere in manner, he became a notable collector and patron of the arts.

Painted in the year that King James came to the throne, this portrait depicts Henry in the hunting-field, with the 11-year-old Sir John Harington (1592–1614), who was to become his closest companion. It is thought that this painting may have been commissioned by Harington's parents, Lord and Lady Harington of Exton, whom James I entrusted with the upbringing of Henry's seven-year-old sister, Princess Elizabeth (no.2), in August 1603. A companion portrait, depicting Elizabeth standing alone in a similar landscape, is now in the National Maritime Museum, Greenwich.[2]

The two boys are identified by heraldic shields painted above their heads, and by their inscribed ages, along with the date 1603 (twice). Harington kneels, while the standing prince either draws or sheathes his sword, apparently having exercised the royal prerogative of making an incision in the neck of the dead stag on the ground before him. The prince is attended by a groom leading his richly caparisoned horse, and by a white hunting dog.[3] As Henry here wears the blue ribbon and St George jewel denoting his membership of the Order of the Garter, this image must post-date his investment to the Order on 2 July 1603.

This is one of the most remarkable British portraits to survive from the early years of the seventeenth century. It is interesting to compare it with van Dyck's celebrated large-scale portrait, *Charles I in the Hunting Field*, of about 1636 (fig.21, p.65), painted more than thirty years after the present work.[4] In his depiction of Henry's younger brother Charles, van Dyck reworked many of the same elements – the countryside setting, two male subordinates, a magnificent horse standing to the right-hand side, viewed in profile – to produce a wholly different effect. Van Dyck showed Charles as a private gentleman, elegant and relaxed, resting his hand on a cane, his sword sheathed at his side.

In about 1606–7 Peake painted another version of this double portrait, probably with help from assistants. The new version is extremely similar to this one, except that instead of Sir John Harington, Prince Henry is accompanied by another young friend, Robert Devereux, 3rd Earl of Essex (1591–1646), son of Elizabeth I's executed former favourite.[5]

Robert Peake had been apprenticed to a London goldsmith in 1565, becoming a freeman of the London Goldsmiths' Company in 1576, the year in which he is recorded as working as a 'paynter' for Elizabethan court festivities.[6] Little is known of the early years of his career. In 1607 he was appointed joint serjeant-painter to James I. He produced a number of portraits of Prince Henry, and appears to have acted as the prince's official portraitist. Particularly after Henry's death, Peake also painted portraits of the prince's younger brother, the future King Charles I, receiving related payments in 1612, 1613 and 1616. KH

Notes
1 T.V. Wilks, 'The court culture of Prince Henry and his circle, 1603–1613', D.Phil. diss., Oxford University, 1987; *ODNB* 2004, vol. 26, pp.560–4, entry on Henry Frederick, Prince of Wales by James M. Sutton.
2 Hearn 1995, no.126, pp.185–6.
3 Baetjer 1999, pp.9–13.
4 Barnes et al. 2004, no.IV.50, pp.466–8. Van Dyck described it as 'Le Roi alla ciasse' in his memorandum listing the pictures he had painted for Charles I.
5 Millar 1963, vol.1, no.100, p.79. It seems to have entered the Royal Collection in the early eighteenth century, see *Princes as Patrons*, exh. cat., National Museum and Gallery, Cardiff, 1998, no.1, pp.25–6.
6 *ODNB* 2004, vol.43, pp.274–5, entry on Robert Peake by Karen Hearn.

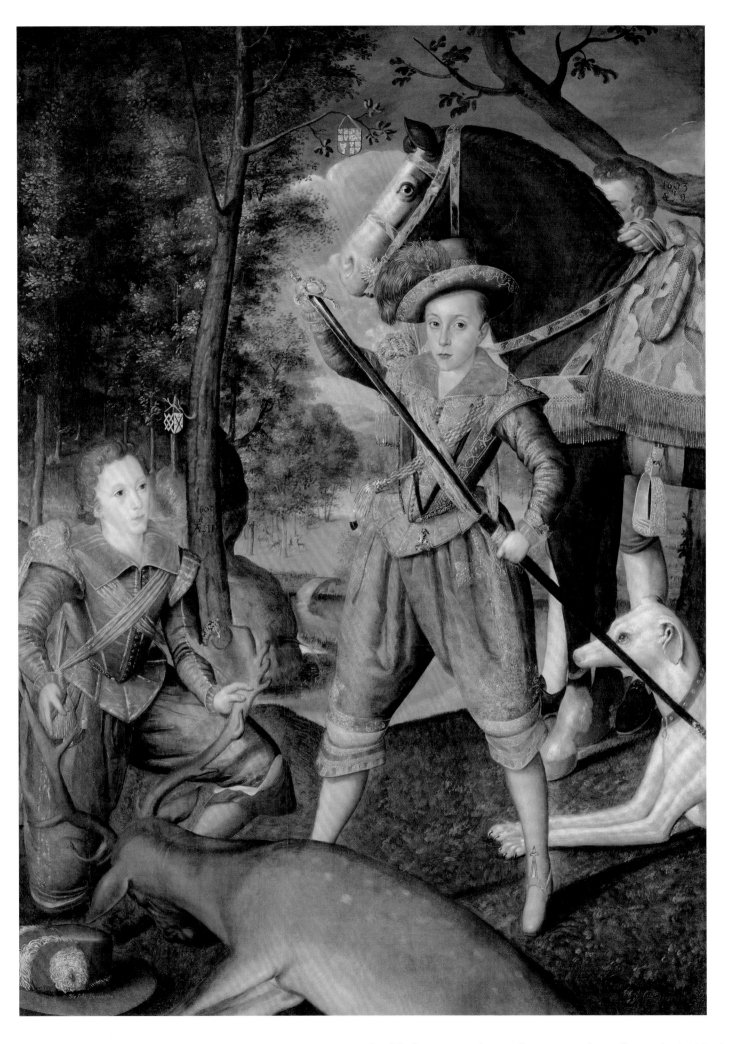

Painting in England before van Dyck: His first visit and its aftermath, 1620–1

2
Robert Peake (c.1551–1619)
Portrait of Princess Elizabeth c.1606
Oil on canvas
154.3 x 79.4
Inscribed on book: 'No Tablet / For thy
brest / Thy Chr[ist]ian mo / ther gives hir
/ Dattere What / Jewell Fits hir / best A
boke not / big but yet ther / in Some hidden
/ Vertu is So christ / So christ Procur. you
/ grace with / God and / give you / endles
[bliss(?)]'
The Metropolitan Museum of Art, New
York, Gift of Kate T. Davison, in memory of
her husband, Henry Pomeroy Davison, 1951

This beautiful royal portrait is at present
little known in Britain.[1] Princess Elizabeth
(1596–1662) was the sister of Prince
Henry Frederick (no.1) and daughter of
James I (no.3) and his queen, Anne of
Denmark (1574–1619). Stiffly vertical and
static in presentation, this work is highly
characteristic of elite English portraiture at
the start of the seventeenth century.

Elizabeth holds a book bearing an
inscription indicating that it had been
presented to Elizabeth by her mother, Queen
Anne.[2] The 'Tablet' referred to in the first
line would probably have been a flat-cut
or table-cut jewel, perhaps similar to the
diamonds making up the chain that runs,
like a sash, over Elizabeth's right shoulder
and across her body. It was characteristic
of English paintings of this period that
diamonds were depicted as black stones; this
convention is still seen in van Dyck's work.

The little princess is dressed like
an adult woman, in a French or wheel
farthingale, a fashion favoured by her
recently deceased godmother, Elizabeth I: it
can be seen, for instance, in the celebrated
'Ditchley' portrait of the queen by Marcus
Gheeraerts II (c.1592; National Portrait
Gallery, London). The embroidery on the
princess's dress, in the form of twining stems
and branches with leaves and blossoms,
is typical of English work of the early
seventeenth century.[3]

On 14 February 1613, in London,
Princess Elizabeth was married to a German
nobleman, Frederick, the Elector Palatine,
and travelled with him to his palace at
Heidelberg. The couple's subsequent
brief reign in Prague as King and Queen
of Bohemia ended in 1620 when they
were forced into exile at The Hague; here
Elizabeth spent most of the rest of her life,
raising her numerous children. Two of her
sons, the princes Charles Louis and Rupert,
were to be among van Dyck's sitters.[4] At
the Restoration of her nephew Charles II

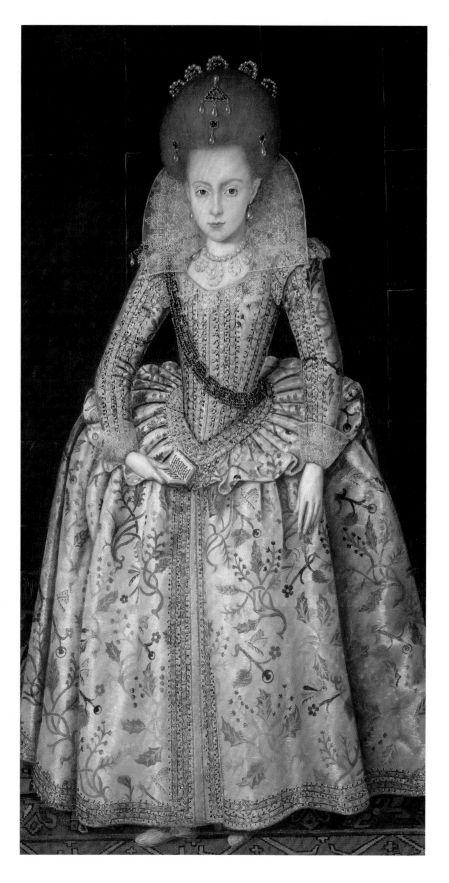

in 1660, she was at last able to return to
England, where she died the following year.
Known to contemporaries as the 'Winter
Queen' or the 'Queen of Hearts', it was
through Elizabeth's line that the House of
Hanover inherited the British throne; her
grandson became King George I. KH

Notes
1 Baetjer 1999, pp.10–13.
2 Ibid., p.11.
3 See Hearn 2002, p.44, and North 2008; see also Lea
Nevinson 1939/40 and Wingfield Digby 1963.
4 Barnes et al. 2004, nos.IV.69–IV.72 and IV.207, pp.485–
7, 591.

3

Daniel Mytens (c.1590–1647)
Portrait of King James I 1621
Oil on canvas
148.6 x 100.6
Inscribed top left: 'BEATI PACIFICI' and
'Jacobus DG / Brit: Magna / Rex / Aet/ svæ
56 / 1621'
National Portrait Gallery, London

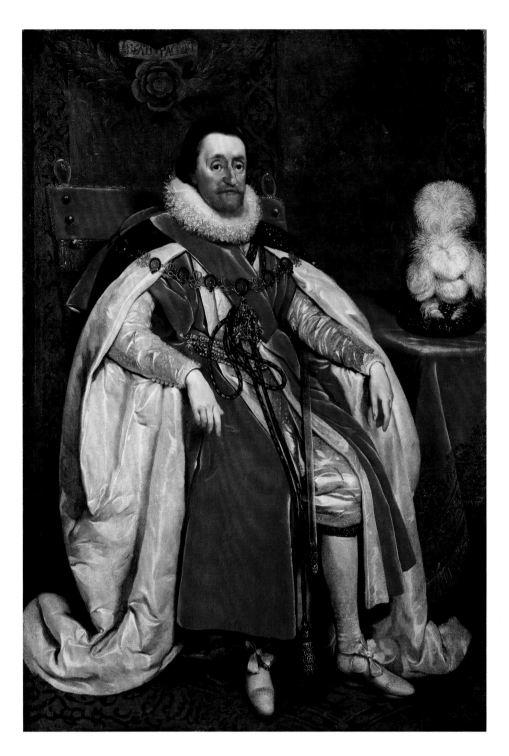

This remarkable portrait depicts the British king shortly after van Dyck's brief first visit to England. Seated, he wears a white satin suit and the scarlet robes of the Order of the Garter. On a table to the right, covered with a red gold-embroidered cloth, is the king's black hat decorated with a jewelled hatband and ostrich feathers. There is a carpet on the floor and behind the chair is a tapestry, with, above, a Tudor rose and a scroll inscribed 'BEATI PACIFICI' ('Blessed are the peacemakers'). An inscription to the left, at the side, identifies the sitter and gives the date of the painting. The history of this work prior to its acquisition by the National Portrait Gallery in 1860 is unknown. Other versions of this image also survive, indicating its official status.[1]

James I (1566–1625) was the son of Mary, Queen of Scots (1542–87) and, following her abdication, was crowned King of Scotland as an infant. At the death of Elizabeth I in 1603 he succeeded to the English throne and strove to unite his two territories as Great Britain. After his accession he made peace with Spain in 1604 and attempted to pursue a policy of peacemaking in Europe. 'Blessed are the peacemakers' was a motto frequently associated with him.

Daniel Mytens, or Mijtens, was born in Delft and probably trained at The Hague and had been working in London since at least 1618 for elite court patrons. In about 1618 he produced the two celebrated seated paired portraits of the Earl and Countess of Arundel (National Portrait Gallery, at Arundel Castle), depicted in front of works of art in their collection.[2] The earl was one of the most discriminating collectors and patrons of the age and was painted by van Dyck in 1620–1 (see no.7). After the departure of van Dyck – who did not paint James I – to Italy, Mytens seems to have taken on the role of royal portraitist.

Mytens conferred on his sitters considerable dignity, in a formal Netherlandish manner, particularly useful for a monarch whose own physical appearance was not naturally royal. In the words of a hostile commentator Sir Anthony Weldon, James I was 'of a middle stature, more

corpulent through his cloathes than in his body, yet fat enough … his eye large, ever rowling after any stranger came in his presence … his Beard was very thin … his legs were very weak …'.[3] Some of these physical elements are evident in the present portrait, and the king seems to cut a melancholy figure. By 1621 his eldest son, Prince Henry (no.1) was dead and his queen, Anne of Demark, had passed away in 1619. Meanwhile, his daughter Elizabeth (no.2) and her husband had lost the throne of Bohemia and were living in exile at The Hague, their cause a matter of intense pressure at court.

On 19 July 1624 James granted Mytens a life pension of £50 a year, on condition that he serve him and his heirs 'faithfullie and diligently'. After James's death in 1625, his son Charles appointed Mytens 'one of our picture-drawers of our Chamber in ordinarie', for life, with a (reduced) annual salary of £20.[4] KH

Notes
1 Strong 1969, vol.1, no.109, pp.177–8, 180.
2 See Hearn 1995, nos.140–1, pp.208–12.
3 Cited in Strong 1969, p.178.
4 *ODNB* 2004, vol.40, pp.91–3, entry on Daniel Mytens by Anne Thackray.

Painting in England before van Dyck: His first visit and its aftermath, 1620–1

4

Paul van Somer (c.1577/8–1622)
Lady Elizabeth Grey, Countess of Kent c.1619
Oil on wood
114.3 x 81.9
Tate. Presented by the Friends of the Tate
Gallery, 1961

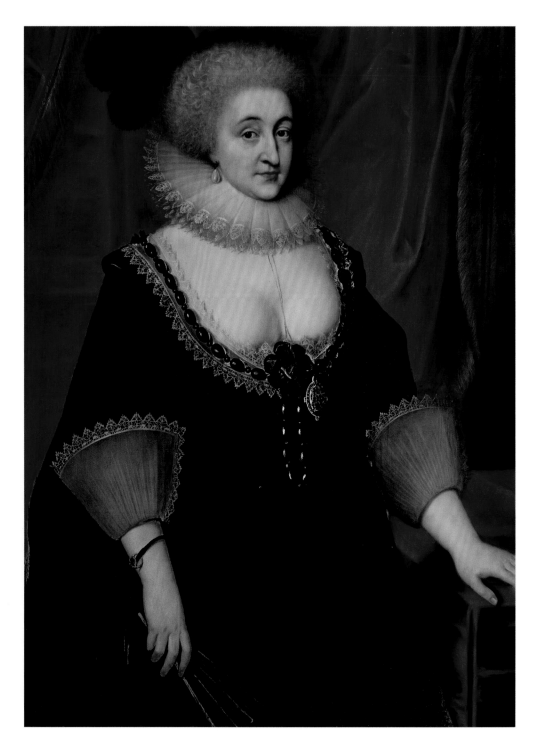

When van Dyck first visited England, in
1620–1, almost all the leading court painters
were incomers who had been born and
trained in the Netherlands. The principal
figures were Daniel Mytens (nos.3, 8, 12),
Abraham van Blijenberch (active in England
1617–21) and Paul van Somer.

Van Somer had worked in Amsterdam,
Leiden, The Hague and Brussels, but had
settled in London by December 1616.
Although his career in England was to last
only five years, from the outset he worked
for the most elite court patrons. In 1617 he
portrayed James I's queen, Anne of Denmark,
at full-length in hunting attire (Royal
Collection), a work in which he reinvented
her visual image. The following year he did
the same for the image of James I himself,
depicting him in line with mainstream
continental fashion, with the royal regalia on
a table at his side (Royal Collection). On 13
May 1619 van Somer attended the queen's
funeral as her 'picture maker'; less than three
years later he, too, had died.[1]

Lady Elizabeth Talbot (1581–1651) was
the daughter and co-heiress of the 7th Earl
of Shrewsbury – one of her sisters, Alatheia,
was married to the Earl of Arundel (see
nos.7, 38, 79). In 1601 Elizabeth had married
Henry Grey, Lord Ruthin (d.1639), who
succeeded his father as 8th Earl of Kent in
September 1623.[2]

The present painting is known to
have belonged to Charles I, as it appears
in the inventory of his collection made in
about 1639. Lady Grey had been a favoured
attendant of Anne of Denmark and had
walked in her funeral procession as a
'Countess Assistante'. The fact that she is
attired in black, including black jewellery
in the form of expensive egg-shaped jet
beads, suggests that this portrait may relate
to the mourning period after the queen's
death. Below her heart she wears a jewel –
possibly a closed portrait-miniature case
– with the crowned monogram 'AR' –for
the Latin 'Anna Regina' ('Anne the Queen').
A similar miniature case, containing the
queen's portrait and presumably given
by her to another of her attendants,
Lady Anne Livingston, survives in the
Fitzwilliam Museum, Cambridge. The
signet ring threaded on a black ribbon round
Lady Kent's right wrist may also have a

memorialising significance. It is engraved
with the image of a breed of dog known as
a 'talbot' – evidently a punning reference to
her maiden surname. Her low décolletage
is a fashion paralleled in other Jacobean
female portraits, including those of Queen
Anne herself.[3] Such exposure, even for ladies
of mature years, was evidently considered
entirely acceptable, although presumably
confined to an elite court circle only. KH

Notes
1 See *ODNB*, vol.51, pp.559–60, entry on Paul van Somer
by Karen Hearn.
2 *Tate Gallery Report*, 1960–1, pp.30–2.
3 Ribeiro 1987, pp.12–13, repr. in colour.

5

Self-portrait c.1620
Oil on canvas
119.7 x 87.9
The Metropolitan Museum of Art, New
York, The Jules Bache Collection, 1949

This is one of three portraits that
van Dyck painted of himself in around
1620, all apparently deriving from the same
sitting.[1] It is thought to have been made
during the eighteen months preceding his
journey to Italy in autumn 1621, when
he lived in both London and Antwerp.
Because the painting is known to have been
in London by 1676, when it was in the
collection of Henry Bennet, 1st Earl
of Arlington (d.1685), it is thought to have
been painted while van Dyck was there.[2] In
support of this, it has been pointed out that
his depiction of his hands closely resembles
that in *The Continence of Scipio* (no.6), also
produced while he was in Britain.

Van Dyck depicts himself with
considerable self-confidence, richly dressed
in black satin and with a dark red velvet
doublet and leaning upon a ledge below a
column.[3] The long, elegant fingers of his
right hand draw attention to his loose white
silk shirt, freely painted. His pose is relaxed
and informal:[4] this is presumably van Dyck
as he wished to be seen by his new clients
and potential patrons at the Jacobean court.

Bellori described the artist's appearance
when he was in Rome thus: 'He was still
young, his beard barely sprouting, yet his
youth was accompanied by grave modesty
of character and nobility of mien, albeit he
was small in stature. His manners were those
of a lord rather than a commoner, and he
appeared resplendent in rich attire of suits
and court dress …'.[5] KH

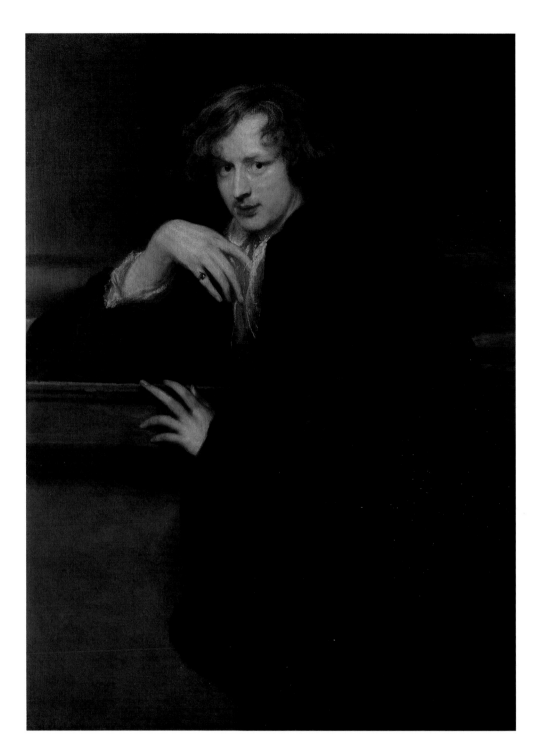

Notes
1 The other two are in the Alte Pinakothek, Munich
(Barnes et al. 2004, no.I.159, p.138), and the State
Hermitage Museum, St Petersburg (Barnes et al. 2004,
no.II.26, pp.169–71).
2 Barnes et al. 2004, no.I.160, p.138; see also Walter
Liedtke et al., *De Vlaamse schilderkunst in Noord-amerikaanse
Musea*, Antwerp 1992, pp.12, 26, 241, 243.
3 See Katlijne van der Stighelen, 'Van Dyck's First
Antwerp period: Prologue to a Baroque Life Story', in
Brown and Vlieghe 1999, pp.42–3.
4 Gordenker 2001, p.61.
5 Bellori 2005, p.216.

Painting in England before van Dyck: His first visit and its aftermath, 1620–1

6
The Continence of Scipio c.1620–1
Oil on canvas
183 x 232.5
The Governing Body of Christ Church,
Oxford

The Continence of Scipio is the only surviving painting by van Dyck from his activities in England which depicts a scene from ancient history. The story is found in the work of the Roman historians Livy (*Ab urbe condita*, XXVI, 50), Valerius Maximus (*Dicta et facta*, IV, III, I) and Polybius (*Histories*, X, 19): during the Second Punic War (218–201 BC), after the capture of Spanish capital of New Carthage (modern-day Cartegena) by the Roman army in 209 BC, the most beautiful young female captive was presented to the youthful commander Publius Cornelius Scipio (later called Africanus). When Scipio found out that she was betrothed to a Celtiberian chief called Allucius, contrary to expectations he returned her to her fiancé. Her parents meanwhile presented the general with a considerable weight of gold as a ransom for her release, but Scipio generously gave this to Allucius as a wedding present. Scipio was praised for his overwhelming magnanimity, and Allucius joined his army bringing with him 1,500 men. The story came to epitomise good statesmanship, chastity, generosity and justice. It was of great appeal to writers in the Italian Renaissance, including Nicolo Machiavelli (*The Art of War*, 1519–20) and Baldassare Castiglione (*The Book of the Courtier*, 1528).[1]

This painting is probably the work listed among the possessions of the young 2nd Duke of Buckingham, attached to a 1635 inventory of the paintings at York House, London, as, 'In the Hall. Vandyke. One great Piece being Scipio'.[2] The work may have been commissioned by George Villiers (1592–1628), the favourite courtier of James I whose rapid rise from a commoner saw him created Earl (1617), Marquess (1618) and finally 1st Duke of Buckingham (1623). One of the foremost English art collectors of his day, his eldest brother, John Villiers, 1st Viscount Purbeck (?1591–1658), had been instrumental in bringing van Dyck to London in October 1620 (possibly with the prompting of Buckingham himself?).[3] A payment to van Dyck by Buckingham, via his agent Endymion Porter (no.15), may be in relation to this painting, though no date or sum is given.[4]

The Continence of Scipio almost certainly dates from van Dyck's first trip to England, from October 1620 to February 1621. The choice of subject was possibly influenced

by Rubens, who had only recently produced a painting of the same title (c.1615–17, destroyed in 1836). The debt of the pupil to his master can further be seen in the painterly treatment of the attendants and the baroque columns. The colouring and composition employed by van Dyck, with the figures placed in a linear manner in the foreground, also makes reference to the work of Veronese (1528–88), particularly his *Esther and Ahasuerus* (c.1585; Kunsthistorisches Museum, Vienna), one of a group of paintings by the Italian master that van Dyck would have seen in the collection of the Duke of Buckingham.[5] It has been suggested that the present painting may have been a design for a tapestry to be woven at the recently founded tapestry works at Mortlake, which might explain its fluid, sketch-like appearance.[6]

The classical story of chaste betrothal and marriage was a particularly appropriate subject in a painting for Buckingham at this time: his courtship with Lady Katherine Manners (d.1649; see no.32) had been scandalised by the accusation of her father, the Earl of Rutland, that Buckingham had spent the night with his daughter, ruining her reputation and the family's honour. A duel was narrowly averted and it was only the intervention of James I that finally resolved the dispute with a just outcome, proving Buckingham's chastity. Their marriage was conducted in May 1620, a few months before van Dyck's arrival in England and the commissioning of this work.[7] This parallel may be taken further in the figures of the painting itself. Comparisons with contemporary images of Buckingham reveal a close physical resemblance to Allucius.[8] The painting might therefore represent Buckingham and his wife as Allucius and his bride. This would explain the prominent positioning of Allucius, dressed in blue, in the centre of the composition, rather than the more important figure of Scipio, shown on the left wearing a red cloak. The linear image of an elephant's head in the carpet on which they stand may be a symbol of their chastity, whilst at the same time referring to Scipio's famous defeat of Hannibal.[9]

Prominently positioned below Scipio in the lower left foreground is a fragment of a second-century Roman marble, similar to carving found on the frieze of the Trajaneum at Pergamon.[10] The marble was discovered during excavations at the site of Arundel House, London, in 1972, and is on long loan to the Museum of London. It may have been acquired by the Earl of Arundel from Buckingham's collection following his assassination at Portsmouth in 1628. Alternatively, it may have always been in

the Arundel collection, a possibility which has led to the suggestion that the painting was commissioned by the Earl of Arundel as a wedding present for Buckingham.[11] This has been reinforced by the argument that the ewer in the bottom right of the painting might also be from the Arundel collection, that the black servant may be the 'blackamoor' employed by Lady Arundel, and that the bearded figure appearing between Allucius and his wife may be a likeness of Arundel himself.[12]

In an alternative interpretation, the figure of Scipio, rather than Allucius, has been likened to the appearance of Buckingham.[13] Famous as an undefeated naval commander, the wise, just and chaste Scipio might be the more appropriate figure to flatter Buckingham, who had been made Lord High Admiral of the Fleet in 1619 when still only in his twenties.[14] A further explanation is that Scipio may represent the judicious actions of James I.[15] This has led to the suggestion that it was in fact the king who commissioned the work as a wedding present for his favourite courtier.[16] TJB

Notes
1 O. Millar in Barnes et al. 2004, no.I.157, pp.135–6.
2 R. Davies, 'An Inventory of the Duke of Buckingham's Pictures, etc., at York House in 1635', *Burlington Magazine*, vol.10, no.48, March 1907, pp.376–82.
3 D. Howarth, 'The Arrival of van Dyck in England', *Burlington Magazine*, vol.132, no.1051, October 1990, pp.709–10.
4 O. Millar, 'Van Dyck's "Continence of Scipio" at Christ Church', *Burlington Magazine*, vol.93, no.577, April 1951, pp.125–6.
5 Millar 1982, pp.12–13 and no.3, pp.43–4.
6 O. Millar in Barnes et al. 2004, no.I.157, pp.135–6.
7 P. Gordon, 'The Duke of Buckingham and van Dyck's "Continence of Scipio"', in *Essays on van Dyck*, National Gallery of Canada, Ottawa 1983, pp.53–5.
8 M. Jaffé, 'Van Dyck's "Venus and Adonis"', *Burlington Magazine*, vol.132, no.1051, October 1990, pp.697–703; and Wheelock et al. 1990, no.17, pp.124–6. The painting known as *Venus and Adonis* by van Dyck (c.1620–1; private collection) is thought to represent Buckingham and his wife, and bears a resemblance to Allucius here, though Millar questions this (O. Millar in Barnes et. al. 2004, no.I.158, p.137).
9 J. Wood, 'Van Dyck's pictures for the Duke of Buckingham – The elephant in the carpet and the dead tree with ivy', *Apollo*, vol.36, no.365, July 1992, pp.37–47.
10 J. Harris, 'The Link between a Roman Second-Century Sculpture, van Dyck, Inigo Jones and Queen Henrietta Maria', *Burlington Magazine*, vol.115, no.845, August 1973, pp.526–30; Howarth 1985, pp.82–3.
11 Parry 1981, pp.139–40; Howarth 1985, pp.156–7.
12 Howarth 1985, pp.196–7.
13 Ibid.
14 Gordon 1983, p.54.
15 G. Martin, 'Review of "The Age of Charles I" at the Tate', *Burlington Magazine*, vol.115, no.838, January 1973, p.59.
16 R. Harvie, 'A present from "Dear Dad"? Van Dyck's "The Continence of Scipio"', *Apollo*, vol.138, no.380, October 1993, pp.224–6.

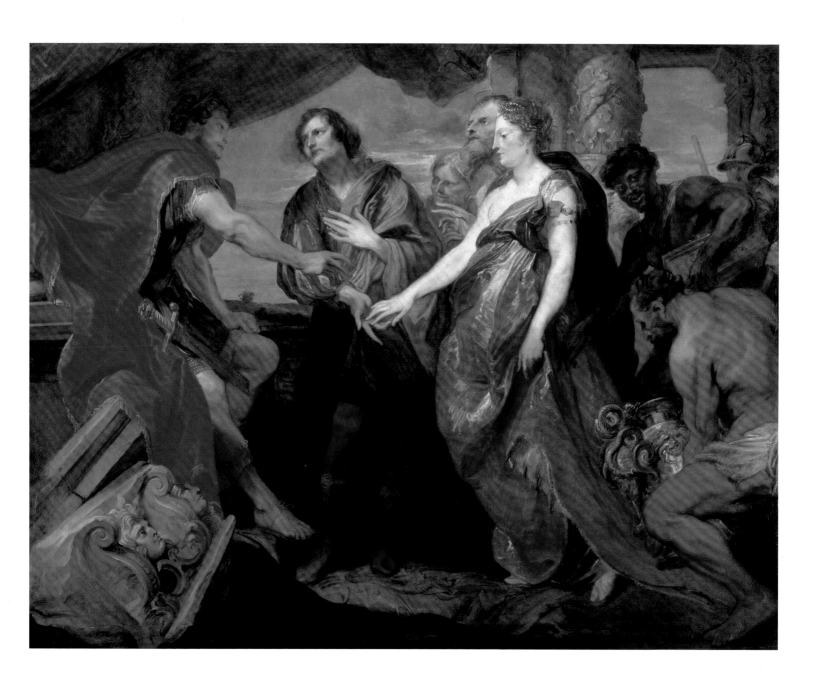

Painting in England before van Dyck: His first visit and its aftermath, 1620–1

7

*Portrait of Thomas Howard, 14th Earl of
Arundel* 1620–1
Oil on canvas
102.8 x 79.4
The J. Paul Getty Museum, Los Angeles

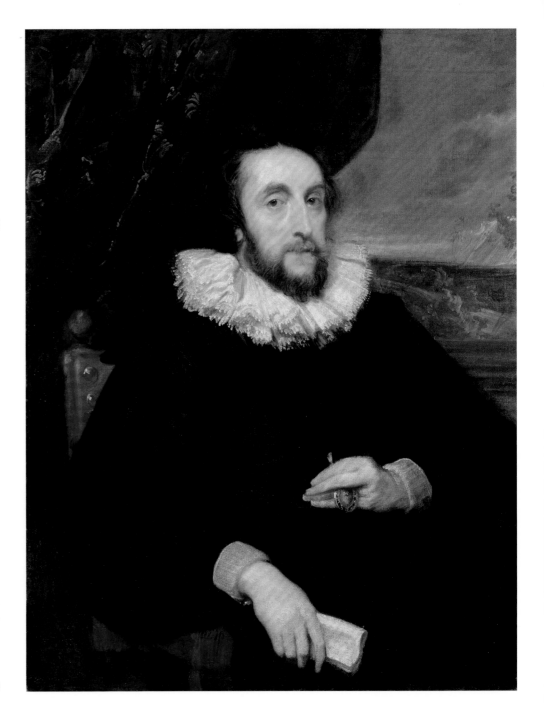

Soberly dressed in his customary black,
the Earl of Arundel (1565–1646), one of
the most discerning collectors of his day, is
seated in a red velvet-covered chair. In his
left hand he grasps the Lesser George, a jewel
denoting his membership of the elite Order
of the Garter, suspended from a ribbon
round his neck. The pigment of the blue
ribbon has changed colour. In his right hand,
resting elegantly on the arm of the chair, he
holds a folded paper. Behind him, to the left,
is a richly patterned curtain, while to the
right a landscape extends under a cloudy sky.

This portrait is thought to have been
painted during van Dyck's first, brief visit
to England from October 1620 to February
1621.[1] It is wholly characteristic of the
connoisseur earl that he should have taken
the opportunity to commission his portrait
from the young Flemish artist recognised as
the celebrated Rubens's most talented pupil.
In 1618 Rubens had discussed supplying
drawings to the earl, and in 1620, when
his wife, Alatheia Talbot, Lady Arundel
(c.1590–1654), visited Antwerp, Rubens was
commissioned to paint an immense portrait
of her with some of her entourage. Rubens
had observed that Arundel was 'one of the
four evangelists, and a supporter of our art'.[2]
Alatheia was a collector in her own right; her
fortune, inherited on the death of her father
in 1616, enabled the couple to spend freely
on works of art.[3]

Although van Dyck was yet to visit Italy,
he had been able to see the work of Venetian
artists such as Titian in the art collections
that were being assembled in London by the
earl and other discriminating collectors.[4]
His rapid, free brush strokes here convey
a remarkable sense of energy and vitality
which would have seemed startling compared
with the more formalised portraits being
produced by the leading painters based in
London at this date.[5]

The influence of this work can be seen in
Daniel Mytens's portrait of Philip Herbert,
later 4th Earl of Pembroke (no.8). KH

Notes
1 Barnes et al. 2004, no.I.161, p.139.
2 Rubens's letter of 1620, cited in Mary Hervey, *The Life,
Correspondence and Collections of Thomas Howard, Earl of
Arundel*, Cambridge 1921, p.176, note 2.
3 Elizabeth Chew, 'The Countess of Arundel and Tart
Hall', in Chaney 2003.
4 For a survey of these, see Chaney 2003, pp.1–124.
5 Hearn 1995, no.146, pp.217–18, entry by C. White.

8
Daniel Mytens (c.1590–1647)
Portrait of Philip Herbert, later 4th Earl of Pembroke c.1625
Oil on canvas
132 x 102
The Marquess of Salisbury

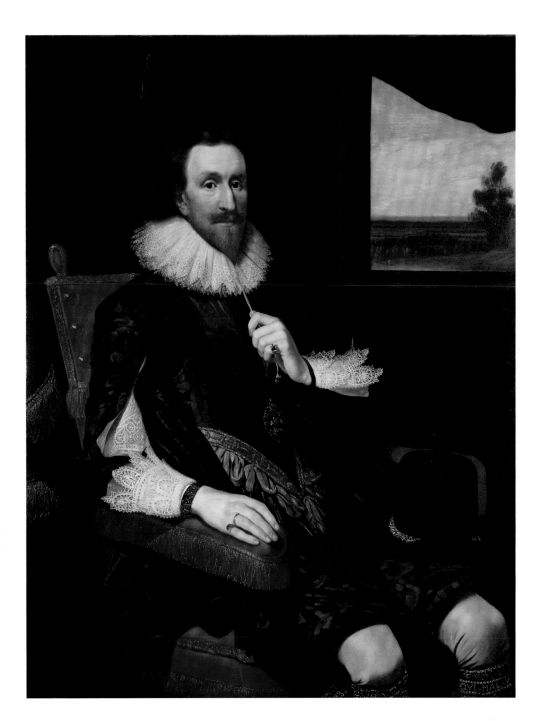

This painting of a nobleman who was to become one of van Dyck's most assiduous clients is clearly influenced by the portrait of the Earl of Arundel painted by van Dyck on his brief first visit to England in 1620–1 (no.7). The two earls were closely related – Arundel's heiress wife, Alatheia Talbot, was Pembroke's sister-in-law – and both were keen collectors of art.

Van Dyck had depicted Arundel seated, at three-quarter-length, with a curtain behind him to the left, and to the right a landscape seen over the parapet of a window opening. Arundel's right hand rested on the arm of his red upholstered chair, while his left discreetly but firmly grasped the jewel that denoted his membership of the Order of the Garter, suspended round his neck. Mytens here shows Herbert in a similar posture, but grasping the strings tying his lace-edged ruff. His own Garter jewel, suspended on the customary blue ribbon, rests against his chest. While Mytens emulates van Dyck's composition he does not attempt his rapid, free brushwork. He does, however, introduce strong lighting that casts shadows defining Herbert's face, hands and lilac-stockinged knees. While clearly echoing van Dyck's earlier 'cutting-edge' image, Mytens's is a powerful portrait in its own right.

Philip Herbert (1584–1650) seems to have been unusually interested in having his portrait painted, and patronised all the principal artists of the day, usually when they were most in vogue. A large and splendid full-length portrait, attributed to the English painter William Larkin (c.1580–1619), depicted Herbert in about 1615 wearing the robes of the Order of the Garter, to which he had been admitted in April 1608 (fig.16, p.39). He is also thought to be the subject of a head-and-shoulders portrait in classical attire by Marcus Gheeraerts II of about 1610.[1] In addition, a portrait miniature of 1611 by Isaac Oliver (c.1565–1617), has recently been recognised as depicting Philip, rather than his brother, William Herbert.[2] Philip and William are today remembered as the 'incomparable pair of bretheren' to whom the First Folio of Shakespeare's works was dedicated in 1623.

Another version of this portrait is in a private English collection.[3] For van Dyck's later portrait of Herbert (who had by then succeeded his elder brother, as 4th Earl of Pembroke), see no.44. KH

Notes
1 *The Tate Gallery: Illustrated Catalogue of Acquisitions 1978–80*, London 1981, pp.7–8, entry by Elizabeth Einberg; Hearn 2002, pp.26–7, fig.17.
2 Folger Shakespeare Library, Washington, DC; see Karen Hearn, review (of *Searching for Shakespeare*, exh. cat., National Portrait Gallery, London, 2006), 'Are you there, Will?', *Apollo*, May 2006, pp.80–2, repr. p.81.
3 Erna Auerbach and C. Kingsley Adams, *Paintings and Sculpture at Hatfield House*, London 1971, no.86, pp.87–8, and col. pl.VIII, opp. p.65.

9

Sir Robert Shirley 1622
Oil on canvas
200 x 133.4
Petworth House, The Egremont Collection
(The National Trust); accepted by HM
Treasury in lieu of death-duties and
transferred to the National Trust in 1957

This celebrated portrait of an English
traveller, with its companion image of
the sitter's wife, are the only works in the
present exhibition to have been painted by
van Dyck in Italy, where he lived from 1621
to 1627. The freedom with which he handles
the paint in these two exceptional works
is characteristic of his Venetian-influenced
style during his early years in Italy.

Sir Robert Shirley (c.1581–1628) was
born at Wiston in Sussex, but was sent
abroad as a boy, to the court of the Grand
Duke of Tuscany. In May 1599, with his
brother Anthony, he travelled to Persia (Iran)
where both were appointed diplomats by
Shah 'Abbas I. In February 1608 Robert set
off with his new wife, Teresa, on embassy
to Europe. He was received by James I at
Hampton Court on October 1611, to discuss
the Shah's offer to give English merchants a
monopoly over the Persian silk trade.[1]

As the representative of the Shah,
Shirley habitually appeared in honorific
high-status Persian attire made of silk and
silk velvet; since negotiations concerning
the silk trade were part of his brief, this was
particularly appropriate. The churchman and
historian Thomas Fuller (1608–61), a near-
contemporary, observed that Shirley 'much
affected to appear in forreign Vestes; and,
as if his Clothes were his limbs, accounted
himself never ready till he had something
of the Persian Habit about him'.[2] By the
end of July 1622 the Shirleys' embassy had
arrived in Rome for negotiations with Pope
Gregory XV, where a contemporary diarist
recorded that they stayed from 22 July to 29
August.[3] It is thought that Sir Robert may
there have encountered a fellow Englishman,
George Gage (c.1582–1638), who also had
his portrait painted by van Dyck in Rome. It
may have been Gage who recommended van
Dyck to the Shirleys.

While he was in Italy van Dyck made
studies from life, and drawings after works
of art that he saw there, in a sketchbook
that survives today in the British Museum.
Here he made three sketches recording the
Shirleys in their exotic attire, noting that
Robert was 'Ambasciatore di Persia in Roma'.
Bellori mentions that 'Anthony portrayed
this gentleman and his wife in Persian dress,
enhancing the beauty of the portraits

with the charm of their exotic garments'.[4]
The resultant portraits have justly been
described as 'sumptuous' and 'dazzling'.[5]

Robert stands, holding a bow and
arrows, wearing his overmantle (or *balapush*)
half off the shoulder, in a characteristically
Persian style. His folded turban cloth,
balapush, sash and close-fitting sleeved under-
robe (or *qaba*) would all have been made
in Persia, probably in the royal tailoring
department which handled the most
important honorific garments. Although no
textiles identical to those depicted by van
Dyck survive, fragments of similar fabrics
– cut and voided velvets – are today in the
Textile Museum in Washington.[6]

Late in 1623 the Shirleys were back in
England, where on 28 June 1624 Robert again
had an audience with James I concerning
the silk trade. Portraits of the couple by an
unknown British artist, today at Berkeley
Castle, were probably painted during this
visit (figs.17, 19).[7] Here Robert is again
depicted in his ambassadorial Persian attire,
wearing the same cloak as in his portrait by
van Dyck but a different under-robe, which
is more Western in cut. Teresa, however, is
dressed in a British fashion and – apparently
uniquely in British art of this period – holds
a small firearm.

The couple returned to Persia in March
1627, where Robert died of a fever in July
1628. In 1634 his widow settled permanently
in Rome, where she remained until her death
in 1668. KH

Notes
1 *ODNB* 2004, vol.50, pp.399–401, entry on Sir Robert
Shirley by Richard Raiswell.
2 Thomas Fuller, *The Worthies of England* [1662], ed.
John Nichols, London 1811, vol.2, p.393, reference kindly
supplied by Patricia L. Baker. See also Christine Riding,
'Travellers and Sitters: The Orientalist Portrait', in *The
Lure of the East*, exh. cat., Tate 2008, p.49.
3 Wheelock et al. 1990, nos.28, 29, p.154; Brown and
Vlieghe 1999, nos.29, 30, pp.160–3; Barnes et al. 2004, nos.
II.62–3, pp.203–5
4 Bellori 2005, p.216.
5 Ibid.
6 Verbal comm. from Patricia L. Baker, June 2008. See also
Patricia L. Baker, 'Islamic Honorific Garments', in *Costume*,
London 1991, pp.32–3.
7 See Laing 1995, no.2, pp.20–1.

Fig.17
Unknown artist, British School, seventeenth century
*Sir Robert Shirley, Envoy of Shah 'Abbas of Persia to the Courts
of Europe* c.1623–4
Oil on canvas
195 x 105
Trustees of the Berkeley Will Trust

Fig.18
Anthony van Dyck
Study for Sir Robert Shirley, from 'The Italian Sketchbook'
(fol.62r) before 1628
Pen and ink
The British Museum, London

Painting in England before van Dyck: His first visit and its aftermath, 1620–1

10

Teresa, Lady Shirley 1622
Oil on canvas
200 x 133.4
Petworth House, The Egremont Collection
(The National Trust); accepted by HM
Treasury in lieu of death-duties and
transferred to the National Trust in 1957

In February 1608, while living in Persia,
the Catholic convert Robert Shirley married
Sampsonia (c.1590–1668), the daughter
of a Christian Circassian chieftan, Isma'il
Khan (Circassia is a region in the northern
Caucusus). Baptised by Carmelites, she was
given the new name Teresa.[1] Shah 'Abbas I
having appointed Robert to lead an embassy
to Europe, the Shirleys set off on 12 February
1608. In August 1611, with Teresa pregnant,
they arrived in England, where the couple's
only child, a son called Henry (after the
Prince of Wales), was born. In January 1613,
leaving Henry behind with Robert's family
in Sussex, they set off on the journey back
to Persia. Their next embassy took them
to Spain, whence they departed for Rome
in March 1622.

 Van Dyck had left England early in 1621,
and by November that year had arrived in
Italy where he was to spend the following
seven years. He spent only a short time
in Rome, basing himself principally in
Genoa, and also carrying out a number of
commissions in Palermo.

 Although van Dyck annotated his sketch
of the sitter 'habito et maniera di Persia'
('Persian dress and style'), in fact Teresa's
attire is not, in the view of Patricia L. Baker,
from Iran.[2] Whereas the costume in which
van Dyck depicts Sir Robert is unmistakably
Persian-made, that worn by Lady Shirley
is largely European – for instance, she is
wearing a stomacher. Even the rich golden
fabric itself appears not to be Persian, and
could be Ottoman in origin. Lady Shirley
is, however depicted sitting upon a Persian
rug. She is accompanied by a monkey – an
exotic pet – and a Roman landscape stretches
behind her. She gazes out at the viewer with
quizzical directness. KH

Notes
1 *ODNB* 2004, vol.50, pp.399–401, entry on Sir Robert
Shirley by Richard Raiswell.
2 Verbal comm., June 2008.

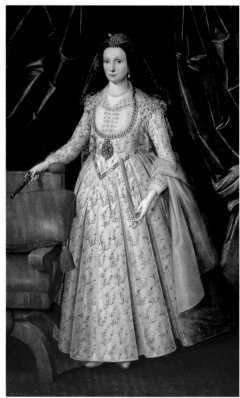

Fig.19
Unknown artist, British School, seventeenth century
Teresa, Lady Shirley before 1628
Oil on canvas
214 x 124
Trustees of the Berkeley Will Trust

Fig.20
Anthony van Dyck
Study for Lady Shirley from 'The Italian Sketchbook'
(fol.60v) before 1628
Pen and ink
The British Museum, London

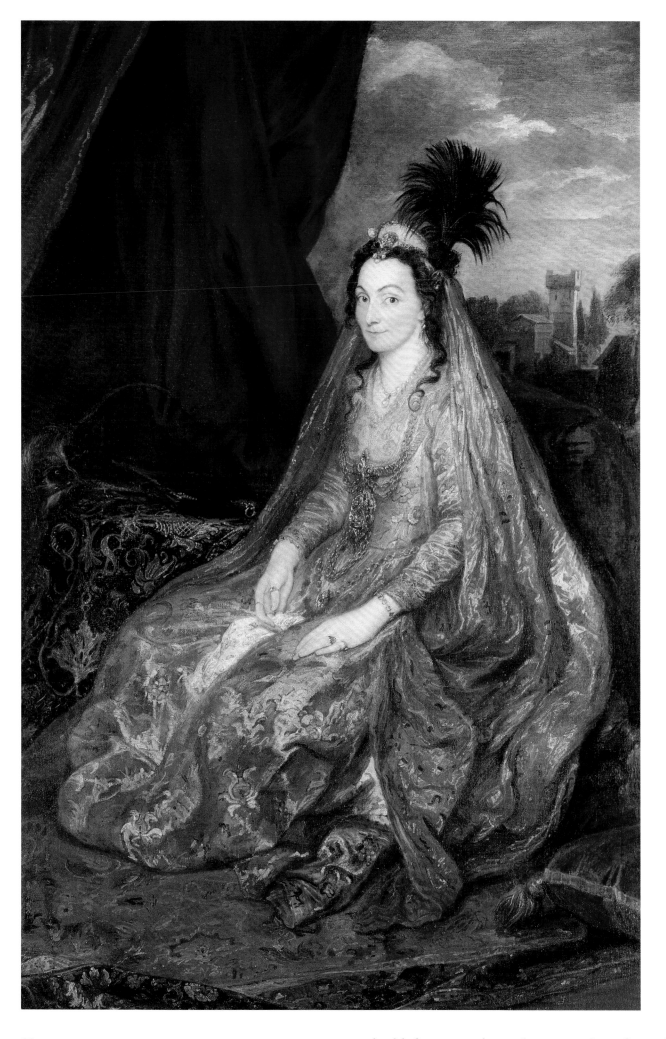

Painting in England before van Dyck: His first visit and its aftermath, 1620–1

11

Titian (Tiziano Vecelli) (c.1485–1576)
*Cardinal Georges d'Armagnac and his Secretary
Guillaume Philandrier* c.1536–9
Oil on canvas
104.1 x 114.3
The Duke of Northumberland, Alnwick

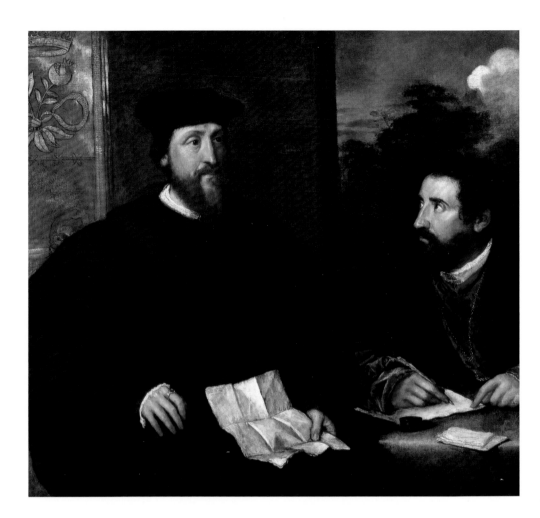

Georges d'Armagnac (1500–85) was Bishop
of Rodez, Archbishop of Tours and later of
Toulouse. He was elevated to the rank of
Cardinal in 1551. This portrait was painted
about fifteen years earlier, during the period
1536–9 when d'Armagnac was serving as
French Ambassador in Venice. The heraldic
devices on the pilaster at the left are a sheaf
of wheat, which is in the d'Armagnac coat
of arms, and, above it, a crown, which refers
to his descent from the counts of Rodez
and d'Armagnac. It has been argued that
the pomegranate refers to the Treaty of
Nice between the Holy Roman Emperor,
Charles V, and the King of France, Francis I,
whom the Bishop served as an ambassador.
D'Armagnac is shown dictating to his
secretary and Titian may have been inspired
to create this composition by Sebastiano del
Piombo's portrait of Cardinal Carondolet
and his Secretaries (Museo Thyssen,
Madrid), painted in Rome in 1511/12.

Van Dyck admired Titian above all
other artists and modelled his technique and
palette on those of the earlier artist. His
passion for the work of the Venetian can be
seen very clearly in his Italian Sketchbook
(British Museum, London), used during
his early years in Italy (1621–4) when he
was travelling extensively in the peninsula
and in Sicily. Although he made drawings
of paintings by other artists (Raphael,
Leonardo, Giorgione, Guercino and others),
the great majority of the drawings are after
the works of Titian, which he sought out
in every city he visited. At the back of the
Sketchbook is a list of 'le cose di Titiano'.

This fine double portrait by Titian[1]
was well-known to van Dyck and he based
his own portrait of Thomas Wentworth,
Earl of Strafford, and his Secretary, Sir
Philip Mainwaring (no.57) upon it. Titian's
portrait had been purchased in France
by Balthasar Gerbier for the Duke of
Buckingham: it was shipped from Boulogne
to England in November 1624 and was hung
in Buckingham's London residence, York
House. It is described in the 1635 inventory
of York House as 'A Picture of the French
Ambassador Enditeing'. By 1652 it was in
the collection of the Earl of Northumberland
(see no.51) at Suffolk House as 'Titian: A
Senator and his Secretary'. (By 1671, at
Alnwick Castle, it had become the 'Duke of
Florence and Machiavil'). Van Dyck had
met the Duke of Buckingham in London
on his first visit to England in 1620/1.
The duke was assassinated in 1628 but
when van Dyck returned to England in
1632 he would certainly have had access to
Buckingham's collection and to that of the
Earl of Northumberland, one of his most
important patrons.

It is not just, of course, Titian's
compositions which van Dyck adopts:
the Venetian's technique, particularly his
modelling of form in subtle gradations
of colour rather than in line, is central to
van Dyck's mature style, as is his ability
to animate the expression of a sitter
with a touch of colour in the eye or lip.
Titian's rich palette is also closely emulated
by van Dyck. It was clearly van Dyck's
profound understanding of and identification
with Titian that formed the basis of
Charles I's admiration of the Flemish
painter. For Charles, Titian was the
greatest of all painters and van Dyck was
Titianus redivivus. CB

Note
1 H. Wethey, *The Paintings of Titian*, II, *The Portraits*,
London 1974, no.8, p.78; P. Humfrey, *Titian: the Complete
Paintings*, Bruges 2007, no.122, p.175.

12

Daniel Mytens (c.1590–1647)
Charles I 1628
Oil on canvas
219.1 x 152
Inscribed lower centre: 'Carolus. Dei. G. /
Magnæ. Britaniæ. Franciæ / et. Hiberniæ. Rex. /
fidei. Defensor &c / Ætatis : Suæ. 28. / anno.
1628. / ad vivum. dep. / D Mytens. p. Regius /
1628.'[1]
Her Majesty The Queen (The Royal
Collection Trust)

This fine full-length by the leading artist at
Charles I's court before van Dyck's arrival
indicates the calibre of portraiture then
available to the young king. In his right hand
he confidently grasps a walking-cane, while
his left hand rests on his hip. The elegantly
crooked elbow, a continental convention
denoting relaxed command, was later used by
van Dyck in several male portraits. Charles
wears the blue ribbon of the Order of the
Garter. Some of the recorded payments to
Mytens for royal portraits state that he had
painted them at Greenwich Palace, and it has
been suggested that the background here
may represent the view of the river bank
from the Queen's House at Greenwich.

The Dutch incomer Daniel Mytens, or
Mijtens, had begun working for the British
monarchy in around 1620, and in 1623 he
was paid for portraits of James I (see no.3)
and Charles, at that time Prince of Wales.[2]
In 1626–7 Mytens visited the Netherlands
again, where he would have seen the latest
developments in portraiture, and where
he painted Elizabeth of Bohemia (Royal
Collection). On 16 May 1628 he was paid
£40 for a 'great' (that is, large) portrait of
the king sent to the Countess of Nassau.

The present portrait entered the
collection of H.M. The Queen only in
1961, when it was bequeathed by Cornelia,
Countess of Craven. Paintings owned by
the countess are thought to have descended
from Elizabeth of Bohemia, Charles I's sister
(no.2) or from her son, Prince Rupert.

When this work was examined in 1998,
prior to conservation, a small amount of
underdrawing was found, indicating that the
composition was outlined before the painting
was started. The tiles seem to have been
drawn with a ruler, the verticals aiming at a
vanishing point on the sitter's right shoulder.
The double-coloured ground is typical for
northern European painting of the period:
the first layer is a strong, dark red, the
second a lighter grey.[3] Van Dyck's full-length
official portait of the king, of 1636, with his
upright stance, hand on hip and extended
arm, is virtually a mirror image of this
portrayal by Mytens.[4] KH

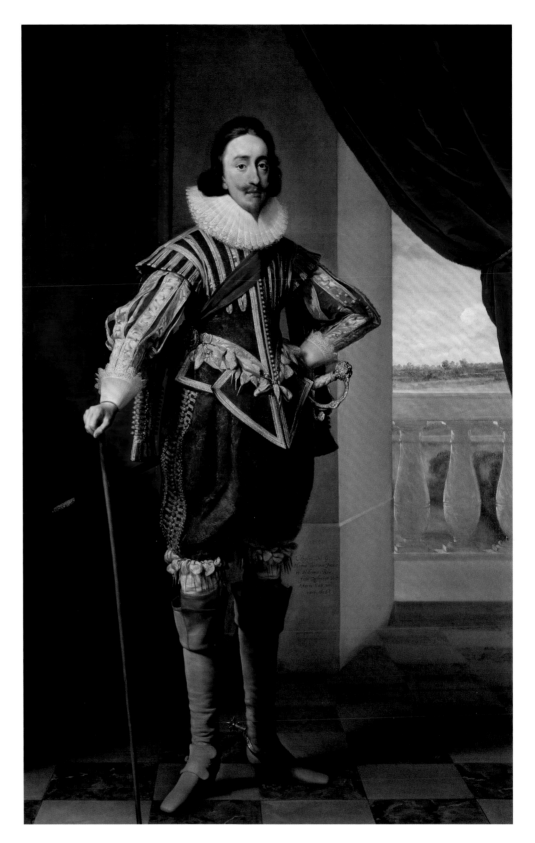

Notes
1 Millar 1963, no.118, pp.85–6.
2 *ODNB* 2004, vol.40, pp.91–3, entry on Daniel Mytens by
Anne Thackray.
3 Report by Marie Louise Sauerberg, Hamilton Kerr
Institute, June 1998, kindly made available by Rupert
Featherstone, formerly Senior Conservator of Paintings,
The Royal Collection.
4 Millar 1963, no.145, pp.95–6.

13

Peter Paul Rubens (1577–1640)
The Apotheosis of James I and other studies:
multiple sketch for the Banqueting House
ceiling, Whitehall c.1628–30
Oil on wooden panel
95 x 63.1
Tate. Purchased with assistance from the
National Heritage Memorial Fund, Tate
Members, The Art Fund in memory of
Sir Oliver Millar, Viscount Hampden and
Family, Monument Trust, Manny and
Brigitta Davidson and the Family, 2008

Rubens was the leading artist in Antwerp
and one of the most renowned European
painters of his time. After eight years in Italy
he returned to Antwerp in 1608 and set up
an extremely productive studio where he was
assisted by many young and talented artists.
van Dyck joined this workshop around 1615,
after his apprenticeship to Hendrik van
Balen (c.1575–1632), and Rubens described
him as 'the best of my pupils'.[1] In 1620
Rubens was contracted to supply thirty-nine
ceiling paintings (destroyed in 1718) for the
side aisles and galleries of the Jesuit church
in Antwerp. It was specified that Rubens
would make the original designs, but that
van Dyck and other assistants would carry
out most of the actual painting, to which
Rubens would then put final touches. By
October 1620, however, van Dyck was on
his first, brief, visit to London. There he
would have been aware of the newly rebuilt
Banqueting House, designed along Palladian
lines by Inigo Jones, which was part of
Whitehall Palace.

Rubens was first approached by the
British court in 1621 about producing
paintings for the ceiling of the Banqueting
House, a prestigious space in which foreign
ambassadors were formally received and
court masques performed. The project
stalled for various reasons, and then James
I died in 1625. During the late 1620s
two written programmes for the subject
matter of the ceiling were devised in
London. Both proposed that the central
oval should celebrate the union of the
crowns of Scotland and England, which
was considered to be James I's principal
achievement.[2] In June 1629 Rubens arrived
at the court of James's son, Charles I, as a
diplomatic envoy of Philip IV of Spain. His
negotiations towards peace were successful,
and during the visit it also seems finally to
have been agreed that he should execute the
Banqueting House ceiling, as a celebration of
Charles's late father's achievements.

This sketch was evidently made by
Rubens for his own personal reference.

Executed in near-grisaille on panel, it is
apparently his first visualisation of the
entire ceiling and comprises his preliminary
ideas for the designs of seven of the nine
compartments. In the centre, instead of
the union of Scotland and England, Rubens
depicts the apotheosis of the late King
James, seen being carried up by Jove's
eagle, assisted by the figure of Justice, with
Minerva (Wisdom) overhead. To either side,
four ovals contain personifications of James's
royal virtues: Liberality triumphs over
Avarice and Discipline over Wantonness;
below, upside down, Knowledge (Minerva
again) triumphs over Ignorance and Heroic
Virtue (Hercules) over Envy. Across the top
(again, upside down) and bottom, putti,
animals and swags of produce symbolise the
benefits of national unity and peace.

Freely sketched in a number of stages,
this design is wholly in Rubens's hand and
demonstrates his remarkable fluidity and
freedom of invention. He was subsequently
to produce a number of small, detailed
modelli (of which around thirteen survive)
for individual elements of the complex
allegorical ceiling design. These were for his
assistants to follow as they worked on the
final canvases in his studio in Antwerp. The
canvases were completed by August 1634,
despatched to London in 1635, and installed
in the ceiling in 1636.

Before Rubens left England in March
1630 he was knighted by Charles I. This
honour was to be similarly bestowed on van
Dyck, when he came to London to work for
Charles in 1632. KH

Notes
1 *ODNB* 2004, vol.17, pp.466–74, entry on van Dyck by
Jeremy Wood.
2 See Hearn 1995, no.151, pp.226–7, entry by Gregory
Martin, and subsequently Gregory Martin, *Rubens: The
Ceiling Decoration for the Banqueting Hall* [*sic*], London and
Turnhout 2005, where the texts of the two programmes
are transcribed in vol.2, pp.306–10, as Appendix 3.

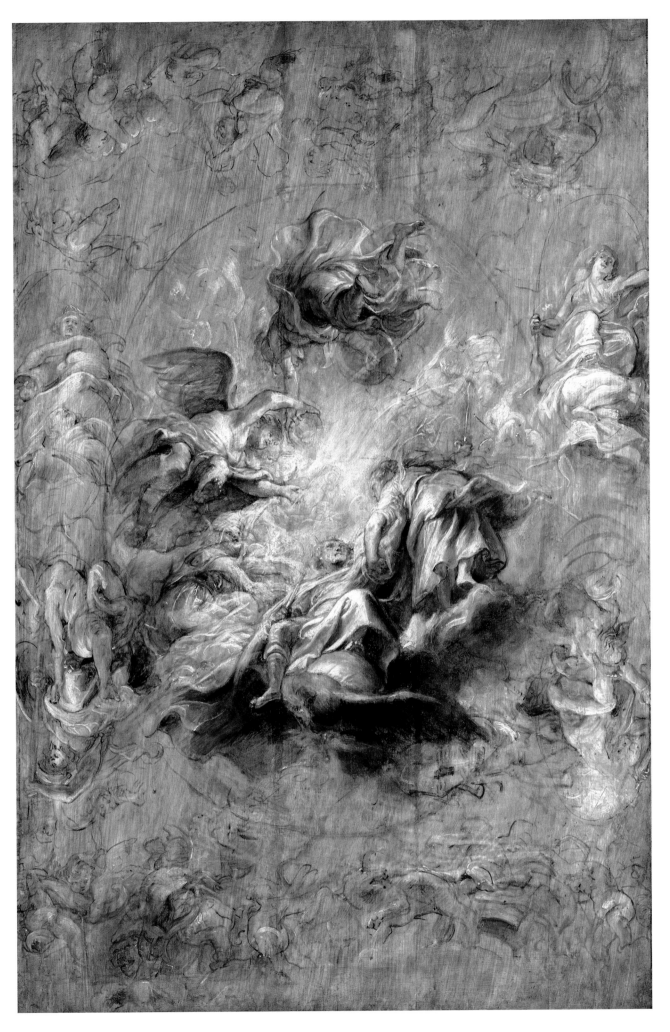

Painting in England before van Dyck: His first visit and its aftermath, 1620–1

14
Nicholas Lanier c.1628
Oil on canvas
111 x 87.6
Kunsthistorisches Museum, Vienna,
Gemäldegalerie
[not exhibited]

Nicholas Lanier (1588–1666) was a musician, composer, artist, designer, collector of paintings and drawings, and also a key figure in the early cultural ambitions of Charles I. As art agent to the king he played an important role in the sourcing and acquisition of paintings from Europe for the royal collection, and he became a leading courtier.

Born in London, Lanier came from a French family of musicians originally from Rouen. His Huguenot grandfather had been a musician at the French court of Henry II before coming to England as a flautist at the court of Elizabeth I; his father performed as a sackbut player with the royal band or 'King's Musick' under James I. The young Nicholas impressed with his singing voice, and was subsequently appointed singer and lutenist with the King's Musick in 1616, alongside the notable musician and composer John Dowland (1563–1626). Over the following years Lanier was involved in the production of a number of court masques, his creative talents extending beyond composing the music to include designing the staging and costumes. Active in the artistic circles at court, he was rumoured to be a lover of the Italian painter Artemisia Gentileschi (1593–c.1653). Through patrons such as the Duke of Buckingham and the Earl of Arundel, Lanier soon came to the attention of Prince Charles and was promoted as Master of the King's Music shortly after Charles's coronation.[1]

Not long after the funeral of James I in May 1625 Lanier was sent by Charles I to Italy to acquire paintings for his collection. This was to be the first of several trips: with his polished connoisseurial eye and his fluent Italian (learnt from his Italian mother), Lanier was the perfect candidate for such a task. Working with the art agent Daniel Nys (active c.1598–c.1640), his efforts eventually resulted in an astounding act of royal collecting: the purchase of the Gonzaga Collection of Mantua, one of the most magnificent art collections in Europe at that time. Masterpieces by Raphael, Correggio, Titian, Tintoretto and Caravaggio, to name but a few, were brought to London and transformed it overnight into one of the leading cultural centres in Europe. Lanier oversaw the safe packing and despatch of the collection by sea and accompanied the most precious pieces himself by land to Antwerp. Rubens recorded on 15 June 1628 that 'The English gentleman who is taking the art collection of Mantua to England has arrived here'.[2]

The identification of the sitter as Lanier was made through comparison with an engraving by Lucas Vorsterman (1595–1675) after a lost painting by Jan Lievens (1607–74), which gives Lanier's name in the legend.[3] Although it is not certain precisely when van Dyck produced his portrait of Lanier, we can be sure that it was not painted in England as van der Doort lists the work in the 1639 inventory as, 'Done by Sr Antho: Vandike Beyond ye Seas'.[4] It was probably painted at the period when Lanier stayed in Antwerp in the summer of 1628 en route to England with the Mantuan collection.[5]

Although van Dyck spent an unusually long time over the portrait – Lanier sat for seven whole days – the figure looks slightly odd, with the head apparently rather detached from the body. Yet it seems to have made a good impression, as Lely reported that Lanier told him it was on the strength of this portrait that Charles I renewed his invitation to van Dyck to come to England.[6] When the artist arrived in London in 1632 he initially lodged with Edward Norgate (1581–1650), Lanier's brother-in-law and a fellow artist, musician and writer on art. The portrait was sold following the death of Charles I: Lanier purchased it on 2 November 1649 for £10.[7]

A further portrait by van Dyck, now lost, depicted Lanier as David playing the harp before Saul. The painting *David Playing the Harp*, attributed to the School of Jordaens (Musée de l'Hôtel Sandelin, Saint-Omer), may be a record in some way of van Dyck's lost original.[8] Lanier painted a self-portrait (c.1644; Faculty of Music, University of Oxford), reversing van Dyck's pose and composition and utilising the rocky outline of van Dyck's original. He depicted himself as an artist, with palette and brush in hand, and also a musician and composer, a sheet of his music resting under a skull (a memento mori).[9] His self-portrait was probably painted whilst Lanier was with the exiled court in Oxford during the Civil War, and presented to the University Music School whilst he was there. Lanier almost certainly also appears in William Dobson's *Portrait of the Artist with Sir Charles Cotterell and (?)Nicholas Lanier* (c.1644–5; Duke of Northumberland), probably also painted in Oxford during this period.[10]

By the spring of 1645 Lanier had fled from England at war for the safety of the Continent, travelling around Europe from his base with the Duarte family in Antwerp. There he made contact with other English exiles, including William Cavendish, 1st Duke of Newcastle, and his wife Margaret, who were staying at Rubens's former house in Antwerp.[11] Following the restoration of Charles II in 1660 Lanier was reinstated to his former positions at court. He died in February 1666 at Greenwich. TJB

Notes
1 *ODNB* 2004, vol.32, pp.529–31, entry on Nicholas Lanier by M.I. Wilson.
2 M.I. Wilson, *Nicholas Lanier – Master of the King's Musick*, Aldershot 1994, pp.83–132.
3 Hollstein 1949, vol.43, p.171, no.168; Wilson 1994, pp.172–4, pl.26.
4 Millar 1958–60, no.34, p.7.
5 H. Vey in Barnes et al. 2004, no.III.92, p.321.
6 Ibid.
7 Millar 1970–2, no.26, p.70.
8 Millar 1982, no.6, pp.45–6; Wilson 1994, p.175, pl. 29.
9 Chaney and Worsdale 2001, no.9. pp.25–6; Wilson 1994, pp.198–9, pl.29.
10 Rogers 1983, no.46, pp.88–90.
11 K. Hearn and L. Hulse in van Beneden 2006, no.54, p.190.

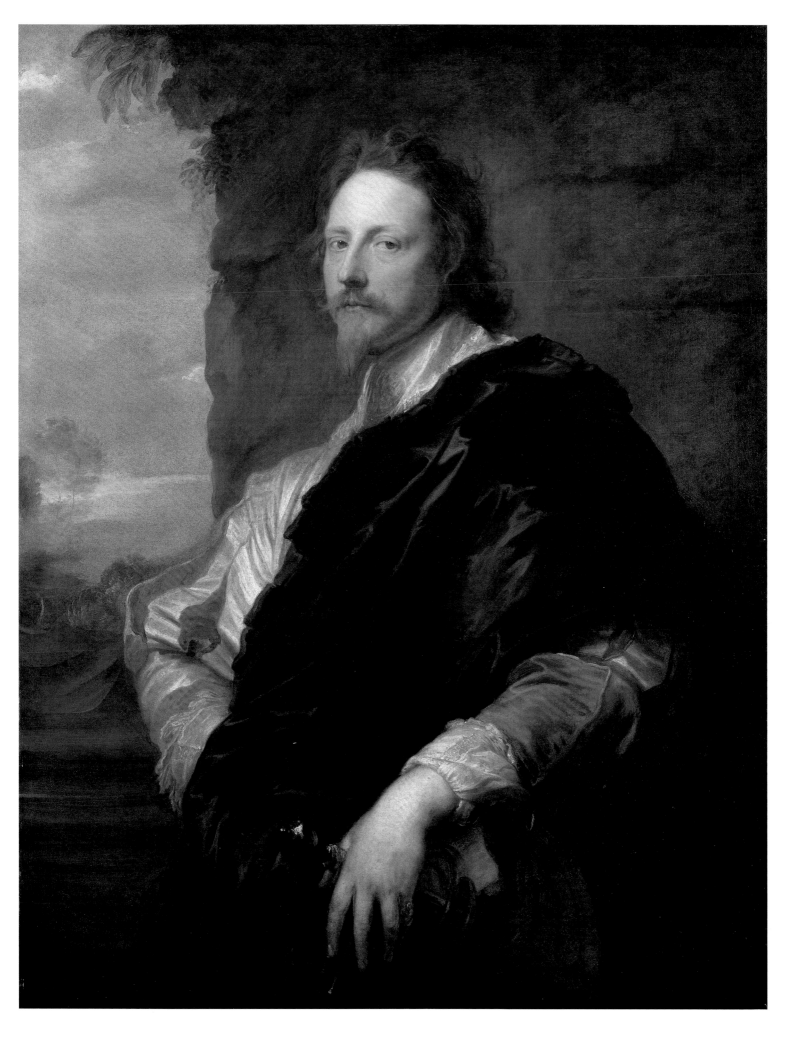

Painting in England before van Dyck: His first visit and its aftermath, 1620–1

15

Portrait of Endymion Porter 1628
Oil on canvas
114.5 x 94
Private collection

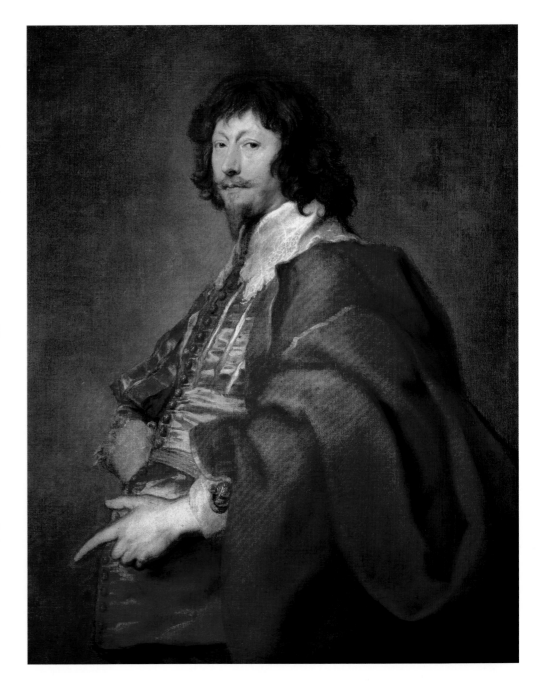

This portrait, which must have been painted in Antwerp, is characteristic of van Dyck's second Flemish period. The sitter, a friend of van Dyck's, was a visitor from the English court travelling on diplomatic business.

Endymion Porter (1587–1649) came from a family of minor gentry with Spanish links.[1] In 1605 he travelled with his brother, in the retinue of the Earl of Nottingham, to Spain where he became a member of the household of the Conde de Olivares. He returned to England in about 1612 with important contacts at the Spanish court, and soon entered the service of George Villiers, the future 1st Duke of Buckingham. In 1623 he accompanied Villiers and Prince Charles, later Charles I, to Spain where he acted as an intermediary between the prince and the Spanish court, and demonstrated his knowledge of art. When Charles came to the throne in 1625 Porter became a member of the Royal Bedchamber, and received various grants and lucrative offices. A patron of painters and writers, he acted as an artistic adviser first to Villiers and later to Charles I, and his judgement on art seems to have been much respected.

In August 1628 Porter travelled to Madrid via The Hague and Brussels on one of his many diplomatic missions. He probably stopped off in Antwerp to see van Dyck, whom he had met on the artist's visit to London in 1620–1, and sat for this fine, expressive portrait.[2] It was probably during this visit that Porter commissioned from van Dyck, on behalf of Charles I, the large and very beautiful narrative painting *Rinaldo and Armida* now in the Baltimore Museum of Art.[3] On 5 December 1629 van Dyck wrote to Porter in London to report that the large work was finished and that it had been entrusted to an agent for delivery;[4] in March the following year Charles I authorised that Porter be paid £78[5] for *Rinaldo and Armida* (fig.22, p.65), which he had bought from 'Monsieur Vandick of Antwerpe'. It is generally considered that this Titianesque narrative painting was one of the works that persuaded Charles to invite van Dyck to London.

Once in England, van Dyck was to paint Porter again, first in a group portrait with his family in around 1632–3 (private collection),[6] a sketch for which is included here (no.83), and later, a more sober image, in around 1638–40.[7] In around 1633 he also painted a self-portrait showing himself with Porter (no.65), evidence of the strength of his friendship with the portly courtier. KH

Notes
1 *ODNB* 2004, vol.44, pp.947–50, entry on Endymion Porter by Ronald G. Asch; see also G. Huxley, *Endymion Porter*, London 1959.
2 Barnes et al. 2004, no.III.119, p.343.
3 Ibid., no. III.61, pp.294–5.
4 Hookham Carpenter 1844, pp.24–5.
5 Gregory Martin, however, in his review of Barnes et al. 2004 in *Burlington Magazine*, vol.147, February 2005, p.119, suggests that this sum was too small to relate to payment in full for this particular painting.
6 Barnes et al. 2004, no. IV.190, pp.576–7.
7 Ibid., no. IV.191, p.578.

16
Cornelius Johnson (1593–1661)
Portrait of Sir Thomas Hanmer 1631
Oil on canvas
77.5 x 62.2
Inscribed bottom left: 'C.J. fecit / 1631'
Amgueddfa Cymru – National Museum
Wales

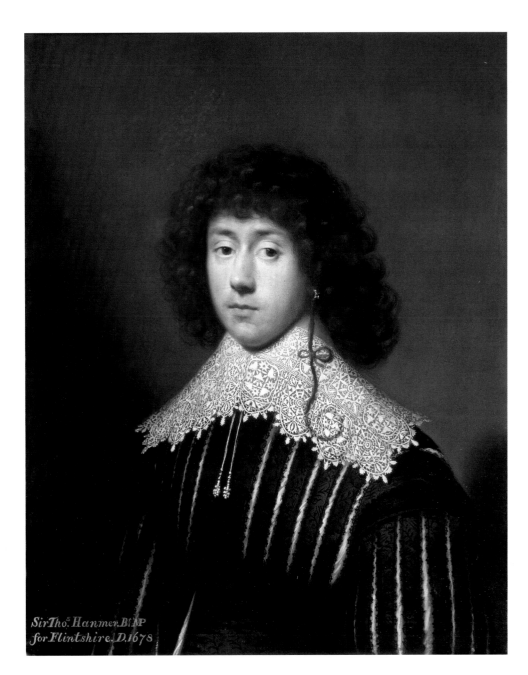

Sir Thomas Hanmer, 2nd Baronet (1612–78), had inherited his title as a boy of twelve.[1] From 1625 to 1627 he was a page at Charles I's court, and some time between 1630 and February 1632 he married Elizabeth, daughter of Sir Thomas Baker of Whittingham, Suffolk, and a lady-in-waiting to Queen Henrietta Maria. Hanmer's brother-in-law, Thomas, was the 'Mr Baker' whose celebrated bust by the Italian sculptor Bernini is today in the collection of the Victoria and Albert Museum. The present portrait probably dates from around the time of Hanmer's marriage. A much later inscription, bottom left, identifies him as sitter.

Between 1638 and 1640 Hanmer made a European tour; probably just before he left, around seven years after the present portrait was painted, he sat to van Dyck (see no.54).[2] The contrast between the two portraits is striking. Van Dyck depicted Hanmer with exceptional energy and elegance: he is barely recognisable as the stolid subject seen here.

Cornelius Johnson was born in 1593 to Flemish/German immigrant parents. His earliest definitely known works are dated 1619; their polished style suggests that he may have trained in the northern Netherlands, although no documentation for this survives.[3] All Johnson's known works are portraits: he worked on every scale, from tiny portrait miniatures to large group images. In 1631 he was appointed official painter to Charles I but, perhaps owing to the arrival of van Dyck the following year, he seems to have received only very occasional royal commissions. He was quick to absorb the lessons of van Dyck's success, and his own works soon became increasingly Van-Dyckian in style (see no.90 and fig.44, p.171). In 1643, during the English Civil War, Johnson emigrated at the age of fifty to the Protestant northern Netherlands. There he continued his career as an artist, working in Middelburg, Amsterdam (where, briefly, he would have been a rival to Rembrandt) and latterly in Utrecht, where he died in 1661.

This portrait is highly characteristic of Johnson's work of the period, reserved but sympathetic and with exceptional attention to the detail – as in the sitter's fine lace collar.[4] His long lovelock, carefully tied with a red ribbon and displayed, hints at his personal stylishness.[5] Following his arrival in England the following year van Dyck himself occasionally echoed this portrait formula of Johnson's – see for instance his *Lucius Cary, Lord Falkland* (no.45) – which suggests that it was one that pleased British clients. KH

Notes
1 *ODNB* 2004, vol.25, pp.64–5, entry on Thomas Hanmer by John Martin.
2 Brown and Vlieghe 1999, no.96, pp.317–19; Barnes et al. 2004, no.IV.111, p.518.
3 Hearn in Roding 2003, pp.113–29.
4 Millar 1958, p.249; Millar 1972, no.35, pp.32–3.
5 Ribeiro 2005, p.186.

Van Dyck's return to England: Royal portraits

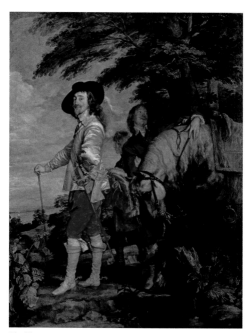

Fig.21
Anthony van Dyck
Charles I in the Hunting Field (Le Roi a la Chasse)
Oil on canvas
266 x 207
Musée du Louvre, Paris

Fig.22
Anthony van Dyck
Rinaldo and Armida 1629
Oil on canvas
235.3 x 228.7
Baltimore Museum of Art

Van Dyck returned to England in 1632, effectively at the invitation of Charles I, who had been impressed by his *Rinaldo and Armida* (fig.22). His status had changed since his previous visit more than a decade earlier, and he now had an international reputation. In Genoa and then back in Flanders, he had become accustomed to patronage at the very highest level.

In Protestant England most clients wanted only portraits. Whereas van Dyck was celebrated in Flanders for his religious art, he received comparatively few British commissions for narrative, religious or 'history' paintings – which connoisseurs would have seen as more prestigious. Of those he is known to have produced, such as the religious pictures commissioned, according to Bellori, by the Roman Catholic Sir Kenelm Digby, barely any now survive (see nos.28, 29); his production of portraits, however, was prodigious.

Royal portraits were needed for many purposes: to be exchanged with other monarchs overseas (and thus to convey the sitter/donor's power); as gifts to be presented to favoured supporters; and for display in palaces to underline the ruler's prestige, both to his or her subjects and to visiting foreign envoys.[1] In Britain, by now influenced by ideas from Continental Europe, the identity of the painter of a work, and the aesthetic quality and inventiveness of his or her product, were becoming matters of importance. Power was thus becoming more subtly conveyed.

Charles I knew that van Dyck could provide the idealising portraits that would bolster his public image and embody his own views on the divine nature of his right to rule and his philosophy of self-regulation of the passions. He was a small man, probably only about 5 ft 4 in tall, but van Dyck devised compositions that made him appear an imposing and heroic figure.[2] In some cases these echoed Titian's grand portraits of the sixteenth-century Habsburg rulers. Meanwhile, Charles's relationship with Parliament had broken down, leaving him increasingly isolated.

Charles's French queen, Henrietta Maria, was described as a small woman with projecting front teeth;[3] nevertheless, van Dyck's portraits made her appear an ideal of beauty (see no.19). This was in line with the attitudes of the court masque, a form of elite entertainment that combined music, dance, drama and poetry with elaborate and expensive fantasy costumes, in which the royal couple and their courtiers participated. In these, the representation of royal love and marriage symbolised order and 'loving rule'. Recent studies have suggested that Henrietta Maria played a more active role in cultural patronage than had previously been thought.[4]

Van Dyck portrayed the royal family, almost for the first time, as an interconnected group. One of his first works in London was the 'Greate Peece' (no.17), which depicts the king and queen and their two eldest children, Prince Charles (later to be Charles II) and Princess Mary, as a stately but affectionate family. This highly innovative painting had a considerable impact, and echoes of it can be found throughout British portraiture, particularly royal portraiture, over the following centuries. When the German artist Johan Zoffany was tasked with painting *George III, Queen Charlotte and their Six Eldest Children* in the late 1760s, he evidently looked towards the 'Greate Peece', as well as van Dyck's celebrated painting of the *Five Eldest Children of Charles I* (fig.23), which George III had purchased back for the Royal Collection in 1765 (see no.124).[5] Van Dyck's individual and group portraits of the royal children are sophisticated images of elite figures, yet convincingly and appealingly childlike (see nos.22 and 23).

Van Dyck soon effectively had a monopoly of royal portraits. According to a

Van Dyck's Return to England: Royal portraits

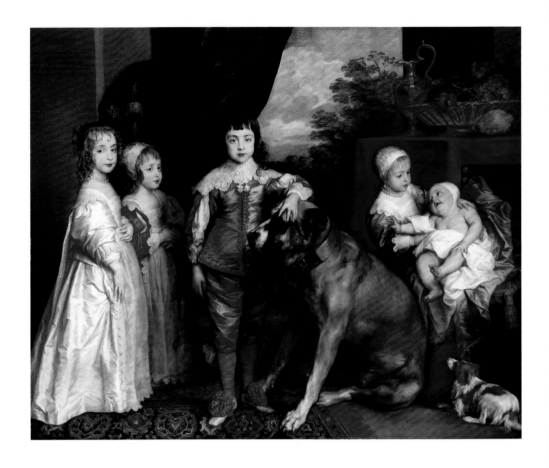

privy seal warrant of 7 May 1633, he was paid £444 for 'nine pictures of or Royall self and most dearest Consort the Queene'. Between May and December 1637 he was paid by the Crown (in three instalments) the sum of £1,200 'for certeyne Pictures by him'.[6] In late 1638 he sent Charles I a 'memoir' requesting payment for twenty-five paintings; on this Charles I inserted cuts to the asking price for some works, including a work described as 'Le Roi alla ciasse' ('the King in the hunting-field'), now in the Louvre (*Charles I in the Hunting Field*, fig.21, p.65). In this document van Dyck also noted that his annual pension of £200 had not in fact been paid for the previous five years. In the event, only £603 was paid for the pictures, in stages in February and May 1639.[7] Like Mytens before him, van Dyck was also tasked by Charles I with painting posthumous likenesses of his deceased relatives.[8]

Portrait miniaturists had to respond immediately to these new forms of royal representation. Small-scale copies or versions of van Dyckian royal pictures soon proliferated, to be presented as gifts or commissioned for purposes similar to large-scale portraits (see nos.20, 24–6). In this respect there seems to have been a special link with the English miniaturist, the elder John Hoskins.[9] For Charles I Hoskins painted not only original miniature portraits from life (see no.27), but also small-scale copies from oil paintings by other artists (see no.18). Surviving letters from Thomas Wentworth, later 1st Earl of Strafford, indicate how this link operated. In August 1636 Wentworth wrote to his agent in London, William Railton, asking him to commission, as he had done before, from 'Hauskins … my picture in little from my original that is at length [that is, full-length]' by van Dyck. He added 'and desire Sir Anthony from me to help him'. In this market, however, it appears that Hoskins had more work than he could cope with.[10] Wentworth wrote separately to his wife that 'Mr Hoskins hath so much work as I fear he will not have time to spare'. Indeed it seems that van Dyck himself

actually preferred to work with another, unnamed, small-scale painter. In September Railton wrote back to Wentworth pointing this out, adding: 'I presume, seing that … Sr Anthony recommends this man, he will contribute more, of his advise and Judgement to him then he will doe to Hoskins …'.[11] It is not known who this other miniaturist was.

Portrait miniatures in enamel after large-scale portraits, and particularly after those by van Dyck, were introduced in London by the Swiss incomer Jean Petitot, often working in collaboration with his fellow Swiss Jacques Bordier (see nos.24–6).[12] Tradition has it that Charles I encouraged Petitot, who was skilled in decorative enamelling, to adapt this technique to portrait-making and to discuss the process with van Dyck.[13] Petitot and Bordier were recorded as 'servants' in Henrietta Maria's household, and various payments to Petitot appear in her financial records.[14]

Whitehall Palace (subsequently destroyed by fire in 1698) was Charles I's principal palace, and this was where the major part of his art collection was kept. The inventory made in the late 1630s by his Surveyor, Abraham van der Doort, is the principal surviving source of information on the collection and the manner in which it was displayed.[15]

Notes
1 R. Malcolm Smuts, 'Art and the material culture of majesty in early Stuart England', in Smuts 1996, pp.86–112.
2 For a range of views on representations of Charles I, see Corns 1999, esp. John Peacock, 'The visual image of Charles I', pp.176–239.
3 Millar 1982, pp.26–7 and p.36 n.29, citing the *Memoirs of Princess Sophia, Electress of Hanover*, trans. H. Forester, London 1888, p.13.
4 For which see particularly Erin Griffey (ed.), *Henrietta Maria: Piety, Politics and Patronage*, Aldershot and Burlington, VT, 2008 and, for the masque, Karen Britland, *Drama at the Courts of Queen Henrietta Maria*, Cambridge 2006.

5 Roberts 2004, no.6, pp.30–1 and no.155, pp.179–81.
6 National Archives, E403/2567 and PSO, 2/104, see *ODNB* 2004, vol.17, pp.466–74, entry on van Dyck by Jeremy Wood.
7 Hookham Carpenter 1844, p.67; National Archives, SP 16/406, 4, T.56/4, f.206; *ODNB* 2004, vol.17, pp.466–74, entry on Sir Anthony van Dyck by Jeremy Wood.
8 For images commissioned by Charles from Mytens, see Millar 1963, vol.1, pp.84–5. From 1620 to 1634 there was a continuous series of payments to Mytens for pictures painted for the Crown, including numerous official royal portraits to present to Charles's friends and allies within Britain, or to send overseas to relatives and members of other ruling houses.

9 Millar 1986, pp.109–23.
10 *ODNB* 2004, entry on John Hoskins the Elder by John Murdoch, vol.28, pp.238–40.
11 Millar 1986, pp.114–15.
12 Lightbown 1968, pp.109–23.
13 Graham Reynolds, *The Sixteenth- and Seventeenth-Century Miniatures in the Collection of Her Majesty The Queen*, London 1999, p.234.
14 Caroline Hibbard, '"By Our Direction and For Our Use": The Queen's Patronage of Artists and Artisans seen through her Household Accounts', in Griffey 2008, pp.122, 126.
15 Millar 1958–60; MacGregor 1989. See also Millar 1970–2; Brotton 2006.

Van Dyck's Return to England: Royal portraits

17
Charles I and Henrietta Maria and their two eldest children ('The Greate Peece') 1632
Oil on canvas
302.9 x 256.9
Her Majesty The Queen (The Royal Collection Trust)

Van Dyck depicts here, as a harmonious group, Charles I, his French queen Henrietta Maria, the royal heir Charles, Prince of Wales (born 1630) and, as a babe in arms, Princess Mary (born 1631). Behind them, to the left, the Parliament House and Westminster Hall can be seen across the River Thames.

The 'great peece of o' royall selfe, Consort and children' was commissioned to be hung in a prominent position in Charles I's Long Gallery at Whitehall Palace.[1] It was painted immediately after van Dyck's arrival in London, and payment to him of £100 for it was authorised by the king on 8 August 1632. As one of the largest pictures that van Dyck had ever painted by this date, the portrait was evidently devised to demonstrate both the authority of the king and the familial harmony that gave the Stuart dynasty new vitality in the person of the healthy male heir, the 2-year-old Prince Charles. Charles I's royal status is made clear by the inclusion of the immense column behind him, the two x-frame chairs of state and, above all, of the regalia – the orb, sceptre and imperial crown – on the table to the left, to which the viewer's gaze is directed by the king's arm. Simultaneously, van Dyck emphasises the personal links of affection within the family in the gesture with which the little prince touches his father's knee and in the queen's affectionate but respectful glance towards her husband. Nevertheless, the viewer's attention is drawn first to the calm but steady gaze of the king himself. While Charles is formally – indeed regally – dressed, contemporaries would have noted that the queen is presented in much more informal attire, signalling a more relaxed form of depiction than had hitherto been seen in Britain.[2] A jacket similar to that worn by the queen is included in the present exhibition (no.61).

Van Dyck had not painted a family group portrait since he had left Italy in 1627. In this grand portrait he may have been tasked with reinventing the royal dynastic image as it had earlier been presented by an unknown artist almost a century before in *The Family of Henry VIII* (fig.1, p.12), a work that in the 1630s hung nearby in the Privy Gallery, also at Whitehall.[3]

Technically, this work is extremely unusual in that it is painted on 'ticking' (a striped herring-bone weave canvas). In areas where the paint is worn, such as the sky area on the left, some of the stripes have become discernible.[4] By the end of the seventeenth century the work was already in problematic condition, possibly because van Dyck had used tobacco pipe clay in priming it.[5] Subsequently – probably in the eighteenth century – additions were made to the edges of the painting, probably to enlarge it to the size of the immense equestrian portrait of the king (no.21), near which it was hung. When it was conserved in the late twentieth century, these additions were folded over behind the stretcher, thus returning the image to its original dimensions.

Many copies of the painting were made, some on a similarly large scale and some much smaller.[6] Copies were also made after the individual portraits of the sitters; these include Cornelius Johnson's small painting on copper of the Prince of Wales (no.20). In addition, Johnson's large group portrait of the royalist Capel family (c.1640; National Portrait Gallery, London) is also partly based on the present composition. In subsequent centuries its influence continued to be felt: Johan Zoffany's portrait of *George III, Queen Charlotte and their Six Eldest Children*, 1770 (no.124) clearly echoes it in both composition and spirit. KH

Notes
1 Millar 1982, no.7, pp.46–7.
2 Gordenker 2001, pp.36–8; Ribeiro 2005, pp.109–10.
3 Barnes et al. 2004, no.IV.45, pp.459–61.
4 Observations made by Viola Pemberton-Pigott, Royal Collection Paintings Conservation department file, 7 April 2000.
5 Millar 1982, no.7, pp.46–7.
6 For a list of examples, see Barnes et al. 2004, no. IV.45, p.460.

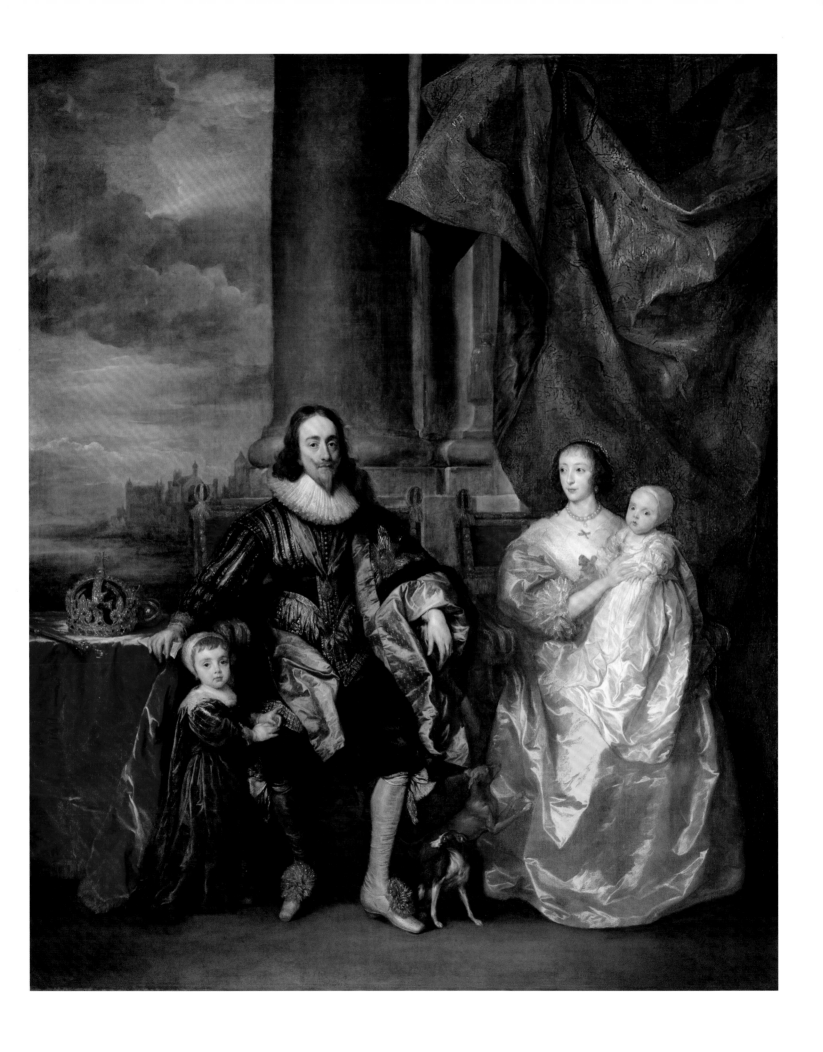

Van Dyck's Return to England: Royal portraits

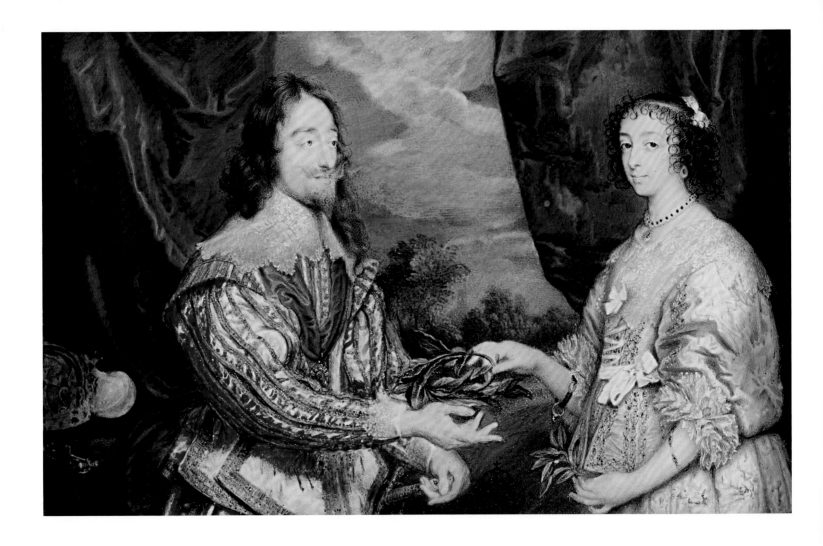

18
John Hoskins (c.1590–1665) after Anthony van Dyck
Charles I and Henrietta Maria 1636
Water-bound pigment on vellum laid on wooden panel (with Charles I's crowned 'C.R.' brand on the reverse)
7.0 x 11.5
Inscribed between the two figures in monogram: 'C.M.R.' and dated: '1636'
The Duke of Northumberland, Alnwick

The brand on the back of the panel indicates that this work was formerly in the collection of Charles I.[1] Before a distant landscape, Charles is depicted gesturing to his French-born queen, who proffers to him a garland of laurel leaves (representing military glory) with her right hand while holding a sprig of olive leaves (symbolising peace) in her left.[2] On a green fabric-covered table behind the king rests the British royal regalia.

Hoskins spent his early career in Blackfriars, an area inhabited by various overseas-trained migrant artists, including van Dyck.[3] He seems to have had an arrangement with van Dyck to make miniature copies after his large-scale portraits.[4]

This is indeed a small-scale, but faithful, copy of one of van Dyck's most important paintings, which he had produced in 1632, very soon after his arrival in London. Later commentators have remarked that van Dyck comprehensively eclipsed Charles's previous principal portraitist, Daniel Mytens. Prior to December 1631 Mytens had been commissioned to produce a royal double portrait (fig.24) to hang above the chimneypiece in the Cabinet at Somerset House, the queen's palace. It seems, however, that Mytens's painting was considered unsatisfactory. After van Dyck's arrival the image of the queen was repainted to copy one of van Dyck's portraits of her.[5] A recently taken X-radiograph of Mytens's portrait (fig.25) clearly reveals the less flattering form of the queen's head that Mytens had originally painted, to the right of her image on the present surface.[6]

Subsequently, however, van Dyck appears to have been asked to paint a wholly new work, based on the same composition. The resultant image (fig.26) is one of his very finest works, and was soon engraved, in a particularly high-quality print by Robert van Voerst, in 1634, the year in which a presumably disheartened Mytens

left England for good.[7] Hoskins's miniature copy is dated 1636, indicating the king's continuing enthusiasm for this important image; van der Doort's inventory of the king's collection shows that he kept this miniature in the Cabinet Room at Whitehall, where he placed his favourite pictures.[8] KH

Notes
1 Alternatively, it has been suggested, based on a comment by Bellori, that the sprig may be of myrtle leaves, which were associated with love: see Barnes et al. 2004, no. IV.46, pp.460–62; also Brown and Vlieghe 1999, no.65, pp.240–3; and Wheelock et al. 1990, no.62, pp.246–9.
2 John Murdoch et al., *The English Miniature*, New Haven and London 1981, pp.100–101.
3 *ODNB* 2004, vol.28, pp.238–40, entry on John Hoskins the Elder by John Murdoch.
4 Ibid., and Millar 1986, pp.109–23.
5 Millar 1963, no.119, p.86.
6 The author is grateful to Rupert Featherstone and his colleagues for kindly commissioning this new X-radiograph in summer 2008.
7 Griffiths 1998, no.42, pp.86–7; Hearn 2002, pp.42–4.
8 John Peacock, 'The Visual Image of Charles I', in Corns 1999, pp.225–8.

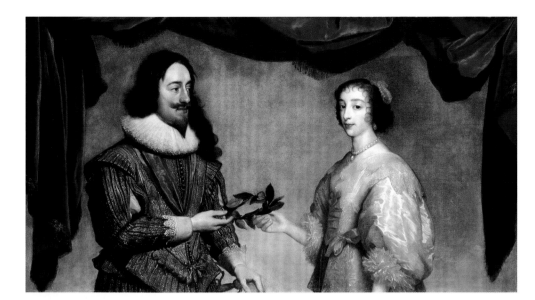

On this page:

Fig.24
Daniel Mytens
Charles I and Henrietta Maria c.1630–2
Oil on canvas
953 x 1750
Her Majesty The Queen (The Royal Collection Trust)

Fig.25
Daniel Mytens
X-ray of *Charles I and Henrietta Maria* c.1630–2

Fig.26
Anthony van Dyck
Charles I and Henrietta Maria 1632
Oil on canvas
113.5 x 163
Archiepiscopal Castle, Kromeriz

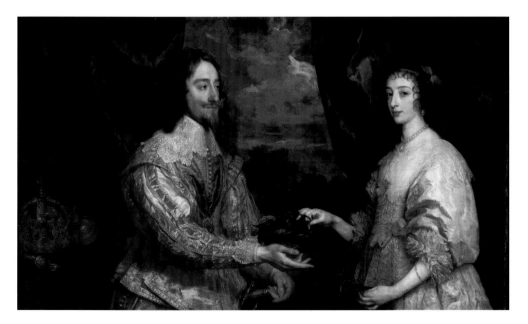

Van Dyck's Return to England: Royal portraits

19
Queen Henrietta Maria 1632
Oil on canvas
107.3 x 86.2
Inscribed in monogram (upper right):
'HMR / 1632'
Private collection

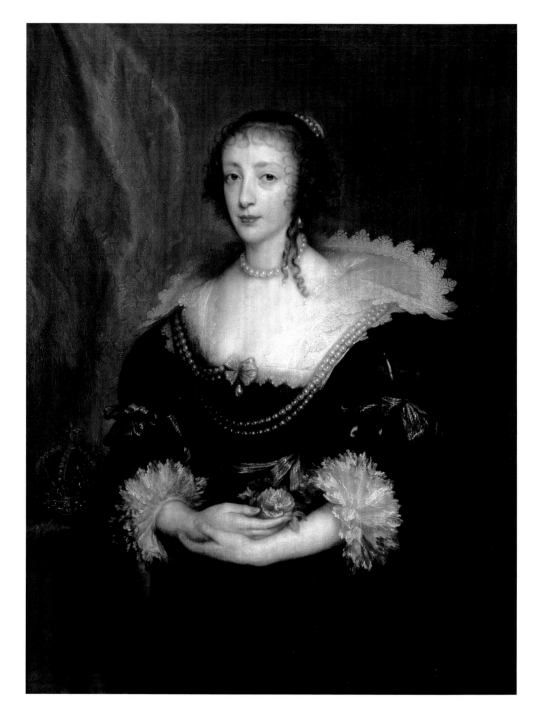

Henrietta Maria (1609–69) was the daughter of Henri IV of France (1554–1610) and Marie de' Medici (1575–1642). A Catholic, Henrietta Maria married Charles I by papal dispensation on 1 May 1625. The marriage was initially unhappy but, after the death in 1628 of Charles's close adviser and friend, the Duke of Buckingham, it became a love match. The queen gave birth to eight children. She took some interest in the arts.

A small imperial crown is depicted on a ledge to the left, by the queen's elbow; such a crown was often to appear in van Dyck's portraits of Henrietta Maria. This work was painted very early in van Dyck's years in London. The inscription, 'HMR' (Henrietta Maria Regina) in monogram, and the date appear beneath a crown at the upper right.[1] Within her linked arms the sitter holds a single red rose. It has been suggested that her gesture refers to a pregnancy; as the work is dated 1632 (which under the calendar in use in England at this period would mean the twelve months between 25 March 1632 and 24 March 1633), it could just fit with the date of birth of her son, James, Duke of York, on 14 October 1633.[2]

Henrietta Maria evidently sat to van Dyck on various occasions, and he and his workshop produced a considerable number of portraits of her. His strategies for enhancing the appearance of a sitter are perhaps seen most clearly in his representations of Henrietta Maria. Images of her by other portraitists, such as Daniel Mytens, Hendrik Pot and Gerrit van Honthorst – and indeed early miniatures by John Hoskins – show that she was not a beauty. Van Dyck's portraits, however, present her as sweet-faced and elegant. He diminished the swarthiness of her complexion and refined her rather heavy features; although she was barely five feet tall, his depictions of her attired in a single colour gave her added height.[3] Famously, Elizabeth of Bohemia's daughter Sophia (Henrietta Maria's niece by marriage) observed that her ideas of the beauty of English ladies had come from 'the fine portraits of van Dyck', and that it was thus a shock when in 1642 she met the queen, '(so beautiful in her picture) a little woman with long lean arms, crooked shoulders, and teeth protruding from her mouth like guns from

a fort'.[4] Henrietta Maria's tribulations and constant child-bearing had no doubt aged her, but nevertheless the contrast between van Dyck's images and the reality was evidently considerable.

The costume that the queen wears here was in fashion at the start of the 1630s. It has been observed that van Dyck never painted the queen again attired in this style.[5] On the other hand, her unusual 'spiky and delicate' cuffs here, made of tightly gathered layers of linen richly tiered in lace, appear in a number of the artist's other images of the queen.

A portrait of John Evelyn's mother, who died in 1635, is clearly based on the present work, which indicates that it must

have quickly been absorbed, and copied, by other artists in Britain (no.93). Lady Evelyn's portrait echoes this work *in reverse*, which suggests that the unknown painter followed an engraving, rather than this original. Indeed, a print after this work is also included here (no.92). KH

Notes
1 Barnes et al. 2004, no.IV.113, p.519.
2 Sumner 1995, no.2, pp.78–9.
3 Ribeiro 2005, pp.114–16.
4 Millar 1982, pp.26–7 and p.36 n.29, citing the *Memoirs of Princess Sophia, Electress of Hanover*, trans. H. Forester, London 1888, p.13.
5 Gordenker 2001, p.35.

20
Cornelius Johnson (1593–1661)
Portrait of Charles II as a Boy c.1632–5
Oil on copper
25.4 x 21
Private collection, courtesy of Hazlitt,
Gooden & Fox

Van Dyck arrived in London in spring 1632 to work for Charles I. That December, the London-born Johnson was appointed Charles's 'servant in ye quality of picture maker', and although he seems to have been asked to produce very few paintings for the monarch, it is likely that the present work may have been one of them.[1]

Here Johnson has copied the small figure of Prince Charles from the 'Greate Peece' (no.17), the group portrait of Charles I and his family painted by van Dyck soon after his arrival in 1632. But Johnson probably did not take the figure directly from the immense painting itself, but from a now-lost related picture of the prince which is thought to have been produced in van Dyck's workshop.[2] A mezzotint was made after that image by Wallerant Vaillant (1623–77), followed by another by Abraham Blooteling (1640–90).[3]

Charles here wears a dress, as was customary at this period for little boys, who were not put into breeches until the age of six or seven.[4] It is likely that the present work was painted quite soon after the 'Greate Peece' because when in 1635 van Dyck depicted the three eldest children of Charles I – in a portrait to be sent to their aunt, the Duchess of Savoy – and he again showed the Prince in a skirt, the king was reported to be displeased, considering that such babyish attire was now undignified for an image of his heir.

The present work, in a substantial carved and gilded frame, appeared in 2003 in a sale of items acquired during the twentieth century by John Parnaby Esq. Labels on the back indicated that it had been sold previously from the Hamilton Palace collection, on 8 July 1882.[5] In a seventeenth-century inventory of the Hamilton collection the picture was described as '… the prince at Length w^th a spanniell of ionston'. It seems likely that it had been a royal gift to James Hamilton, 3rd Marquess and later 1st Duke of Hamilton (1606–49), Charles I's Master of Horse, gentleman of the bedchamber and 'the most important Scot at court'.[6] Hamilton was himself a keen collector of art, and had his own portrait (in armour) painted by van Dyck in 1640 (Vaduz Castle, collections of the Prince of Liechtenstein).[7] His wife, Lady Mary (nee Feilding, ?1612/13–1638),

was a lady of Henrietta Maria's bedchamber and personally close to her. By 1759 the present work was listed in another Hamilton inventory as 'King Charles II with a dog on copper by Vandyke', and this remained the attribution up to and including the time of its sale in 1882.[8]

A second example of this small portrait, of about the same dimensions and again probably by Johnson, is in another private collection,[9] and may originally been a gift to another favoured courtier. Johnson was also to produce a later small full-length of the prince, this time in breeches, in a composition of his own, which is signed and dated 1639.[10] KH

Notes
1 K. Hearn, 'The English Career of Cornelius Johnson', in Roding 2003, pp.113–29.
2 See Barnes et al. 2004, no.iv.A11, p.632.
3 New Hollstein, pt v, no.420, pp.129–31, as '*Ant: van Dÿck Pinx*'.
4 Barnes et al. 2004.
5 Messrs H.Y. Duke & Son of Dorchester, sale of collection of John Parnaby Esq., from Netherhampton House near Salisbury, 16 June 2003 (lot 217). In 1882 it had been acquired by Messrs Thos. Agnew and Sons for £231 and apparently sold to James Reiss Esq.
6 *ODNB* 2004, vol.24, pp.839–46, entry on James Hamilton, 1st Duke of Hamilton, by John J. Scally.
7 Barnes et al. 2004, no.iv.10, pp.517–18.
8 The author is grateful for the assistance of Mrs Celia Curnow of The Virtual Hamilton Palace Trust, May 2008.
9 Oil on copper, 25.5 x 21.0, see Roding et al. 2003, where repr. as col. pl.i, facing p.128. See also *A Noble Visage: A catalogue of early portraiture*, exh. cat., Weiss Gallery, London, 2001, no.24, fig.
10 Oil on panel, 29 x 20, National Portrait Gallery, London, no.5103.

21

Charles I on Horseback with M. de St Antoine 1633
Oil on canvas
368 x 269.9
Inscribed left: '1633'
Her Majesty The Queen (The Royal Collection Trust)

In this huge painting Charles I is shown in armour, with a baton of command, riding an elegant white horse through a high classical arch, over which is draped a green silk curtain. It resembles a great stage set. To the right, holding the king's helmet and gazing up at him adoringly, is his French equerry and riding-master, the Seigneur de St Antoine. A very celebrated horseman, he had been sent over by Henri IV of France to teach *haute école*, or 'riding the great horse', to the late Henry Prince of Wales; he also taught Charles himself and William Cavendish, later Duke of Newcastle.[1]

The work is inscribed, left, on a ledge above an imperial crown, '1633'.[2] Below this is a large fictive shield painted with the arms adopted by James I when he ascended the English throne. To the lower right is a later inscription identifying M. de St Antoine. Charles's head is very carefully finished; the equerry's is more roughly painted.

An earlier very large painting of Prince Henry on horseback in profile, by Robert Peake, survives, but it is very different from this one (see fig.2, p.12). An English print of about 1614–15, by Renold Elstrack, had also depicted Charles, at that time Duke of York, on horseback in an attitude of easy command (fig.27).[3]

Van Dyck has here brought the baroque of Rubens to British royal portraiture. Rubens had used this composition of horse and rider in his celebrated portrait of the Duke of Lerma of 1603 (Prado, Madrid), which Charles must have seen on his visit to Spain in 1623. Van Dyck himself had already used it for sitters in Italy. Here he depicts Charles as effortlessly in control of the powerful horse, which is about to turn at his command, apparently performing a *passage*, a particularly refined dressage movement.[4] The message is clear: Charles is presented as a consummate horseman, and his easy control is a visual metaphor for his command of his 'empire': England and Scotland.

Charles I had this painting hung at the end of the Gallery in St James's Palace, for which it had presumably been specifically designed. Here Titian's portraits of the Caesars were also displayed, with smaller pictures of Roman emperors on horseback by Giulio Romano.[5] Van Dyck's picture would

have dominated this context.

Various pentimenti are visible on this canvas: to the left of Charles's body and of his head, to the horse's raised front hoof and to its bit and bridle. Van Dyck's drawn studies of a horse in a similar position survive; one sheet is included here (no.82).

A large number of copies of this painting survive, some on a large scale, some considerably smaller.[6] Remarkably, this composition was to be appropriated in about 1655 by Pierre Lombart for an engraved equestrian portrait of Oliver Cromwell (no.100), in which the figure of the king was replaced with that of the Lord Protector, and M. de St Antoine by a youthful page. KH

Notes
1 Van Beneden 2006, pp.38–40; Giles Worsley, *The British Stable*, London 2005, pp.57–61.
2 Millar 1982, no.11, pp.50–2; Barnes et al. 2004, no.IV.47, pp.462–4.
3 Gudrun Raatschen, 'Van Dyck's "Charles I on Horseback with M. de St Antoine"', in Vlieghe 2001, pp.139–50.
4 Ibid.
5 John Peacock, 'The Politics of Portraiture', in Sharpe 1993, pp.199–228.
6 For a list of examples, see Barnes et al. 2004, no. IV.47, pp.462–4.

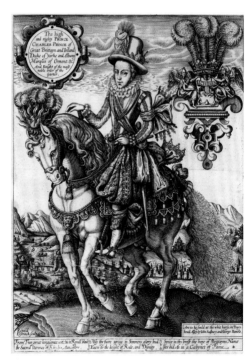

Fig.27
Renold Elstrack
Charles I, as Prince of Wales, riding on horseback in a landscape, with the Prince's feathers beside him c.1612/6
The British Museum, London

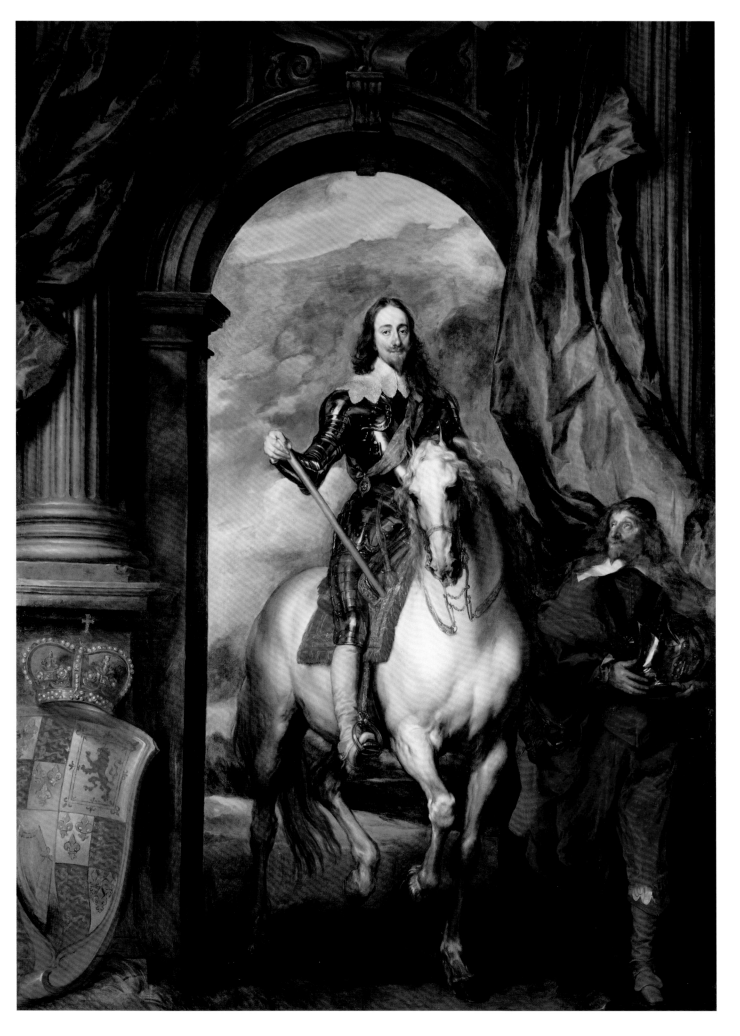

Van Dyck's Return to England: Royal portraits

22

Princess Mary c.1636
Oil on canvas
136 x 106.7
Museum of Fine Arts, Boston. Given in
memory of Governor Alvan T. Fuller by the
Fuller Foundation

The eldest daughter of Charles I and
Henrietta Maria, Mary was born at St
James's Palace on 4 November 1631.
In van Dyck's early group portrait of the
Royal Family, the 'Greate Peece' (no.17),
Mary is the baby in the queen's arms.
She also appears as a little girl in van Dyck's
three group portraits of the couple's
eldest children, painted in 1635 and 1637
(fig.23, p.66).[1]

It is thought that Mary is shown here
at the age of about five or six.[2] There are
pentimenti in the areas of her hands and lace
cuffs and in the line of the dress across her
chest.[3] The manner in which her hands are
held, linked across her stomach, is an echo
of van Dyck's early portrait of her mother,
of 1632 (no.19); he also used versions of
this composition for other adult female
sitters. Here, there is a poignant contrast
between Princess Mary's dignified bearing
and high-status, silver-braided attire and the
vulnerability of her childish person.

The textile to the right – a large
assymetrical branched pomegranate cloth
of gold – was apparently about 150 years
old, and appears in a number of van Dyck's
portraits between 1629 and 1641, which
suggests that it was a prop in his studio.[4] It
is also seen in no.47.

On 2 May 1641, at the age of just nine,
Mary was married in London to William
(1626–50), son of the Dutch ruler, Frederick
Henry. In March the following year her
mother, Henrietta Maria, took her to The
Hague to join her young husband.[5] Mary's
only child – a son, also called William – was
born in 1650, eight days after the death of
her husband from smallpox. Mary herself
died in late 1660, soon after travelling to
England at the Restoration of her brother,
Charles II. Her son was to marry his cousin
Mary Stuart, daughter of King James II, and
become William III of Great Britain in 1689.

The early history of this portrait is
unknown. Another contemporary version
of it survives, of slightly lesser quality but
thought to have been hanging at Hampton
Court Palace in 1647, before being sent out
to The Hague, to her mother-in-law the
Princess of Orange, Amalia van Solms.[6] Van
Dyck depicted Princess Mary again in 1641,
at around the time of her wedding, both
on her own and with her young husband,
although it was reported at the time that the
artist was seriously ill and struggled to finish
the portraits.[7] KH

Notes
1 Barnes et al. 2004, nos.IV.60–IV.62, pp.477–80.
2 Ibid., no.IV.161, pp.554–5.
3 The painting was conserved in 1995, at which time later
strips of canvas that had been added across the top and
bottom were also removed.
4 Lisa Monnas, *Merchants, Princes and Painters*, New Haven
and London 2009, pp.259–67, 371 n.85 , and see p.266 for a
surviving example of this velvet cloth of gold.
5 *ODNB* 2004, entry on Mary, Princess Royal by Marika
Keblusek. The queen was accompanied by a large
consignment of jewellery and plate to be traded in the
Netherlands for money and weapons for Charles I's military
campaigns.
6 Barnes et al. 2004, no.IV.162, p.556.
7 Ibid., nos.IV.163–4, and IV.242, pp.556–8, 616–17.

23

Charles II as Prince of Wales, in Armour
c.1637–8
Oil on canvas
125.7 x 102.9
Private collection

Van Dyck here shows the future Charles II (1630–85) as a young boy, yet attired in armour, like a military commander, and holding a newly fashionable wheel-lock pistol.[1] The late Kate Gibson noted that Charles is not shown wearing the Lesser George (a small image of St George worn round the neck by Knights of the Garter when not wearing full regalia), which suggests that the portrait was painted before the young Prince's installation as a Knight of the Garter on 21 May 1638.[2] The child-sized armour had previously belonged to the prince's late uncle, Henry, Prince of Wales (see no.1). Prince Charles's head is similar to that in van Dyck's group portrait, *The Five Eldest Children of Charles I* (fig.23), painted for Charles I and inscribed 1637, suggesting that it may derive from the same portrait sitting.[3] The armour presents him as ready for command at the time of the Scots War.

Recent cleaning of this work has revealed the high quality of its brushwork, as well as a number of pentimenti, especially to both the prince's hands. It is clear from infra-red reflectography that some free underdrawing in translucent paint was initially used to establish some of the elements.[4] Another version remains in the Royal Collection, but the present portrait is likely to have been owned (and perhaps even commissioned) by William Cavendish, later 1st Duke of Newcastle (see p.85). It would certainly have been a demonstration of Cavendish's status in relation to the young heir to the British throne – and to his father Charles I, who in July 1638 appointed him Governor to the Prince, a court position for which he had angled hard and towards which he had spent a good deal of money.[5]

A miniature in enamel by Jean Petitot with the head and shoulders of the Prince from the present portrait (no.26) demonstrates the contemporary practice of making miniature copies of van Dyck's portraits in different media. KH

Notes
1 Barnes et al. 2004, no.IV.64, pp.481–2.
2 Gibson 1997, vol.1, pp.19–20, and vol.2, p.275.
3 Repr. Barnes et al. 2004, no.IV.62, p.480.
4 Mark Roberts, unpublished conservation report, 2006–8.
5 Hearn 2006, p.91, and no.35, pp.156–7.

24

Jean Petitot the Elder (1607–1691) after
Anthony van Dyck
Charles I 1638
Enamel on gold
Oval, 5.1 x 4
Inscribed on reverse: 'J. Petitot fec.1638'
Private collection

Jean Petitot was born in Geneva, where
he was apprenticed to his goldsmith uncle,
Jean Royaume. In around 1633 he moved
to Paris, where he learned the technique of
painting in enamel on gold. By 1637 he was
in London, as a member of the household
of Charles's French-born queen, Henrietta
Maria.[1] There he found a strong local taste
for tiny portrait miniatures painted in
water-bound pigments on vellum stuck to
card (see for example, nos.18, 27). It was
Petitot who introduced the techniques of
enamelling portraits on gold to England,
where his miniatures became extremely
popular, and where he, in turn, learned much
about the properties of enamel from the
Swiss-born physician Sir Theodore Turquet
de Mayerne (1573–1655). For much of his
career Petitot collaborated with his fellow
Genevan Jacques Bordier (1616–84). He
left England in 1643 or 1644, soon after the
outbreak of the Civil War, and returned to
France, where he had considerable success
and gained the patronage of Louis XIV.

 Some of Petitot's miniatures are direct
copies of large-scale portraits in oils,
including some by van Dyck. The head
of Charles I here seems to derive from
van Dyck's portrait of the monarch now
at Chequers, c.1636 (fig.28).[2] In both cases
he is depicted wearing the blue ribbon of
the Order of the Garter.[3] This miniature is
signed and dated on the reverse, which is of
pale blue enamel. KH

Notes
1 See Caroline Hibbard, '"By Our Direction and For Our
Use": The Queen's Patronage of Artists and Artisans seen
through her Household Accounts', in Griffey 2008, esp.
pp.122, 126.
2 Barnes et al. 2004, p.475, no.IV.58, repr.
3 Van Beneden 2006, no.28, p.146.

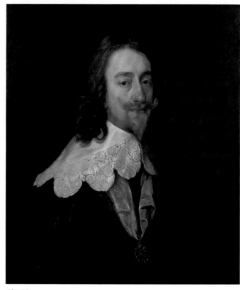

Fig.28
Anthony van Dyck
Charles I c.1636
Oil on canvas
72.1 x 61.9
The Chequers Trust

25
Jean Petitot the Elder (1607–1691) after
Anthony van Dyck
Queen Henrietta Maria 1639
Enamel on gold
Oval, 5.1 x 4
Inscribed on reverse: 'J.P.f.1639'
Private collection

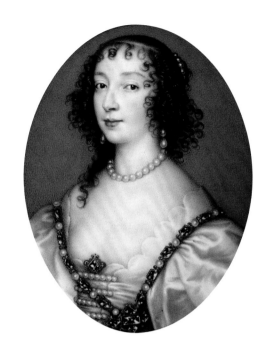

Although they were Protestants, while
they were in England Jean Petitot and his
colleague Jacques Bordier were members of
the household of Charles I's Catholic queen,
Henrietta Maria.

The queen's head in this miniature is
probably based on a lost portrait of her by
van Dyck. Although no example by van Dyck
himself is thought to survive, the best extant
copy is considered to be that in the Royal
Collection.[1] A similar portrait miniature in
enamel of Henrietta Maria by Petitot, dated
1638 and deriving from the same original,
is now in the Willem V Gallery, The Hague,
attesting to a demand for such miniatures of
the queen.[2] KH

Notes
1 Barnes et al. 2004, p.635, no.IV.A20, repr.
2 Lightbown 1968, pp.82–91, fig.11, and van Beneden
2006, no. 29, p .147.

26
Jean Petitot the Elder (1607–1691) after
Anthony van Dyck
Charles, Prince of Wales, in Armour 1638
Enamel on gold
Oval, 5.1 x 4.0
Inscribed on reverse: 'J Petitot fec. 1638'
Private collection

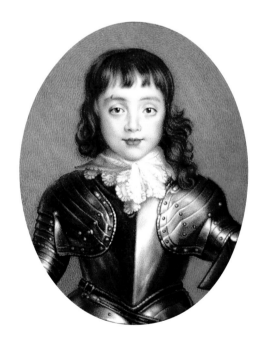

Charles's head here is copied from that in
van Dyck's full-length portrait of the young
prince (no.23). Both are thought to have
been owned by William Cavendish, later
1st Duke of Newcastle (1593–1676), into
whose care the young prince's education was
entrusted. Cavendish was appointed sole
Gentleman of the Bedchamber to the prince
in March 1638, and his governor on 4 July
the same year. Affectionate letters sent by
the little prince to his governor around 1639
survive in the British Library.[1]

In neither van Dyck's full-length nor
in this miniature does the prince wear the
insignia of the Order of the Garter, into
which he was installed on 21 May 1638. KH

Note
1 For example, see van Beneden 2006, no.38, p.161.

27
John Hoskins (c.1590–1665)
Portrait of Charles I c.1640–5
Water-bound pigment on vellum laid on card
Oval, 7.5 x 6.2
Signed centre left: 'I H fe'
Her Majesty The Queen (The Royal
Collection Trust)

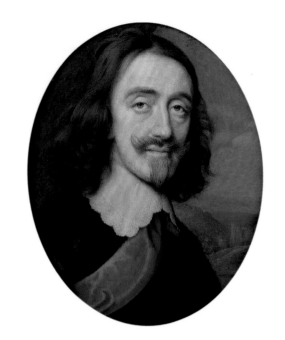

In this expressive portrait miniature the
king is depicted wearing a black satin jacket,
lace-edged falling collar and the blue ribbon
of the Order of the Garter. Behind him is a
landscape, with buildings to the right,

 John Hoskins the Elder is thought to
have spent his early career in Blackfriars.
This area of London was outside the control
of the London Painter-Stainers' Company
and was therefore popular with migrant
artists born and trained overseas, including
van Dyck himself.[1] In 1634 Hoskins moved
to Covent Garden, and on 30 April 1640
Charles I granted him an annuity of £200 for
life, 'provided that he work not for any other
without his majesty's licence'. However,
after the first instalment the deteriorating
political situation meant that the annuity
was not paid, and at his death in 1665
Hoskins was apparently impoverished.

 Hoskins had originally trained as a
'Face-Painter in Oil'[2] before moving into
the field of miniature portraits painted in
water-bound pigments on vellum stuck on
card, in the tradition of Nicholas Hilliard
(c.1547–1619), with whom he may have
trained. He trained his miniaturist nephews,
Samuel and Alexander Cooper, as well as his
son, John Hoskins the Younger (born about
1617), whose oeuvre is hard to distinguish
from his own. In the 1630s Hoskins began
to enlarge his miniatures and reintroduced
to the genre landscape settings and sky
backgrounds. He was evidently also often
called on by the king and others to provide
miniature versions of large-scale portraits
such as one of Charles I by Daniel Mytens.
He seems to have had a specific arrangement
with van Dyck to make miniature copies
after his large-scale portraits (see no.18).
This is clear from Thomas Wentworth's
instructions to his agent on 17 August 1636,
'I pray to get Hauskins to take my picture
in little from my original that is at length
[by van Dyck], and to make it something
like those that he last drew, and desire Sir
Anthony from me to help him'.[3]

 The fashion of the king's collar and
his ageing features suggest that present
miniature dates from after Hoskins's 1640
agreement. While it is indebted to van
Dyck's depictions of Charles I generally, it is
not a copy of any of them and may have been
produced after the Flemish artist's death
in December 1641. This was evidently a
successful image, as a number of versions of
it by Hoskins survive.[4] KH

Notes
1 *ODNB* 2004, vol.28, pp.238–40, entry on John Hoskins
the Elder by John Murdoch.
2 See ibid. and Hearn 1995, no.144, p.215.
3 Ibid., and Millar 1986, pp.109–23.
4 Reynolds 1999, p.111, no.80.

28

The Infant Christ and John the Baptist
c.1638–40
Oil on canvas, mounted on panel
72.4 x 58.1
The Trustees of the Lamport Hall
Preservation Trust, Lamport Hall,
Northamptonshire

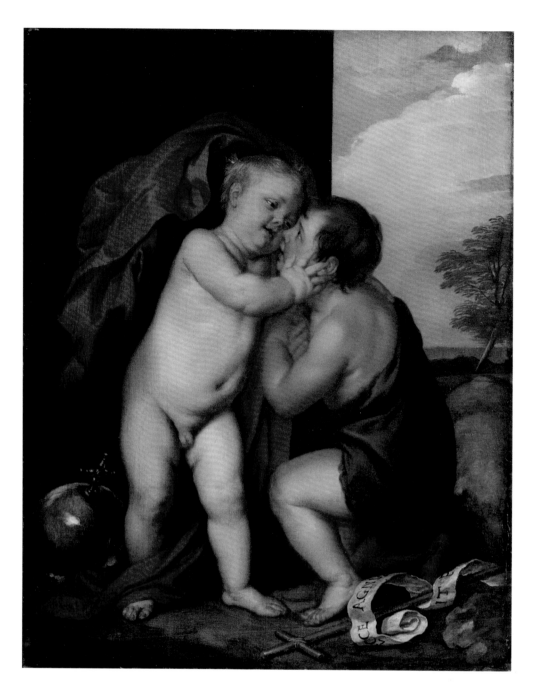

This is a very rare example of a religious painting produced by van Dyck during his stay in Britain. The subject is the apocryphal meeting of the infant Christ with the young John the Baptist during the Holy Family's journey home from Egypt. The young Jesus is shown standing, embracing John, the *globus cruciger* (cross-bearing orb) at his feet. The earliest extant tale of the infancy of John the Baptist is in the second century *Infancy Gospel of St James*, also known as the *Protoevangelium of James* (c. AD 150). This fictitious biography of the young saint was developed by other figures over the years, and the 'Life of St John the Baptist' formed part of the *Volgarizzamento delle vite dei SS. Padri* by Fra Domenico Cavalca, written in 1320–42. Cavalca tells how the 5-year-old John started to wander alone into the woods, walking deeper and deeper into the darkness and eventually staying overnight. At the age of seven he declares that he must leave for a life of solitude and contemplation in the desert. His parents realise that this must be the will of God and allow him to go, with their blessing. Soon after, he encounters Mary, Joseph and the infant Jesus travelling on their return from Egypt. They remain together for a day and night, and pay a visit to John's mother and father, Elizabeth and Zachariah. The Holy Family then continue their journey, and John returns to the desert.[1]

Cavalca's text had an almost immediate impact on the art of renaissance Florence, and the early life of St John the Baptist was absorbed into fourteenth and fifteenth-century Italian culture. Depictions of the meeting of the two holy children were produced by various Italian renaissance artists. One example is that attributed to Girolamo Mazzola Bedoli (c.1500–1569), which during van Dyck's period in England was hanging in the Cabinet Room at Whitehall and was believed to be the work of Parmigianino.[2] It is possible that van Dyck was inspired by this work to produce his own version.[3] However, his composition is quite different from Bedoli's and he may have been aware of the subject through other works viewed during his time in Italy. The face and features of the infant Christ bear a striking resemblance to those of the cupid

in *Margaret Lemon as Erminia* (?) (no.69). Possibly produced around the same time as this work, van Dyck may have used the same model or referred to the same sketches.

The Infant Christ and John the Baptist became very popular and a number of other versions of this painting were produced, including one in the Royal Collection and another unlocated version once owned by the painter Sir Peter Lely (1618–80).[4] TJB

Notes
1 M. Lavin, 'Giovannino Battista: A Study in Renaissance Religious Symbolism', *Art Bulletin*, vol.37, no.2, June 1955, pp.85–101.
2 J. Shearman, *The Early Italian Pictures in the Collection of Her Majesty The Queen*, Cambridge 1983, no.35.
3 O. Millar in Barnes et al. 2004, no.IV.1, p.429.
4 This is known from a dedication to Lely on an engraving after the painting by Arnold de Jode (c.1638–67), 1666. See Griffiths 1998, no.145.

29
Cupid and Psyche c.1638–9
Oil on canvas
199.4 x 192.4 (including small early additions
at top and bottom)
Her Majesty The Queen (The Royal
Collection Trust)

This is the only English painting on a
mythological subject by van Dyck that
has survived. In his biography of the artist,
Bellori (see no.75) mentioned other similar
canvases that he painted in London,
which have since been lost.[1] Painted for
Charles I, this is one of van Dyck's most
beautiful works.

The story of Cupid and Psyche was
recounted by Apuleius in *The Golden Ass* in
the second century AD. The goddess Venus
punished Psyche for her beauty by setting
her a series of apparently impossible tasks,
of which the final one was to take a box
down to the Underworld to be filled with the
secret of beauty. Although ordered by Venus
not to open it afterwards, Psyche could not
resist doing so, upon which she was punished
by being sent into a deep sleep. At this
moment Cupid, the winged son of Venus,
rapidly arrived to waken and rescue her from
the spell.[2] Here Psyche slumbers – her hand
still resting on the opened casket – as Cupid,
partly powered by his wings, rushes to spark
her to consciousness as a divinity.

In neoplatonic thought, which was
central to the ethos of the court of Charles
I and Henrietta Maria, love was defined
as desire aroused by beauty; thus Cupid
represented divine desire and Psyche earthly
beauty. The narrative was familiar to the
court and had, for instance, been the subject
of Shackerley Marmion's *Cupid and Psyche,
An Epic Poem*, performed before Charles's
nephew, Charles Louis, Elector Palatine,
eldest son of Elizabeth of Bohemia (see no.2)
on his visit to London in 1637.

This sensual image is clearly influenced
by van Dyck's study of the paintings of
Titian, whose work was also admired, and
collected, by Charles I. Tradition has it that
van Dyck's figure of Psyche is modelled on
his mistress, Margaret Lemon, and there
are clear parallels with the drawing in the
Fitzwilliam Museum thought to represent
her (no.86). The paint is rapid and lively
in handling; indeed some areas – such as
Cupid's right hand – are barely finished.[3]
Apart from the sky, which has in the past
suffered some abrasion, the painting is
in very good condition. Remains of an
ultramarine glaze on Psyche's blue robe
indicate that it must originally have been a
very bright blue.

It is believed that this work relates to
a scheme initiated in November 1639 to
decorate the Queen's Cabinet at Greenwich
Palace with canvases by the Antwerp painter
Jacob Jordaens (1593–1678) illustrating
the story of Cupid and Psyche. In the draft
catalogue of Charles I's collection compiled
by Abraham van der Doort, the present
work was recorded as hanging unframed
(presumably because it was newly painted)
in the King's Gallery at Whitehall Palace.
The painting was subsequently owned by Sir
Peter Lely. KH

Notes
[1] Bellori 1672, p.263.
[2] Wheelock et al. 1990, no.85, pp.316–19; Brown and
Vlieghe 1999, no.100, pp.326–9; and Barnes et al. 2004,
no.IV.4, pp. 433–1.
[3] I am grateful to Rupert Featherstone, formerly Senior
Conservator of Paintings, The Royal Collection, where this
painting was conserved in 1989–90, for discussing it with
me, May 2008.

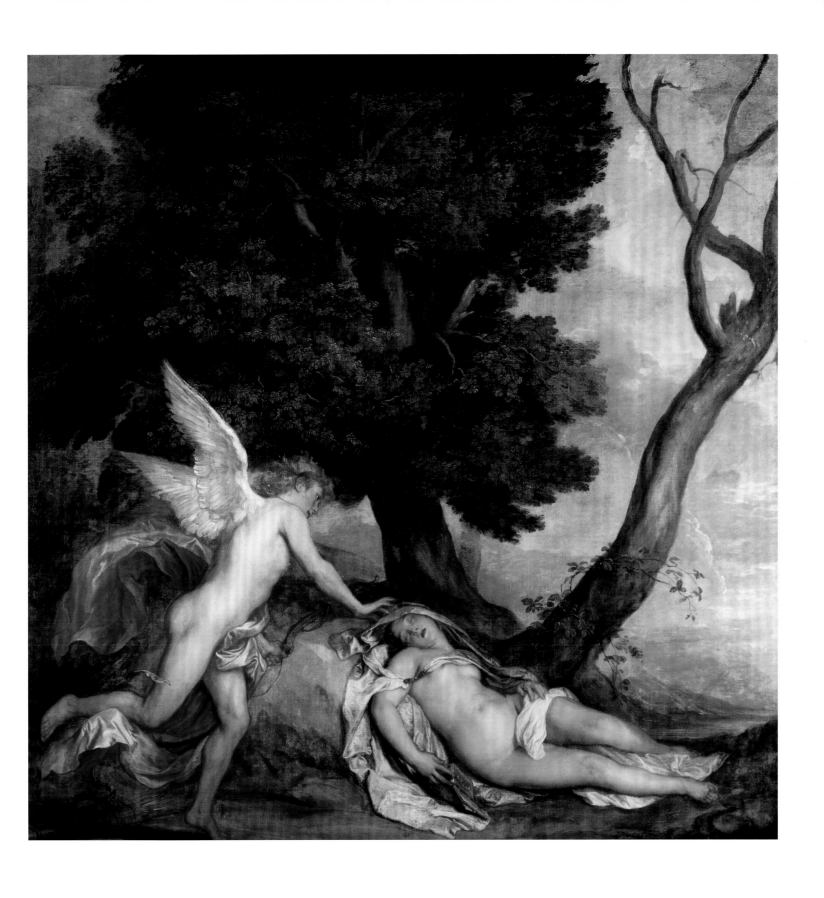

Van Dyck's Return to England: Royal portraits

Other Patrons and Sitters

Van Dyck's role as Charles I's principal painter did not exclude him from working for other clients. His work was greatly in demand among the leading figures at Charles I's increasingly fractured and isolated court. As a Catholic in a Protestant country, his position might have been uncertain, but he was secure in the circle around the French-born Catholic queen, Henrietta Maria.[1] His clients reflected the nature of the court, with aristocrats of both English and Scottish descent intermingled. While the majority were Protestant, some, like Lord George Stuart, Seigneur d'Aubigny, were Catholics; the number of Catholic converts was to increase during the 1630s, especially among the women who attended the queen. Some of the Protestant nobles were Puritans – and, paradoxically, they were among van Dyck's keenest patrons.[2] Subsequently, when the Civil War broke out they would take the side of parliament rather than that of the king. They included Philip, Lord Wharton (no.30); Robert Rich, 2nd Earl of Warwick (no.35); Francis Russell, 4th Earl of Bedford; and Philip Herbert, 4th Earl of Pembroke (no.44), not to mention Algernon Percy, 10th Earl of Northumberland (no.51). Other leading politician sitters included Thomas Wentworth, 1st Earl of Strafford, and the Archbishop of Canterbury, William Laud (nos.41, 42 and 57), the councillors upon whom Charles I relied most. The Earl of Arundel continued to be a patron (no.38).

Although most were politically active in varying degrees, some of van Dyck's sitters chose to be depicted in private or fictive roles, such as poet, shepherd or, latterly, soldier, often with appropriate fantasy costume. Such presentations were not new in British art. From the 1590s onwards, elite English sitters had sometimes chosen to be depicted in symbolic attire – such as *Captain Thomas Lee* as painted by Marcus Gheeraerts II in 1594 (Tate) – or in versions of the elaborate fantasy costume of the courtly 'masque'. Where previous British portraits had privileged dignified stasis, however, van Dyck introduced a sense of spontaneity and liveliness. His British portraits are quite distinct from those he made in Flanders and Italy because he was simultaneously absorbing and adopting elements from locally produced images, tailoring his own representations to the expectations of his British sitters.

In February 1637 William Cavendish, Marquess of Newcastle, later 1st Duke of Newcastle (1593–1676), wrote a remarkable letter to van Dyck from his estate at Welbeck in Nottinghamshire,[3] presumably at around the time when he sat for his full-length portrait.[4] His text shows an unusual degree of warmth towards the painter, whom he would in other circumstances have considered a social inferior, indicating van Dyck's status among members of the court.[5] Presumably some of the 'sweet conversation' to which the marquess refers took place during his sittings for the portrait. The friends he mentions will have included Thomas Wentworth (no.42), who in 1636 had arranged for his portrait to be sent direct from van Dyck's studio to Welbeck.[6] The text of the letter, with modern spelling, is as follows:

> Noble Sir
> The favours [faces] of my friends you have so transmitted unto me as the longer I look on them, the more I think them nature and not art. It is not my error alone; if it be a disease it is epidemical, for such power hath your hand on the eyes of mankind. Next the blessing of your company and sweetness of conversation, the greatest happiness were to be an Argus, or all over but one eye so it, or they, were ever fixed upon that which we must call yours. What wants in judgement I can supply with admiration and escape the title of ignorant

Other Patrons and Sitters

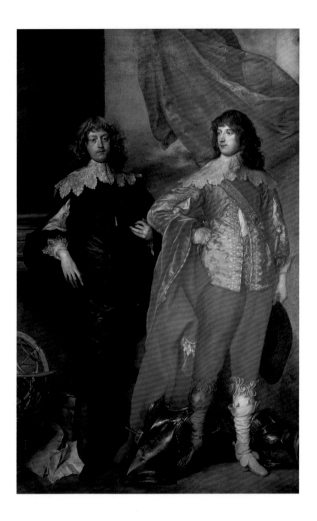

since I have the luck to be astonished in the right place and the happiness to
be passionately your most humble servant W. Newcastle

Welbeck this [...] of Feb: 1636[7]

In his British portraiture van Dyck chose to convey an innate authority and
virtue in the sitter, rather than to itemise the props of authority, and this resulted
in 'a combination of grandeur and relaxation'.[8] Among the individuals who
particularly prized his work was Philip, Lord Wharton, who commissioned and
assembled a large group of his portraits of his relatives (see no.30), while a number
of members of the Killigrew family, minor courtiers, were painted in around the
year 1638 (nos.47, 48, 49, 50).[9]

The specific circumstances in which many of van Dyck's portraits were
commissioned are now unknown. There can be no doubt, however, that in some
cases the female sitters initiated their own portraits or those of family members.
Before her second marriage in April 1635, the widowed Duchess of Buckingham
seems to have commissioned various portraits of herself, either alone (no. 32)
or with her children, as well as individual images of her offspring (nos.33, 34).
In 1637 the widowed Countess of Carlisle was involved in initiating van Dyck's
images of herself (no.43), while the fact that the widowed Lady Stanhope refused
to pay the sum that van Dyck charged her for a portrait presumably indicates her
control of her own money (no.66). As is well known, the Countess of Sussex sat to
van Dyck in the winter of 1639–40; although her portrait has not survived, her
trenchant comments on it have done so. She considered the money spent on it
'ill bestowde' and that van Dyck had made her look 'very ill favourede, makes me

quite out of love with myselfe, the face is so bige and so fate [fat] that it pleses me not att all. It lokes lyke on of the windes poffinge [puffing] – but truly I thinke it tis lyke the originale'. Because 'i think that makes me wors than I am', the countess planned, on her next visit to London, to ask him to make changes to the portrait.[10] She also observed that van Dyck had painted her wearing jewellery that was richer than any that she actually owned, 'but tis no great mater for another age to thinke me richer then i was'.[11]

Van Dyck's changes to the forms in his female portraiture were if anything even more radical than those in his male portraits. English costume, which was generally looser and plainer than that worn by Continental women, offered him the opportunity to add luminosity and movement to shimmering satins. Moreover, he seems to have introduced a new way of representing costume, removing fashionable and status-indicating elements like lace collars and cuffs that would usually have been seen as essential in portraits at this period, and showing loosened bodices and billowing sleeves that gave a radical new air of informality (they also took much less time to paint than fiddly, intricate lace and embroidery).[12] Again, the emphasis was on the inner qualities of the individual, rather than on outward detail.

Van Dyck seems to have been largely responsible for introducing the double or 'friendship' portrait to Britain. Such an image depicts in one frame two people who are not a married couple (and are indeed of the same gender) but are personal friends or political allies and have chosen to record their connection in painted form. This was a convention that had arisen in Italian art, beginning with Mantegna, who painted two double portraits of friends together (now lost); it was subsequently taken up by such artists as Raphael, in his double portrait of about 1516 thought to depict Andrea Navagero and Agostino Beazzano (Galleria Doria Pamphlij, Rome).[13] The most magnificent of van Dyck's friendship portraits is his large painting of *George, Lord Digby, later 2nd Earl of Bristol, with William Lord Russell, later 5th Earl of Bedford*, who were related by marriage (c.1635; fig.29), a work that was to have a considerable influence on later portraiture in Britain.

Courtiers generally displayed their art collections, including their portraits, in their great London houses, rather than their country seats. Whitehall Palace (subsequently destroyed by fire in 1698) was Charles I's principal palace, and the majority of his art collection was located here, in rooms to which visitors and members of the court had varying levels of access. Leading aristocrats also had quarters at Whitehall, in addition to their great houses in the fashionable areas of London, such as The Strand, and in the streets of the more mercantile City over to the east. Covent Garden was being developed for the first time during this period, providing accommodation for those who needed to be close to the court: this was conveniently close to St Martin's Lane, where many of the artists who served the court were already based.

Notes
1 Jeremy Wood, 'Van Dyck: A Catholic Artist in Protestant England', in Vlieghe 2001, pp.167–98.
2 Jeremy Wood, 'Van Dyck and the Earl of Northumberland: Taste and Collecting in Stuart England', in Barnes and Wheelock 1994, pp.281–324.
3 British Library, Add. MS 70499, fol.218.
4 Although the principal version of that portrait survives (private collection), its appearance has been altered by subsequent over-painting, apparently in order to 'update' it by converting the red ribbon of the Order of the Bath, in which van Dyck depicted Cavendish, to the blue ribbon and other insignia of the more senior Order of the Garter,

to which he was appointed after the artist's death; see Barnes et al. 2004, no.IV.168, pp.560–1. See also van Beneden 2006, no.15, pp.130–1.
5 Van Beneden 2006, no.37, p.160.
6 Millar 1986, pp.109–23.
7 At this period, in England the year still officially began on 25 March – thus 'February 1636' was in fact February 1637.
8 Millar 1982, p.12.
9 Malcolm Rogers in Howarth 1993.
10 Millar 1982, p.26, citing Frances P. Verney (ed.), *Memoirs of the Verney Family during the Civil War*, 1892, vol.1, pp.257–61.

11 Gordenker, 'Aspects of Costume in van Dyck's English Portraits', in Vlieghe 2001, p.213.
12 Gordenker 2001, and Ribeiro 2005.
13 See *Renaissance Faces*, exh. cat., National Gallery, London, 2008–9, pp.164–7, 172–3.

Other Patrons and Sitters

Philip, 4th Lord Wharton 1632
Oil on canvas
Inscribed: 'Philip Lord Wharton / 1632
about ye age / of 19'
133 x 106
National Gallery of Art, Washington,
Andrew W. Mellon Collection
[not exhibited]

Philip, 4th Lord Wharton (1613–96), was
the son of Sir Thomas Wharton of Easby,
Yorkshire, and Philadelphia Carey, daughter
of the 1st Earl of Monmouth. On the death
of his grandfather in 1625 he inherited the
baronetcy of Wharton, and considerable
northern estates which included profitable
lead mines in North Yorkshire. In his youth
Wharton found favour with the king and
queen. He was a visible presence at court and
a regular performer in court masques, but
his puritan sympathies eventually led him
into active opposition to the king. He was
one of the opponents to the court in the May
1640 parliament and fought at the Battle of
Edgehill on the side of the Parliamentarians,
but he did not support the execution of the
king and during the Interregnum preferred
to retire to the country to improve his
estates rather than take an active role.

Van Dyck's portrait shows Wharton
as a handsome, youthful courtier. Cast as an
arcadian shepherd, or platonic lover, he wears
the rustic tunic and holds the shepherd's
staff associated with that role in pastoral
plays and poetry then fashionable in court
circles.[1] Painted in 1632 (if the inscription is
accurate), the theme of devotion to a lover
would have had a more personal resonance
for Wharton, who on 23 September that year
married his first wife, Elizabeth Wandesford.[2]
One of van Dyck's first private commissions
following his arrival in England in March
1632, this is also his first to follow an
arcadian/theatrical theme (for the later *Lord
George Stuart, Seigneur d'Aubigny*, see no.46).[3]
Despite Wharton's participation in court
theatricals, his portrait does not appear to be
associated with a specific event. Van Dyck's
combination of portraiture with literary
pastoral ideals, however, immediately
identifies his sitter as a young man who
associated himself with the intellectual and
cosmopolitan culture of the court, and its
fashionable emphasis on virtue, elegance
and beauty.[4]

Over the next decade Wharton built up
the largest collection, next to the king's, of
van Dyck's works.[5] Varying in quality, and
including works with a large degree of studio
participation (which does not seem to have
troubled Wharton), they included portraits
of the Royal Family, Wharton's own family,
and friends and associates. During Wharton's
lifetime they were displayed at his country
house, Wooburn, in Buckinghamshire
(which had come to him through his second
marriage, in 1637, to Jane Goodwin) in a
specially constructed 120ft-long gallery.
All Wharton's pictures, including those by
other artists, bear identifying inscriptions in
light-coloured paint, probably applied c.1674
and later (see no.91). From these we learn
that his portraits of Charles I and Henrietta
Maria (State Hermitage Museum, St
Petersburg) were produced in 'about 1638',
and many of the others in 1639, including
four full lengths of himself and members of
his family, their size presumably chosen to
create an ordered and symmetrical hang.

Wharton's collection had become known
and celebrated by the early eighteenth
century. In 1713 both Arnold Houbraken
and George Vertue recorded seeing the van
Dycks in the gallery at Upper Winchendon,
the beautiful mansion, with parterres
and terrace walks, of Wharton's son and
heir, Thomas, Marquess of Wharton.
Houbraken recounts the story of the artist
Sir Godfrey Kneller's application to borrow
two of the pictures in order to make copies,
which Wharton refused, fearing that he
would receive back copies rather than the
originals.[6] The story presumably relates to
the Marquess of Wharton rather than to
his father, although the latter had known
Kneller, who had painted him 1685 in a bold
and daring portrait showing him seated in
his Parliament robes (fig.31): he appears very
close to the description of him in the same
year as 'an old and expert Parliament man, of
eminent Piety and Abilities, besides a great
friend of the Protestant Religion and Interest
of England'. Perhaps as a corrective to the
high value placed on pictures today, it should
be noted that despite his connoisseurship,
Wharton failed to make any mention of his
van Dycks in his will, finding importance
instead in his parliament robes and the
equestrian equipment he used at the annual
Wooburn fair.[7]

In 1715 Wharton's pictures were
inherited by his profligate grandson, created
Duke of Wharton in 1718. In 1725, before
his estates were forfeited, he sold the van
Dycks to Sir Robert Walpole, and in 1779
those that remained at Houghton were sold
by Walpole's grandson, 3rd Earl of Orford,
to Catherine the Great of Russia. They
now form part of the collection of the State
Hermitage Museum, St Petersburg. TB

Notes
1 Gordenker 2001, pp.21, 45.
2 Wheelock et al. 1990, no.63, p.250.
3 Barnes et al. 2004, no.IV.237, pp.612–13.

4 For arguments concerning van Dyck's fresh visual
rhetoric created for the fashionable elite, see Smuts 2004,
pp.103–17.
5 For Wharton's collection see Millar 1994, pp.517–30.
6 A. Houbraken, *De Groote Schouburgh*, I, Amsterdam 1718,
pp.147–8, quoted in Millar 1994, p.522 n.31.
7 The National Archives, PRO PROB/11/430.

Fig.30
Anthony van Dyck
Portrait of Philadelphia and Elizabeth Wharton c.1640
Oil on canvas 163.5 x 130.2
The State Hermitage Museum, St Petersburg

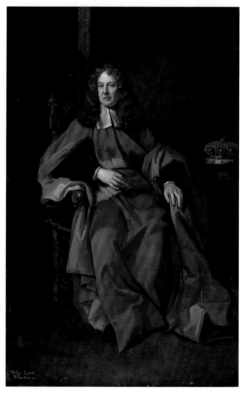

Fig.31
Godfrey Kneller
Philip, 4th Lord of Wharton 1685 Oil on canvas 228.6 x 144.8
Tate. Presented by Tate Members 2005

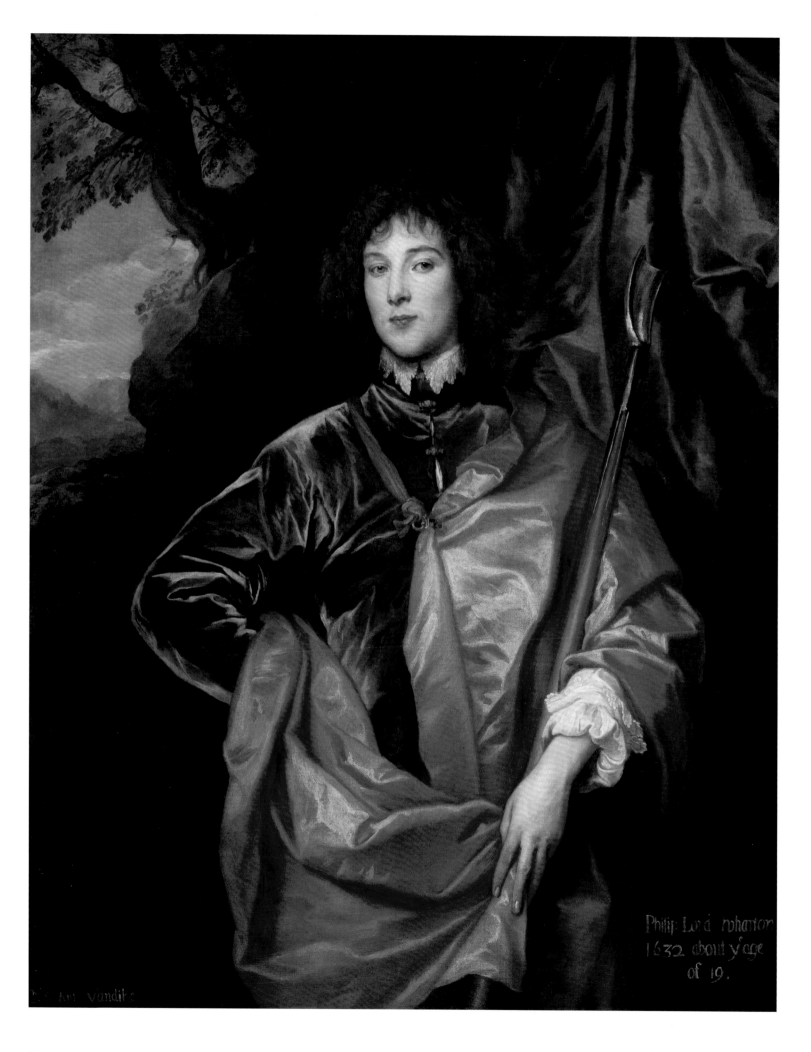

Philip Lord wharton
1632 about y age
of 19.

An: vandike

Other Patrons and Sitters

31
James Stuart, 4th Duke of Lennox, later Duke of Richmond c.1633
Oil on canvas
215.9 x 127.6
The Metropolitan Museum of Art, New York, Marquand Collection, Gift of Henry G. Marquand, 1889

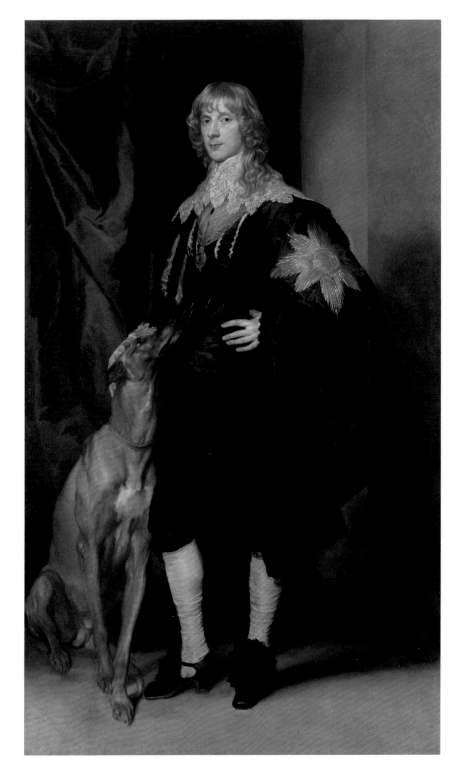

As Charles I's cousin, James Stuart was one of the king's closest relatives. Indeed, James had a claim to the Scottish throne, although not to that of England. In 1624, at the death of his father, he had inherited the title of Duke of Lennox, and James I had become his guardian.[1]

In April 1633, just before his twenty-first birthday, Lennox was nominated by Charles I to the Order of the Garter, the most elite order of chivalry in Britain; he was formally installed as a Knight of the Garter seven months later. Following his accession in 1625 Charles I had deliberately raised the prestige of the Order; in 1629 he added the aureole around the cross of St George to create the substantial device here worn by Lennox on his cloak – indeed, Lennox's hand-on-hip gesture displays this badge to particular advantage. He also wears the order's blue ribbon with its suspended Garter jewel, and a blue and gold garter below his left knee. This portrait is thus likely to have been begun in 1633 to mark this prestigious honour.[2] In this comparatively early portrait, van Dyck has depicted Lennox's fine lace collar with considerable fidelity.[3]

The portrayal of a ruler or aristocrat with a large but subservient dog was a European tradition that went back to full-length portraits of the Emperor Charles V by Jakob Seisenegger (c.1504–67) in 1532, and Titian.[4] Van Dyck, an admirer of Titian's work, was to use the same motif, with a different dog, in a portrait of Thomas Wentworth (no.42). He also employed it in portraits of Charles I's heir, the future Charles II, as a young boy (see fig.23, p.66, and no.20). In the present work Lennox rests his right hand in a calming gesture on the head of a tall, adoring, greyhound which quivers with suppressed energy. Van Dyck's preparatory chalk drawings for both the greyhound and Lennox himself are included here (nos.81 and 80 respectively).

Van Dyck also painted Lennox's younger brothers, Lord George Stuart, Seigneur d'Aubigny (no.46) and Lords John and Bernard Stuart (no.40), as well as his future wife, Mary Villiers (no.34), whom he was to marry in 1637.

Lennox remained deeply loyal to Charles I, who created him Duke of Richmond in 1641. During the Civil War he acted on behalf of the king in peace talks. He attended Charles during his trial and was present at his funeral. Afterwards Lennox retired to Cobham Hall, his property in Kent, where he died on 30 March 1655. He was buried in Westminster Abbey, in Henry VII's Chapel.[5]

Sir Joshua Reynolds copied Lennox's greyhound exactly in his portrait of Sir Richard Symons (1768–80; Cincinnati Museum of Art).[6] KH

Notes
1 *ODNB* 2004, vol.53, pp.159–61, entry on James Stuart, 4th Duke of Lennox and 1st Duke of Richmond by David L. Smith.
2 Wheelock et al. 1990, no.66, pp.259–60; Brown and Vlieghe 1999, no.71, pp.257–9; Barnes et al. 2004, no.IV.200, pp.584–6.
3 Gordenker 2001, p.38.
4 See Lorne Campbell, *Renaissance Portraits*, New Haven and London 1990, figs.255, 256, pp.235–6.
5 See note 1.
6 Barnes et al. 2004, no.IV.200, pp.584–6; Mannings 2000, vol.1, no.1729, pp.438–9, repr. vol.2, fig.965, p.402.

32
*Katherine Manners, Duchess of
Buckingham* 1634–5
Oil on canvas
219.7 x 132.7 (including an early addition of
11.4 cm at the top)
Private collection

Lady Katherine Manners (?1603–49) was the
widow of James I's great favourite, George
Villiers, 1st Duke of Buckingham, who had
been murdered in 1628. Buckingham had
assembled a considerable art collection,
which remained in the couple's great central
London residence, York House.[1] By the time
of his death it included works by Titian,
Tintoretto, Andrea del Sarto, Francesco
Bassano, Veronese and Domenico Fetti, as
well as paintings by the most celebrated
northern European artists.

On his first visit to England in 1620–1
van Dyck had encountered Buckingham,
who may have commissioned from him
the narrative painting *The Continence of
Scipio* (no.6). The circumstances in which
a curious early double *portrait historié* was
painted, apparently depicting a nearly naked
Buckingham and his wife as Adonis and
Venus, are unclear.[2] Van Dyck evidently had
access to Buckingham's collection in 1620–1,
and presumably also after his return to
England in 1632.

Katherine and her three children were
great favourites of Charles I, and they were
all painted by van Dyck (see nos.33 and 34).
Among the artist's other portraits of the
duchess[3] are versions of a group portrait of
her with her children,[4] incorporating the late
duke's image either in the form of a portrait
miniature worn by his widow, or in a framed
portrait hanging on a fictive wall behind
her. In the present portrait his image does
not appear, although Katherine is depicted
as his widow, attired in black with a black
band with a diamond on it round her wrist
and a black velvet bow at her breast. In her
hair, however, she wears small red, pink and
white flowers, while behind her to the left
is a rosebush bearing large red roses – often
a symbol of love. In April 1635 she was
remarried, to Randall MacDonnell, 2nd Earl
and 1st Marquis of Antrim.

In 1638 Katherine and her second
husband moved to Ireland.[5] The following
year one of van Dyck's portraits of the
duchess was used as the basis for a miniature
by David des Granges (no.94). KH

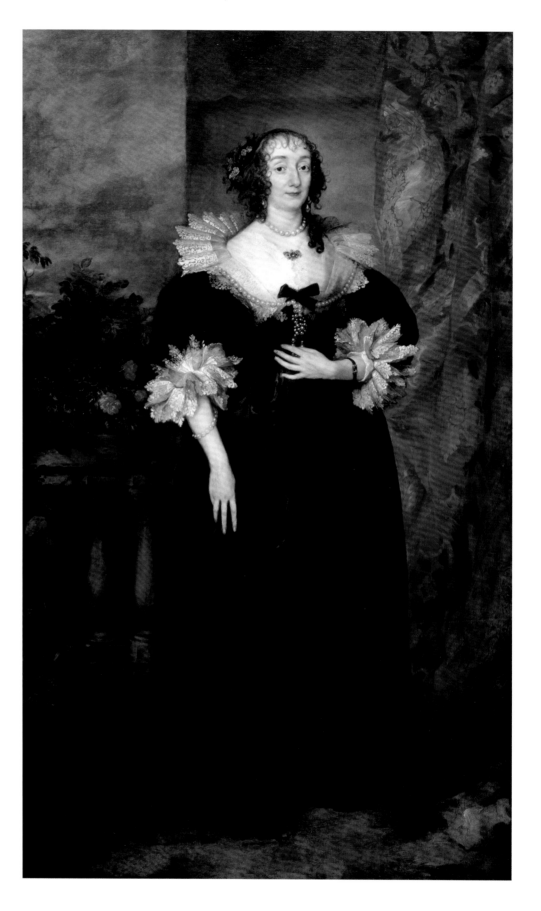

Notes
1 On the Duke of Buckingham's collection see, for
instance, Philip McEvansoneya, 'Italian Paintings in the
Buckingham Collection', in Chaney 2003, pp.315–36.
2 Barnes et al. 2004, no.i.158, p.137.
3 Ibid., nos.iv.31–3, pp.449–51.
4 Ibid., no.iv.33, p.451.
5 *ODNB* 2004, vol.35, pp.304–5, entry on Katherine
MacDonnell, Duchess of Buckingham and Marchioness of
Antrim by Jane Ohlmeyer.

33
Lords George and Francis Villiers 1635
Oil on canvas
137.2 x 127.7 (there is an original canvas
addition at the bottom of about 7.6 cm)
Inscribed top right: 'GEORGIVS DVX
BUCKINGHAMT[or Y]E / CVM FRATRE
FRANCISCO / 1635'
Her Majesty The Queen (The Royal
Collection Trust)

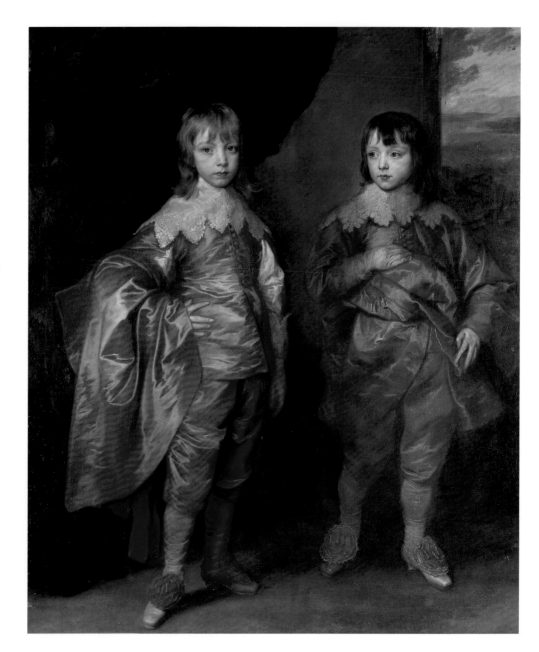

The young sitters were the sons of George
Villiers, 1st Duke of Buckingham, who had
been murdered in 1628. With their sister
Mary (no.34) they were brought up with the
children of Charles I at Richmond Palace.
This double portrait was painted for Charles
I and displayed near a portrait of their sister
in the Gallery at St James's Palace. The
back of the canvas bears the king's crowned
'CR' mark of ownership. The boys' mother,
Katherine, was also portrayed by van Dyck
(see no.32).

　　The fatherless aristocratic boys, aged
seven and six respectively, are poignantly
posed in attitudes of adult confidence
and swagger. Their heads are especially
sensitively painted and their satin suits
lusciously rendered.[1] Apart from the small
area of the sky and tree above right, this
work is in exceptionally good condition;
it has been newly cleaned for the present
exhibition.[2] The inscription has been much
strengthened, although it is probably of
early date.

　　After van Dyck's death, as the political
situation deteriorated, the interests of
the two boys were put in the hands of
Algernon Percy, the parliamentarian Earl of
Northumberland (no.51). In 1646 they were
sent on a Continental tour, but subsequently
returned to fight on the royalist side in the
Civil War. Francis (1629–48), the boy on the
right, was killed in a skirmish near Kingston-
on-Thames on 7 July 1648; George, on the
left (1628–87), was later to join Charles II's
court in exile, but in 1657, he married Mary,
the daughter and heir of the parliamentarian
Thomas, Lord Fairfax (1612–71). Following
the Restoration, in August 1661 he was
appointed a Gentleman of the Bedchamber
and, after a series of political dramas, was
reappointed to the Privy Council which he
had joined during the earlier exile. Dismissed
officially in 1674, he devoted himself to
writing, intellectual activity and friendships,
to building a grand mansion at Cliveden and
to attempts at political intrigue. He died at
his property in Yorkshire in 1687 and was
buried in the great Villiers family vault in
Westminster Abbey.[3]

　　This portrait was to have a considerable
influence on eighteenth-century British
artists, including Sir Joshua Reynolds,
and was appropriated particularly for
child portraits. Johann Zoffany included
it in the background of his portrait of
the two eldest sons of George III, while
Thomas Gainsborough seems to have based
the composition of his *Blue Boy* (c.1770;
Huntington Art Gallery, California) on
George Villiers's pose here, in reverse.　KH

Notes
1　Barnes et al, no.ɪᴠ.34, pp. 451–2.
2　I have benefited greatly from discussing this work
with Karen Ashworth, Paintings Conservator, The Royal
Collection, who conserved this work during 2008.
3　*ODNB* 2004, vol.56, pp.500–507, entry on George
Villiers, 2nd Duke of Buckingham by Bruce Yardley.

34
Lady Mary Villiers as St Agnes c.1637
Oil on canvas
186.7 x 137.2 (including an addition on the
right of about 51cm)
Her Majesty The Queen (The Royal
Collection Trust)

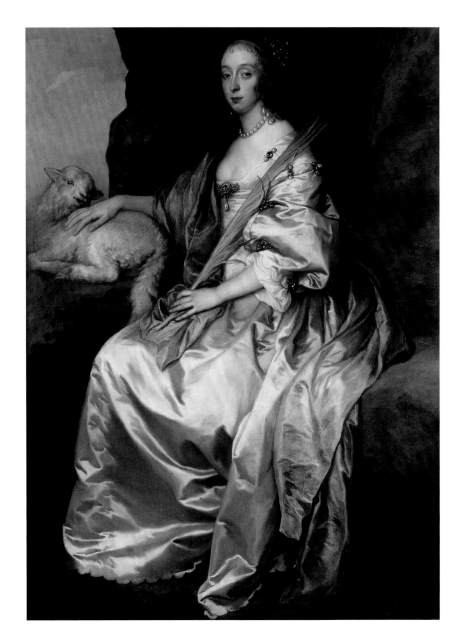

Mary Villiers (1622–85) was the daughter
of the 1st Duke of Buckingham and his
wife, Katherine Manners (nos.32, 94), and
the sister of Lord George and Lord Francis
Villiers (no.33). As a child Mary was a
great favourite of James I and Charles I
and, like her brothers, was raised with the
royal children.[1] From 1630 she participated
in court masques, and at Michaelmas 1634
she played Sabrina in a performance of John
Milton's *Comus* at Ludlow Castle. In 1626
she had been betrothed to Charles Herbert,
the son of Philip Herbert who subsequently
succeeded as 4th Earl of Pembroke and was
a great patron of van Dyck (see nos.8, 44).
They were married on 8 January 1635 in the
Royal Closet at Whitehall Palace. Pembroke
marked their union by commissioning from
van Dyck the immense dynastic group
portrait, now at Wilton House, of his family
with the young Mary in a white dress
standing on the steps in the foreground (fig.
32, p.108). Herbert set off for an educational
tour to Italy soon after their marriage and
died in Florence in January 1636, leaving
Mary a 13-year-old widow.

Mary sat for a number of portraits by
van Dyck,[2] of which this *portrait historié*
is the most beautiful.[3] Seated in a rocky
cave, Mary holds a palm branch in her left
hand, while her right hand rests on a lamb.
These are the attributes of St Agnes, the
patron saint of those about to be married,
suggesting that the portrait was painted
just before her second marriage, to Charles
I's cousin, James Stuart, Duke of Lennox
(no.31), on 3 August 1637. Emilie Gordenker
has noted that while Mary's garments here
retain the outline and construction that
were in fashion at this date, van Dyck does
not show her wearing the lace cuffs and the
lace at the neck that were also in style, thus
giving her attire an element of fantasy. The
bottom edge of her sleeve and the hem of her
skirt are scalloped, an ornamentation seen in
other contemporary images as well as on a
surviving bodice of the period (see no.61).[4]
Her dress is of white satin, suggesting
purity, and she has a blue mantle, a colour
associated with the Virgin Mary.[5]

It is likely that this portrait was painted
for Charles I, and that it was the 'Peece of
the Dutchesse of Lenox before shee was
married By Sr Anthony Vandike' that hung
in the Gallery at St James's Palace, as noted
in van der Doort's inventory.

The *portrait historié* or historicised
portrait, in which contemporary individuals
are portrayed as figures from the Bible,
mythology or ancient history in order to
draw parallels between their virtues and
those of their historical models, had barely
been used in Britain before. Among others,
Sir Peter Lely was later to use the convention
for female court portraits; Sir Godfrey
Kneller (1646–1723) depicted his daughter
Catherine as St Agnes, apparently on the eve
of her marriage in 1708, in a painting now
known only through the mezzotint made
after it by John Smith (1652–1743).[6]

At the death of her husband, the Duke
of Richmond, in 1655, Mary left for the
exiled royalist community in Paris. Following
the Restoration she returned to the English
court and became a Lady of the Bedchamber
to the dowager queen, Henrietta Maria. In

1664 she was married for the third time,
to Colonel Thomas Howard (d.1678). It
has been suggested that she may have been
the poetess 'Ephelia' whose verse was in
circulation from 1679 to 1682. Mary died in
1685 and was buried in Westminster Abbey.[7]

A number of copies of this portrait
survive, some indicating that this original
version was once larger in size.[8] The *portrait
historié* of a lady of the Kentish Dalison
family (no.103) by John Hayls, who was
known as a copyist of van Dyck's work,
appears to echo the present painting. KH

Notes
1 *ODNB* 2004, vol.56, pp.520–2, entry on Mary Lennox,
Duchess of Lennox and Richmond by Freda Hast.
2 Barnes et al. 2004, no.IV.203–6, pp. 587–91.
3 Ibid. no. IV.205, pp.589–91.
4 Gordenker 2001, pp.53–4.
5 Ribeiro 2005, pp.143–5.
6 Douglas Stewart 1983, no.373, p.111, repr. as no.80d.
7 See note 1.
8 Millar 1963, no.159, p.102.

35
Robert Rich, 2nd Earl of Warwick c.1633
Oil on canvas
213.4 x 128
Inscribed: 'Warwick Uncle to Lady Mary
Countess Breadalbane'
The Metropolitan Museum of Art, New
York, The Jules Bache Collection, 1949

This magnificent portrait of Robert Rich, 2nd Earl of Warwick (1587–1658), is relatively unusual in the work of van Dyck in that the sitter was not an active member of court and was publicly critical of Charles I and his policies.[1]

Probably born at Leighs Priory, Essex, Warwick was the eldest son of Robert Rich, 3rd Baron Rich, later 1st Earl of Warwick (1559?–1619). His mother was Penelope Rich, née Devereux (1563–1607), sister of the 2nd Earl of Essex (who was executed for treason in 1601); she is perhaps best known as 'Stella' in Philip Sidney's sonnets. As a young man Warwick was initially active at the court of James I, proficient at the tilt, and performed in Ben Jonson's *The Hue and Cry After Cupid (Lord Haddington's Masque)* in 1608. But he was increasingly drawn towards a life of maritime adventure as a naval commander and privateer. A founding member of the Bermudas Company (1614) for the plantation of the Somers Islands, in 1616 he was commissioned by the Duke of Savoy to attack Spanish shipping. By 1618 he was involved with further dealings in the West Indies, the Guinea Company and the Amazon River Company, as well as the American colony of Virginia. His naval activities continued throughout the 1620s, and in 1627 he made an unsuccessful attempt to plunder a Spanish silver fleet from Brazil, narrowly evading capture as he passed by Gibraltar. From 1625 he was joint Lord Lieutenant of Essex, charged with guarding the east coast from possible Spanish invasion.[2]

With the accession of Charles I Warwick found himself increasingly at odds with the position of the king. He was active with other noted Puritans, Lord Saye and Sele (1582–1662), Lord Brooke (1608–43) and John Pym (1584–1643), and spoke against the king during the debate over the Petition of Right (1628). In 1634 he was in direct conflict with the king over his attempts to revive ancient forest laws which would have subjugated most of Warwick's vast estates in Essex. Warwick was appointed Commander of the Fleet by Parliament in 1642, and replaced the Earl of Northumberland as Lord High Admiral the following year (until 1645). The late 1640s and 1650s saw him step back from the front line of battles and politics, though he remained close to Cromwell, his grandson and heir Robert Rich marrying Cromwell's daughter Frances in 1657. He died the following year at Warwick House in London, and was buried at Felsted, Essex.[3]

Probably painted in 1633 for Warwick himself, the inscription suggests that the painting might have been intended for his brother Henry Rich, 1st Earl of Holland (1590–1649), whose daughter, Countess Breadalbane, inherited it.[4] Unlike the Earl of Northumberland in van Dyck's portrait of c.1638 (no.51), Warwick is not shown in the attire of a naval commander but in the ornate and sumptuous day wear of richly decorated silk and lace. His armour lies on the ground beside him, the baton indicating his high position, and the dramatic sea battle behind him further emphasising his prowess on the seas.

Whilst van Dyck's depiction of Warwick introduces more ease and fluidity than Mytens's rather stiff portrait of him of 1632 (National Maritime Museum, London), Millar goes further in suggesting that there is an inherent sense of 'swinging, balanced movement in the figure' which anticipates Reynolds's portrait of *Commodore Augustus Keppel* of 1752–4 (National Maritime Museum, London).[5] TJB

Notes
1 Wheelock et al. 1990, no.68, p.266.
2 *ODNB* 2004, vol.46, pp.685–91, entry on Robert Rich, 2nd Earl of Warwick, by S. Kelsey.
3 Ibid.
4 O. Millar in Barnes et al. 2004, no.IV.234, p.610.
5 Ibid.

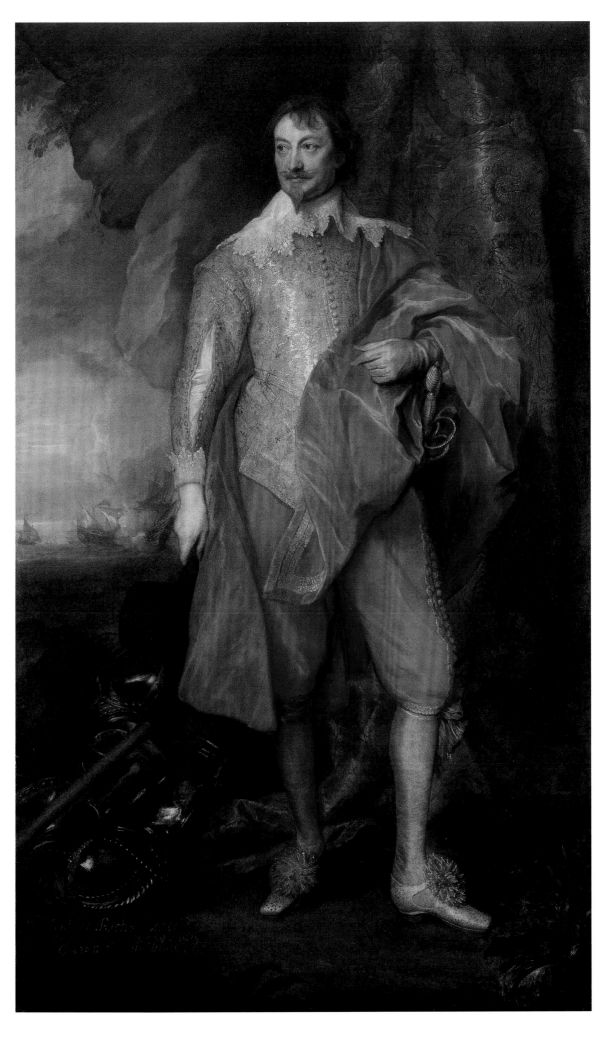

Other Patrons and Sitters

36

*Portrait of Venetia Stanley, Lady Digby, as
Prudence* c.1633–4
Oil on canvas
101.1 x 80.2
National Portrait Gallery, London

This elaborate allegorical portrait is one of
the most striking and unusual painted by van
Dyck in England. It depicts Venetia Stanley
(1600–1633), a famous beauty who married
Sir Kenelm Digby (1603–65; no.74). Digby,
a courtier and natural philosopher, became
a great friend and important patron of van
Dyck. Venetia's unexpected and sudden
death at the age of thirty-three prompted
her grief-stricken husband to commission a
number of memorials, including a painting
by van Dyck of her on her deathbed.[1]
Another of his commissions for the artist
was a large-scale allegorical portrait,
probably also posthumous, celebrating
Venetia's virtues (now in Milan).[2] According
to van Dyck's biographer, Giovanni Pietro
Bellori, the artist was so pleased with this
painting that he produced a second, smaller
version, which is the present picture.[3]

The symbolic programme of the
portrait, likely to have been devised by
Kenelm Digby, reflects his anxiety both
during his wife's lifetime and afterwards to
restore what was perceived as her tarnished
reputation. Before her marriage she was said
to have been promiscuous, and in particular
to have had an affair with the 4th Earl of
Dorset, an accusation Digby passionately
repudiated in his memoir, *Loose Fantasies*.[4]
The joint themes of the painting are wisdom
and innocence, or prudence and chastity. The
snake held in one hand, and the pair of turtle
doves by the other reflect a passage from the
Gospel of St Matthew (10:16), 'Behold, I
send you out as sheep in the midst of wolves;
so be wise as serpents and innocent as doves'.
They also recall the figures of Prudenza
(Prudence), shown with a snake, and Castita
(Chastity), associated both with a defeated
Cupid and with turtle doves, from the most
popular emblem book of the time, Cesare
Ripa's *Iconologia*.[5] Venetia places her foot on
Cupid, symbolising her defeat of carnal love,
and two-faced Deceit is chained to the rock
on which she sits. Above her three heavenly
cherubs hold a wreath over her head,
celebrating her triumph over vice.[6]

This picture stands out among van
Dyck's English works in a number of
respects: its superb quality, small-scale
figures and complex composition give it a
concentrated, vivid intensity not present
in the simpler, grander, large-scale portraits
that are most characteristic of the artist's

oeuvre at this time. Its hybrid nature as
part portrait, part subject picture reflects
both artist's and patron's knowledge of
Continental painting; it is in effect a
portrait historié, part of a genre much better
established at this time in Italy and France
than in England. Digby, a Roman Catholic,
commissioned at least five subject pictures
from van Dyck (all with biblical themes) in
addition to this and other more conventional
portraits of himself, his wife and his family.[7]

As well as the large and small-scale
autograph versions of this portrait, there
are a number of copies, and the composition
seems to have been fairly well known from
an early date. According to Bellori, both
van Dyck versions were taken to France,
probably by Digby, during the Civil
War. Here Digby served as Chancellor to
Henrietta Maria, and it is likely to have been
during this time that an unidentified artist
painted the widowed queen in a variant
of this composition.[8] The three cherubs
appear to have been a particularly popular
motif, and were used in a painting of Faith
attributed to David Teniers, now in the State
Hermitage Museum, St Petersburg (which
also includes the defeated Cupid); they were
also adapted by John Hayls for his *Portrait
of a Lady and a Boy, with Pan* (no.103). The
present, small-scale version of the painting
seems to have passed into the collection of
Cardinal Mazarin in France, but it was back
in England by the mid-eighteenth century,
where it was greatly admired by, among
others, the antiquarian and writer on art
George Vertue, who described it as 'perfect
clear & beautifull picture – surely a master
pece of Art by Vandyke'.[9] CM

Notes
1 Now in Dulwich Picture Gallery, London; Barnes et al.
2004, no.IV.97, pp.506–7.
2 Soprintendenza per i Beni Ambientali e Architettonici,
Palazzo Reale, Milan; Barnes et al. 2004, no.IV.98, pp.507–8.
3 Bellori 1672, reprinted Rome 1931, p.261. There are
some distinct differences between the compositions of the
two autograph versions of this picture. See Barnes et al.
2004, pp.507–10, nos.IV.98 and IV.99.
4 Sir Kenelm Digby, *Loose Fantasies*, ed. Vittorio Gabrieli,
Edizioni di Storia e Letteratura, Rome 1968. There is no
indication that this memoir was intended for publication,
and it was first published in the nineteenth century.
5 See Brown and Vlieghe 1999, p.254; for further analysis
of the iconographical programme see Wheelock et al. 1990,
p.253, and Sumner 1995, pp.108–9.
6 Bellori's account of the picture differs markedly from
both the autograph versions, including more allegorical
figures. The differences may perhaps reflect an inaccurate
recollection on the part of either Digby or Bellori, or may
record Digby's original conception for the picture, rather
than what was actually carried out. See Barnes et al. 2004,
p.507.
7 See Barnes et al. 2004, nos.IV.94, IV.95, IV.96 and p.510.
8 See London 1995–6, p.109, no.39 (illus.).
9 George Vertue, 'Notebooks', vol.III, *Walpole Society*,
vol.22, 1934, p.141.

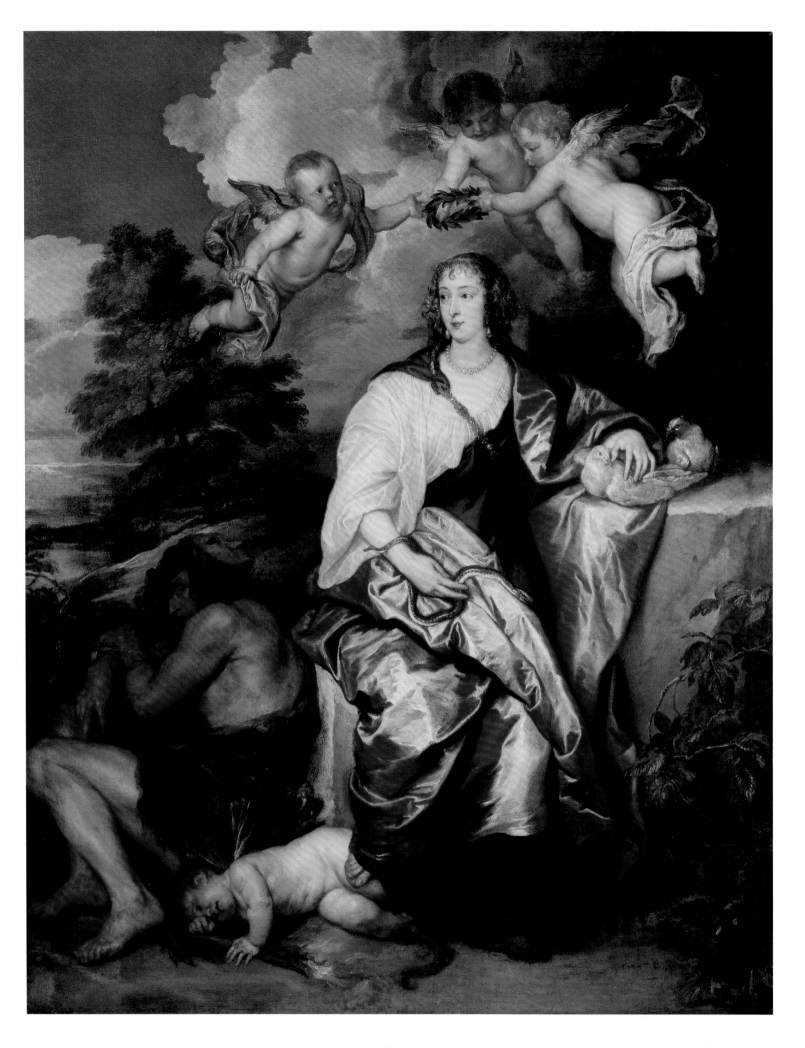

Other Patrons and Sitters

37
William Feilding, 1st Earl of Denbigh c.1635–6
Oil on canvas
247.5 x 148.5
The National Gallery, London. Presented by
Count Antoine Seilern, 1945

In this extraordinary image an English
nobleman, grasping a flint-lock fowling-
piece (a long-barrelled gun), glances up at a
green-winged macaw in a palm tree, to which
his attention has been drawn by a turbaned
Indian boy. Denbigh himself, attired in rose-
pink silk with a narrow gold stripe, wears
what has been described as a combination
of Eastern and Western styles.[1] His long
trousers, tied with a cord at the waist, are
based on the Indian *paijama*. His coat is
looser, longer and of plainer cut than the
English doublet of the period, but the way
in which it is buttoned tightly over the chest
and worn with a shirt collar turned down
at the neck conforms with contemporary
European fashion. His shoes, too, are
European in style.

In depicting Denbigh in a distinctive
outdoor setting, with a snow-capped
mountain in the distance, van Dyck may
have been echoing a form of full-length
portrait that had been popular with the
English elite since the 1590s. Large-scale
examples of this format – with the subject
in a country setting, beside the dominant
vertical of a particular tree – include Marcus
Gheeraerts II's *Captain Thomas Lee* (1594;
Tate) and the British School *Lady, called
Elizabeth Tanfield* (1615; Tate).[2]

William Feilding (c.1587–1643), naval
officer and courtier, owed his rise to royal
favour to his brother-in-law, the 1st Duke
of Buckingham. Although a man of 'modest
abilities', in 1622 he was appointed Master
of the Great Wardrobe – a post worth
about £4,000 a year – and subsequently
became a Gentleman of the Bedchamber. In
1623 he had travelled to Spain to join the
entourage of Prince Charles (subsequently
Charles I) and Buckingham on their visit
to the Spanish court. On the outbreak of
war with Spain in 1625 he embarked on
a series of senior naval posts. In January
1631, with royal consent, he set off on a
tour of India and Persia, landing at Swally
in November and travelling overland to the
court of the Mughal emperor. In 1632 he was
in Persia, returning to England in August
1633. He was the first English nobleman
ever to tour the Far East, an achievement
evidently considered so remarkable that it
was marked by the commissioning of the
present portrait. By the 1640s it was in the
collection of Denbigh's son-in-law, the art
collector the 1st Duke of Hamilton, where
an inventory described it as 'One peice of
my lords denbighs at length, with a fowlinge
peece in his hande, and a Blackamore by
him of Sr. Anthony: Vandyke'.[4] Elsewhere in
the Hamilton inventories the Indian boy is
named as 'Jacke'.

Following the outbreak of Civil War,
Denbigh fought on the Royalist side,
receiving injuries at the siege of Birmingham
that led to his death in 1643. KH

Notes
1 Gregory Martin, *National Gallery Catalogues: The Flemish
School c.1600–c.1900*, London 1970, no.5633, pp.52–5;
C.A. Bayly (ed.), *The Raj: India and the British 1600–1947*,
exh. cat., National Portrait Gallery, London, 1991, no.67,
pp.73–4.
2 Miniature examples by the English limner Nicholas
Hilliard include *George Clifford, 3rd Earl of Cumberland*,
c.1590 (National Maritime Museum).
3 *ODNB* 2004, vol.19, pp.243–5, entry on William
Feilding, 1st Earl of Denbigh by Andrew Thrush.
4 Barnes et al. 2004, no.IV.86, p.496.

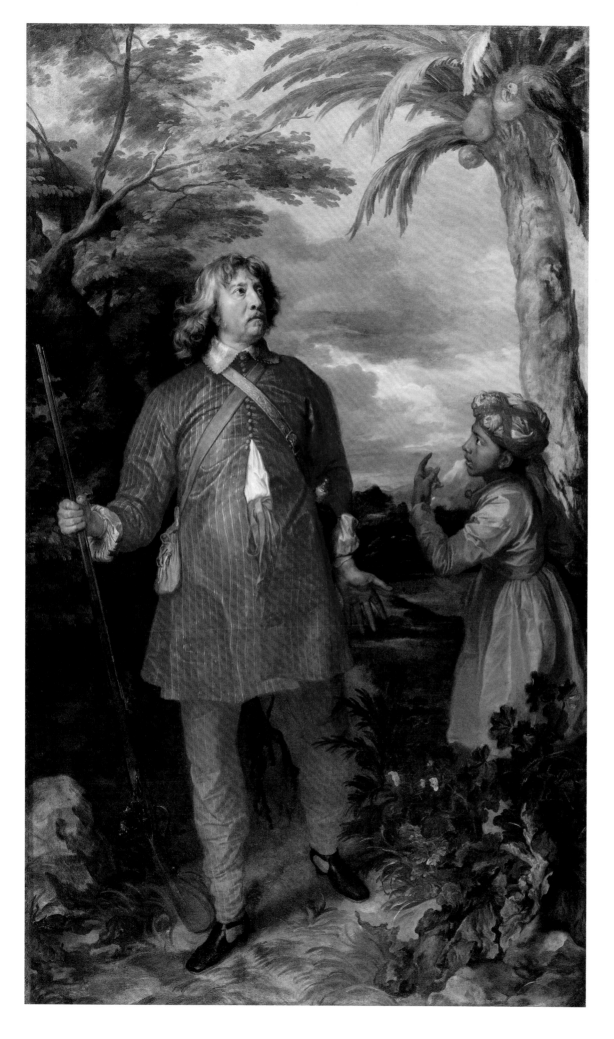

Other Patrons and Sitters

38

Thomas Howard, 14th Earl of Arundel, with his Grandson, Thomas, later 5th Duke of Norfolk c.1635–6
Oil on canvas
144.8 x 121.9
The Duke of Norfolk, Arundel Castle, West Sussex

In a display of both authority and tenderness, Thomas Howard, Earl of Arundel (see no.7), is shown in armour standing with his arm around the shoulder of his grandson, Thomas Howard (1627–77). Arundel proudly holds the gold baton of the Earl Marshal, one of the Great Offices of State which placed him at the head of the nobility and gave him responsibility for the College of Arms and all state ceremonials. His young grandson looks up at the baton, contemplating the role that will one day come to him. Van Dyck has positioned Arundel against a rocky background, representing his strength and fortitude, whilst the young Thomas is set against the more comforting and enveloping decorated curtain.

The title of Earl Marshal had been stripped from Arundel's grandfather, Thomas Howard, 4th Duke of Norfolk (1536–72) by Elizabeth I. Norfolk was executed as a result of his involvement in the Ridolfi Plot (1571), the unsuccessful scheme in which he was to marry Mary, Queen of Scots, who would then replace Elizabeth as Roman Catholic monarch.[1] Arundel's own father, Philip Howard (1557–95), was also later imprisoned in the Tower of London because of his religion, eventually dying there as a Catholic martyr and never seeing his son.[2] The young Arundel grew up intent on restoring the titles and estates that had been seized from his forebears. He was restored as Earl of Arundel in 1604, and was created a Knight of the Garter in 1616 – he is shown here wearing the badge of the Garter, the 'Lesser George'. The office of Earl Marshal was finally bestowed on him in 1621.[3]

In prominently displaying Arundel's staff of office, van Dyck echoes Holbein's portrait of his great-great-grandfather, *Thomas Howard, 3rd Duke of Norfolk* (c.1539; Royal Collection), which he would have seen in Arundel's magnificent art collection. The Arundel family was exiled from England during the Civil War, fleeing via the Low Countries and finally settling in Padua, Italy. Shortly after they arrived there young Thomas fell ill with a fever which left him insane. He never recovered and, although his title of Duke of Norfolk was restored to him following the Restoration of Charles II in 1660, he spent the rest of his life in seclusion in Italy.[4]

This portrait probably dates from between spring 1635, following van Dyck's return from Flanders, and early 1636, before Arundel's departure on his embassy to the Emperor of Austria in April. In November 1636 Arundel wrote to William Petty in Rome that he was sending out

> a Picture of my owne and my little Tom: bye me; & desire it may be done at Florence in Marble Basso relievo, to trye a yonge Sculptor there whoe is sayde to be valente Huomo, Francesco hath his name I could wish Cavaliere Bernino, or Fra[ncesco Fi]amengo [believed to be the sculptor Du Quesnoy], might doe another of the [sam]e.[5]

The original sculptor is unknown, though Dieussert has been proposed as a possibility,[6] and apparently nothing came of the project. Arundel was inspired by Charles I, who had only recently sent van Dyck's portrait *Charles I in Three Positions* (1636; Royal Collection) to Bernini in Rome so that he could refer to it while carving his bust.[7] It is unknown whether Arundel himself chose to wear armour for this portrait, but van Dyck would have relished the opportunity to produce a work to compare with Rubens's portrait of Arundel in armour, painted during his stay in London in 1629–30 (Isabella Stewart Gardner Museum, Boston). TJB

Notes
1 *ODNB* 2004, vol.28, pp.429–36, entry on Thomas Howard, 4th Duke of Norfolk, by M.A.R. Graves.
2 *ODNB* 2004, vol.28, pp.406–9, entry on Philip Howard, 13th Earl of Arundel, by J.G. Elzinga.
3 *ODNB* 2004, vol.28, pp.439–47, entry on Thomas Howard, 14th Earl of Arundel, 4th Earl of Surrey and 1st Earl of Norfolk, by R. Malcolm Smuts.
4 N. Penny, *Thomas Howard, Earl of Arundel*, exh. cat., Ashmolean Museum, Oxford, 1985, no.6, p.16, and no.8, p.18.
5 O. Millar in Barnes et al. 2004, no.IV.9, p.436; Wheelock et al. 1990, no.76, pp.291–2.
6 Howarth 1985, pp.161–4.
7 O. Millar in Barnes et al. 2004, no.IV.48, pp.464–6.

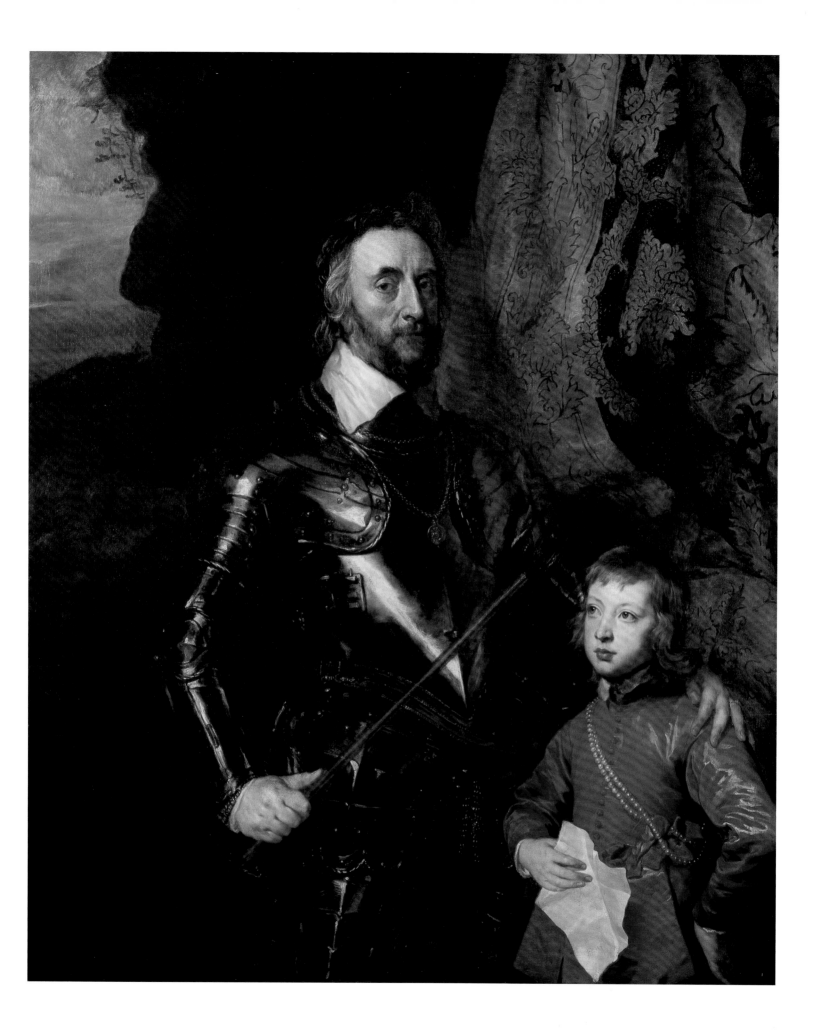

Other Patrons and Sitters

39
Frances, Lady Buckhurst, later Countess of Dorset c.1637
Oil on canvas
187 x 128
Knole, The Sackville Collection (The National Trust); accepted by HM Treasury in lieu of tax and transferred to the National Trust in 1992

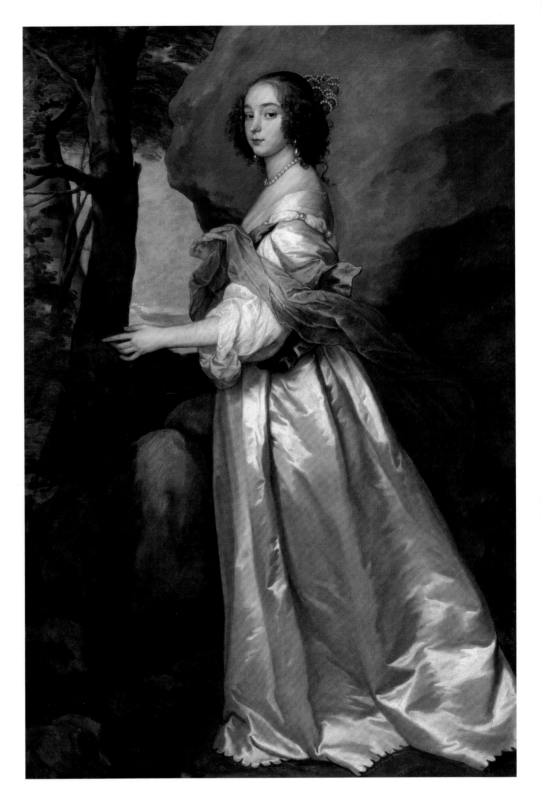

Lady Frances Cranfield (?1622–87) was the daughter of, and subsequently the sole heiress to, Lionel Cranfield, 1st Earl of Middlesex.[1] This portrait may have been commissioned by her father, around the time of her marriage to Richard Sackville, Lord Buckhurst, later 5th Earl of Dorset, which took place in about 1637.[2] Much later, in 1674, Frances was to inherit her father's extensive collection of paintings and furniture, which is why they eventually came to, and have remained at, the Sackville family seat at Knole in Kent.[3]

Van Dyck used versions of this composition for more than one of his female sitters, including the portrait of Frances's own niece, *Lady Anne Carey, later Viscountess Clandeboye and Countess of Clanbrassil* (late 1630s; Frick Collection, New York).[4] Frances fingers a gauze shawl with her right hand while she turns to gaze directly at the viewer. She stands before a barren rock-face, but seems to move towards the shelter of trees to the left. With the scalloped hem to her dress, bare arms and absence of lace at her breast and her wrists, Frances is depicted in informal attire.[5]

This was a composition that later portraitists in Britain such as Sir Peter Lely[6] were to borrow, both for easel paintings (see fig.47, p.172) and for portrait miniatures (see no.101 by Samuel Cooper). The portrait conveys a sense of the sitter's energy, showing the work of van Dyck and his team at its most assured.

The carved and gilded frame, which is of pre-Sunderland type and without auricular ornament, is of exceptional interest. A surviving bill in the National Portrait Gallery archive suggests that it may originally have been supplied by the painter George Geldorp (1595–1658) with a contemporary copy of this portrait (this copy is also still at Knole). If the frame does indeed date from the 1630s, it is a very rare British survival.[7] KH

5 Gordenker 2001, pp.54–5.
6 For example, for a portrait called 'Miss Ingram' (Temple Newsam, Yorkshire), Laing 1995, pp.22–3.
7 Ibid. Information also kindly supplied by Helen Fawbert, National Trust, August 2008.

Notes
1 Barnes et al. 2004, no.IV.101, pp.510–11.
2 *ODNB* 2004, vol.19, pp.243–5, entry on Edward Sackville, 4th Earl of Dorset, by David L. Smith.
3 Alastair Laing, *In Trust for the Nation*, exh. cat., National Gallery, London, 1995, no.3, pp.22–3. 197.
4 Barnes et al. 2004, no. IV.77, pp.490–1.

40
Lord John Stuart and his Brother, Lord Bernard Stuart, later Earl of Lichfield c.1638
Oil on canvas
237.5 x 146
The National Gallery, London. Purchased 1988

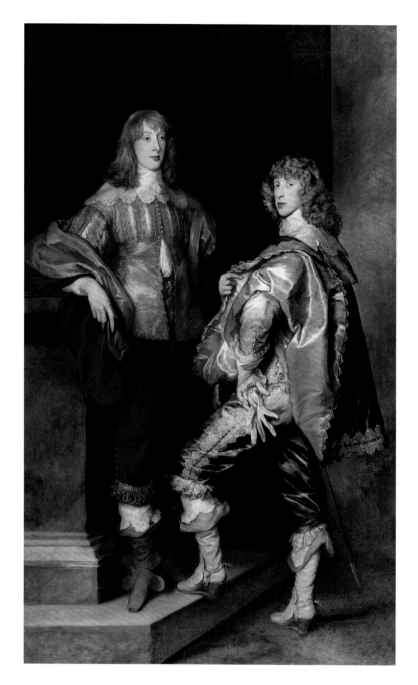

This iconic double portrait epitomises the full glamour and swagger of the Caroline court, depicting the haughty bearing and grandeur of aristocratic young men. The fact that these handsome youths died tragically young in the Civil War adds, with hindsight, a certain poignancy to the painting. Sons of Esmé Stuart, 3rd Duke of Lennox (1579–1624), Lord John and Lord Bernard were the younger brothers of James Stuart, 1st Duke of Richmond and 4th Duke of Lennox (nos.31, 80) and Lord George Stuart, Seigneur d'Aubigny (no.46), and cousins of Charles I.

Nonchalantly looking over his shoulder at the viewer is the younger brother, Lord Bernard (1622–45), the light reflecting off his flamboyant blue and silver satin suit. Aged about sixteen when this portrait was painted, in accordance with conventional hierarchy he is positioned below his elder brother. Bernard was knighted by Charles I at York in April 1642, and at the outbreak of the Civil War later that year he was appointed Captain of the King's Lifeguard, serving under the command of Prince Rupert. So dashing and well equipped was this brigade that it became popularly known as the 'Show Troop'. He saw action in the first major battle of the Civil War, the Battle of Edgehill, on 23 October 1642, subsequently learning that his elder brother, Lord George Stuart, had been killed in the fighting. He went on to serve with Prince Rupert when he retook Lichfield in April 1643, and fought at the Battle of Newbury in September 1643. One of the few to survive at the king's side at the Battle of Naseby in June 1645, before the fighting he was created Baron Stuart of Newbury and 1st Earl of Lichfield. He was killed in battle at Rowton Heath in September 1645 during the siege of Chester, Charles I observing his bloody demise from the city walls.[1]

Lord John Stuart (1621–44), leaning against a column, wears a richly decorated golden doublet and fine lace collar; he stares past his younger brother into the distance. He also fought for the king during the Civil War, and died from wounds received during the Battle of Cheriton near Alresford, Hampshire, on 29 March 1644. He had been in command of a cavalry troop in the Royalist army led by the Earl of Forth

against Sir William Waller's much larger Parliamentarian force.[2] All three Stuart brothers who died in the Civil War were buried together at Christ Church Cathedral, Oxford.

Van Dyck probably painted this portrait in 1638, as the brothers were given a licence to travel abroad for three years on 30 January 1639. The compositional stance of Lord Bernard may be a reference to the figure of St George in Correggio's *Madonna and Child with St George* (c.1532; Gemäldegalerie Alte Meister, Dresden). A chalk study on paper for the figure of Lord Bernard also exists in the Department of Prints and Drawings at the British Museum, and is unusual in that it is squared for scaling up.

This painting fascinated Thomas Gainsborough, who produced a full-length

scale copy in the 1760s (Saint Louis Art Museum, Missouri)[3] and also a copy of the head and shoulders of Lord Bernard (Gainsborough's House, Sudbury). He would probably have seen the painting in Lord Darnley's collection in his London house.[4]

Another painting which Millar confidently states is by van Dyck, *Two Unknown Men* (National Gallery, London), seems to be based on this work and may depict the same sitters.[5] TJB

Notes
1 O. Millar in Barnes et al. 2004, no.IV.221, p.603; Millar 1982, no.44, p.89.
2 Ibid.
3 Rosenthal and Myrone 2002, no.85, p.168.
4 H. Belsey in Chaney and Worsdale 2001, no.24, pp.44–6.
5 O. Millar in Barnes et al. 2004, no.IV.244, p.618.

41

William Laud, Archbishop of Canterbury
c.1638
Oil on canvas
121.6 x 97.1
The Syndics of the Fitzwilliam Museum,
Cambridge

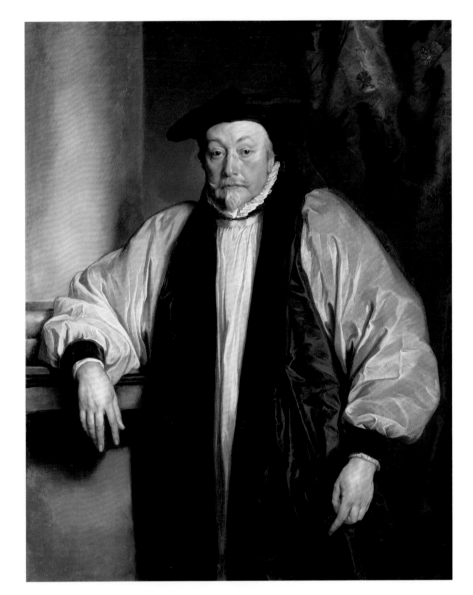

William Laud (1573–1645), the son of a
Reading clothier, was appointed Bishop
of London in 1628 and Archbishop of
Canterbury in 1633. At first the close
associate of the royal favourite, the Duke
of Buckingham, whose assassination in
1628 he felt keenly, he devoted himself to
strengthening the Church of England and to
the enforcement of ceremonial conformity
and discipline. His powerful position at
court, however, and his closeness to the king,
led to intrigues against him. Accused of
imposing popish ceremonies and the target
of increasing popular hostility, in 1640
Laud was impeached, imprisoned and finally
executed in 1645.[1]

Van Dyck's portrait, his only one of
an English prelate in Convocation dress,[2]
shows Laud at the height of his powers. The
pose – standing with the right arm, slack
at the wrist, resting on the pedestal of a
column, the left arm hanging freely by the
side – is based on a composition by Titian
which van Dyck had recorded in his Italian
sketchbook (f.104v) and which he had used
earlier in his full-length portrait of the Abbé
Scaglia (1592–1641), painted in Brussels in
1634 (National Gallery, London).[3] Laud's
portrait does not match the impressive
dignity of the latter, with its easy grandeur
and sophisticated harmony of muted tones.
Scaglia was a lover of art and an admirer
of van Dyck, whereas Laud was a less
sympathetic character. Short of stature and
red-faced, intellectual but intractable, quick-
tempered and socially awkward, despite his
powerful position at court he seems to have
cared little for its aesthetic graces. Van Dyck
nevertheless has created a compelling image,
the focus of which is Laud's commanding and
authoritative stare. In 1744, when painting
Archbishop Herring (1693–1757), William
Hogarth praised the portrait of Laud as one
of van Dyck's 'most excellent heads'.[4]

Until conservation by the Hamilton Kerr
Institute in 1981 this portrait was dismissed
as either a studio version or a contemporary
copy, but cleaning has revealed it to be the
best and primary version of the several
that exist.[5] There are pentimenti in the
confused area of the ruff and the outline
of the sitter's left arm, but otherwise the
drapery is handled with confidence and
fluency. The provenance of the work before
1920 is unknown, as is its exact date.[6] There
is no record of a commission from Laud
to van Dyck (indeed, Laud is supposed to
have considered van Dyck one of Charles I's
unnecessary extravagances)[7] but van Dyck's
portrait became the most widely known
image of the Archbishop, both in painted
versions and in print (engravings by Hollar
appeared in 1640 and 1641, based on the
Fitzwilliam version). Laud himself presented
a copy to St John's College, Oxford. 'What
a pity it is Sir Anthony Vandyke's hand
was not to the curious picture', he wrote
in a letter to Viscount Wentworth, 'but
'tis no matter, for had it been valued at so
high a rate, it had neither been mine nor
theirs'.[8] Although the version at Lambeth
Palace, by tradition there since Laud's
day, is inscribed 1633, this most likely
records the date of Laud's consecration
as Archbishop rather than the date of the
portrait.[9] The Hermitage version, owned in
the seventeenth century by Lord Wharton,
the great collector of van Dyck's works (see
no.30), is inscribed c.1638, a possible date
for the original, although the inscription
was added by Wharton who did not purchase
the picture directly from van Dyck's studio
but later, in 1656, as one of a group of
'originall coppyes' owned by Sir Henry
Vane of Raby Castle.[10] TB

Notes
1 *ODNB* 2004, vol.32, pp.655–70, entry on Archbishop
William Laud by Anthony Milton.
2 Barnes et al. 2004, no.IV.153, p.550.
3 Barnes et al. 2004, no.III.126, p.350.
4 Douglas Stewart 1983, p.79.
5 Michael Jaffé, 'Van Dyck Studies I: The Portrait of
Archbishop Laud', *Burlington Magazine*, vol.124, October
1982, pp.600–6.
6 Sold by Mrs W.F. Wrangham, née Grimston, of Neaswick
Hall, Driffield, Yorkshire, Christie's, 30 January 1920,
no.267, it was purchased by Charles Ricketts and C.H.
Shannon and later bequeathed to the Fitzwilliam Museum
as part of the Shannon bequest.
7 Sumner 1995, no.8, p.85.
8 Jaffé 1982, p.603.
9 John Ingamells, *The English Episcopal Portrait 1559–1855*,
London 1981, pp.266–72.
10 Millar 1994, p.519; Jaffé 1982, p.605.

Thomas, Viscount Wentworth, later 1st Earl of Strafford, with a Dog c.1635–6
Oil on canvas
230.5 x 142.9
The Trustees of the Rt Hon. Olive Countess Fitzwilliam's Chattels settlement by permission of Lady Juliet Tadgell

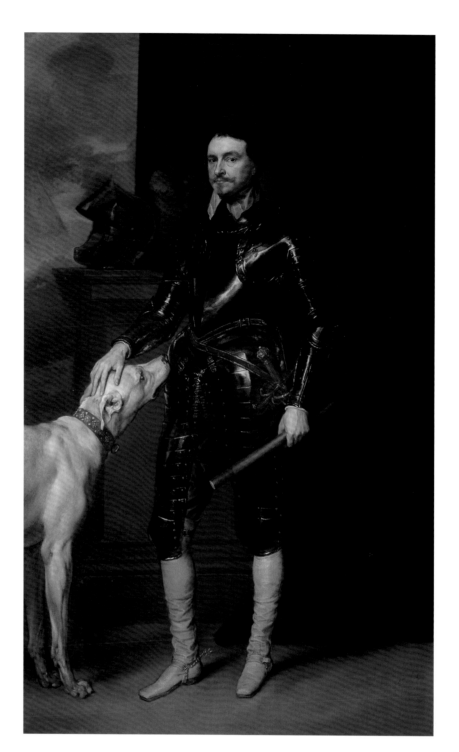

In a magnificent display of power and authority alluding to his recent activities in Ireland, Thomas Wentworth, later 1st Earl of Strafford (1593–1641), is shown in full armour with baton in hand, his helmet resting on the side. At the same time, the attentive gaze of the Irish wolfhound and Wentworth's gentle touch add an element of tenderness, the dog symbolising Wentworth's unwavering fidelity to the king.

As Member of Parliament for his native Yorkshire, Wentworth had initially opposed Charles I in his attempts to raise money against the will of Parliament. From June to December 1627 he was imprisoned for refusing to pay a forced loan to fund the war with France, and in the following year he supported the Petition of Right which curbed the power of the king. However, with a new understanding between Crown and Parliament in place Wentworth now felt it necessary to support the king, stating that 'The authority of a king is the keystone which closeth up the arch of order and government'. As a result, Charles increasingly showed him favour, making him Viscount Wentworth and Lord President of the Council of the North in December 1628, Privy Councillor in 1629, and Lord Deputy of Ireland in 1632.

Wentworth was known for his strong and autocratic rule in Ireland, extending the power of the Crown. He was recalled to England by Charles in 1639 to sit on his War Council and became chief unofficial adviser to the king. As evidence of his closeness and importance to the monarch, in early 1640 he was created Lord Lieutenant of Ireland, 1st Earl of Strafford, and Baron Raby. The 'Short Parliament' (April to May 1640) resisted the king's attempts to raise funds to fight the Scots, and Wentworth was Captain-General of the Army at the disastrous defeat at the Battle of Newburn (August 1640). Characterised as 'Black Tom Tyrant' by pamphleteers, Wentworth was to suffer the consequences of the unpopular policies and course of action employed by the king. Charles recalled Parliament in November 1640 (the 'Long Parliament'), and despite the king's personal assurances to guarantee his safety Wentworth was impeached on charges of treason. He was beheaded at Tower Hill on 12 May 1641.[1]

Previously thought to date from before Wentworth left for Ireland in 1633, this portrait is now believed to have been painted around 1635–6.[2] It is probably the painting referred to as 'my picture in great' in a letter Wentworth wrote to his wife on 29 June 1636. On 5 September 1636 he wrote to William Railton, his agent in London, from Wentworth Woodhouse (his family seat in Yorkshire), 'I would have you send the first originall of my Picture at large hither to Woodhouse'. Other letters indicate that miniatures were made by Hoskins and another unnamed artist based on this work.[3]

Van Dyck's composition is partly inspired by Titian's portrait of *Charles V with a Hound* of 1533 (Museo del Prado, Madrid). That painting was given as a present to Charles I by Philip IV when he travelled to Madrid in 1623 as Prince of Wales, and was kept on display in the Bear Gallery at Whitehall.[4] TJB

Notes
1 *ODNB* 2004, vol.58, pp.142–57, entry on Thomas Wentworth, 1st Earl of Stafford, by R.G. Asch.
2 O. Millar in Barnes et al. 2004, no.IV.214, pp.596–7.
3 Millar 1986, pp.109–23.
4 Millar 1958–60, p.4.

Other Patrons and Sitters

43
Lucy Percy, Countess of Carlisle 1637
Oil on canvas
218.4 x 130.8
Inscribed: 'The Lady Lucy Percy Countess of Carlisle'
The Trustees of the Rt Hon. Olive Countess Fitzwilliam's Chattels settlement by permission of Lady Juliet Tadgell

Lucy Percy (1599–1660) was the youngest of the four surviving children of the 9th Earl of Northumberland, and thus the sister of van Dyck's great patron Algernon Percy, the 10th Earl (see no.51).[1] In 1617 she married James Hay, 1st Earl of Carlisle (c.1580–1636). In 1625, following the accession of Charles I and his queen, Lucy became increasingly influential at court, and established a salon where courtiers, poets and writers mingled. Following the death of her husband in April 1636, Lucy was reputed to be the mistress of her political associate Thomas Wentworth, later 1st Earl of Strafford (see nos.42 and 57). Having inherited her husband's properties in Ireland, she needed Wentworth's goodwill. The present portrait belonged to, and seems to have been commissioned by, Wentworth, a version of whose own half-length portrait van Dyck had painted for Lady Carlisle in the summer of 1636.[2]

The inscription identifying the sitter, painted at the top of the canvas before 1695,[3] was subsequently painted over and only uncovered again in the late twentieth century; in fact, for many years before that this portrait was mistakenly thought to depict Wentworth's second wife.

This is the most beautiful of a number of portraits by van Dyck of the countess, including a double one showing her with her sister Dorothy, Lady Leicester.[4] The present painting has a powerful sense of movement, as she advances towards a curtained space, turning to look at the viewer with an expression that is simultaneously flirtatious and challenging.[5] The countess was famous for her beauty and her strong personality. The luxurious fabrics of her costume, rapidly painted by van Dyck with considerable freedom, have made this image of particular interest to historians of dress.[6] Gordenker has pointed out that the voluminous, pinned-back gold-brocade-lined sleeve seen here was unknown in British portraiture, and she suggests that van Dyck borrowed its form from masque costumes designed by Inigo Jones. As can be seen from the preliminary sketch for this portrait (no.85), the sitter's attire in the finished oil differs from van Dyck's original concept in a number of details: in the sketch there is no sign of the voluminous sleeve, the shape of the bodice is different and the décolletage is higher. Moreover, the substantial jewellery in the painting is absent in the sketch.

This work was shown in the major exhibition of van Dyck's work at the Royal Academy in London in 1900, although at that date it was still misidentified as a portrait of Strafford's second wife (see no.130). Its influence can be clearly detected in a portrait painted in 1915 by Philip de László (no.133). KH

Notes
1 *ODNB* 2004, vol.25, pp.1026–8, entry on Lucy Hay, Countess of Carlisle by Roy E. Schreiber. See also Lita-Rose Betcherman, *Court Lady and Country Wife: Two Noble Sisters in Seventeenth-Century England*, New York 2005.
2 Millar 1986, pp.109–23.
3 Barnes et al. 2004, no.IV.37, pp. 453–5.
4 Ibid., nos.IV.37–8 and IV.155, pp.453–5, 550–1. Among her brother Northumberland's considerable collection of female portraits by van Dyck was a fine three-quarter-length image of Lucy Percy, which remains at Petworth today (Barnes et al. 2004, no.IV.38, p.455).
5 See Wilton 1992, no.4, pp.70–1. The pose repeats that in van Dyck's earlier, Flemish portrait of *Beatrice de Cusance, Princess of Cantecroix* (Barnes et al. 2004, no.III.76) as noted in Gregory Martin's review of Barnes et al. 2004, *Burlington Magazine*, vol.147, February 2005, pp.118–20.
6 Gordenker 2001, pp.55, 57.

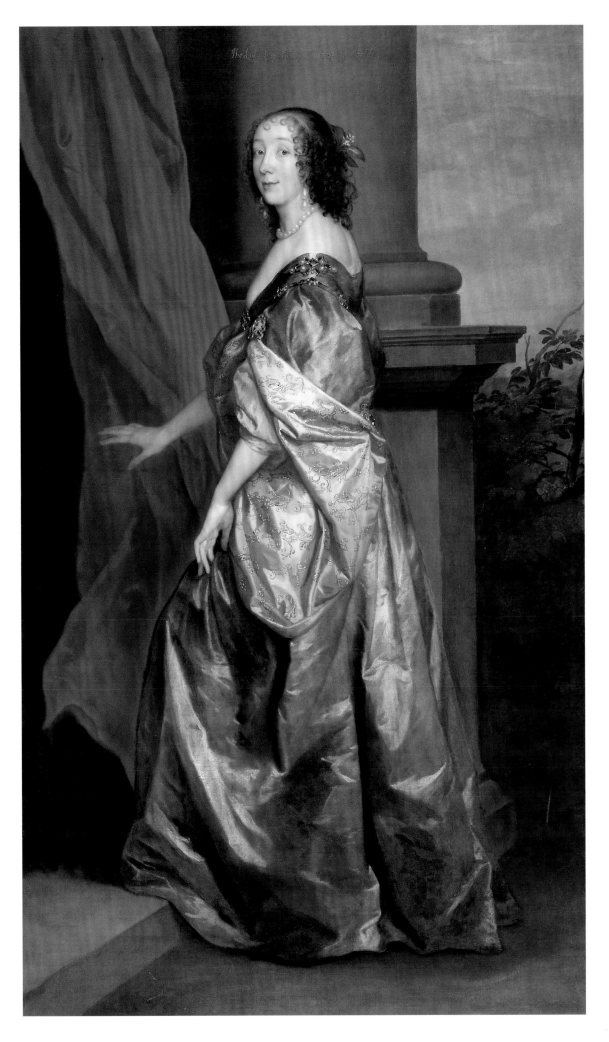

Other Patrons and Sitters

44
Philip Herbert, 4th Earl of Pembroke c.1637
Oil on canvas
133.5 x 108
Private collection

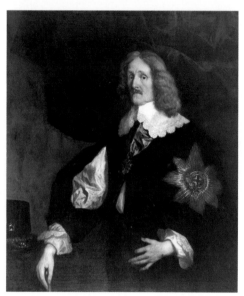

Fig.32
Anthony van Dyck
The Pembroke Family Group c.1635
Oil on canvas
330 x 510
The 18th Earl of Pembroke and Montgomery and the
Trustees of the Wilton House Trust, Salisbury

Fig.33
Peter Lely
Philip Herbert, 4th Earl of Pembroke
Oil on canvas
The Burghley House Collection

Remembered today as one of the two aristocratic brothers to whom the First Folio of works by the deceased Shakespeare was dedicated in 1623, Philip Herbert (1584–1650) was keenly interested in commissioning portraits of members of his family and, particularly, of himself. He invariably chose the leading court painters of the moment – his earlier portrait by Daniel Mytens is included here (no.8) – and he was to become one of van Dyck's most significant patrons. It was, for instance, Pembroke who gave van Dyck one of his most challenging commissions, for the immense Pembroke Family group portrait of about 1635 (Wilton House, Wiltshire), the largest surviving painting of his career.

In the present portrait, Pembroke's light-coloured staff (in reality white) and the key suspended from a bunched blue ribbon, left, both denote his senior court post as Lord Chamberlain. He held this post from 1626 to 1641, and it put him in control of court ceremonies and procedures, protocols and entertainments. He also wears the blue ribbon of the elite Order of the Garter with its suspended jewel, the Lesser George, and the Garter star on his cloak.[1] The cuffs of his gloves are richly embroidered. In an earlier, better-known three-quarter-length portrait of about 1634 van Dyck had depicted Pembroke as keen-eyed and commanding.[2] In the present portrait, while still commanding, Pembroke appears a more careworn figure, who rather anxiously grasps his status-denoting staff, glove and sword, while gazing out in a challenging manner.

An early favourite of James I after his accession to the English throne in 1603, Philip – who had been named after his mother's brother, the poet Sir Philip Sidney (1554–86) – had a reputation for 'rough, foul-mouthed, and even violent behaviour'.[3] He had succeeded his brother William (whose wife's sister was married to the 'Collector' Earl of Arundel, see no.7) as 4th Earl of Pembroke in 1630. In the same year he married his second wife, the formidable woman known to posterity as 'Lady Anne Clifford' (1590–1676), but the union soon became an unhappy one.[4]

Pembroke's considerable wealth enabled him to acquire and, particularly, to commission architecture and works of art. According to John Aubrey, he 'did not delight in books, or poetry: but exceedingly loved painting and building, in which he had singular judgement, and had the best collection of any peer in England, and was the great patron to Sir Anthony Van Dyck: and had most of his painting'.[5]

Every summer Pembroke entertained Charles I at his great house, Wilton, where the sophisticated gardens had been designed by Isaac de Caux (active 1634–5), and architectural work commissioned from his brother Saloman de Caux (1576–1626). After the outbreak of Civil War, and after a fire at Wilton in 1647, Pembroke rebuilt and redecorated the house to designs by Inigo Jones (1573–1652; see no.72) and John Webb (1611–72). He was also interested in colonial enterprises and was involved with the Virginia Company, the North-West Passage Company, the Guiana Company and the East India Company.

A devout Protestant, Pembroke was opposed to Archbishop Laud (no.41) and became increasingly alienated from the court. In 1641 he sided with Parliament – as did others among van Dyck's most assiduous patrons, such as the Lords Northumberland and Wharton (nos.51 and 30) – although his political allegiance in later years was to vary.

Following van Dyck's death, Pembroke was to commission a final portrait of himself from Sir Peter Lely (Burghley House). KH

Notes
1 Barnes et al. 2004, no.IV.183, p.571.
2 See Millar 1972, no.104, p.75; Millar 1982, no.12, p.53; Brown and Vlieghe 1999, no.75, pp.266–7; Barnes et al. 2004, no. IV.182, pp.570–1.
3 *ODNB* 2004, vol.26, pp..714–20, entry on 'Philip Herbert, 1st Earl of Montgomery and 4th Earl of Pembroke' by David L. Smith.
4 For Lady Anne's own patronage of painters and architects, see *Lady Anne Clifford: Culture, Patronage and Gender in 17th-Century Britain*, ed. Karen Hearn and Lynn Hulse, Leeds [forthcoming 2009].
5 See note 3.

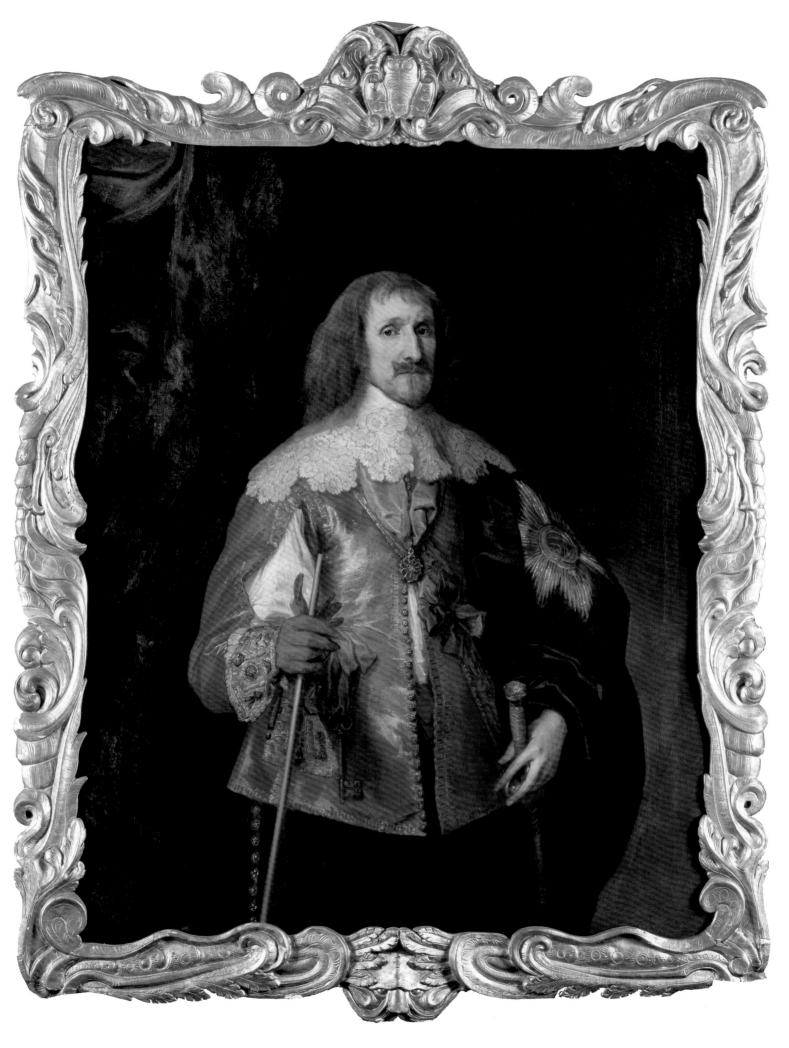

Other Patrons and Sitters

45

Lucius Cary, 2nd Viscount Falkland
c.1638–40
Oil on canvas
69.9 x 57.8
The Trustees of the Chatsworth Settlement

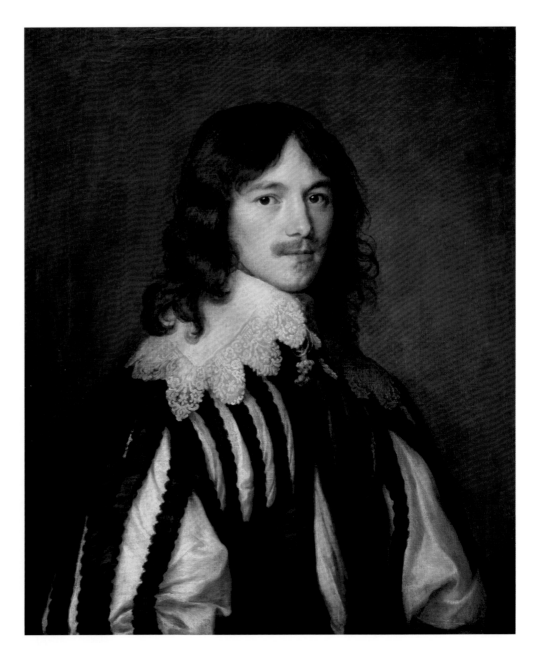

In this work van Dyck seems to have been influenced by the plain, self-contained portrait style of the London-born painter Cornelius Johnson:[1] see, for example, Johnson's image of *Sir Thomas Hanmer* (no.16). The large number of surviving portraits by Johnson suggests that his modest manner of presentation was popular with English clients.

Lucius Cary (1609/10–43) inherited his title from his father in 1633. During the 1630s he lived quietly at Great Tew, near Oxford, where he read and studied widely, wrote poetry and assembled around him a remarkable circle of friends and visitors who became known as the 'Great Tew circle'.[2] These included Edward Hyde, later 1st Earl of Clarendon (1609–74), clergymen such as Gilbert Sheldon (1598–1677), and poets like Sir John Suckling (1609–42), Edmund Waller and Ben Jonson (1572–1637), as well as the political philosopher Thomas Hobbes (1588–1679).

Small in stature, Cary was much loved for his hospitality and his gift for friendship: he was known for his ecumenical views and his respect for intellectual differences among the group. Here he is depicted at the age of about thirty, just before he entered Parliament: in 1640 he became MP for Newport on the Isle of Wight, in both the Short and Long Parliaments. Cary was committed to the rule of law, and disapproved of ship money, the levy raised by Charles I without the consent of Parliament. From a position critical of the king he gradually moved towards supporting him, and in January 1642 he became a Privy Councillor and then Secretary of State. Cary continued to maintain his moderate views, and as the Civil War unfolded his friends observed that he fell into a deep depression. Clarendon described how 'his natural cheerfulness and vivacity grew clouded'; his death in the first battle of Newbury on 20 September 1643 was effectively considered to have been suicide.[3] Clarendon wrote of his friend's 'sweetness ... goodness ... simplicity and integrity ...' – qualities which van Dyck seems to suggest in the alert and intelligent features depicted here.

Cary's black doublet is extensively slashed – or rather, 'paned' (see p.126) – to reveal swathes of his white shirt beneath. In addition, the doublet is largely unbuttoned, introducing a degree of informality.

Clarendon owned a posthumous three-quarter-length image of Cary based on the present portrait.[4] KH

Notes
1 Barnes et al. 2004, IV.103, p.512.
2 *ODNB* 2004, vol.10, pp.440–5, entry on Lucius Cary by David L. Smith.
3 Sumner 1995, no.5, pp.81–2.
4 Robin Gibson, *The Clarendon Collection*, London 1977, no.62, pp.56–7, 163; Barnes et al. 2004, no. IV.103. p.512.

46

*Lord George Stuart, Seigneur
D'Aubigny* c.1638–40
Oil on canvas
218.4 x 133.4
Inscribed on rock: 'ME FIRMIOR AMOR'
National Portrait Gallery, London

Lord George Stuart (1618–42) was the
younger brother of James Stuart, Duke of
Lennox (no.31) and the older brother of
Lords John and Bernard Stuart (no.40).
The four young men were all cousins of
Charles I. Lord George inherited his French
title as Seigneur of Aubigny-sur-Nère, near
the Loire, at the age of fourteen, in 1632.[1]
A Roman Catholic, he was raised in France
by his grandmother.

It is thought that this portrait was
painted at around the time when Lord
George made a secret marriage to Katherine
Howard, the daughter of the 2nd Earl
of Suffolk.[2] The Latin inscription on the
rock can be translated as 'Love is stronger
than I am', which probably alludes to the
considerable opposition to this union, both
from the earl and from Charles I himself, who
was Lord George's guardian. The couple had
a son, Charles, born in 1639, and a daughter,
Katherine, born in 1640.

Contemporary viewers would have read
this as an allegorical image of Lord George
in the role of a pensive shepherd, in an
internationally understood visual language.
Van Dyck depicts him in an outdoor
setting – in a knee-length blue tunic, often
associated on stage with pastoral themes –
as if in an Arcadian masque. Leaning
elegantly upon a rock, from which runs a
small stream of water, he holds a 'houlette',
a rustic implement to denote his fantasy
shepherd status. His gold-coloured cloak
is fastened with a jewelled pin.[3] Van Dyck
conveys a sturdy masculinity in Lord
George's capable bare right arm and rather
large head, as he gazes out at the viewer with
a firm determination.

It has been suggested that the rosebush
to the left and the thistle to the right
symbolise both the pleasures and the pain
of marriage, and also the union of the
English Howard family (denoted by the
roses) with the Scottish Stuart family
(the thistle).[4] A stream or fountain is often
associated with fertility.

Van Dyck had already used Arcadian
fantasy costume for his three-quarter-length
portrait of Lord Wharton of 1632 (no.30 –
indeed, Lord George's pose is Wharton's in
reverse) and again for the full-length of the
courtier and poet Sir John Suckling of 1638.

Lord George was killed at the age of

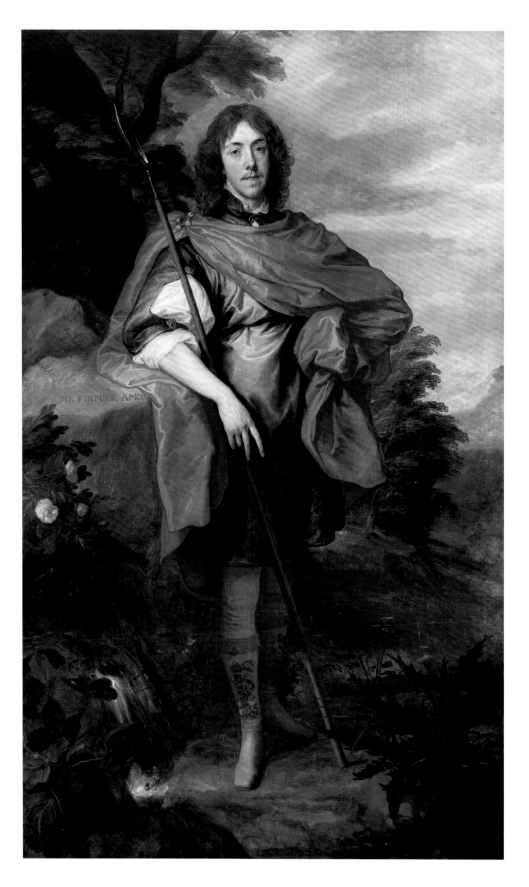

twenty-four during the Civil War, at the
Battle of Edgehill on 23 October 1642, where
he was in command of the Duke of York's
troop of horse. KH

Notes
1 The title had been in the Stuart family since 1423.

2 Barnes et al. 2004, no. IV.15, pp.439–40.
3 Gordenker 2001, pp.21, 44–5.
4 Millar 1982, no.61, pp.101–2; and Malcolm Rogers, 'Van
Dyck's Portrait of Lord George Stuart, Seigneur d'Aubigny,
and Some Related Works', in Barnes and Wheelock 1994,
pp.263–79.

Other Patrons and Sitters

47

Thomas Killigrew and another Gentleman 1638
Oil on canvas
132.7 x 143.5
Inscribed on base of column, centre: 'A, van, Dyck 1638'[1]
Her Majesty The Queen (The Royal Collection Trust)

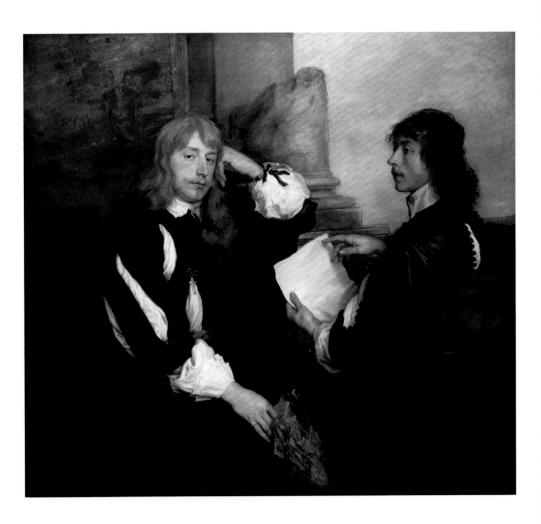

Thomas Killigrew (1612–83), courtier, poet and playwright, was the younger brother of Sir William Killigrew (see no.49).[2] Anne Kirke (nee Killigrew) was his sister and Lady Mary Killigrew his sister-in-law (see nos.48, 50). In around 1638 van Dyck was evidently commissioned to portray a number of members of the family,[3] and these portraits, including another half-length of Thomas (fig.34), bear inscriptions similar to this one. It is thought that these inscriptions could have been made by van Dyck himself.

This outstanding, and moving, double portrait depicts the 26-year-old Killigrew, left, in mourning for his wife, Cecelia Crofts, a lady-in-waiting to Henrietta Maria, who had died on 1 January 1638, less than two years after their marriage. Sixteen days later Cecelia's sister, Lady Cleveland, also died.

Killigrew rests his left elbow on the base of a broken column, supporting his head on one hand in the attitude that traditionally denotes melancholy (often in a context of intellectual ambition). His attire is dishevelled, which may be read both as a sign of distracted melancholy and as associating the wearer with artistic or literary interests.[4] A ring – perhaps a wedding ring – is threaded through the black ribbon round his left wrist, while pinned to his right sleeve is a cross engraved with a linked 'CC', his late wife's maiden initials. Hanging down from his right hand is a sheet of paper bearing the figures – or rather effigies – of two adults and a child, in shrouds, evidently a design for a funerary monument.[5]

The black-and-white tonality of the work is appropriate for the subject matter. There has been much debate as to the identity of the gentleman on the right, who gazes at Killigrew.[6] Although more formally dressed, he evidently empathises with Killigrew's grief and seems to be trying to draw his attention to the blank sheet of paper in his hand. In recent years this figure has been though to be fellow courtier William Crofts, later 1st Lord Crofts (c.1611–77), nephew of Cecelia Killigrew and Lady Cleveland.[7] KH

Notes
1 Barnes et al. 2004, no.IV.146, pp.542–3.
2 *ODNB* 2004, vol.31, pp.564–8, entry on Thomas

Killigrew by J.P. Vander Motten.
3 See Malcolm Rogers in Howarth 1993; also Wheelock et al. 1990, no.84, pp.313–15, and Brown and Vlieghe 1999, no.95, pp.314–16.
4 Gordenker 2001, pp.64–5.
5 This insight comes from Adam White, whose paper, 'Commemorating Mrs Killigrew', is forthcoming (?2009).
6 George Vertue proposed that he was the poet Thomas Carew (1594/5–1640), an identification that was maintained until the end of the nineteenth century, when it was realised that the sitter shown here is too young to be Carew.
7 See note 1.

Fig.34
Anthony van Dyck
Sir Thomas Killigrew 1638
Oil on canvas
106.1 x 86
Weston Park

48

Anne Kirke c.1637–8
Oil on canvas
222.2 x 130.5
The Huntington Library, Art Collections,
and Botanical Gardens, San Marino,
California. Purchased with funds from the
Adele S. Browning Memorial Bequest

Anne Kirke, née Killigrew (1607–41) was
the sister of Sir William (no.49) and Thomas
Killigrew (no.47). This portrait is presumed
to date from around 1637–8 – a period
during which the Killigrew family apparently
commissioned a number of portraits from
van Dyck.[1] This is the only full-length
among them, and it has been described
as 'one of the most carefully devised and
sumptuously painted of van Dyck's English
works, of superb quality all through the
composition and of great splendour'.[2] Anne's
dress is of amber-coloured satin, a colour
known as 'orange-tawny';[3] her scarf recurs in
other portraits by van Dyck (such as no.39)
and it has been suggested that it may have
been a studio prop.

 In April 1637 Anne Kirke was appointed
to the prestigious post of Dresser to Queen
Henrietta Maria, and this portrait was
probably painted to mark this honour.[4]
George Kirke, whom she had married in
1627, had been appointed Gentleman of the
Robes to Charles I, and was thus serving a
similar role (see pp.30–1).[5]

 Van Dyck portrays Anne in an
ambiguous space, simultaneously both
indoors and outside, with various items
of symbolic significance. She points
commandingly towards a flowering rose
bush; roses were connected with the
classical goddess Venus, and thus with love
and marriage. She had been married for
ten years, so this work may also celebrate a
decade of happy union. A small dog, leaping
as it chases a butterfly, rests its paws on a
large urn with four carved lions' heads.
The dog, which responds to her gesture,
may be symbolic of loyalty, perhaps both
fidelity in her marriage and a faithful
willingness to serve the royal family, while
the butterfly may represent the soul, and its
immortality. In fact, Anne Kirke drowned
in July 1641, when the Royal Barge capsized
near London Bridge. She was much mourned
at court, with the queen particularly affected
by the news.

 This painting subsequently belonged
to Sir Peter Lely, and is mentioned among
the works by van Dyck that he owned at
his death (see no.111). Lely was to re-use
the pose and setting for a portrait of one
of Charles II's mistresses, Barbara Villiers,

Duchess of Castlemaine (private collection,
California).[6] KH

Notes
1 Malcolm Rogers, '"Golden houses for shadows": Some
portraits of Thomas Killigrew and his Family', in Howarth
1993, pp.220–42.
2 Barnes et al. 2004, no.IV.150, pp.545–7.
3 Ribeiro 2005, pp.129–31.
4 Asleson 2001, no.108, pp.484–91
5 *ODNB* 2004, vol.31, pp.793–4, entry on George Kirke by
Philip Lewin.
6 See Diana Dethloff, 'Portraiture and Concepts of Beauty
in Restoration Painting', in MacLeod and Alexander 2001,
pp.28–30. See also note 4.

Other Patrons and Sitters

49
Portrait of Sir William Killigrew 1638
Oil on canvas
105.2 x 84.1
Inscribed lower left: 'SVR WILLIVM
KILLIGR[E]W / A.Van.Dyck.pinxit. / 1638'
Tate. Accepted by H.M. Government in lieu
of tax with additional payment made with
assistance from The Art Fund, the Patrons of
British Art, and Christopher Ondaatje, 2002

Sir William Killigrew (1606–95) was a
courtier under Charles I, and also later
a playwright. Van Dyck depicts him as a
meditative scholar, his gaze withdrawn from
the viewer. He leans pensively against the
base of a column, and the viewer's attention
is drawn to a ring tied with a ribbon to his
black satin jacket – perhaps in allusion to,
or in memory of, a loved one. Van Dyck
depicts the fabrics with bravura: the white
satin shirt and lace cuff on the right arm
are sumptuously painted, while Killigrew's
elegant right hand is tensed, belying the
apparently relaxed nature of the pose.[1]

Killigrew was descended from an old
Cornish family, but was himself born in
Middlesex, where his courtier father resided
near the royal palace of Hampton Court. He
and his siblings received a good education
and most of them, including his sisters,
were in their turn to hold significant court
positions. His younger brother Thomas is
the best known of them today, as a dramatist
and theatre manager after the Restoration
of the Stuart monarchy in 1660 (no.47).
In April 1624 William set off on a lengthy
journey across Europe – a Jacobean version
of the 'Grand Tour' – though his precise
itinerary is unknown. By May 1626, he was
back in England, where he was knighted
by Charles I. At around the same time he
married Mary Hill of Honiley, Warwickshire,
and was appointed a Gentleman-Usher of
the Privy Chamber to Charles I. In 1628
he was elected Member of Parliament for
Penryn in Cornwall, and from 1633 to 1635
he was Governor of Pendennis Castle, a
post previously held by his father. He also
involved himself in his father's project of
draining fenlands – the Lindsey Level – in
Lincolnshire. This was ultimately to exhaust
his economic resources, and meant that he
was to be financially hard pressed for much
of the rest of his life.

Van Dyck painted a number of portraits
connected with the Killigrew family in
and around the year 1638.[2] These include
the sombre double portrait of his brother,
Thomas Killigrew and another Gentleman,
surrounded by symbols of mourning (no.47).

The composition of this fine, sensitive

portrait from the middle of van Dyck's
English career reflects his study of Venetian
art.[3] Titian had frequently included a column
in the background of his male portraits
to convey the status of the sitter. He had
probably first used this in the three-quarter-
length portrait of Giacomo Doria, dressed
in black satin and painted around 1533–5
(Ashmolean Museum, Oxford). In turn, this
type of van Dyckian composition was to be
particularly influential for some later British
artists, including Sir Joshua Reynolds (see
no.128) and Thomas Gainsborough.

The inscription resembles those on van
Dyck's images of other Killigrew family
members, including the companion portrait
of the sitter's wife, *Mary Hill, Lady Killigrew*,
also in the Tate collection (no.50). KH

Notes
1 Karen Hearn, *Sir Anthony van Dyck: Portrait of William
Killigrew, 1638*, Tate Patrons' Papers 6, 2003.
2 Malcolm Rogers, 'Golden Houses for Shadows': Some
portraits of Thomas Killigrew and his family', in Howarth
1993, pp.220–42.
3 Barnes et al. 2004, no.IV.147, pp.543–4.

50

Portrait of Mary Hill, Lady Killigrew 1638
Oil on canvas
106.5 x 83.3
Inscribed lower left: 'My Lady.
KILLIGR[E]W / van..Dyck 1638'
Tate. Purchased with assistance from The
Art Fund, Tate Members and the bequest of
Alice Cooper Creed, 2003

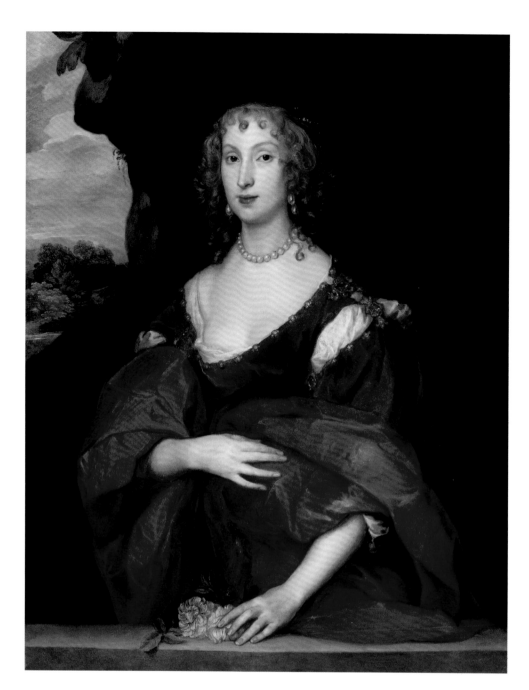

Van Dyck's portrait of Sir William Killigrew
(no.49) was acquired by Tate in 2002. This
portrait of his wife was acquired from an
entirely different source less than a year
later. The two pictures were known to
have been apart for at least 150 years. The
reunited works are now thought to be the
only companion pair of husband-and-wife
portraits from van Dyck's English period in a
British public museum.[1]

Neither the dates of Mary Hill's birth
nor her death are recorded. She and Sir
William Killigrew were married in about
1626 and were to have seven children in
all. The circumstances in which van Dyck
painted their portraits are unknown. As
Royalists, the couple were forced by poverty
to live apart during the Civil War and
Commonwealth period. They were reunited
at the Restoration of the Stuart monarchy in
1660, when Sir William regained his earlier
court post and Lady Mary became Dresser to
the dowager queen Henrietta Maria.

Lady Mary here gazes out at the
viewer directly. By the late 1630s van Dyck
had devised for his female portraits a less
specifically fashionable form of dress: clearly
the prestige of being painted by him was
such that his sitters were prepared to accept
this. Lady Mary is shown in just such a gown
– simplified, and without the kind of richly
textured lace that was so time-consuming
to paint – and which has thus become a
'timeless' version of contemporary dress.[2]
The border of her shift appears just above
the edge of her deep red gown, both pulled
low to reveal an expanse of creamy breast.

It is clear here that van Dyck has
absorbed ideas from Venetian painters.
Titian's *Flora*, of around 1515–20 (Galleria
degli Uffizi, Florence) is, for instance, a
comparable image of a beautiful woman,
perhaps in the role of the classical goddess
Venus, golden hair trailing across her cheek,
cream shift barely covering her breast and
shoulder, and roses held in one hand. Lady
Mary also holds roses, which, as attributes
of Venus, are symbols appropriate to a
happily married woman. Moreover, her
position behind a stone parapet echoes other
images by Titian, such as the portrait of *La
Schiavona (The Dalmatian Woman)* of around

1510–12 (National Gallery, London).

The form of the inscription on this
painting resembles those on the artist's
paintings of other Killigrew family members,
including that of Lady Mary's husband
(no.49), companion portrait
to this one.[3] KH

Notes
1 Karen Hearn, *Sir Anthony van Dyck: Portrait of William
Killigrew, 1638*, Tate Patrons' Papers 6, 2003.
2 Barnes et al. 2004, no.IV.148, p.544.
3 Malcolm Rogers, 'Golden Houses for Shadows': Some
portraits of Thomas Killigrew and his family', in Howarth
1993, pp.220–42.

51
Algernon Percy, 10th Earl of Northumberland c.1636–8
Oil on canvas
221.9. x 130.2
The Duke of Northumberland, Alnwick

Algernon Percy, 10th Earl of Northumberland (1602–68), is depicted at full length, surrounded by symbols of his marine responsibilities. Admitted to the Order of the Garter in 1635, he was appointed admiral in command of Charles I's ship money fleet in March 1636.[1] Resting one arm upon a great anchor, he wears his blue Garter ribbon and sash over elaborate military dress; he grasps his baton of command in his right hand and the hilt of his sword in his left. In the right background are two ships engaged in battle. Pentimenti can be seen in the outline of Percy's far shoulder and sleeve.[2]

Northumberland was one of van Dyck's most important patrons, and during the mid-1630s also commissioned a group portrait of his family (showing his first wife, who died in 1637; see no.84), posthumous portraits of his father and grandfather, and a half-length version of the present portrait, again with an anchor.[3] Payments to the artist are recorded in Northumberland's accounts.[4] Portraits of other family members by van Dyck – including the earl's sister, Lucy Percy, and his niece, Dorothy (no.53) – later entered his considerable art collection.

Percy's father, the 9th Earl, was imprisoned in the Tower of London from 1605 to 1621 for suspected complicity in the Gunpowder Plot against James I. Between 1618 and 1624 the young Percy undertook a Continental tour to the Netherlands, Italy and France, and in January 1629 he married Anne Cecil (1612–37), daughter of the 2nd Earl of Salisbury. Having succeeding to his earldom in November 1632, he attended court assiduously. As admiral he began to play a major role in Charles I's government, going to sea with his fleet in summer 1636. In April 1638, prompted by Thomas Wentworth (see nos.42, 57), Charles appointed Northumberland Lord Admiral, a post that he retained until the king revoked it in June 1642.

While not apparently a Puritan, the wealthy Northumberland was always opposed to Catholicism. Having become increasingly estranged from his friend Wentworth, at the Long Parliament in November 1640 he criticised royal policy. He was the highest-ranked member of Charles's government to join the Parliamentary side in the Civil War, which enabled Parliament

to control the Navy against the Royalists. In the 1640s he rented York House, the former London home of the late 1st Duke of Buckingham, which still housed his great art collection; Northumberland adroitly protected the collection from a parliamentary committee set up to appropriate it. In March 1645 he was given charge of the king's two younger children, the Duke of Gloucester (1640–60) and Princess Elizabeth (1635–50), and there were rumours that if Charles I proved intractable the little duke might be made King, with Northumberland as Lord Protector. After Charles's court in Oxford fell in July 1646, his second son, the Duke of York (1633–1701) was also entrusted to Northumberland.

Northumberland became one of Peter Lely's earliest and most important patrons. It is assumed that it was largely through viewing the earl's van Dycks that Lely, in emulation, modified his own approach to portraiture. In the 1640s Northumberland commissioned from Lely some politically charged portraits of the royal children in his care, including one of the now captive Charles I with the young Duke of York.[5]

During the Commonwealth and Protectorate, Northumberland acquired further old master paintings, including Titian's *Vendramin Family* (formerly owned by van Dyck; fig.40, p.134) and portraits by van Dyck himself, thereby assembling a set of 'Beauties' at his London residence, Northumberland House.[6] A posthumous inventory of his pictures there, drawn up in 1671, lists seventeen originals by van Dyck and four copies.

At the Restoration of Charles II Northumberland re-entered politics and was sworn in as a Privy Councillor in May 1660, although ultimately he failed to secure significant power. He died at his Sussex estate, Petworth, in October 1668, by which time he was 'one of the five wealthiest English peers'.[7]

Northumberland gave the present portrait to his daughter, Lady Elizabeth Percy, Lady Capel (for whose own portraits by Lely in a van Dyckian idiom see figs.35 and 47). It 'occupies a prominent position in the tradition of British portraiture', and inspired numerous later grand manner images, including Sir Joshua Reynolds's *Philip Gell* (1763; private collection) and *Lord Rodney* (1788–9; Royal Collection),[8] as well as Gainsborough's *3rd Earl of Bristol* (no.126). KH

Notes
1 *ODNB* 2004, vol.43, pp.678–84, entry on Algernon Percy by George A. Drake, which regrettably does not cover his activities as a patron of artists and a collector.
2 Barnes et al. 2004, no.IV.177, p.567.

3 Ibid., no.IV.173–6, pp.564–6.
4 Millar 1982, no.24, p.69; Jeremy Wood, 'Van Dyck and the Earl of Northumberland: taste and collecting in Stuart England', in Barnes and Wheelock 1994, pp.281–324, and Jeremy Wood, 'Van Dyck: A Catholic Artist in England …', in Vlieghe 2001, p.186.
5 See Millar 1978, no.6, pp.37–8; James Loxley, *Royalism and Poetry in the English Civil Wars*, London 1997, pp.155–68.
6 See Wood 1994; Christopher Rowell, 'Reigning toasts: Portraits of beauties by Van Dyck and Dahl at Petworth', *Apollo*, vol.157, 2003, pp.39–47.
7 *ODNB*, op. cit. (see note 1).
8 See note 2.

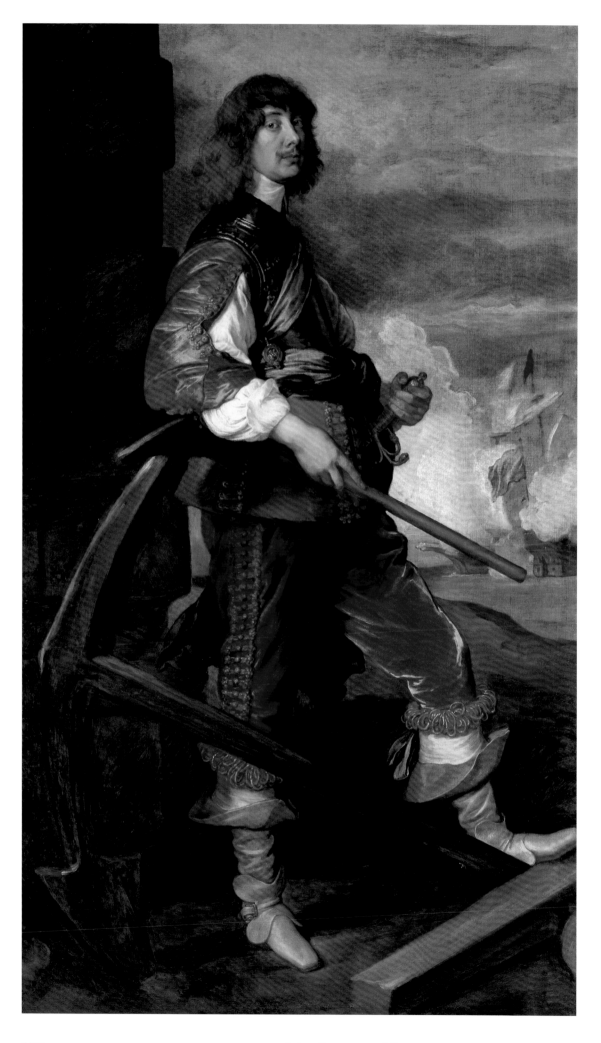

Other Patrons and Sitters

52
Edmund Waller (1606–1687)
Poems, 1645
Displayed open at pp.18–19
The British Library, London

Van Dyck's works were praised in verse
by many poets at court: Robert Herrick,
Richard Lovelace, Sir John Suckling and
others all lauded him as the finest exponent
of the painter's art.[1] Like van Dyck, the
poets recognised that their main tasks were
to praise Charles I and Henrietta Maria and
to enhance the royal image.

Edmund Waller, poet, Member of
Parliament and courtier, inherited an estate
of more than £2,000 a year, and in 1631
married an heiress (who died in 1634). He
remained a wealthy man.[2] He was a member
of the circle of Lucius Cary, Lord Falkland
(see no.45), and was influenced by his
ideas on toleration. Waller celebrated Lady
Dorothy Sidney (1617–84) in his poetry,
addressing verses not only to her, but also to
other members of the Percy family, including
her uncle the Earl of Northumberland and
her aunt, Lucy Percy.[3]

One portrait of Dorothy by van Dyck
– probably the one at Penshurst, which
depicts her in fantasy pastoral dress – was
the subject of Waller's poem 'On my Lady
Dorothy Sidney's picture' (*Poems*, p.18).
The 'matchless Sidney' referred to here is
Dorothy's great-uncle, the poet and soldier
Sir Philip Sidney (1554–86). Waller declares
that van Dyck's painting of Dorothy is even
lovelier than the heroines described in words
in Sidney's great poem 'Arcadia'.[4]

Dorothy's portrait is also the focus
of Waller's verse 'To Vandyck'(*Poems*, pp.19–
20), in which he extols the artist's ability to
make images that are lifelike and expressive
(p.20). The 'shop of beauty' referred to in
line 3 is evidently van Dyck's address in
Blackfriars, which housed his studio, while
lines 29–30 imply that Dorothy sat to
van Dyck a number of times. Timothy
Raylor and Michael P. Parker date both
poems to between spring 1637 and the end
of 1638.[5] The Royalist publisher Humphrey
Moseley issued this collection of Waller's
Poems in 1645. KH

Notes
1 Graham Parry, 'Van Dyck and the Caroline Court Poets',
in Barnes and Wheelock 1994, pp.247–60.
2 *ODNB* 2004, vol.56, pp.971–7, entry on Edmund Waller
by Warren Chernaik.
3 T. Raylor, 'The Early Poetic Career of Edmund Waller',
Huntington Library Quarterly, vol.69, no.2, pp.239–65.
4 M.P. Parker and T. Raylor, *The Poems of Edmund Waller*,
forthcoming. At present the standard edition remains *The
Poems of Edmund Waller*, ed. G. Thorn-Drury, 2 vols., 1905.
5 Ibid.

53
*Dorothy, Lady Spencer, later Countess of
Sunderland* c.1637–9
Oil on canvas
136.2 x 109.2
Lord Egremont, Petworth House

Dorothy Sidney (1617–84) was the eldest
of the 13 children of Robert Sidney, 2nd
Earl of Leicester, and the niece of Algernon
Percy, 10th Earl of Northumberland (see
no.51), and Lucy Percy, Countess of Carlisle
(see no.43), both of whom commissioned
paintings from van Dyck.[1] Dorothy was
raised at Penshurst, the family's house in
Kent, which had been celebrated in verse
by the writer Ben Jonson. On 20 July 1639
she married Henry, 3rd Lord Spencer of
Wormleighton, who was later created Earl
of Sunderland and was killed at the Battle of
Newbury in 1643.[2]

The poet Edmund Waller eulogised
Dorothy under the name of 'Sacharissa'. His
courtship has been described as ' … semi-
public and fashionably platonic'.[3] Various
candidates for her hand were proposed, but
it is unlikely that Dorothy's family seriously
considered Waller as a suitor.

Van Dyck painted a total of five
portraits of Dorothy, all perhaps based
on a single series of sittings.[4] One of them
was the subject of Waller's poem 'On my
Lady Dorothy Sidney's Picture' (for which
see no.52), which Michael P. Parker and
Timothy Raylor date between spring 1637
and the end of 1638.[5] A portrait of Dorothy
is also effectively the focus of Waller's verse
'To Vandyck'.[6]

Van Dyck here depicts Dorothy pointing
to a rose bush growing in a classically
decorated urn.[7] The roses, symbolic of the
goddess Venus and thus of love, suggest
that this portrait was painted during the
protracted negotiations for her marriage.
Parker observes that although Dorothy's
portraits have been thought to date from
around her wedding in July 1639, a picture
of her was in existence by 9 December 1638,
when Lady Leicester wrote to her husband,
who was in Paris on ambassadorial duties,
that 'Lady Dorothy's picture will be sent to
you as soon as we arrive in London'.[8] Indeed,
van Dyck could have painted Dorothy as
early as spring 1637 when she was in London
between 8 March and 15 June.[9] In autumn
1636 Lady Leicester had written to her
husband in Paris that she was worried that
'Doll' would become an old maid, and Raylor
and Parker suggest that the portraits might
have been commissioned in an effort to
interest eligible prospective husbands.

Sir Peter Lely was to borrow this
composition for female portraits, including
an early one of Northumberland's daughter,
Lady Elizabeth Percy, Countess of Essex, of
about 1650 (fig.35), and, more broadly,
*Lady Elizabeth Wriothesley, Countess of
Northumberland*, of 1665 or later (Royal
Collection).[10] These are evidence of the fact
that Northumberland's patronage of van
Dyck and then of his emulator, Lely, ensured
a visual continuity among the portraits on
the Earl's walls. Lely's much later portrait
of Mary of Modena, the second wife of
James, Duke of York (later James II) painted
in around 1674–5, is another echo of the
present work (see no.109). KH

Notes
1 *ODNB* 2004, vol.51, pp.835–7, entry on Dorothy Spen-
cer, Countess of Sunderland by Warren Chernaik.
2 Barnes et al. 2004, no.IV.223, p.605.
3 Timothy Raylor, 'The Early Poetic Career of Edmund
Waller', *Huntington Library Quarterly*, vol.69, no.2, pp.239–
65.
4 Barnes et al. 2004, nos.IV.223–IV.227, pp.605–7.
5 M.P. Parker and T. Raylor,, *The Poems of Edmund Waller*,
forthcoming.
6 Graham Parry, 'Van Dyck and the Caroline Court Poets',
in Barnes and Wheelock 1994, pp.247–60.
7 On the analogy between the curved vase and the female
figure, see Zirka Zaremba Filipczak, 'Reflections on Motifs
in Van Dyck's Portraits', in Wheelock et al. 1990, pp.59–68.
8 Sidney Papers, 1626–1698, *Report on the Manuscripts of
the Right Honourable Viscount de L'Isle, V.C.*, HMC 77, ed. G.
Dyfnallt Owen, VI.153 (I am indebted to Michael P. Parker
for this reference).
9 Email to author, 1 September 2008.
10 C. MacLeod and J. Marciari Alexander, 'The "Windsor
Beauties" and the Beauties Series in Restoration England',
in Alexander and MacLeod 2007, pp.110–11.

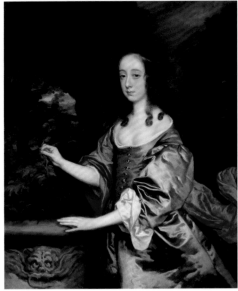

Fig.35
Peter Lely
Lady Elizabeth Percy, Countess of Essex c.1650
Oil on canvas
Petworth House, The Egremont Collection (The National
Trust); acquired by HM Treasury in lieu of death-duties
and transferred to the National Trust in 1957)

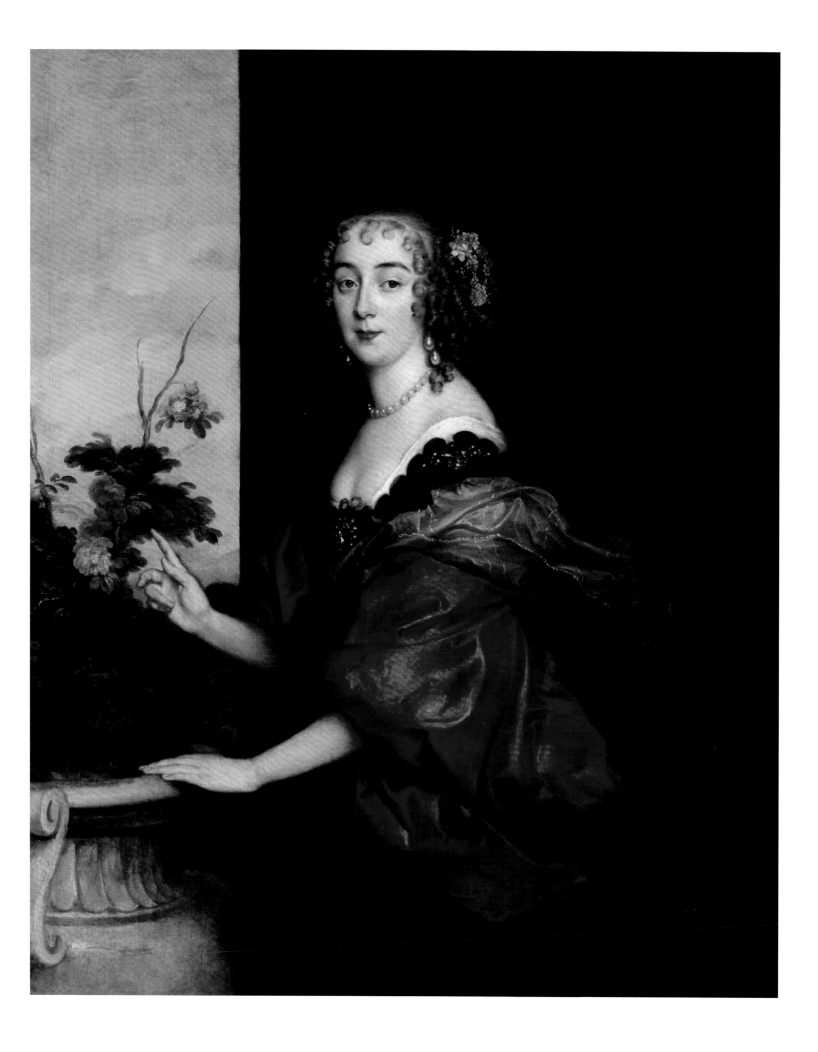

Other Patrons and Sitters

54
Portrait of Sir Thomas Hanmer c.1638
Oil on canvas
117.5 x 85.7
The Weston Park Foundation, Staffordshire

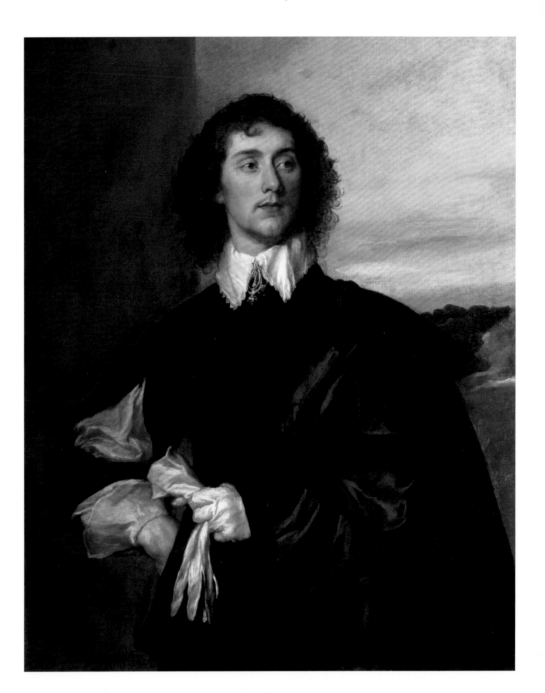

One of van Dyck's most outstanding
English-period portraits, this is presumed
to have been made just before Hanmer set
off in autumn 1638 for three years' travel on
the Continent. Van Dyck has here endowed
Hanmer with a remarkable sense of energy
and movement, and exceptional elegance.
Titian's influence can be seen not only in the
free and spontaneous brushwork, but also in
the glove-grasping composition.[1] There are
a number of pentimenti to the left shoulder,
the lower edge of the jacket and the outline
of the wall behind Hanmer's head.

Seven years previously, in 1631,
Hanmer had been portrayed by the English
painter Cornelius Johnson, in a signed and
dated head-and-shoulders image (no.16)
that contrasts markedly with the present
portrait, demonstrating the major differences
in presentation that van Dyck introduced to
portrait painting in Britain. While Johnson's
Hanmer was static, stolid and rather
reserved, van Dyck shows the stylish and
sophisticated connoisseur that the evidence
suggests Hanmer actually was.[2]

Sir Thomas Hanmer was a page to
Charles I from 1625 to 1627.[3] Later, in
around 1642, he became Cupbearer to the
King and, following the outbreak of the
Civil War, was appointed Prince Rupert's
representative in northern Wales. In 1644
he was given leave to retire to France, but
later returned to Wales where he compiled a
horticultural manuscript that was eventually
published in 1933 under the title *The Garden
Book of Sir Thomas Hanmer*. He became a
very influential gardener, and corresponded
with the leading horticulturalists of the
age, including John Evelyn (1620–1706);
after Hanmer's death Evelyn observed of the
present portrait that it was 'one of the best
[van Dyck] ever painted'.[4]

A copy of this work by Thomas
Gainsborough appeared at auction, at
Christie's in New York on 24 January 2008
(lot 69).[5] KH

Notes
1 Brown and Vlieghe 1999, no.96, pp.317–19; Barnes et al.
2004, no.IV.111, p.518.
2 Millar 1958, p.249.
3 *ODNB* 2004, vol.25, pp.64–5, entry on Sir Thomas
Hanmer by John Martin.
4 Cited in Millar 1982, no.37, p.80.
5 Noted previously in Postle 2002, pp.24–5.

55

'Mrs Howard' c.1638–9
Oil on canvas
106 x 81.3
Inscribed upper left: 'M^rs Howard. V.Dyke
Pinx^t'
Private collection, Boston, USA

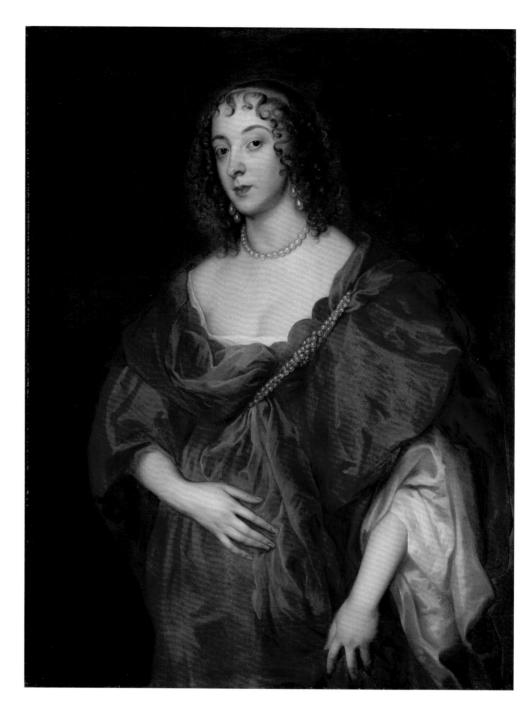

The identity of the sitter in this beautiful portrait is unclear. The inscription, upper left, post-dates the painting;[1] in the latter seventeenth century, when it was in the collection of the Earls of Clarendon, it was recorded as 'M^rs Howard'. However, it is uncertain whom is meant by this. Both Malcolm Rogers and Alastair Laing have suggested that the sitter is Elizabeth Howard (b.1613), a Maid of Honour to Queen Henrietta Maria and a granddaughter of Thomas Howard, 1st Earl of Suffolk. In 1654, at The Hague, Princess Mary (see no.22) proposed 'My lady Howard' as governess for her young son, William of Orange. A number of copies of the work are known, suggesting that the sitter was a woman of note. Most are linked with the name 'Mrs Howard', although a seventeenth-century label on the back of an early miniature copy of the head (Ham House, National Trust) states that it depicts 'Miss Cary / Maid of Honour / after Vandyke / Pret: £2'.[2]

A head-and-shoulders copy of this work is among the set of twelve images of ladies associated with the English court, thought to have been painted in 1638–9 and now in the Museum Schloss Mosigkau, Germany, of which ten are based on portraits by van Dyck.[3] This set was in the collection of the Dutch rulers Amalia van Solms and Frederick Henry in The Hague in the mid-seventeenth century, and may have been sent to them around 1641, when their son William married the British Princess Mary (no.22).

The sitter is dressed in semi-imaginary informal dress: her shift is revealed and she wears loose drapery with scalloped edges, anchored by a thick diagonal rope of pearls.[4] It is possible that she is pregnant: her loose attire conceals the outline of her body, and the gesture of her right hand, placed meaningfully on her stomach, echoes that of *Mary, Lady Verney* in van Dyck's portrait of 1636 (private collection), when she is known to have been pregnant with her son Edmund Verney.[5] KH

Notes
1 Barnes et al. 2004, no.iv.138, pp.536–7.
2 John Murdoch, *Seventeenth-Century English Miniatures*, London 1997, no.37, pp.73–4, listed as by John Hoskins.
3 See Peter van der Ploeg and Carola Vermeeren, *Princely Patrons: The Collection of Frederick Henry of Orange and Amalia of Solms in the Hague*, The Hague and Zwolle 1997, no.16h,

pp.164–8; see also *Schloss Mosigkau: Das Braune Kabinett*, Museum Schloss Mosigkau, Dessau 1994, no.9, pp.61–2 and fig.p.21 (information from Alastair Laing) .
4 Gordenker 2001, p.47 and fig.76.
5 See Barnes et al. 2004, no. iv.232, p.609.

Fig.36
Attributed to John Hoskins
'Miss Cary' 1638–40
Water-bound pigment on vellum
7 x 5.6
Ham House (The National Trust)

Other Patrons and Sitters

56

Dorothy Savage and her Sister Elizabeth, Lady Thimbleby (?) c.1635
Oil on canvas
132 x 149.9
The National Gallery, London. Purchased 1977

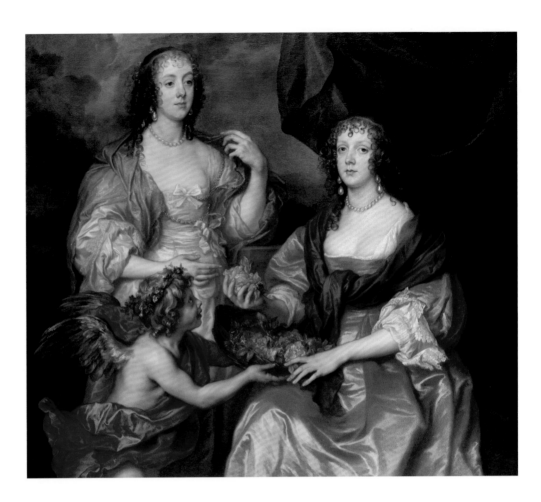

Dorothy (c.1611–91) and Elizabeth (born 1612) Savage were sisters, the eldest surviving daughters of Thomas 1st Viscount Savage (1586–1635), chancellor to Henrietta Maria. Elizabeth married the Catholic Sir John Thimbleby of Irnham, Lincolnshire, on 29 September 1634.[1] Until now, this double portrait has been thought to mark the clandestine marriage of Dorothy to Charles Howard, Viscount Andover, later 2nd Earl of Berkshire, on 10 April 1637.

Whereas portraits that celebrate a wedding usually represent the bride and bridegroom, this one, unusually, depicts the bride and her sister.[2] Until now it has been thought that both ladies had embraced Catholicism in the face of strong family opposition, and that various elements in this work reflected this.[3] Jennifer Hallam described it as 'a picture of self-defense [sic] rather than one of self-deprecatory regret. The bride's sister stands beside her in the dual role of character witness and counsel'.[4]

A forthcoming paper, however, reveals that in fact the Savage family was staunchly Catholic.[5] It also presents evidence, based upon the inscriptions on a newly cleaned early replica of this work, that, contrary to previous opinion, it is the as-yet-unmarried Dorothy who stands, left, while the new bride, seated right, is in reality Elizabeth. It proposes that the painting was commissioned by Lord or Lady Savage to mark Elizabeth's marriage in autumn 1634 and that van Dyck painted it soon after his return to England in March 1635. Van Dyck has included a Cupid in a scarlet cloak and a wreath of roses and violas, proffering to Elizabeth a basket of roses, an attribute of Venus. Dorothy, meanwhile, raises her veil in a gesture that alludes to chastity. The sitters' attire is a complex combination of fashionable costume and the informal 'undress' that van Dyck had introduced in his later female portraits. Elizabeth's gown is saffron in colour, at that time thought to be the colour worn by brides in antiquity.[6]

Sir Peter Lely was a subsequent owner of this painting (see no.111 for the sale catalogue of his collection). He himself was to use the basic two-female-figure format for a number of portraits, including that of the *Two Ladies of the Lake Family* included here (no.106), while a similar juxtaposition of one seated and one standing figure can be seen in his *Self-portrait with Hugh May* (no.107). KH

Notes
1 Barnes et al. 2004, no. 3#.8, pp.434–6.
2 Zirka Zaremba Filipczak, 'Reflections on Motifs in Van Dyck's Portraits', in Wheelock et al. 1990, pp.59–68.
3 Malcolm Rogers, 'Van Dyck's Portrait of Lord George Stuart, Seigneur d'Aubigny, and Some Related Works', in Barnes and Wheelock 1994, pp.263–79.
4 Jennifer L. Hallam, 'All the Queen's Women: Female Double Portraits at the Caroline Court', in *Women and Portraits in Early Modern Europe*, ed. Andrea Pearson, Aldershot and Burlington 2008, pp.137–60.
5 Walter Liedtke and Michelle Safer, 'Reversing the roles: Van Dyck's portrait of Lady Elizabeth Thimbleby with her sister Dorothy Savage', *Burlington Magazine*, vol.151, February 2009, pp.79–83.
6 Gordenker 2001, p.53; Ribeiro 2005, pp.129, 136.

57

Thomas Wentworth, 1st Earl of Strafford, with Sir Philip Mainwaring c.1639–40
Oil on canvas
131.8 x 142.9
The Trustees of the Rt Hon. Olive Countess Fitzwilliam's Chattels settlement by permission of Lady Juliet Tadgell

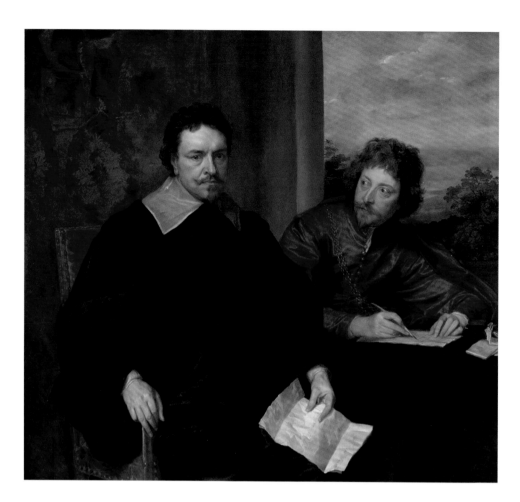

Thomas Wentworth (1593–1641) was recalled to London by Charles I in September 1639 from Dublin, where he had been acting as Lord Deputy of Ireland (see no.42). He was to become the king's closest and most trusted adviser during the difficult final years of the king's personal rule, for which he would pay the ultimate price: he was beheaded for treason in May 1641. Van Dyck probably painted this double portrait between Wentworth's arrival in London and his return to Ireland in March 1640.[1] During his short stay he was elevated to the title of Earl of Strafford and promoted as Lord Lieutenant of Ireland.[2]

Wentworth is accompanied here by Sir Philip Mainwaring (1589–1661). Having studied at Grays Inn and Brasenose College, Oxford, Mainwaring worked as an agent for the Earl of Arundel in the Netherlands in the second half of the 1610s. By 1629 he had started to report the news from court and foreign affairs events to Wentworth, who was by now increasingly finding favour with the king. In 1634 Wentworth appointed him to the post of Irish Secretary to replace the elderly Sir Dudley Norton; this brought membership to the Privy Council and a knighthood a few weeks later. Wentworth arranged for Mainwaring to be returned as Member for Morpeth in the 'Short Parliament' (April to May 1640), in which he urged the Commons to follow the Irish Parliament in supporting the king. Mainwaring lost his entire estate in the war and rebellion in Ireland, and died in London in 1661.[3]

In an intensely powerful portrait which conveys the pressure and immensity of the responsibility at hand, Wentworth stares directly out to the viewer whilst Mainwaring looks towards him, awaiting instruction, pen poised for action. The painting is a testament to their close and productive working relationship. Van Dyck's composition is closely based on Titian's portrait of *George d'Armagnac with Guillaume Philandrier* (no.11), which during van Dyck's period in England was in the collection of the Earl of Northumberland. The Titian in turn was probably influenced by Sebastiano del Piombo's *Cardinal Carondolet and his Secretaries* (1510–12; Museo Thyssen-

Bornemisza, Madrid), which was then in the collection of the Earl of Arundel, having been acquired in 1617 possibly with the help of Mainwaring (whose knowledge of and connection with the painting may have also influenced van Dyck's choice of composition).[4]

Van Dyck's portrait of Wentworth and Mainwaring was frequently copied, and inspired the compositions of subsequent British artists, such as Kneller's *George of Denmark with George Clarke* (c.1705; All Souls College, Oxford) and Reynolds's *Charles Watson-Wentworth, 2nd Marquess of Rockingham with his Secretary Edmund Burke* (c.1766; Fitzwilliam Museum, Cambridge). The composition is virtually copied by Shackleton in his portrait of the *Rt Hon. Henry Pelham, as 1st Lord of the Treasury, with John Roberts* (c.1752; private collection; another version is in the Government Art Collection).[5] TJB

Notes
1 O. Millar in Barnes et al. 2004, no.IV.218, p.600.
2 *ODNB* 2004, vol.58, pp.142–57, entry on Thomas Wentworth, 1st Earl of Strafford, by R.G. Asch.
3 *ODNB* 2004, vol.36, pp.176–7, entry on Sir Philip Mainwaring by F. Pogson.
4 Howarth 1985, pp.68–9.
5 M. Jaffé, 'The Picture of the Secretary of Titian', *Burlington Magazine*, vol.108, no.756, March 1966, pp.114–26.

58

Mountjoy Blount, 1st Earl of Newport, and George, Lord Goring c.1639
Oil on canvas
128.3 x 151.1
Petworth House, The Egremont Collection (The National Trust); accepted by HM Treasury in lieu of death duties and transferred to the National Trust in 1957

This double portrait shows two gentlemen in military dress readying themselves for battle. On the left, gazing out at the viewer, is Mountjoy Blount, 1st Earl of Newport (c.1597–1666). His right hand rests on his baton whilst his left hand grasps the sash on his breastplate, which he wears over a buff doublet with silver-white sleeves and red breeches. On the right is his friend George, Lord Goring (1608–57). He wears a pale red sash with silver embroidery, van Dyck capturing the moment of it being tied into position by a page. The portrait was painted at the time when both men were to fight for the king in the 'Bishops' Wars' (1639–40), the battles against the Scottish Covenanters which ended in defeat in the Battle of Newburn (1640) and acted as a prelude to the English Civil War.

Newport was the illegitimate son of Charles Blount, 1st Earl of Devonshire (1563–1606), and Lady Penelope Rich, wife of Lord Rich, 1st Earl of Warwick. He was half-brother to Robert Rich, 2nd Earl of Warwick (no.35) and Henry Rich, 1st Earl of Holland. In 1627 he married Anne Boteler (d.1669), sister of Olivia Porter, the wife of van Dyck's great friend Endymion Porter (no.65), and the following year he was created 1st Earl of Newport. A favourite at court, he performed in masques including Thomas Carew's *Coelum Britannicum* (Banqueting House, Shrove Tuesday night, 18 February 1634) alongside the king and the Earl of Holland, his half-brother; he was appointed Master of the Ordnance for life by Charles I in 1634, guaranteeing a vast annual income. Around the time this portrait was painted he was made Colonel of a regiment of foot, and shortly afterwards, General of the Artillery in the King's Army in the North. However, during the Civil War he also maintained links with leading Parliamentarians, hedging his bets and arousing suspicion. A survivor of the second Battle of Newbury (October 1644), he was captured following the fall of Dartmouth Castle in 1646. His estates were seized and he spent much of the Commonwealth and early Restoration in relative obscurity; he died at Oxford in February 1666, having left London to avoid the plague.[1]

Lord Goring was the eldest son of George Goring, later 1st Earl of Norwich (1585–1663). He was related to Newport by marriage: Goring's sister, Diana, married George Porter, Newport's nephew by marriage. Goring's marriage in 1629 to Lettice, third daughter of the Earl of Cork (b.1610), brought a huge dowry, and he wasted no time in spending it freely and enjoying life at court. But by 1633 the money was gone and he agreed to restore their fortunes with an army career, commanding an English horse troop in Dutch service. He was shot in the ankle during the Siege of Breda (1637) which left him lame; he returned to England with a reputation as a hero and was appointed Governor of Portsmouth in January 1639. His military experience saw him appointed by Charles I to command a foot regiment later that year, leading it in the advance guard to Kelso at the outset of the Bishops' Wars and winning many plaudits. He went on to become one of the king's most prominent cavalry commanders. He led the horse on the left wing at the Battle of Marston Moor (July 1644) before becoming a trusted regional general in the west of England, leading various campaigns against the Parliamentarians until his eventual defeat by the New Model Army. Surrounded on all sides in south Devon in October 1645, he sailed for safety in France. He found life in exile very difficult and died in Madrid in July 1657.[2]

This portrait is possibly that mentioned by Bellori, who wrote: 'He painted General Goring in the act of negotiating, and the Earl of Newport …'.[3] Van Dyck's introduction of the figure of the page tying the sash was virtually copied by Robert Walker in his portraits of Oliver Cromwell (see no.99). Millar has noted that the motif is not original to van Dyck but rather, like much of his style and composition, is Venetian in origin, being found, for example, in the Giorgionesque *Gaston de Foix* (Castle Howard).[4] The painting was also of great influence on the work of Sir Peter Lely. The dashing figure of Newport with his arm stretched out, leaning on his baton and looking over his shoulder, is echoed in Lely's portrait of *Sir Charles Compton* (c.1650s; The National Trust, Ham House) and his *Portrait of an Officer* (c.1650s; National Gallery of Canada, Ottawa). Another double portrait of Newport and Goring by van Dyck is in the collection of the Newport Restoration Foundation, Rhode Island, whilst his slightly earlier full-length portrait of Newport is at the Yale Center for British Art, New Haven.[5] TJB

Notes
1 *ODNB* 2004, vol.6, pp.305–8, entry on Mountjoy Blount, 1st Earl of Newport, by D.L. Smith.
2 *ODNB* 2004, vol.22, pp.1006–9, entry on George, Baron Goring, by R. Hutton.
3 O. Millar in Barnes et al. 2004, no.IV.172, p.563.
4 Ibid.
5 J. Marciari Alexander and M. Warner, *This Other Eden – Paintings from the Yale Center for British Art*, exh. cat., Yale Center for British Art touring, New Haven and London 1998, no.4, p.30.

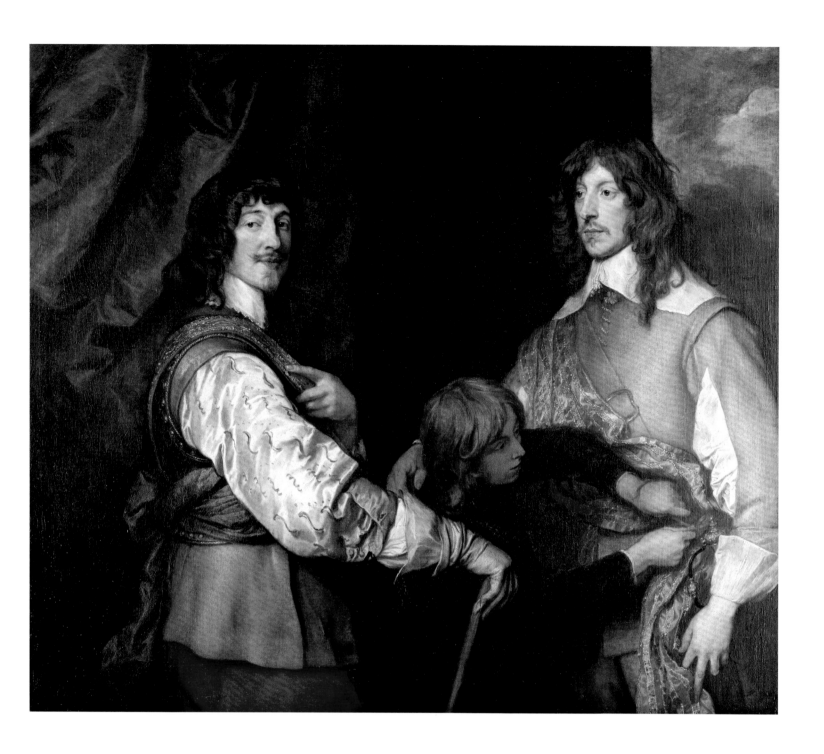

Other Patrons and Sitters

59
Doublet and breeches c.1630–40
English
Stamped and pinked silk satin
Victoria and Albert Museum, London

This ensemble of doublet and breeches is typical of a wealthy man's clothing and would have been worn with a matching or contrasting cloak. The style is characteristic of the 1630s, with the longer streamlined breeches replacing the bulbous trunk hose of earlier decades and corresponding to the breeches seen in van Dyck's male portraits. By the 1630s the waistline of the doublet had lowered slightly and the tabs below were larger and longer. Van Dyck's portraits and surviving garments reveal a range of styles for men's doublets during the 1630s; the paning (narrow strips of fabric) seen in his portrait of *Charles I and Henrietta Maria*, 1632 (fig.26, p.71), also appears in his portrait of *Lords John and Bernard Stuart*, c.1638 (no.40), and his self-portrait with Endymion Porter, 1633 (no.65). The style of doublet in this ensemble corresponds to the plainer cut worn by *Robert Rich*, c.1635 (no.35), without the open sleeve seen in the portrait.

A row of silk ribbon bows outlines the doublet waistline here, mirroring similar decoration in van Dyck's male portraits, such as the portrait of *Charles I and Henrietta Maria*. At the beginning of the seventeenth century the doublet and breeches were laced together with silk ribbons, which tied in bows around the waist. By the 1630s the inner construction of the doublet had changed so that the two garments were held together with metal hooks and eyes; the row of silk bows became a purely decorative feature. The doublet is also trimmed with what is now called braid (referred to as 'lace' in the seventeenth century, a term which is easily confused with the decorative linen laces) along the seams and edges of the garment. Worked on a narrow loom with silk and silk-wrapped thread in a weave creating loops on either side, the braid is one of a variety used on dress in the 1630s. It was particularly effective for edging the paning of men's doublets and can be seen in van Dyck's portraits of *Lucius Cary*, c.1638–40 (no.45), and the unknown man in his double portrait of *Thomas Killigrew*, 1638 (no.47).

The satin has been stamped and pinked for decorative effect. Stamping was done with tools similar to those used for tooling leather, and pinking – the tiny decorative holes in between the stamped motifs – was made with a tool resembling an awl. Pinking has a similar history to that of slashing (see p.128), and it remained a

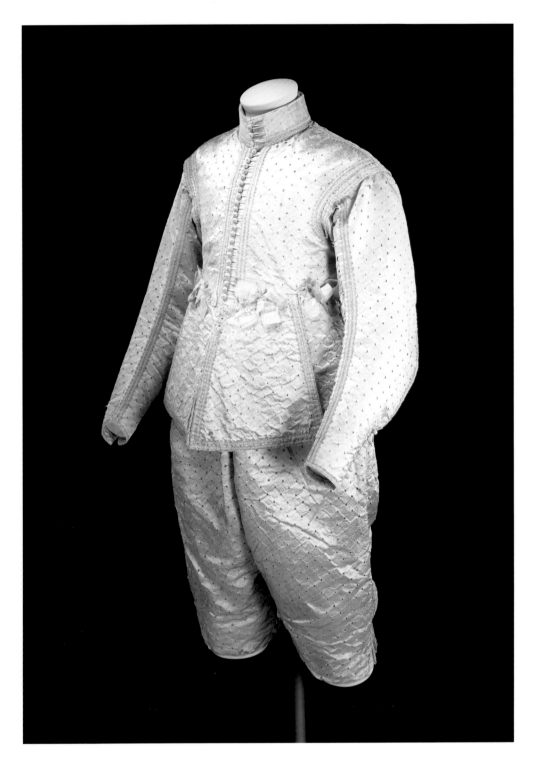

method of embellishing dress throughout the eighteenth century and can still be seen in women's dress of the 1840s. The texture of Henrietta Maria's blue silk petticoat and bodice in van Dyck's portrait of her with Jeffrey Hudson, 1633 (fig.8, p.20), suggests a pattern of pinked holes or short slashes.

In the 1630s a richly decorated suit of clothes could cost more than twice as much as one of van Dyck's paintings. His portrait of Henrietta Maria with Jeffrey Hudson, (fig.8), cost £40,[1] whereas Charles I paid £97 4s 6d for a suit (doublet, breeches and cloak) of grey wrought satin, edged with silver-gilt and silver lace, just one payment out of £4,058 1s 8½d spent on the king's wardrobe between 29 September 1633 and 29 September 1634.[2] SN

Notes
1 Barnes et al. 2004, p.524.
2 Roy Strong, 'Charles I's clothes for the years 1633 to 1635', *Costume*, vol.14 (1980), pp.73–89 (the price of the grey – 'greedeline' – wrought suit is on p.77).

60
Lace for a man's band c.1630
Flemish bobbin lace
Victoria and Albert Museum, London

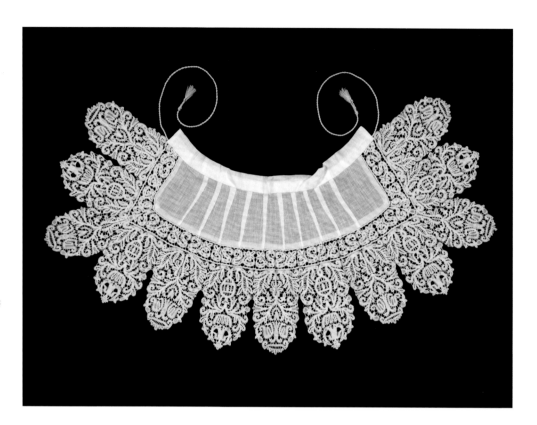

The newly fashionable bobbin lace was worn
by both men and women in the 1630s, edging
neckwear and cuffs worn at the wrist or
elbow. The high neckline of a man's doublet
required a band (collar) in a shape different
from those worn by women, but edged with
lace of the same pattern. This piece of lace
has been sewn to a modern reproduction to
illustrate how it was worn. Flemish bobbin
lace was the most fashionable and expensive
lace worn between the 1620s and the 1670s.
Bobbin lace is worked with dozens, sometimes
hundreds, of fine threads, each wound on a
separate bobbin, and plaited or twisted over
each other in designs outlined with pins on a
pillow. Although it was made in a number of
countries throughout Europe, that produced
in Flanders was the most prized in the
seventeenth century. This was due primarily
to the superlative linen thread, dependent
on the flax from which it was grown and
other aspects of the complex processing it
underwent from plant to lace pillow, requiring
months of labour and highly specialised skills,
including the bleaching of the yarn.[1]

Almost all van Dyck's aristocratic male
sitters wear lace trimmed bands; they feature
in the portraits of the Royal Family, the
Villiers brothers, 1635 (no.33), the Stuart
brothers, c.1638 (no.40), and *Robert Rich*,
c.1633 (no.35), and *Philip Herbert*, c.1637
(no.44); they are even shown with armour,
for example, *Charles I on Horseback with M. de
St Antoine*, 1633 (no.21), and the portrait of
Prince Charles Louis and Prince Rupert, 1637 in
the Louvre. Between 1632 and about 1638
the lace-trimmed band appears to designate
social status; in van Dyck's *Self-portrait with
Endymion Porter*, c.1633 (no.65), the artist's
plain linen band contrasts with Porter's deep
edging of bobbin lace. However, in his later
male portraits, such as *Thomas Wentworth with
Philip Mainwaring*, c.1639–40 (no.57), and
Thomas Killigrew with another Gentleman, 1638
(no.47), plain linen bands and sombre black
doublets predominate, suggesting either a
more informal presentation or possibly a
disinclination toward sartorial finery. In van
Dyck's portrait of *Henrietta Maria and Jeffrey
Hudson*, c.1634 (fig.8, p.20), she wears a man's
lace-trimmed band which, coupled with
the masculine-style hat, suggests the whole
ensemble was designed for riding, walking or
some other outdoor activity. SN

Note
1 Santina Levey, *Lace: A History*, Leeds/London 1983, p.52.

61
Bodice c.1630–40
English
Slashed silk satin
Victoria and Albert Museum, London

Women's dress in the 1630s featured a high waistline worn with short, full sleeves as demonstrated by this bodice, which contrasts sharply with the tightly fitted, long narrow bodice and sleeves that remained in fashion in England at the death of Elizabeth I (see no.2 for an example). Paris had regained its prominence in the fashion industry and its influence on European aristocratic dress with the coronation of Henry IV in 1594 and the restoration of peace in France after decades of religious war. However, new French styles were late to arrive in England. Anne of Denmark retained the court dress of Elizabeth I and the new styles instigated by Marie de' Medici did not begin to appear in England until after Anne's death in 1619. With her marriage to Charles I in 1625, the 15-year-old Henrietta Maria reinforced French influence characterised by a high waistline and paned puffed sleeves. By the 1630s the female silhouette had softened further, as this bodice illustrates, although the garment's construction reveals a narrow band of boning inside.

Part of formal dress with a petticoat of matching fabric, this style of bodice features in many of van Dyck's early female portraits, for example those of Henrietta Maria (1632, with Charles I, fig.26, p.71; 1633, with Jeffrey Hudson, fig.8, p.20) and others, such as *Katherine Duchess of Buckingham*, c.1634–5 (no.32). What the surviving example shows, but is rarely seen in portraits, is how deeply the full, elbow-length sleeves were set into the back of the bodice. As van Dyck's female portraits begin to take on their classicising format, the shape of the fashionable bodice can still be seen in portraits such as that of *Anne Killigrew with an Unidentified Lady*, c.1638 (State Hermitage Museum, St Petersburg).

The plain satin of the bodice is enhanced with slashing, a technique of deliberately cutting the fabric in a decorative pattern. Slashing is thought to have originated in the dress of Swiss mercenaries in the late fifteenth century and became fashionable throughout Europe by the 1530s.[1] In this particular garment, the cuts take the form of a curving line, which would have been punched through the silk using a tool with a sharpened, serpentine edge. A very similar style of slashing appears on the red doublet of William, Lord Russell, in van Dyck's portrait of him with George, Lord Digby, of c.1637 (fig.29, p.86). Another fashionable

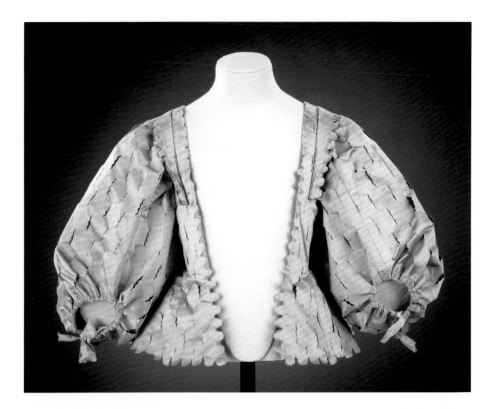

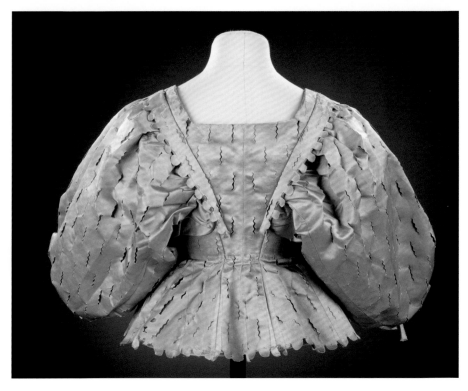

decorative technique is the scalloped hem and edges of the bodice, created with a tool similar to that used in slashing. Cut with a curved, serrated edge, scalloping prevented the raw edge of fabric, particularly silk, from fraying and provided an attractive finish. Garments with scalloped hems can be seen in van Dyck's portrait of *Frances, Lady Buckhurst*, c.1637 (no.39), and *Lady Mary Villiers*, c.1637 (no.34). Van Dyck may well have had lengths of silk with scalloped

edges in his studio, as these appear in several portraits of a more fanciful format, such as the *Countess of Southampton as Fortuna*, c.1640 (National Gallery of Victoria, Melbourne), and *Sir John Suckling*, c.1638 (The Frick Collection, New York). SN

Note
1 Janet Arnold, 'Decorative Features: Pinking, Slashing, Snipping and Slashing', *Costume*, vol.9 (1975), p.22.

62
Woman's band and cuffs c.1630–5
English
Linen edged with bobbin lace
Victoria and Albert Museum, London

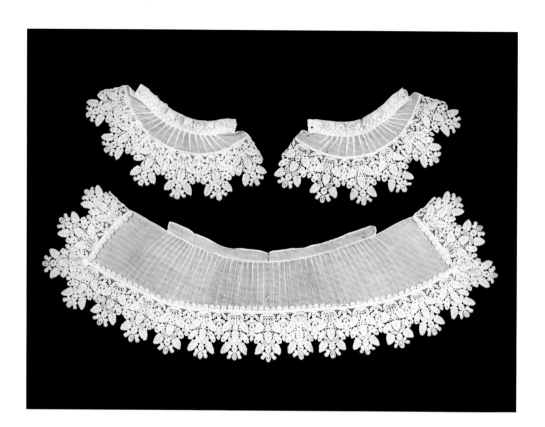

Van Dyck's portraits of women show elaborate ensembles of accessories trimmed with bobbin lace, including two or more bands (collars) layered on each other, as well as kerchiefs and cuffs; this is particularly evident in his images of Henrietta Maria (with Charles I, 1632, fig.26, and in black, 1632, no.19). Flemish bobbin lace dominated fashion during this period, its draping qualities complementing the new softer silhouette. Light and delicate, made with finer thread yet in denser patterns than the Italian needle lace of the Elizabethan era, it was ideally suited for edging the new 'falling band' which replaced the stiff, starched ruff of earlier decades.

This band and cuffs correspond with those in van Dyck's portrait of *Princess Mary*, c.1636 (no.22), although they may well have formed part of a larger lace ensemble. The edgings are made in the bobbin lace technique used for Flemish lace, but its design and the type of thread suggest that it was probably made in England. The quality of English lace in the seventeenth century was affected by the type of linen thread available. English thread was softer and more irregular than Flemish, though it was praised for its whiteness and in demand at the highest social level. English and imported Flemish laces embellished not only clothing, but also edged a range of household linens including coverlets, bed sheets, pillow biers (cases), towels and napkins. Charles I's lace expenditures were estimated at over £2,000 per year; a 'project' put forth in 1632 to reduce this by half unsurprisingly came to naught.[1]

The linen parts of the band and cuffs would have required more frequent washing than the lace edgings, which were regularly unpicked and sewn to freshly laundered band and cuffs. Such a translucent quality of linen, very finely pleated and sewn with tiny stitches and extremely thin sewing thread, is characteristic of seventeenth-century linens. If necessary, the lace itself could be washed, although even with the gentlest handling this sometimes compromised its smooth finish. SN

Note
1 Santina Levey, *Lace: A History*, Leeds/London 1983, p.24.

63
Wenceslaus Hollar (1607–1677)
Muffs and lace 1647
Etching
11 x 20.3
Lettered below centre: 'WHollar fecit Aqua
forti 1647'; and towards right: 'Antuerpiæ,.'
Nicholas Stogdon

Hollar was the most extraordinary and
prolific printmaker working in England
in the seventeenth century. The sheer
variety of his output and the mastery of
his unconventional etching technique must
have been a revelation to those accustomed
to contemporary engraved products such as
title-pages and portraits. Among his most
admired prints are the allegorical full-length
female figures representing the Four Seasons
made in London in 1643–4;[1] the series of
shells (undated);[2] the *Muscarum Scarabeorum*,[3]
comprising a set of butterflies and other
insects of 1646; and his large, multi-plate
'long view' of London[4] published in 1647.
The exquisite still-life studies of muffs,[5]
of which he made a number, are among the
most novel and famous of all of Hollar's
prints, and they are arguably his most
original contribution to the history
of printmaking.

 This print shows an assortment of
luxurious accessories: muffs, a pair of gloves,
two sorts of fans, lace, and even a mask
seemingly flung in a pile. The rendering
of the fur, its qualities of softness and
warmth, is utterly convincing. The muff
with a brocade band appears in another
print by Hollar,[6] for which there also seems
to be a related brush drawing in the British
Museum.[7] But we look in vain for muffs in
van Dyck's paintings, and it is something of
a twist to discover that van Dyck actually
removed fashionable items, preferring a more
inventive approach than merely portraying
accoutrements as signs of taste and wealth.

 This expertly crafted print is signed
and dated and was made while Hollar was in
Antwerp. He departed London for Antwerp
in 1644 to escape the Civil War, no doubt
also out of loyalty to his exiled patron the
Earl of Arundel and in order to try his
luck in a new European city, close to the
Brussels court. Antwerp was renowned as
a competitive and advanced printing and
printmaking centre, for the Plantin-Moretus
press and the generation of engravers
associated with Rubens and van Dyck.
Hollar made many acquaintances there,
and it is significant that he even produced a
print in collaboration with Paulus Pontius
(1603–58), the most prolific contributor
to van Dyck's *Iconography*. This was a
particularly productive episode in Hollar's

career and he worked for a number of the
leading publishers in the city such as Joannes
Meyssens and Frans van den Wyngaerde.
He nevertheless returned to London in 1652
and started his long association with the
antiquarian Sir William Dugdale (1605–86)
and entrepreneur John Ogilby (1600–76),
producing book illustrations and a myriad
of other prints and maps. ST

Literature
Pennington 1982, no.1951.

Notes
1 Pennington 1982, nos.606–9; Godfrey 1994, no.44;
Griffiths 1998, no.67.
2 Pennington 1982, nos.2187–224; Godfrey 1994, no.93.
3 Pennington 1982, nos.2164–75; Godfrey 1994, no.95.
4 Pennington 1982, no.1014; Godfrey 1994, no.62.
5 Pennington 1982, nos.1945–52; Godfrey 1994, no.92.
6 Pennington 1982, no.1946.
7 Inv. Sloane 5214.7; Franz Sprinzels, *Hollars
Handzeichnungen*, Vienna 1938, no.21; Edward Croft-Murray
and Paul Hulton, *Catalogue of British Drawings in the British
Museum. Volume I: XVI & XVII Centuries*, London 1960,
no.47.

Fig.37
Wenceslaus Hollar
A Dark Fur Muff 1647
Etching
Nicholas Stogden

Fig.38
Wenceslaus Hollar
A Dark Fur Muff 1647
Etching
Nicholas Stogden

Other Patrons and Sitters

Self-portraits
and Life

By the beginning of the seventeenth century there had long been a tradition of self-portraiture among artists on the Continent.[1] In Britain, too, painters had produced images of themselves, a number of which still survive. In 1554/5 the German emigré at the Tudor court Gerlach Flicke (c.1495–1558) had made a tiny double portrait of himself with a gentleman called Henry Strangwish (National Portrait Gallery, London); its inscription reveals that it was painted when the two were prisoners in the Tower of London. Flicke holds a palette, defining his profession as an artist.[2] Twenty-five years later, in 1579, the English-born George Gower produced the only known surviving large-scale self-portrait by a British sixteenth-century artist, in which he too holds a painter's palette. Gower included in his self-portrait his family's coat of arms and an eight-line verse expressing his pride in his professional skill, which he considered comparable to the military feats that had gained his forebears the status of gentlemen.

In 1577, while on a visit to France, the Exeter-born miniaturist Nicholas Hilliard (1547–1619) had painted himself on a small scale, in dashing, courtier-like style (Victoria and Albert Museum).[3] In Hilliard's limning of himself, as in van Dyck's self-portraits more than forty years later, there is no evidence that the subject is an artist, a profession which at that time was still viewed in England as artisanal. In about 1590 the French-born Isaac Oliver, Hilliard's one-time pupil, had similarly portrayed himself in miniature (National Portrait Gallery),[4] hand on hip and with a Netherlandish gentlemanly swagger, in an image comparable to van Dyck's own early self-portraits.[5]

During his few months in England over the winter of 1620–1, van Dyck may have produced his self-portrait (no.5), an image of considerable youthful self-confidence. Following his departure early in 1621 for Flanders and then Italy, two of the leading court painters in London, the elderly Marcus Gheeraerts II (who in his youth had painted Elizabeth I) and Daniel Mytens, both produced head-and-shoulders images of themselves. Gheeraerts's 1627 painting is now lost and known only from an engraving made after it in 1644, by Wenceslaus Hollar.[6] Mytens's self-portrait (Royal Collection) was painted on wooden panel in around 1630. Plainly attired in black but with a fine lace-edged falling ruff, the bearded, dark-eyed painter gazes out intently at the viewer. As it has Charles I's 'CR' brand-mark on the back, Mytens probably painted it for the king who, according to the inventory taken by Abraham van der Doort in the late 1630s, displayed it above a doorcase in Whitehall Palace, near to self-portraits by van Dyck and Rubens.[7]

Fig.39
Wenceslaus Hollar
London Before and After the Great Fire 1666
Etching
22.4 x 67.8
The British Museum, London
Blackfriars, where van Dyck lived by the Thames, is to the extreme left in both views.

Self-portraits and Life

Such was the quality and impact of Mytens's self-portrait that by the late eighteenth century it was incorrectly identified as a work by van Dyck.

Following his return to England in 1632, van Dyck was extremely conscious of his special relationship with the king and of his unique social status in London, and carefully fostered both. Previously, despite the aspirations demonstrated in their self-portraits, artists in Britain had generally been seen as of comparatively low rank. Van Dyck, however, was the son of a wealthy Antwerp merchant. He had already attained international celebrity by 1632, and was determined to be seen to live the elite life style of his court clients. Contemporaries commented on his fine clothes and aristocratic demeanour. Highly ambitious and intensely hard-working, he made himself the subject of a number of elegant self-portraits which demonstrated his position at court, including one placing him alongside the courtier Endymion Porter (no.65), evidently a much-valued friend – and a high-level contact.

Fig.40
Titian
The Vendramin Family, Venerating a Relic of the True Cross
mid-1540s
Oil on canvas
206.1 x 288.5
The National Gallery, London

Van Dyck's collection of Italian paintings, which he had brought with him to London, was much admired. It demonstrated that he was on the same wavelength as the king – a keen enthusiast of Italian art, especially the work of Titian – and other courtier art-collectors. Van Dyck's collection included Titian's immense *Vendramin Family* (fig.40), which was acquired by the Earl of Northumberland (see no.51) after his death.[8]

Key figures in van Dyck's life in London included the courtier and polymath Sir Kenelm Digby (no.74), the architect and designer Inigo Jones (no.72) and the printmaker Robert van Voerst (see no.73). Digby was evidently a close friend of the artist and would subsequently provide van Dyck's first biographer, Gian Pietro Bellori (no.75), with much information about his life in London, as well as commissioning paintings from him (including some, now lost, on religious subjects). Jones, like van Dyck, had travelled to Italy where he had studied works of art and classical and contemporary architecture. Initially active at court designing costumes and sets for court masques – enormously expensive entertainments that combined texts, music, dance and drama, in which leading courtiers and members of the royal family participated – Jones was appointed Surveyor of the King's Works in 1615. More precisely, he took on the role of artistic arbiter at court.

The Dutch engraver Robert van Voerst arrived in London in 1627, where he worked with various painters, including Mytens. He also worked directly for Charles I and in 1635, the year before he died in London, he was appointed Engraver in Copper to His Majesty. Van Voerst was the only London-based engraver to produce prints for van Dyck's ambitious series of etched and engraved portraits of famous contemporary men and women, subsequently known under the title *Iconography* (see nos.72–4).[9] For these van Dyck made chalk or wash drawings which were then developed in near-monochrome oil sketches that were supplied to the various engravers, including Lucas Vorsterman and Paulus Pontius in Antwerp, as well as van Voerst in London. Van Dyck had started work on this project in the 1620s, but continued it during the 1630s while he was in England. The engravings were distributed by the Antwerp dealer and publisher Martinus van den Enden, and the first known edition with a title page was published (after van Dyck's death) in 1645. Jeremy Wood has observed that 'The importance of this series was enormous, and it provided a repertory of images that were plundered by portrait painters throughout Europe over the next couple of centuries'.[10]

Van Dyck painted and drew a number of images of Margaret Lemon, his

mistress in London about whom little is known today. He used her as a model for narrative works (see no.69), portraits and fancy pictures.[11] He married for the first (and only) time comparatively late in life, in 1640. His bride was a Scottish noblewoman, Mary Ruthven, about whom, again, few facts are known. His portrait of her (no.70) was to become the subject of an admiring, detailed verbal account by William Sanderson (no.71), published in 1658.

Very shortly before his death in December 1641 van Dyck made a new will, leaving most of his property, including his pictures, to be divided between his wife and his newborn daughter (no.76), and expressing his wish to be buried in St Paul's Cathedral. There is conflicting evidence as to the precise nature of the monument that was erected to him there, 'near the tomb of John of Gaunt … near the Quire the north side of the Altar':[12] the monument did not survive the 1666 Great Fire of London and the subsequent rebuilding of St Paul's.[13]

Notes
1 A. Bond and J. Woodall, *Self Portrait: Renaissance to Contemporary*, exh. cat., National Portrait Gallery, London, and Art Gallery of New South Wales, Sydney, 2005–6.
2 See ibid., no.2, pp.86–7; Hearn 1995, no.67, p.120; Lorne Campbell et. al., *Renaissance Faces: Van Eyck to Titian*, exh. cat., National Gallery, London, 2008, no.45, pp.174–5.
3 Hearn 1995, no.73, pp.125–6; Karen Hearn, *Nicholas Hilliard*, London 2005, no.8, pp.42–3.
4 Hearn 1995, no.77, p.131.
5 See Barnes et al. 2004, nos.I.99, I.159–60, II.26, pp. 92–3, 138, 169–71.

6 Hearn 2002, fig.2, pp.10, 15.
7 Millar 1963, vol.1, no.114, p.84, and vol.2, pl.53.
8 C. Brown and N. Ramsay, 'Van Dyck's collection: some new documents', *Burlington Magazine*, vol.132, 1990, pp.704–9.
9 See *ODNB* 2004, vol.17, pp.466–74, entry on van Dyck by Jeremy Wood.
10 Ibid.
11 See Millar1963, vol. 1, no.157, p.101; Barnes et al. 2004, nos.IV.156–8, pp.551–3; and Desmond Shawe-Taylor and Jennifer Scott, *Bruegel to Rubens: Master of Flemish Painting*, exh. cat., Royal Collection 2007, no.37, pp.156–7.

12 George Vertue, 'Note Books', *Walpole Society*, vol.2, Oxford 1932, p.12. Unfortunately the monument does not appear in Hollar's engravings of interiors of old St Paul's Cathedral, as these were made just before it would have been erected. Bellori confirms that he 'was interred in Saint Paul's Church, to the sorrow of the king and the court…' (*Giovan Pietro Bellori: The Lives of the Modern Painters, Sculptors and Architects*, trans. Alice S. Wohl, Cambridge 2005, p.220).
13 I am grateful to Nigel Llewellyn for discussing the monument with me.

64
Wenceslaus Hollar (1607–1677) after
Anthony van Dyck
Van Dyck with Chain and Sunflower 1644
Etching
13.3 x 11.4
Lettered with dedication to John Evelyn by
Hendrick van der Borcht and dated 1644.
Below left: 'Ant: van dyck pinxit and at right:
W: Hollar fecit Londini.'
The British Museum, London

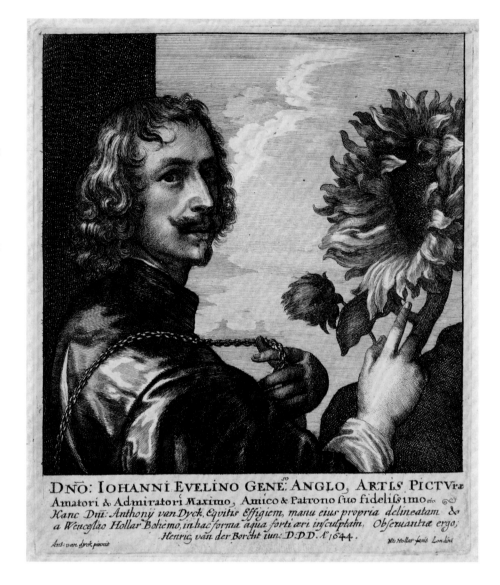

The etching reproduces a striking,
nonchalantly posed self-portrait by van Dyck
(fig.6, p.16),[1] which in all likelihood was
painted c.1633 after he had been knighted
and received a gold chain from King Charles
I. Much has been written on the chain
and the symbolism of the sunflower; it is
certainly not merely a still-life of a beautiful
flower, innocent of meaning.[2] Essentially
the painting is a declaration of the artist's
constancy to his royal patron and a proud
proclamation of his status as a courtier; but
there seem to be other themes in play too.
Despite all that has been written on the
painting, its early provenance is still
not known.

 The small print made in 1644 was the
first to reproduce van Dyck's painting and
is an important document in its own right.
It introduces two talented foreigners in
England, namely the Bohemian printmaker
and draughtsman Wenceslaus Hollar and
its publisher Hendrick van der Borcht the
Younger (1583–1660), born in Frankenthal,
although of Flemish extraction, colleagues
in the retinue of Thomas Howard, 14th
Earl of Arundel (1585–1646). Both Hollar
and van der Borcht had been taken into
Arundel's service in 1636 when he was on a
diplomatic mission on behalf of Charles I
to meet the German Emperor, Ferdinand II,
in order to negotiate the restitution of the
Palatinate to Prince Charles Louis, the son
of Charles's sister, Elizabeth of Bohemia.
In his other guise as connoisseur, Arundel
had encountered Hollar in Cologne and was
impressed by his printmaking ability: 'I have
one Hollarse wth me, whoe drawes and eches
printes in strong water quickely, and with
a pretty spiritte'.[3] Van der Borcht's father,
living in Frankfurt, was one of Arundel's
art agents, knowledgeable about antiquities
and old coins, and he must have encouraged
him to employ his son. Arundel had in mind
training the young man as an art curator to
his own collections and promptly posted
him to Italy where he was taken under the
wing of his chief agent, Rev. William Petty.[4]
Hollar and van der Borcht thereafter worked
together in Arundel House on the Strand
with secure patronage.

 The upheaval of the Civil War brought
a change of fortunes, and in 1642 Arundel
moved from London and started the
evacuation of his outstanding and extensive
collections to Antwerp. This called for a
new resourcefulness, and it seems that Hollar
made prints under his own initiative, in
collaboration with van der Borcht who was
acting now as a dealer and in the additional
capacity of publisher and distributor.
Many of the prints that Hollar made at
this time reproduce works from the Arundel
collection, including paintings by Elsheimer,
Holbein, Leonardo da Vinci
and Parmigianino.

 The present print after van Dyck's
portrait is dedicated to the famous versatile
intellectual John Evelyn. Evelyn was a
client of van der Borcht, and a number
of fascinating letters survive among the
Evelyn papers now in the British Library:[5]
this print of van Dyck with the sunflower
is even mentioned. It appears from the
correspondence that some impressions
of the print were sent to Evelyn while he
was on his European travels or Grand Tour,
but that they were lost in the post and never
reached him. ST

Literature
Pennington 1982, no.1393; Godfrey 1994, no.47; Griffiths
1998, no.53; New Hollstein, pt v, no.428.

Notes
1 O. Millar in Barnes et al. 2004, no.iv.4. See also the
portrait of the artist (ibid., no.iv.a1) in which the chain is
also prominent, engraved by Lucas Vorsterman (Mauquoy-
Hendrickx 1991, no.79; New Hollstein 59) for the
Iconography series and lettered 'EQVES' (Sir), emphasising
his knighthood.
2 See most recently Peacock 2006.
3 BL, Add. MS 15970, fol.26; Mary F.S. Hervey, *The Life,
Correspondence and Collections of Thomas Howard, Earl of
Arundel and Surrey*, Cambridge 1921, pp.365–7; Francis
Springell, *Connoisseur & Diplomat: The Earl of Arundel's
Embassy to Germany in 1636 …* , London 1963, p.143,
Appendix A, letter xvii, p.240 and repr. fig.[50].
4 David Howarth, 'A Question of Attribution: Art Agents
and the Shaping of the Arundel Collection', in H. Cools,
M. Keblusek and B. Noldus (eds), *Your Humble Servant:
Agents in Early Modern Europe*, Hilversum 2006, pp.17–28.
5 Robert Harding, 'John Evelyn, Hendrick van der Borcht
the Younger and Wenceslaus Hollar', *Apollo*, vol.144,
no.414, 1996, pp.39–44.

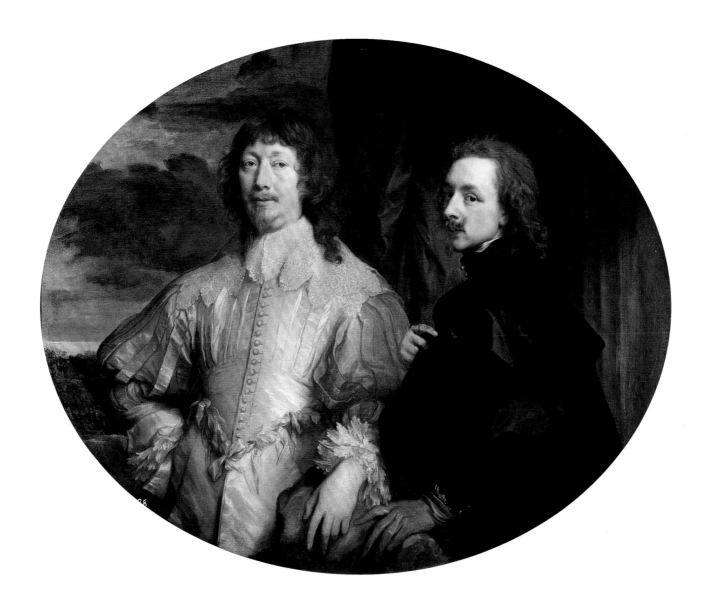

65

*Self-portrait: Van Dyck with Endymion
Porter* c.1633
Oil on canvas
Oval, 110 x 114
Museo Nacional del Prado, Madrid

Van Dyck effectively introduced to
Britain the 'friendship portrait', a genre
that depicts a pair of sitters who are not a
married couple (and indeed may not even
be related); he executed a number of such
portraits in London during the 1630s. Van
Dyck had known Endymion Porter since his
first brief visit to London in 1620–1, and
this is one of several portraits he painted of
his friend (see no.15). Knowledgeable about
art, Porter was, according to Anthony Wood,
'beloved' by both James I and Charles I,
'for his general learning, brave stile, sweet
temper, great experience, travels and
modern languages ...'.[1]

This is the only self-portrait in which
van Dyck depicts himself with another
person. Porter had played a key role in
bringing the artist and his work to the
attention of Charles I, and this work is thus
a declaration of an important friendship. The
two men are carefully differentiated: Porter's
figure is larger and he is depicted almost
frontally, while van Dyck's slight figure,
attired in black satin with gold buttons, is
presented sideways on. It has been suggested
that this expresses the two men's differences
in station and personality, and their
'hierarchical yet reciprocal relationship'.[2]
The rock upon which both men rest their
hands represents the firmness and solidity of
their friendship, while the unusual horizontal
oval format emphasises their closeness.[3]
Their costumes – contrasted in colour – are
rendered in considerable detail.[4]

There has been some uncertainty as
to where this work was painted. It was
probably made in England in 1633, at which
time Porter was aged around forty-six and
van Dyck thirty-four, although it has also
been suggested that it may date from the
winter of 1634–5, when both men were in
the Spanish Netherlands.[5] The early history
of the painting is obscure, including the
circumstances in which it was initiated.

A unique copy of this image in the form
of a Mortlake tapestry survives at Knole,
Kent.[6] KH

Notes
1 *ODNB* 2004, vol.44, pp. 947–50, entry on Endymion
Porter by Ronald G. Asch; see also Gervas Huxley, *Endymion
Porter, the Life of a Courtier 1587–1649*, London 1959.
2 Wheelock et al. 1990, no.73, pp.281–3; Anthony
Bond and Joanna Woodall, *Self Portrait: Renaissance to
Contemporary*, exh. cat., National Portrait Gallery, London,
and Art Gallery of New South Wales, Sydney, 2005, no.12,
pp.105–6.
3 Filipczak in Wheelock et al. 1990, p.62.
4 Gordenker 2001, p.61.
5 Barnes et al. 2004, no.IV.6, pp.432–3; Brown and Vlieghe
1999, no.88, pp. 298–9; *Velázquez, Rubens y Van Dyck*, exh.
cat., Prado, Madrid, 1999, no.3, pp.118–21; *The Sale of the
Century: Artistic Relations between Spain and Great Britain,
1604–1655*, ed. Jonathan Brown and John Elliott, New
Haven/London and Prado, Madrid, 2002, no.17, pp.176–8.
6 Barnes et al. 2004, no.IV.6, pp.432–3.

66
Portrait of Katherine, Lady Stanhope, later Countess of Chesterfield c.1635–6
Oil on canvas
77.5 x 64.8
Private collection

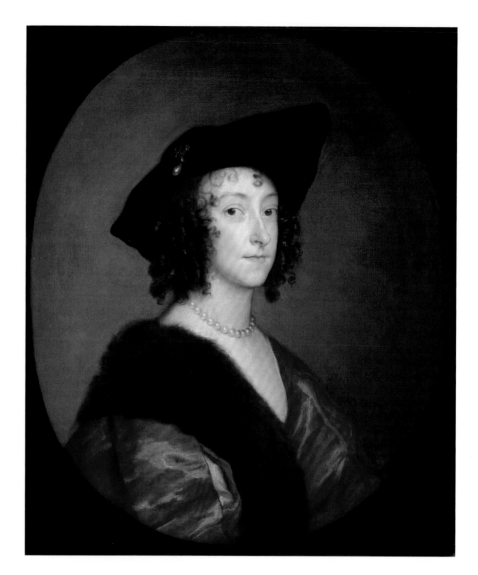

When the catalogue raisonné of van Dyck's paintings was published in 2004, the location of this work was not known and it had not been seen by the authors. Only subsequently did it emerge from an American private collection, appearing at auction in 2006.[1] One of van Dyck's most beautiful portraits, it is powerful in its simplicity.[2] Originally a rectangular image, the fictive oval opening was painted later over the original greyish background,[3] although it was already described as 'An Ovall head of my Lady Chesterfield by Vandike' by the time it was in the collection of the 1st Duke of Marlborough (1650–1722).[4] The canvas retains its original tacking edges – with scalloping – on all four sides, indicating that it still has its original dimensions.[5]

It seems that van Dyck had a personal involvement with the sitter. In January 1636 Lord Conway wrote to Lord Wentworth, referring to Lady Stanhope, that van Dyck was known for 'his Gallantrye for yͤ love of that Lady: but hee is Come with a Coglioneria for hee disputed with her about yͤ price of her picture and sent her word that if shee would not give yͤ price hee demanded hee would sell it to another yͭ would give more'.[6] Two other portraits by van Dyck of Lady Stanhope also survive.[7]

The first husband of Katherine Wotton (1609–67), Henry, Lord Stanhope, son of the 1st Earl of Chesterfield, had died in 1634.[8] As a widow Katherine divided her time between Boughton Malherbe in Kent, where her two surviving children were being raised, and her house in fashionable Covent Garden in London. As well as her alleged involvement with van Dyck, it was rumoured that Lord Cottington wanted to marry her, and that she was in love with Carew Raleigh. Early in 1641, however, she married a Dutch nobleman, Jehan van der Kerckhove (1594–1660), the Lord of Heenvliet, who had visited London to negotiate a marriage between Charles I's daughter, Mary (see no.22) and the young William, Prince of Orange. The couple were given senior appointments in the young princess's household in The Hague, Katherine becoming her governess and gaining her lifelong affection. Heenvliet died in March 1660 and two months later, on Charles II's return to England, Katherine was created Countess of Chesterfield for life. She returned to London to prepare for Princess Mary's arrival, although Mary died shortly afterwards and Katherine's long years of service to her ended. By October 1662 she had married again, to Daniel O'Neill, and died a very wealthy widow at the fine new house he had built for her in Belsize, north of London, in 1667. KH

Notes
1 Christie's, New York, 6 April 2006, lot 71.
2 Barnes et al. 2004, no.IV.73, p.488.
3 Short condition report by Sarah Walden, dated 16 May 2006, kindly supplied by Richard Green Galleries.
4 Cited in Barnes et al. 2004, p.488.
5 Walden 2006.
6 Ibid. The *Oxford English Dictionary* includes the following seventeenth-century usages of 'Gallantry': 'Loyalty, devotion', and 'amorous intercourse or intrigue'. 'Coglioneria' relates to the Italian word for 'testicle', and thus to 'stupid behaviour' by a male (information supplied by Peter Taylor).
7 Barnes et al. 2004, nos.IV.74 and IV.75, pp.488–9.
8 *ODNB* 2004, vol.52, pp.130–4, entry on Katherine Stanhope *suo jure* Countess of Chesterfield by Sarah Poynting.

67
Self-portrait c.1640–1
Oil on canvas
57.3 x 44.3
Private collection

This is thought to be van Dyck's last self-portrait, painted towards the end of his years in London.[1] While his shoulders face towards the right, the artist turns his head and, from a raised viewpoint, engages the gaze of the spectator. (In reality he will have been looking in a mirror.) His expression is serious, even sombre, and he is formally attired in a plain white collar and a black paned jacket.[2] The face is very subtly painted but the costume is more rapidly modelled. A number of alterations are discernible and it has been suggested that the painting may not be completely finished.

Early in 1640 van Dyck married for the first time. His teenage bride was Mary Ruthven (see no.70), the daughter of a Scottish nobleman, Patrick Ruthven (d.1652), fifth son of the Earl of Gowrie.[3] Later in 1640 van Dyck was in Flanders and in January 1641 he was 'newly arrived in Paris' with his wife. On his return to England he was reported to be suffering from ill health, which was affecting his ability to finish the second of two portraits of Princess Mary. His daughter Justina (or Justiniana) was to be baptised on 9 December 1641, shortly before van Dyck's death.

The present portrait may subsequently have been owned by Sir Peter Lely. Lely's posthumous sale included, among the works by van Dyck, 'His Own Picture in an Oval', measuring 22 x 18 in (equivalent to 55.9 x 45.7 cm); see no.111.[4]

The English-born painter William Dobson seems to have chosen to emulate van Dyck's painting for his own self-portrait (no.96) no more than five years later. By the late seventeenth century both Dobson's self-image and the present one by van Dyck were in the collection of the writer and art enthusiast Richard Graham (active 1695–1727), from whom they were acquired by a forebear of the present owner. Both paintings retain their remarkable seventeenth-century auricular carved and gilded matching frames. KH

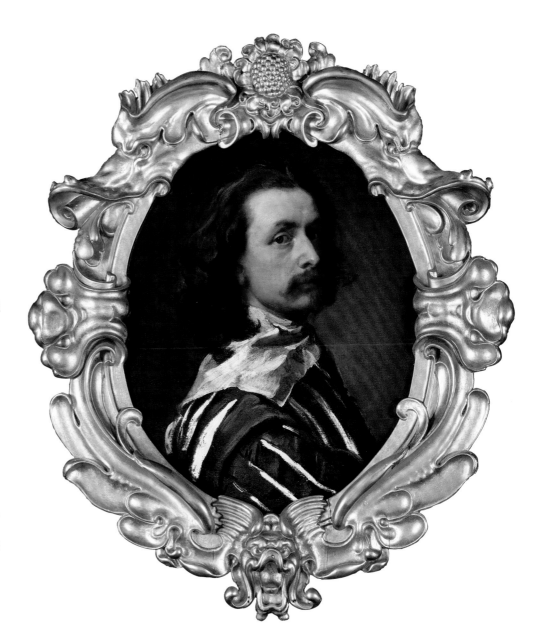

Notes
1 Barnes et al. 2004, no.IV.5, p.432.
2 Gordenker 2001, p.61.
3 Charles Mosley, ed., *Burke's Peerage, Baronetage & Knightage*, 107th edn, Wilmington 2003, vol.1, p.690.
4 Barnes et al. 2004, no.IV.5, p.432.

Self-portraits and Life

68
Wenceslaus Hollar (1607–1677) after
Anthony van Dyck
Margaret Lemon 1646
Etching
26.0 x 18.0
Lettered: 'MARGVERITE LEMON
ANGLOISE'. Two columns of French verse,
each five lines: 'Flore, Thisbe, Lucresse …
Louanges' and 'R.G. S.[r] D. L.'; below:
'Omnia vincit Amor & nos Cedamus Amori,
[] Virgil,'; below left: 'Anton: van Dyck
Eques pinxit', centre in engraved letters
'Henr. Vander Borcht excudit'; and at right:
'W: Hollar fecit, 1646.'
The British Museum, London

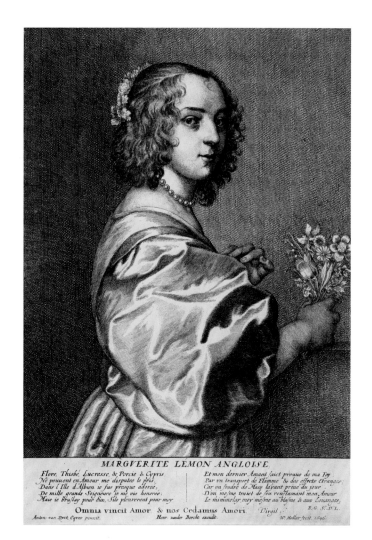

Many portrait paintings exist of unidentified men and women, and frequently there is a lack of secure evidence to confirm who a sitter is. Prints can sometimes help, and in this instance the legend beneath the design in the margin unequivocally names this Englishwoman as Margaret Lemon.

Margaret Lemon (born c.1614) has been called van Dyck's mistress and a high-class courtesan, and there are a number of paintings in which she appears as a model, or there is at least a startling resemblance. An anecdote about Lemon is even attributed to Hollar: she was supposedly a dangerous woman and a demon of jealousy who caused the most horrible scenes when London society ladies sat to her lover, without chaperone, for portraits. On one occasion she reputedly tried to damage van Dyck's hand by biting his thumb. The source of this colourful anecdote is obscure and may or may not be true, but is often repeated.

The print certainly plays on the alluring beauty of Margaret Lemon. In the margin of the print are two columns of French poetic verse by the unidentified 'R.G. S[r] D.L', saturated with love themes. There is also a Latin quotation from Virgil, 'Omnia vincit Amor, & nos Cedamus Amori' ('Love conquers all, let us too yield to love'), usually a cue for painters to include Cupid.

The related painting by van Dyck is in a private collection,[1] and it has been described as almost certainly cut from a larger canvas; it seems that Hollar's print preserves not only the name of the sitter, but the original format of the canvas: the most notable addition to the composition in Hollar's print is the bouquet of flowers held by the sitter, an allusion to Flora, the ancient goddess of flowers, whose name occurs at the start of the French verse. There is a remarkable wash drawing of the same sitter in Paris (Fondation Custodia, Institut Néerlandais, Collection Frits Lugt),[2]

which formerly belonged to Sir Peter Lely; this was no doubt an inspiration for his often titillating paintings of women at the court of Charles II.

Hollar's print was made in Antwerp in 1646, after van Dyck's death. It is revealing to compare the posthumous and obviously unsanctioned print with the engraving of van Dyck's wife Mary (née Ruthven), Lady van Dyck, after no.70, by Schelte Bolswert. This print, showing Mary handling a rosary to suggest her piety, her hair decorated with oak leaves, was published by Gillis Hendricx in his *Iconography* series,[3] and was singled out as exemplary by William Sanderson in his *Graphice*, 1658 (containing a copy engraved by Faithorne). Hollar never properly participated in the *Iconography* project (see no.73), and the portraits that he made after van Dyck in the format associated with this series, such as of those of the Earl and Countess of Arundel,[4] were produced in 1646 and issued by another publisher, Joannes Meyssens (1612–70). Hollar must have encountered van Dyck in London but was never directly employed by him, despite his credentials and ability. The simple reason for this is that Hollar was an etcher rather

than an engraver, and van Dyck wanted uniformly executed and robustly engraved plates that could yield many impressions by printmakers already known to him, who had been schooled by Rubens. ST

Literature
Pennington 1982, no.1456; New Hollstein, pt VI, no.468.

Notes
1 O. Millar in Barnes et al. 2004, no.IV.156.
2 Repr. in Gordenker 2001, fig.61.
3 Mauquoy-Hendrickx 1991, no.101; New Hollstein 86.
4 Pennington 1982, nos.1353–4.

69
Margaret Lemon as Erminia(?) late 1630s
Oil on canvas
109.2 x 129.5
The Duke of Marlborough, Blenheim Palace,
Oxfordshire

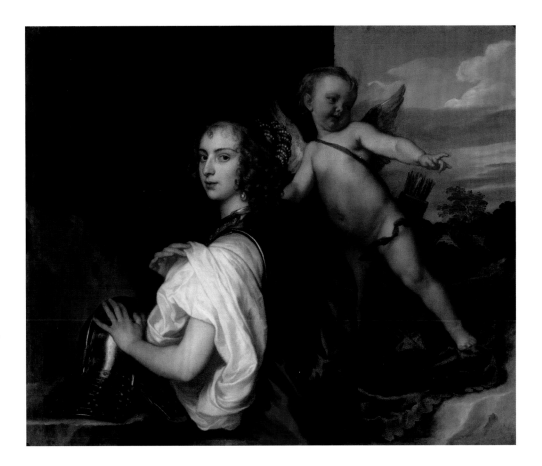

The young woman dressed in little more
than a white chemise and a metal breastplate
is thought to be van Dyck's mistress,
Margaret Lemon.[1] Her features and lively
turning pose, with one hand fingering her
sleeve, derive from earlier paintings by
van Dyck of Margaret Lemon.[2] The artist
probably first worked out the pose in a
drawing based on a female portrait by Palma
Vecchio (c.1480–1528), now in Vienna.[3]

This painting has been assumed to be
portrait in the guise of a mythological figure,
but the subject has been difficult to pin
down. It has been associated with a passage
by the seventeenth-century biographer
Bellori describing one of van Dyck's English
works as Pallas[4] and also as Venus in the
armour of Mars.[5] Sir Oliver Millar was the
first to suggest the most probable subject,
that the sitter is in the guise of Erminia.[6]

The story of Erminia derives from
Tasso's romantic epic poem *Jerusalem
Delivered* (1581). The daughter of a Saracen
king, Erminia loved the Christian knight
Tancred. Believing him to be wounded, she
went in search of him disguised in armour
belonging to the female warrior Clorinda. A
translation of the poem by Edward Fairfax
from 1660 describes Erminia as 'Stript to her
petticote' under 'rugged steele'. He refers
to her 'locks of shining gold' and her 'tender
arme' as well as to Cupid 'Fast by her side
unseene'. Although Fairfax's version post-
dates this portrait, van Dyck nevertheless
seems to have captured the spirit of the
English translation.

The supposition that Margaret Lemon
was van Dyck's mistress derives from a
note of c.1651–2 by Richard Symonds about
the artist.[7]

In this painting van Dyck successfully
marries the depiction of a history with
a portrait. The loosely painted rocky
background and shining armour locate the
sitter as an actor in the fictional realm of
poetry. The lush satin drapery with scalloped
edge is a fanciful touch that he employed in
other historiated and allegorical portraits.[8]
But the chemise was a real garment worn
under the clothes and normally only revealed
in the bedroom. Margaret Lemon's gesture,
which draws attention to the undergarment
and exposes the creamy skin of her upper
arm, seems entirely appropriate for an
attractive mistress. EG

Notes
1 For general information about the painting, see Barnes et
al. 2004, no.IV.158, p.553.
2 Barnes, et al. 2004, no.IV.156, pp.551–2.
3 The drawing is now in the Fondation Custodia, Institute
Néerlandais, Paris. On the link to Palma Vecchio, see
Jeremy Wood, 'Van Dyck's "Cabinet de Titien": The
contents and dispersal of his collection', *Burlington
Magazine*, vol.132, October 1990, p.693.
4 Bellori 1672, p. 261.
5 Gustav Glück, *Van Dyck, des Meisters Gemälde, Klassiker
der Kunst*, no.13, 2nd rev. edn, Stuttgart, New York and
London 1931, p.408; S.G. Tasch, *Studien zum weiblichen
Rollenporträt in England von Anthonis van Dyck bis Joshua
Reynolds*, Weimar 1999, pp.30–1.
6 Millar 1982, no.42, p.85.
7 British Library, Egerton MS 1636, fol.205. Quoted in
Barnes et al. 2004, no.IV.156, p.551.
8 Such as *Rachel de Ruvigny, Countess of Southampton as
Fortuna*, c.1640 (National Gallery of Victoria, Melbourne)
and *Portrait of Sir John Suckling*, 1638 (Frick Collection,
New York).

70

*Portrait of the Artist's Wife, Mary Ruthven,
Lady van Dyck* c.1640
Oil on canvas
104 x 81
Museo Nacional del Prado, Madrid

Van Dyck depicts his wife, Mary Ruthven,
in three-quarter length against a plain dark
background. She wears an oak sprig in her
hair and fingers a string of lapis lazuli and
gold rosary beads with a diamond cross
wrapped around her left wrist. Although
simple, the composition is enlivened by the
shimmer of Mary's blue silk dress, the turn
of her head and her expressive hand gesture.[1]

Mary Ruthven (c.1622–44) was the
daughter of a Scottish nobleman, Patrick
Ruthven, fifth son of the Earl of Gowrie. She
has been described as a Maid of Honour to
Queen Henrietta Maria and is said to have
been very beautiful.[2] Like van Dyck, Mary
was a Roman Catholic – the rosary beads
with jewelled cross in her hands refer to her
faith. The couple were married in February
1640; their only child, Justina (or Justiniana),
was born on 1 December 1641, just eight
days before van Dyck's death.

The painting is described at length by
William Sanderson (see no.71):[3] he refers
to her beauty, noting her 'inticeing *Italianed*
eyes, able to confound a Saint'; explains the
unusual headdress, 'A sap-green and golden
coloured *Oken-branch* tackt to her *head*. The
Emblems, *Strong* and *lasting*. So was she … to
endure forever'; and mentions the rosary as
'the Ensigne of *Religion*; for having done her
devotion, she wraps her Row of Beads about
her Arm, lifting up the pendant cross, as who
should say: *At the end of all. Look upon this
Sir, and you shall never sinne*'. An engraving by
William Faithorne of this portrait is inserted
in Sanderson's book, generally opposite
the description.

Significantly, Sanderson also describes
Mary's dress. He struggles to name the
garment – 'call it a *Petty-coate* and *Wast-coate*
or morning dresse' – but clearly associates
it with informal or morning attire. He notes
that the jewelled clasps holding the bodice
together are unusually large and beautiful
'(Such is the *Painters* Art to make it)', and is
intrigued by Mary's smock peeping out from
her bodice, a hint that she does not wear
stays, noting the absence of lace collar and
cuffs: '(with little paines, but much passion)
you come to the *smock*, which peeps out
beneath them [the jewels]; and at the *hand-
wrest* careless prufled of purest *Holland* …
which needs no *Flanders*-lace to come neer it.'
It is precisely this combination of informal
attire, fantastically large jewels and lack

of lace covering the wrists and décolletage
that distinguishes the dress in van Dyck's
English portraits, making him one of the
most innovative painters of costume in the
seventeenth century.[4]

In 1642 Lady van Dyck married a Welsh
gentleman, Sir Richard Pryse, Bt, but died
just two years later, by which time not only
van Dyck's collection of pictures but also his
personal estate in England had passed out of
her possession.[5]

It has been suggested that Mary is here
shown with child, as Van Dyck depicted
his Catholic sitters wearing pearls and
making a cradling gesture to refer to their
pregnancy.[6] This seems unlikely, because the
pearl earrings and necklace were common in
portraits and the occasion for the portrait
far more probably the couple's marriage.
Furthermore, the rare portraits depicting
women in pregnancy show the condition
much more obviously.[7] EG

Notes
1 For general information about the painting, see Barnes et
al. 2004, no.IV.7, pp.133–4.
2 Charles Mosley (ed.), *Burke's Peerage, Baronetage &
Knightage*, 107th edn, Wilmington 2003, vol.1, p.690.
3 William Sanderson, Graphice. *The use of the pen and pensil.
Or, The most excellent art of painting: in two parts*, London
1658, p.37.
4 Gordenker 2001, pp.57–8; Ribeiro 2005, p.140.
5 Christopher Brown and Nigel Ramsay, 'Van Dyck's
Collection: Some new Documents', *Burlington Magazine*,
vol.132, October 1990, pp.704–9.
6 Malcolm Rogers, 'Van Dyck's Portrait of Lord George
Stuart, Seigneur d'Aubigny, and Some Related Works', in
Barnes and Wheelock 1994, pp.275–6.
7 Karen Hearn, 'A fatal fertility? Elizabethan and Jacobean
pregnancy portraits', *Costume*, vol.34, 2000, pp.39–43.

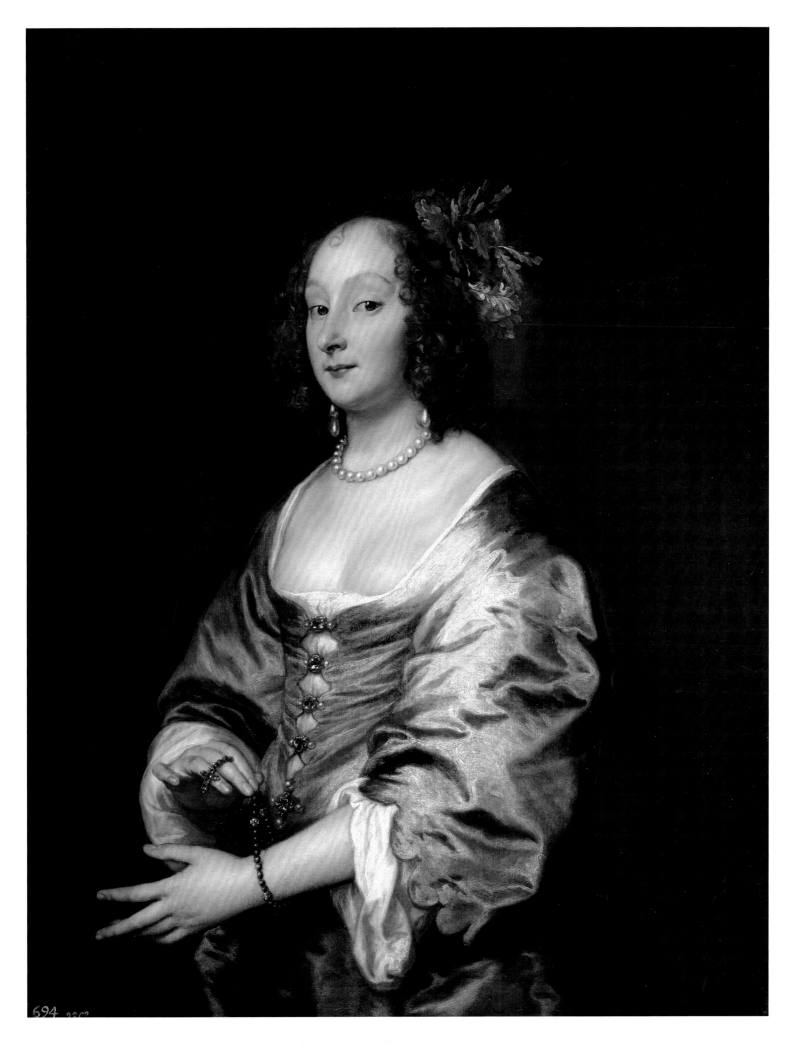

694

Self-portraits and Life

71
William Sanderson (1590–1676)
Graphice. The use of the pen and pensil. Or,
The most excellent art of painting: in two
parts London, 1658
Kingston Lacy, The Bankes Collection (The
National Trust)

William Sanderson was a Royalist Gentleman
of the Privy Chamber under Charles
II.[1] Born in Lincolnshire, he was the son
of a merchant; his friend James Howell
(c.1594–1666) later described him as having
been bred up at court and having been
abroad.[2] In 1626 Sanderson married Bridget
(1592/3–1681/2), daughter of Sir Edward
Tyrrell (1573–1656), baronet, of Thornton,
Buckinghamshire, who later served as
the ceremonial 'mother of the maids', or
Mother to the Queen's Maids of Honour, to
Catherine of Braganza. The couple remained
childless. Sanderson is primarily known as
a historian who published three historical
books that are polemical in character and
defend the Stuart monarchs.[3] He died in
London at the ripe age of ninety. The diarist
John Evelyn attended his funeral on 19 July
1676, and described him uncharitably as an
'author of two large but mean histories'.[4]

Graphice is Sanderson's final work.
Divided into two parts, the first is largely
devoted to theoretical considerations and the
second is intended as a manual for painters.
Curiously, its author never claimed to have
practised the art of painting himself, because
he was a gentleman, but he seems to have
dabbled as an amateur. He stated that he
derived much of the information for his book
from his own observations and experience,
but the text was largely plagiarised from
other sources.[5]

Sanderson's discussion of van Dyck
is one of the few sections that he did not
derive from previous publications. His
comments have a significant impact on our
understanding of van Dyck's innovations
in the depiction of costume. Significantly,
Sanderson noted: 'T is *Vandiks*. The first
Painter that e're put Ladies' dresse into a
careless Romance' (p.39). In introducing the
phrase 'careless Romance', he was the first
writer to link the use of fantastic dress
in portraiture with van Dyck. During his
second English period (1632–41), van Dyck
employed a type of costume in his portraits
that was partially based on actual costume,
but that incorporated fantastic elements.
Until this time Northern European portrait
painters showed formal clothing in detail or
fantastic dress that was part of a broader
programme of narrative or allegory. Van
Dyck changed this by presenting his sitters

in informal attire, eliminating fashionable
accessories, adding fantastic details, and
featuring plain satin fabrics set down
in broad brushstrokes. In doing so, he
established new conventions for dress in
portraiture that were influential well into the
eighteenth century.[6] EG

Notes
1 *ODNB* 2004, vol.38, pp.887–8, entry on William
Sanderson by D.R. Woolf.
2 Address to author in *A compleat history of the life and
raigne of King Charles, from his cradle to his grave*, London
1658; *Graphice*, London, 1656.
3 *Aulicus coquinariae: or, A vindication in answver to a pamphlet,
entitled The court and character of King James, 1650*, London
1651; *A compleat history of the lives and reigns of, Mary Queen
of Scotland, and of her son and successor, James the Sixth, King
of Scotland, and (after Queen Elizabeth) King of Great Britain,
France, and Ireland, the First … reconciling several opinions in
testimony of her, and confuting others, in vindication of him,
against two scandalous authors, 1. The court and character of
King James, 2. The history of Great Britain …* , London 1656;
*A compleat history of the life and raigne of King Charles, from his
cradle to his grave*, London, 1658.
4 John Evelyn, *The Diary of John Evelyn*, ed. E.S. De Beer,
Oxford 1955, vol.IV, p. 94.
5 Kirby Talley 1981, pp.228–44.
6 Gordenker 2001.

72
Robert van Voerst (1597–1636) after
Anthony van Dyck
Inigo Jones c.1636
Engraving
24.3 x 17.6
Lettered: 'CELEBERRIMVS VIR INIGO
IONES PRÆFECTVS ARCHITECTVRÆ
/ MAGNÆ BRITTANIÆ [] REGIS ETC.';
below left: 'Ant. van Dijck pinxit'; and at
right: 'Mart. vanden Enden excudit Cum
priuilegio'
The British Museum, London

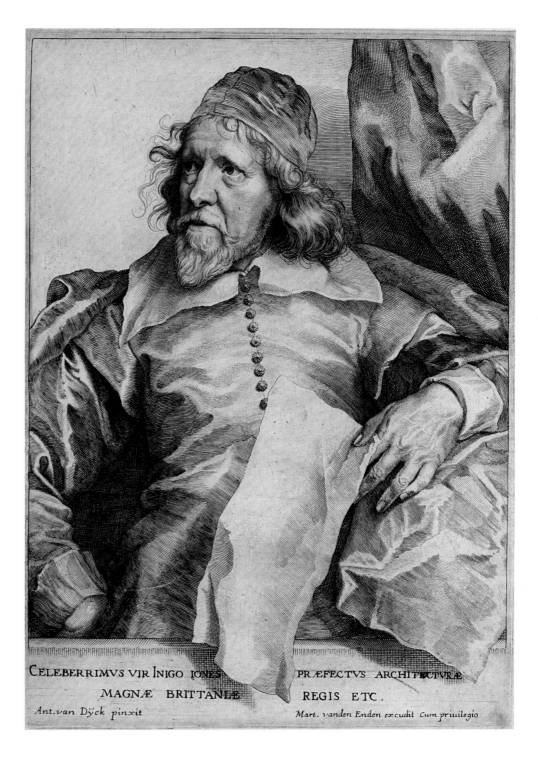

Inigo Jones (1573–1652) was an architect
and theatrical stage designer and a hugely
influential artistic figure. Early in his
career he was in the service of James I's
queen, Anne of Denmark, producing
courtly entertainments, masques and plays,
frequently in collaboration with Ben Jonson.
Jones was briefly surveyor to Henry, Prince
of Wales, whose premature death meant
that Prince Charles would succeed to the
throne. He then travelled to Italy in the
entourage of the Earl of Arundel, ostensibly
escorting Princess Elizabeth, the daughter
of James I, to Heidelberg to meet her
husband Frederick of Bohemia, the ill-fated
Elector Palatine. The party subsequently
made a detour in order to study art and
architecture, including acquiring some work
by Parmigianino (1503–40) and absorbing
the work of Andrea Palladio (1508–80),
which was to inform Jones's own work and
helped place him at the vanguard of taste.
On his return, Jones was appointed Surveyor
of the King's Works in 1615 (until 1643),
taking responsibility for such royal buildings
as the Queen's House in Greenwich and the
Banqueting House in Whitehall, for which
Rubens painted the ceiling decorations (see
no.13). He was also responsible for designing
the Italian Piazza in Covent Garden, and
from 1631 he supervised the restoration of
St Paul's Cathedral, including a new west
façade: a classical portico with columns
surmounted by statues of James I and
Charles I (destroyed by the Great Fire in
1666).

The black chalk drawing by van Dyck
for this print, which was followed closely by
van Voerst, is in the Devonshire Collection
at Chatsworth.[1] A former proud owner
of the drawing, Richard Boyle, 3rd Earl
of Burlington (1694–1753), arbiter of
the eighteenth-century Palladian revival,
inscribed the mount 'Vandyke's original
drawing, from which the Print by van
Voerst was taken, in the Book of Vandyke's
Heads'. The famous animated image of
Jones, multiplied in impressions of the

print, has served as the standard model for
other likenesses, including that of Hollar,
who etched the portrait as a frontispiece
to a volume based on Jones's writings
on Stonehenge by his pupil John Webb
(published in 1655), and in the following
century the busts by Michael Rysbrack
(1694–1770) and the painting by William
Hogarth (1697–1764) (1757–8; National
Maritime Museum, London).

For information on van Dyck's series of
prints of his contemporaries, the *Iconography*,
from which this engraving comes, see
no.73. ST

Literature
Hind 1964, pp. 206–7, no.14; Mauquoy-Hendrickx 1991,
no.72; New Hollstein, pt II, no.70.

Note
1 Inv.1002A; Vey 1962, no.271; M. Jaffé, *The Devonshire
collection of northern European drawings*, London and Turin
2002, no.955.

Self-portraits and Life

73
Robert van Voerst (1597–1636) after
Anthony van Dyck
Robert van Voerst c.1636
Engraving
23.8 x 16.9
Lettered: 'ROBERTVS VAN VOERST';
below left: 'Ant. van Dijck pinxit'; and at
right: 'Mart. Vanden Enden excudit cum
priuilegio'
The British Museum, London

This is a curious self-portrait, after van
Dyck but engraved by the printmaker sitter
himself and included in the famous series
of prints best known as the *Iconography*.[1]
This series of prints – popularly known by
this name from the French title (*Iconographie
ou vies des homes illustres*) of the last edition,
published in 1759 – was engraved in the
1630s by a group of highly skilled engravers
based in Antwerp, apart from Voerst who
worked in London. The series comprised
eighty uniform prints after portraits by
van Dyck and published by Martinus van
den Enden (1605–74) in Antwerp and
subsequently enlarged to a hundred by
Gillis Hendricx (d. before 1677) in 1645.
Hendricx used van Dyck's own etched self-
portrait[2] as a title-page and all the prints
are lettered with his initials, '*G.H.*'. Of the
three main categories of sitters (headed by
Principum and then *Virorum Doctorum*) the
largest group were portraits of artists and
art lovers, mostly Flemish contemporaries,
such as van Dyck's teacher Hendrik van
Balen[3] and of course Peter Paul Rubens,
the Antwerp Apelles.[4] Others relate to
van Dyck's years in England and include
Orazio Gentileschi (1563–1639)[5] and
Daniel Mytens.[6] The principal printmakers
involved in the project were honoured with
inclusion, namely Paulus Pontius and Lucas
Vorsterman, whose portraits were actually
etched by van Dyck himself.[7] Pontius also
engraved his own likeness,[8] as did Pieter
de Jode the Younger.[9] It is significant that
a portrait of the contemporary French
printmaker Jacques Callot (1592–1635)[10] was
included, an acknowledgement of van Dyck's
wide interest in prints and printmaking.
Nevertheless, his ultimate concern was in
the reproduction and multiplication of his
own work, spreading his art and fame far and
wide and to posterity.

The *Iconography* was van Dyck's most
sustained engagement with printmaking
and was an ambitious collaborative project;
it is one of the marvels in the history
of printmaking. His intentions, and the
practical preparations, the precise make-
up of the series, its omissions, inclusions
and arrangement, are fascinating. He was
involved in the project to an unprecedented
extent, ensuring the excellence of the prints
by providing the printmakers with copious
preparatory material from which to work
and sometimes correcting proofs, a practice
established by Rubens. In addition to the
original portrait, which might not always
be available, van Dyck produced drawings
as exact guides and also small tonal grisaille
oil sketches, emphasising the highlights
and dark areas. A group of these sketches
survive together in the collection of the
Duke of Buccleuch at Boughton House,
Northamptonshire.[11] The surviving drawings
are in diverse collections;[12] his vivid drawing
of Voerst for the present print is in the
Cabinet des Dessins, département des Arts
graphiques, Musée du Louvre, Paris.[13]

Robert van Voerst was a Dutch engraver
who learnt to engrave under Crispijn de
Passe (1565–1637) in Utrecht. Two of his
sons, Simon and Willem, were also trained
as engravers and came to work in London
(Willem engraved a magnificent equestrian
portrait of the Duke of Buckingham in
1625[14]). Robert arrived in London in 1627,
and his first dated print is of Robert Bertie,
1st Earl of Lindsey (1572–1642), after a
portrait by George Geldorp.[15] This is a fine
print but poles apart from the revolutionary
lively and wonderfully posed van Dyckian
Iconography prints. As can be deduced from
his prints, Voerst was successively closely
associated with Geldorp, Mytens and
van Dyck. His talents were also noticed
by Charles I, who commissioned from
him engravings of his sister Elizabeth,
the 'Winter Queen' of Bohemia, after a
portrait by Gerrit van Honthorst, and
also of Emperor Otho after Titian from a
painting in Charles I's collection. In 1634
Voerst engraved van Dyck's double portrait
of Charles I and Henrietta Maria,[16] a
magnificent print, and in 1635 he was given a
royal appointment as Engraver in Copper to
His Majesty.[17]

Voerst produced four plates for the
earliest edition of the *Iconography* as
published by van den Enden. These portray
the Englishmen Sir Kenelm Digby (no.74)
and Inigo Jones (no.72), the French painter
Simon Vouet (1590–1649)[18] and himself. It is
plausible that van Dyck intended that Voerst
engrave further portraits, those of Charles
I and Henrietta Maria, which are notably
absent from the *Iconography* series proper.
Voerst's output of very fine prints ended
abruptly in 1636 with his death, apparently
during an outbreak of the plague. A
comparable contemporary print of Henrietta
Maria by the native engraver George Glover
(active 1634–52)[19] dated 1640, although
exceptional in terms of ambition in Glover's
oeuvre and somewhat in the manner of
the engravings by Willem Jacobsz. Delff
(1580–1638) after Michiel van Mierevelt
(1567–1641), is of much poorer quality than
Voerst's work. ST

Literature
Hind 1964, p.210, no.24; Mauquoy-Hendrickx 1991, no.73;
New Hollstein, pt II, no.97.

Notes
1 See Ger Luijten, 'The Iconography: Van Dyck's portraits
in print', in Depauw and Luijten 1999, pp.73–91.
2 Mauquoy-Hendrickx 1991, no.4; Depauw and Luijten
1999, no.5; New Hollstein 1.
3 Mauquoy-Hendrickx 1991, no.42; New Hollstein 48.
4 Mauquoy-Hendrickx 1991, no.62; New Hollstein 85.
5 Mauquoy-Hendrickx 1991, no.83; New Hollstein 65.
6 Mauquoy-Hendrickx 1991, no.56; New Hollstein 77.
7 Mauquoy-Hendrickx 1991, nos.9 and 14; New Hollstein
8 and 12.
8 Mauquoy-Hendrickx 1991, no.59; New Hollstein 82.
9 Mauquoy-Hendrickx 1991, no.104; New Hollstein 69.
10 Mauquoy-Hendrickx 1991, no.76; New Hollstein 53.
11 See H. Vey in Barnes et al. 2004, nos.III.145–67.
12 See Vey 1962, pp.40–5, and nos.242–81; J. Spicer,
'Unrecognized Studies for van Dyck's Iconography in the
Hermitage', *Master Drawings*, 7, 1985–6, pp.537–44.
13 Inv.19908; Vey 1962, no.272; Torres 2008, no.24, repr.
14 Griffiths 1998, no.25.
15 Ibid., no.37.
16 Ibid., no.42.
17 See A. Griffiths, 'The Print in Stuart Britain'
Revisited', *Print Quarterly*, vol.17, no.2, 2000, p.115.
18 Mauquoy-Hendrickx 1991, no.74; New Hollstein 100.
19 Griffiths 1998, no.59.

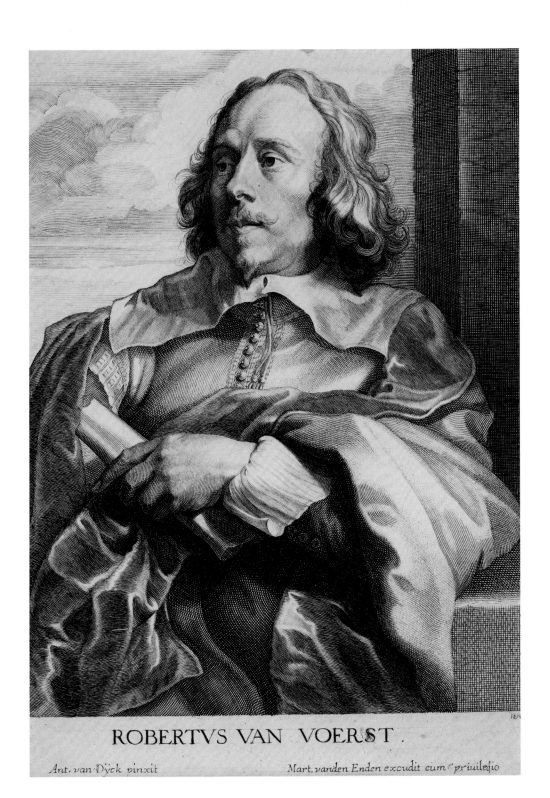

ROBERTVS VAN VOERST .

Ant. van Dÿck pinxit Mart. vanden Enden excudit cum priuilegio

74
Robert van Voerst (1597–1636) after
Anthony van Dyck
Sir Kenelm Digby c.1636
Engraving
26.4 x 19.4
Lettered below right in the design:
'IMPAVIDVM / FERIENT'; in the margin
'D. KENELMVS DIGBI EQVES'; below left:
'R.V. Vorst sculp'; and centre: 'Ant. van Dyck
pinxit'; at right the address: 'Mart. vanden
Enden excudit Cum priuilegio'
(P,3.218; mounted with R,1a.95, in a
different state with additional lettering: 'ET
ASTROLOGVS CAROLI REGIS MAGNÆ
BRITANIÆ.')
The British Museum, London

The life and character of Sir Kenelm Digby
(1603–65) are not easily summarised. He
was a natural philosopher, friend of Thomas
Hobbes and René Descartes (1596–1650),
author of *Two Treatises* (Paris 1644),
comprising 'On bodies' and 'On the soul',
and a courtier. He was also an alchemist,
diplomat, patron of the arts, book collector
and even a privateer. He wrote an early
private memoir about his relationship with
Venetia Stanley (no.36), whom he later
married, *Loose Fantasies*, and later *In Praise
of Venetia.*

Digby was a close friend of van
Dyck and commissioned a variety of
paintings from him. It was he who in about
1645 provided Gian Pietro Bellori with
information concerning van Dyck's life and
career in London for Bellori's famous *Le vite
de' pittori, scultori et architetti moderni* (Rome
1672; no.75). Van Dyck's first painting
was a group portrait of Digby and his
family,[1] featuring an armillary sphere, an
astronomical instrument, primarily a model
of the universe demonstrating the relative
positions and movements of the planets.
The armillary sphere featured in the present
engraving, however, is smashed, an explicit
allusion to his desolation at the sudden death
of his wife, Venetia, at the age of thirty-
three. On this tragic occasion van Dyck
was called to paint her in a remarkable and
intensely personal portrait as she was found
lying lifeless in bed (Dulwich Picture Gallery,
London).[2] He subsequently portrayed the
mourning and bearded Digby, described
by Bellori as in 'the dress of a philosopher
with the device of a broken sphere', like the
present engraving; the best-known surviving
painting of Digby, however, like van Dyck's
own self-portrait, features a sunflower.[3]

To commemorate his wife's virtues
Digby further commissioned an allegorical
portrait of her with a dove and snake,
among other things (c.1633; Palazzo Reale,
Milan),[4] of which there is also a reduced
version (no.36). There is a further portrait
of Digby in armour by van Dyck (c.1640;
National Portrait Gallery, London),[5] recalling
martial poses used for Charles I. Another
important artist patronised by Digby was
the miniaturist Peter Oliver (1589–1647),
the son of Isaac Oliver, and a specialist in
'subject limnings'.

After losing his wife, Digby retreated
into seclusion to pursue his intellectual
interests, particularly chemistry, at Gresham
College in London's Bishopsgate; he was
later a founding Fellow of the Royal Society
and published *A Discourse Concerning the
vegetation of plants* (1661). He reconverted to
Catholicism in 1635, becoming in the eyes of
many a 'Popish recusant'.

The present print is also significant
owing to its mention in a surviving letter,
dated 14 August 1636, from van Dyck to
Franciscus Junius, Arundel's librarian.
The letter is ostensibly to thank Junius
for the copy of his treatise on art *De Pictura
Veterum* (1637), a compilation of references
to painting in classical literature; but
van Dyck also took the opportunity
to ask Junius to provide an appropriate
caption for this print. Given the lack of
dates on the prints, this is a vital piece
of evidence – although there seems to be
a discrepancy in the year. The letter in
Flemish, now preserved in the Harleian
collection in the Department of Manuscripts
of the British Library, reads: 'It occurred to
me to ask you to be so kind, as I have had a
portrait of Sir Kenelm Digby cut in a plate
which I should now like to see published,
to write a small inscription to print
beneath it'.[6] It seems that Junius suggested
'impavidum ferient', taken from Horace,
Odes, 3.3, praising fortitude in adversity:
'Si fractus illabatur orbis Impavidum ferient
ruinae' ('Should the firmament come
crashing down, the ruins will find one who
will ever be undaunted'). ST

Literature
Hind 1964, pp.204–5, no.8; Mauquoy-Hendrickx 1991,
no.71; New Hollstein, pt I, no.35.

Notes
1 O. Millar in Barnes et al. 2004, no.IV.94, private
collection.
2 Ibid., no.IV.97; see Sumner 1995.
3 O. Millar in Barnes et al. 2004, no.IV.95 (private
collection).
4 Ibid., no.IV.98.
5 Ibid., no.IV.96.
6 MSS Harley 4935, folios 44–45v. See Hookham
Carpenter 1844, pp. 55–6, and Torres 2008, fig.1.

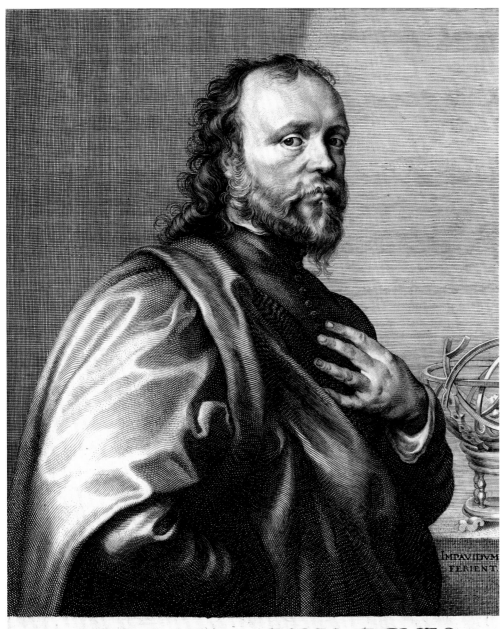

D. KENELMVS DIGBI EQVES

R.V. Vorst sculp. Ant. van Dyck pinxit Mart. vanden Enden excudit Cum priuilegio

Self-portraits and Life

75
Gian Pietro Bellori (1613–1696)
Le Vite de' Pittori, scultori et architetti moderni 1672
First edition, Rome 1672, pp.253–64
The British Library, London

Bellori's *Vite* contain the earliest extended account of van Dyck's life and works, recording in considerable detail his activity from his birth in Antwerp in 1599 until his death in London in 1641.[1] Bellori has proved to be – in those details which can be confirmed by contemporary documents – remarkably accurate and is especially well informed about his years in England. He describes with great accuracy paintings made for Sir Kenelm Digby, and reveals Digby to be his source: 'While this gentleman was living in Rome during the pontificate of Urban VIII, as resident of the queen of England, he acquainted me with van Dyck's career after he went to the court in London.' When van Dyck, a fervent Catholic, moved to London in 1632 he was drawn towards the Catholic circle around Queen Henrietta Maria, of which Digby was a prominent member. The two men had a close friendship: indeed, according to Bellori, 'Van Dyck, with whom he [Digby] had a mutual sympathy of mind and spirit [*una vicendevole collegatione di genio e di benevolenza*], entrusted his every turn of fate to him'. As he told Bellori, Digby commissioned a number of paintings from van Dyck which, for Digby, had a powerful personal significance. There were a number of portraits of Digby 'in many guises, in armour, and in the dress of a philosopher with the device of a broken [armillary] sphere and the motto from Horace: Si Fractus Illabatur Orbis Intrepidum Ferient Ruinae [If the heavenly vault should crack and crumble, the ruins will fall on a fearless head] '. There was also a portrait of Lady Digby (no.36), the complex iconography of which had been devised by her husband in a deliberate attempt to enhance her posthumous reputation. Finally, Digby commissioned a number of religious paintings from van Dyck – *The Descent from the Cross, St John the Baptist, The Magdalene* and *The Crucifixion* – which do not survive, but Bellori's account is a very important corrective to the idea that van Dyck spent all his time in England painting portraits of the Royal Family and the aristocracy.

Digby, a Catholic for most of his life, went into exile in Paris at the outbreak of the Civil War. The queen was already in exile in France, and he acted as her treasurer; he was in Rome in 1645 and again in 1647, raising money for the Royalist cause. It must have been on one of these visits that he met Bellori and provided him with the information for his life of van Dyck. Bellori, a painter and theorist as well as a historian of art, did not publish the *Vite* until almost thirty years later. A surprising aspect of his life of van Dyck, especially in view of his reliance on Digby, is that he does not mention van Dyck's first visit to England in 1620/1: Digby presumably did not meet him on that occasion and, although it proved an important moment in the artist's career, he was in London for only four months before returning to Antwerp. CB

Note
1 See Brown 1991, pp.17–23, for an annotated English translation of Bellori's *Life* of van Dyck.

76
Van Dyck's Last Will and Testament 1641
The National Archives, Kew

We know of two wills made by van Dyck.[1] The first was drawn up in Antwerp on 6 March 1628, shortly after the artist's return from a six-year stay in Italy. One of his sisters, Cornelia, had died in November of the previous year and this may have prompted him to make his will. He chose, like Cornelia, to be buried in the church of the Begijnhof in Antwerp, made a number of small bequests to a family servant and the poor of two local parishes and, being unmarried, left the rest of his goods to his sisters, Susanna and Isabella. All three sisters were Beguines.

The will shown here was drawn up in very different circumstances. It is dated 4 December 1641, five days before the artist's death in London. He had been ill for months; his failing health is mentioned in a letter dated 13 August of that year. Nevertheless, he was in Paris in November in the hope of receiving a major commission from Cardinal Richelieu (1585–1642) for the decoration of the Louvre. He and his wife, Mary Ruthven (no.70), whom he had married early in 1640 – were back in London by mid-November. On 1 December Lady van Dyck gave birth to Justina, their only child, and van Dyck's only legitimate child. In his will, written three days later, van Dyck describes himself as 'borne in Antwerp in Brabandt, weake of body yet injoyinge my senses memorie'. He asks that his body be buried 'in the Cathdrall Church of St Paul in London'. His property in Antwerp was for the most part left to his sister Susanna for the benefit of his illegitimate daughter, Maria Theresia van Dyck. A small annuity was also to be paid to his other Beguine sister, Isabella. If both Susanna and his daughter in Antwerp were to die, the property in the town was to pass to his 'lawfull daughter borne here in London on the first day of December Anno Dni One Thousand six hundred fortie and one Stilo Angliae'. All his other property, comprising 'moneys debts pictures & goods bonds bills & writings whatsoever left behind me in the kingdom of England with all such debts as are owinge & due unto mee by the kings Matie of England or any of the Nobility or by any other person or persons whatsoever the same shall all with that which shall be recovered thereof be equally divided between my wife Lady Maria Vandyke and my Daughter new borne in London aforesaid in just and equal portions'.

This will, evidently drawn up in a hurry on van Dyck's deathbed, does not include a list of the artist's possessions. There are, however, two lists of his collection of paintings, compiled in the subsequent legal tussle over his estate. They contain many works by Titian, confirming the comment of Pierre de la Serre who had seen the artist's celebrated 'cabinet de Titien' in Antwerp in 1631. Among those works were *The Vendramin Family* (fig.40, p.134) and *Perseus and Andromeda* (Wallace Collection, London), both of which were in the collection of the Earl of Northumberland within a few years of van Dyck's death. CB

Note
1 Hookham Carpenter 1844, pp.75–7; J. Matthews and G.F. Matthews (eds.), *Abstract of Probate Acts in the Prerogative Court of Canterbury*, London 1905, p.148.

Self-portraits and Life

Van Dyck's London Studio

Fig.41
Unknown (Studio of van Dyck?)
Three Dogs
Oil on canvas
77 x 109.5
Private collection, Boston

Fig.42
Anthony van Dyck
Portrait of Everhard Jabach c.1636–7
Oil on canvas
113 x 91.5
The State Hermitage Museum, St Petersburg

After his return to London in 1632, van Dyck initially lodged with the herald and painter Edward Norgate. Charles I subsequently provided him with a house and garden on the waterside at Blackfriars. This was where he had his studio. It was easily reached by boat from Whitehall, and in 1635 a new causeway and stairs were built by the royal Office of Works to enable Charles I to alight there 'to goe to Sʳ Anthony Vandikes howse there to see his Paintings ...'.[1] Indeed, late in 1635 or early in 1636, it was reported that Charles I 'sate jesterday at Vandykes' for his portrait at his house 'closse by blake Friers'.[2] Little is known about this property, except that it had a garden and that it was subsequently destroyed in the Great Fire of 1666, but it would have meant that the artist was neighbour to a number of other painters, including Cornelius Johnson, and the miniaturists Peter Oliver and David des Granges. Blackfriars was outside the jurisdiction of the guild – the London Painter-Stainer's Company. The area was thus popular with overseas-born craftspeople who were excluded from joining the London guilds, which attempted to exercise strict control over production in the City of London. Van Dyck was also given rooms at the palace at Eltham in Kent.

When van Dyck arrived in London, his royal appointment to Charles I presented him with a new challenge: the requirement to produce numerous images and versions of images, of the king and queen and, in due course, their children.[3] The number of paintings that he produced during his years in London show that he worked extremely hard,[4] supported by a team of studio assistants. As official painter to Charles I, and the most fashionable painter in London, he seems to have run a disciplined and productive workshop. Although it is not known exactly how this operated, it is likely to have been organised along the lines of the studios in Flanders where he had been trained.[5] It was not generally van Dyck's practice to sign his English paintings.

The banker and collector Everhard Jabach (1618–95; fig.42) described the experience of being painted by van Dyck in London.[6] Sittings would last for an hour; a servant would then clean the artist's brush and bring him another palette while he welcomed the next sitter, enabling him to keep a number of works in production simultaneously. He would paint the sitter's head directly from life, arranging the sitter in a pose 'that he had thought out beforehand' – having presumably discussed this with the client. He would make a compositional drawing of the figure and clothing from life in chalks on coloured paper; he gave this to his assistants, who would enlarge and paint it in on the canvas. Van Dyck, Jabach stated, would then 'pass his brush lightly and quickly over what they had done'.

Another sitter, the English painter Richard Gibson (1615–90), recalled how 'Vandyke would take a littel piece of blue paper upon a board before him & look upon the Life & draw his figures & postures all in Suden lines, as angles with black Chalk, & heighten with white chalk'.[7] A number of these rapid sketches survive.

So van Dyck worked closely with his assistants, including those who specialised in drapery. Jabach referred to them as 'the skilful people he has with him'. It is surprisingly difficult to establish who, and how many of them, there were. Documentary references to people in van Dyck's London household seldom distinguish between those who were painter assistants and those who were household servants. In his first weeks in London, when he was lodging with Norgate, van Dyck had his own 'servants' whom he may have brought with him. In 1635 he was recorded as having six 'servants', and at the end of his life, on his visit to Paris with his new wife, he took five, with another four for his coach.[8]

Van Dyck's portraits often survive in a number of versions, variants and

Van Dyck's London Studio

Fig.43
Remigius van Leemput
Anne Kingsmill, Lady Forster (signed lower right, '... 1648 remi[...]')
Oil on canvas
105.4 x 82.6
Private collection

copies. The specific means by which these copies were made is not known, although it has been suggested that in some cases it may have been through the use of tracings.[9] Many of these versions and copies must have been executed by the artist's assistants under his supervision, as was common practice in Netherlandish art production.[10] Copies of portraits by van Dyck were also made by other artists, some no doubt commissioned by the owner of the first portrait, but others copied subsequently, by later painters. Thus numerous copies and derivations of van Dyck's portraits of British sitters survive, in both public and private collections, which has long proved confusing to viewers and visitors.

In his later years in London van Dyck sometimes repeated patterns for the figures in his portraits, and even their backgrounds (see no.105).[11] He made drawings of plants and landscapes for use in his portrait compositions (see nos. 86, 87 and 88), as well as other landscape drawings for his own interest (see no.89).

Malcolm Rogers suggests that a high-quality seventeenth-century painting of three dogs (fig.41) may have come from van Dyck's studio. In it, the mastiff, left, and spaniel, front right, relate closely to the two dogs in van Dyck's portrait of the *Five Eldest Children of Charles I* (fig.23, p.66).

Various established painters seem likely to have worked for van Dyck.[12] There were a number of fully trained Flemish artists in London, including Remy (or Remee or Remigius) van Leemput (1607–75), who was born and trained in Antwerp, and became well known in London as a copyist, collector and dealer (fig.43).[13] There are documented links between van Dyck and George Geldorp (died 1665), who had arrived from Antwerp back in 1623; Geldorp was later associated with Sir Peter Lely.[14] Adrian Hanneman (c.1601–71), born and trained at The Hague, was active in London from 1626 to about 1637. Certainly, he was greatly influenced by van Dyck, and following his return to The Hague his van Dyckian compositions and style were to make him popular both with the members of the ruling House of Orange and, during the Civil War and Commonwealth periods, with royalists in exile there.[15] Jan van Belcamp (c.1610–53), who was in London by 1624–5, was also known as a copyist; documented examples of his work survive in the Royal Collection. Shortly after Belcamp's death, the Royalist art enthusiast Richard Symonds (d.1660) described him as a 'paynter good at copying ... This Belcamp was an under copyer to another Dutchman that did fondly Keepe the Kings pictures & when any Nobleman desird a coppy, he dircted him to Belcamp'.[16] Theodore Roussel or Russell (1614–89) was said by his son to have trained in London under his uncle Cornelius Johnson and then spent a year with van Dyck, as well as copying van Dyck's 'pictures on small pannells'.[17] Another English portraitist, Edward Bower (d.1666/7), had set up his own studio, at Temple Bar on the border between the Cities of London and Westminster by 1637; nevertheless, a letter of 1646 is thought to refer to him as 'the workman who was servant' to van Dyck.[18] Because his portraits are so heavily influenced by the Flemish painter, Robert Walker has sometimes been assumed to have worked with van Dyck, although there is no firm evidence for this.[19]

Early in 1639, two members of van Dyck's household were buried at St Anne's, Blackfriars: 'Iasper Lanfranck a Duchman from S[r]. Anthony Vandikes' and 'Martin Ashent S[r]. Anthony Vandikes man'.[20] In 1649, Theodore or Dierick Hess(e), who was described as a 'Limbner' (that is, a painter) deposed that he had been 'A servant unto the said Sir Anthony Vandike in his life tyme'.[21]

As described earlier, one strategy that van Dyck employed to speed up the studio's rate of production – especially after his return to England from Flanders

in 1635 – was to depict his sitters in simplified forms of dress. In reality, early seventeenth-century formal costume consisted of numerous elements and could be extremely elaborate, but van Dyck chose to blur the boundaries between fact and fantasy, especially in women's portraits, by eliminating their fashionable lace collars and cuffs (so time-consuming to paint), by presenting them in informal attire, and even by adding fantasy elements (see nos.50 and 55).[22]

Notes

1 Barnes et al. 2004, p.9l.

2 Ibid., p.10.

3 Oliver Millar, 'The Years in London: Problems and Reassessments', in Vlieghe 2001, pp.129–38.

4 Gregory Martin, referring to his 'phenomenal rate of work', has calculated that while he was in England van Dyck was completing approximately one work every seven or eight days; see his review of Barnes et al. 2004 in *Burlington Magazine*, vol.147, February 2005, pp.118–20.

5 For suggestions as to how Rubens's workshop functioned, see Arnout Balis, '"Fatto da un mio discepolo": Rubens's Studio Practices Reviewed', in *Rubens and his Workshop: The Flight of Lot and his Family from Sodom*, ed. Toshiharu Nakamura, National Museum of Western Art, Tokyo, 1993, pp.97–127, and Arnout Balis, 'Rubens and his Studio: Defining the problem', in *Rubens: A Genius at Work*, Royal Museums of Fine Arts of Belgium, Brussels 2007, pp.30–51.

6 Roger de Piles, *Cours de Peinture par Principes*, Paris 1708,

pp.291–3 (English trans. in Brown 1991, p.35).

7 Barnes et al. 2004, p.7.

8 See Edmond 1978–80, p.203 n.296; Barnes et al. 2004, pp.8–9, 12.

9 Linda Bauer, 'Van Dyck, replicas and tracing', in *Burlington Magazine*, vol.149, February 2007, pp.99–101.

10 In Antwerp, for instance, there were workshops specialising in copying, although frequently the studio that originated the prime version would also produce copies of it, to be sold at a lower price; see Balis 1993 (see note 5), p.105.

11 O. Millar, 'The Years in London: Problems and reassessments', in Vlieghe 2001.

12 *ODNB* 2004, vol.17, pp.466–74, entry on van Dyck by Jeremy Wood.

13 *ODNB* 2004, vol.33, pp.140–1, entry on van Leemput by L.H. Cust, rev. by Ann Sumner.

14 *ODNB* 2004, vol.21, p.727, entry on Geldorp by L.H. Cust, rev. by P.G. Matthews. In January 1633 he and van Dyck were paid for pictures and frames for the 10th Earl of

Northumberland. See also Wood 1994, p.309.

15 *ODNB* 2004, vol.25, pp.78–9, entry on Hanneman.

16 Millar 1963, vol.I, pp.111–12. Mary Beal, *A Study of Richard Symonds*, New York and London 1984, p.309.

17 *ODNB* 2004, vol.48, pp.340–1, entry on Theodore Russell by L.H. Cust, rev. by Ann Sumner.

18 *ODNB* 2004, vol.6, p.917, entry on Edward Bower by Arianne Burnette.

19 *ODNB* 2004, vol.56, entry on Robert Walker by Ann Sumner, p.885.

20 Edmond 1978–80, p.125.

21 See Christopher Brown and Nigel Ramsay, 'Van Dyck's collection: some new documents', *Burlington Magazine*, vol.132, 1990, pp.704–9.

22 Emilie Gordenker, 'Aspects of Costume in van Dyck's English Portraits', in Vlieghe 2001, pp.211–26. See also Ribeiro 2005, pp.138–40.

77
*Charles I and the Knights of the Garter in
Procession* c.1639–40
Oil on panel
29.2 x 131.8
Ashmolean Museum, Oxford. Accepted by
H.M. Government in lieu of Inheritance Tax
from the estate of the 10th Duke of Rutland
and allocated to the Ashmolean Museum,
2002

This is van Dyck's largest and most
important oil sketch.[1] It is painted in
grisaille and shows the Knights of the Order
of the Garter taking part in a procession
which was held annually on St George's day,
23 April. The king, Charles I, can be clearly
seen beneath a canopy on the left-hand
side of the composition. The sketch is the
only remaining physical record of a highly
important but sadly uncompleted royal
commission for a series of tapestries which
were to have been hung in Inigo Jones's
Banqueting House at Whitehall, beneath the
great painted ceiling by Rubens. The sketch
was in Charles I's collection. The king's 'CR'
brand is on the back of each of the two oak
panels which make up the support, described
in Abraham van der Doort's inventory as
'painted in black and white in oyle Cullors
a long narrow peece – which was made for
a model for a bigger piece where yor Maty
and the Lords of the Garters, goeing a
Precessioning upon St Georgs day'.

The earliest account of the project
of which this sketch was part is in Bellori's
1672 life of van Dyck (no.75). The author
has been describing the painter's poor health
and his wish to 'retire from the continuous

activity of painting portraits and other
pictures'. He continues:

instead he hoped to dedicate himself
to a more tranquil type of work, far
removed from the business of the court,
which would bring him both honour
and profit, and thus leave a record and
memorial of his talents for posterity. To
this end he negotiated with the king,
through the good offices of Digby [Sir
Kenelm Digby, Bellori's informant about
the artist's life], to make designs for
hangings and tapestries for the great
saloon of the Royal Court of Whitehall
in London. The individual compositions
and general themes were related to the
election of the king, the institution
of the Order of the Garter by Edward
the Third, the procession of knights in
their robes and the civil and military
ceremonies, and other royal functions.
The king liked this proposal, because he
already owned both the very rich set of
tapestries by Raphael of the Acts of the
Apostles, and the original cartoons; and
these new ones would have been twice
the number and larger in scale. Yet the
king's intention was not realized, for
Van Dyck had reached the point where
he did not hesitate to ask three hundred
thousand scudi for the cartoons and
paintings needed for the tapestries. The
price seemed excessive to King Charles,
but the problem would have been
resolved if the death of Van Dyck had
not intervened.

This immensely informative account,

which is based on the testimony of a close
friend of van Dyck, tells us that this project
dated from shortly before the artist's
death in December 1641. In Bellori's *Vite*
it is placed just before his trip to Paris late
in 1640 and so we may imagine that the
negotiations for the project, and therefore
the execution of this oil sketch, took place
in 1639 or 1640. Bellori records van Dyck's
wish to get away from portrait painting
and undertake an ambitious decorative
commission of this type. It is significant
that shortly afterwards he travelled to Paris
in a vain attempt to secure the commission
for the decoration of the Grande Galerie of
the Louvre. He was conscious of the need
to leave a legacy and to emulate not only
Rubens, beneath whose ceiling the tapestries
would have been displayed, but Raphael,
the most graceful and most 'universal' of all
painters who had been in court service.

The sketch was acquired by Sir Peter Lely
as part of his great collection of the work
of van Dyck, the artist he admired above
all others. Later it was bought by Sir Joshua
Reynolds for the 4th Duke of Rutland and
was at Belvoir Castle, the seat of the Dukes
of Rutland, until it was acquired by the
Ashmolean in 2001. A print was made after
it in 1782 by Richard Cooper (c.1740–1814),
which has a lengthy description, identifying
the scene and a number of participants
including Van Dyck and Inigo Jones. CB

Notes
1 Barnes et al. 2004, no. IV.59, p.476; Christopher Brown,
'"A Record and Memorial of his Talents for Posterity":
Anthony van Dyck's Sketch of the Garter Procession', in
Marieke van den Doel et al. (eds.), *The Learned Eye : Essays
for Ernst van de Wetering*, Amsterdam 2005, pp.132–9.

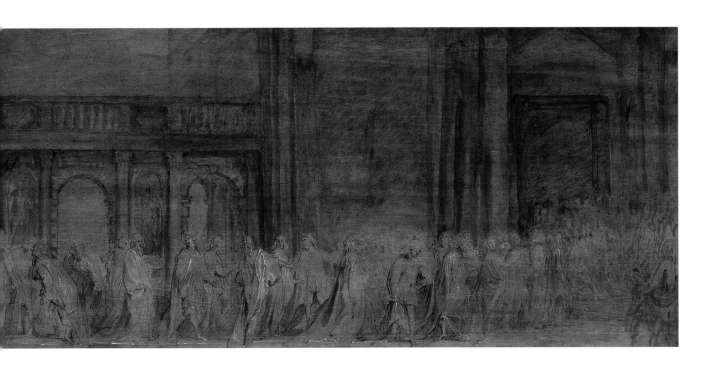

Van Dyck's London Studio

78

Nicholas Lanier c.1628
Black chalk, heightened with white, on blue
paper
39.2 x 28.5
National Gallery of Scotland, Edinburgh

This is the preparatory sketch for van
Dyck's portrait of Nicholas Lanier (no.14),
probably executed in Antwerp in June 1628
when Lanier was on his way back to England
with the Mantua collection, and is one of
the earliest portrait studies by the artist.[1]
Van Dyck makes no reference here to the fact
that Lanier was an accomplished musician,
composer, and Master of the King's Music,
portraying him simply as a courtier wearing
his sword.[2]

 The drawing gives us an invaluable
insight into the working mind of the artist.
The original thought was to have the sitter's
right hand extended and holding an object,
most likely a glove or perhaps a slip of paper,
the earliest faint loose outline of which can
still be seen. However, van Dyck has changed
his mind and altered the composition to
have Lanier resting his right hand on his
hip, his elbow pointing outwards – as in the
finished painting – which is more worked up
and in keeping with the rest of the sketch.[3]
Little attention is paid to the sitter's facial
features as the artist focuses on his body and
the curves of the fabric, the way the light
catches the folds indicated prominently
through the strong use of white heightening.

 In the eighteenth century the drawing
passed into the collections of the painters
Joseph van Aken (no.121) and Allan Ramsay
(1713–84). Ramsay's working method and
his oeuvre were influenced by van Dyck, and
particularly by this chalk drawing through
its composition and its indication of van
Dyck's own way of working.[4] TJB

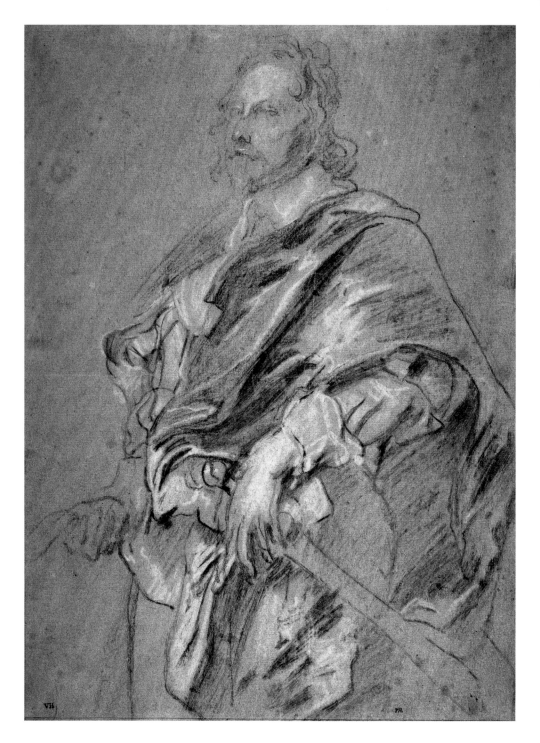

Notes
1 Millar 1982, no.67, p.104.
2 H. Vey in Barnes et al. 2004, no.III.92, p.321.
3 Lurie 1995, no.15, pp.48–9.
4 *Allan Ramsay (1713–1784) – his masters and rivals*, exh.
cat., National Gallery of Scotland, Edinburgh, 1963, no.45,
p.18.

79

Thomas Howard, 14th Earl of Arundel
c.1635–6
Black chalk with white chalk highlights on
green-grey paper
48 x 35.6
The British Museum, London

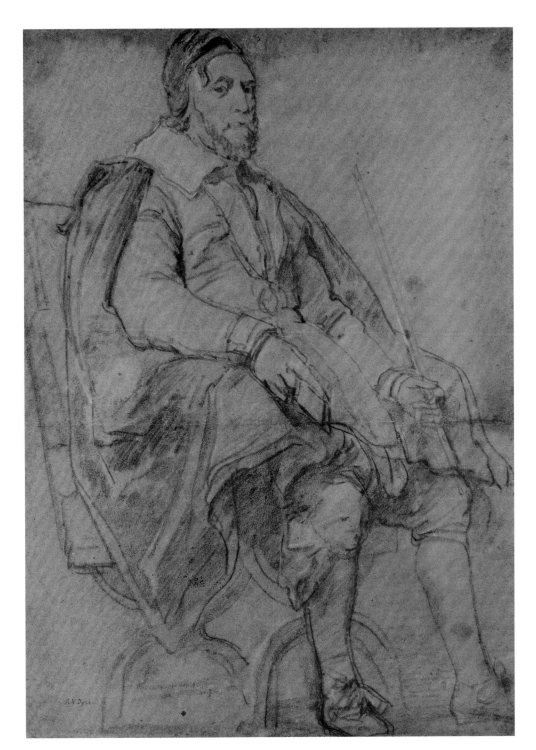

This is a preparatory sketch for an unknown
portrait of Thomas Howard, Earl of Arundel
(1585–1646). He is shown wearing a cap
and staring out at the viewer, a letter or
piece of paper held in his right hand and
the gold baton signifying his position as
Earl Marshal in his left. Around his neck
he wears the badge of the Order of the
Garter – the 'Lesser George' – and he sits
in a chair contemporary to the period.
The sketch probably dates from the period
between van Dyck's return from Flanders
in spring 1635 and Arundel's departure on
his embassy in early 1636, around the same
time that van Dyck painted Arundel with
his grandson Thomas (no.38). The angle of
the composition suggests that the figure is
viewed from below, and that he is slightly
raised, as if on a platform or dais.[1]

Arundel was one of van Dyck's most
important supporters and patrons, and at
around this time it seems the artist was
working on a very large and grand group
portrait of the Arundel family, similar
to that which he produced for the Earl
of Pembroke. The claim that the original
composition for this work can be seen in
a watercolour by Philip Fruytiers (dated
1643, private collection) is unsubstantiated.[2]
However, a pen and ink compositional sketch
of *The Earl of Arundel and his Family*, possibly
after van Dyck (Stedelijk Prentenkabinet,
Antwerp), may give an indication of the
artist's plans for this unrealised painting:
it shows the earl and countess seated in
the centre of the composition, raised on a
platform, their children and grandchildren
on either side. Lord Arundel and his wife are
seated facing forward, Lord Arundel turning
his head slightly to the right as he receives
a piece of paper from his grandson. Though
Arundel is presented in this chalk sketch in
three-quarter view, it is possible that the
drawing is related to van Dyck's scheme for
the uncompleted larger group portrait.[3] TJB

Notes
1 Millar 1982, no.77, p.110.
2 Millar 1972, no.134, p.86; a copy in oil on copper
(private collection) is reproduced and discussed in
N. Penny, *Thomas Howard, Earl of Arundel*, exh. cat.,
Ashmolean Museum, Oxford, 1985, no.11, pp.10–11.
3 Brown 1991, no.81, pp.256–8.

80
James Stuart, 4th Duke of Lennox, later 1st Duke of Richmond c.1633
Black chalk heightened with white on light brown paper
47.7 x 28.0
The British Museum, London

This is the first of two drawings included here that van Dyck made in preparation for his important full-length portrait of James Stuart, 4th Duke of Lennox (no.31).[1] The duke stands, left hand on hip, with his cloak over his left arm, displaying the Garter Star as he does in the painted portrait.[2] In this sketch van Dyck pays closer attention to the duke's attire than to his facial features. The resultant painting closely follows the basic outlines of the costume in this drawing, although the position of the legs differs slightly.

The duke, a cousin of Charles I, was installed as a Knight of the Garter on 6 November 1633, and the portrait was presumably painted to mark this honour. He was to remain wholly loyal to the king. On 8 August 1641 he was created 1st Duke of Richmond, and four months later Lord Steward of the King's Household.[3]

This sketch has at some stage been folded along the centre. KH

Notes
1 Vey 1962, no.214, pp.287–8 and fig. 269; Brown 1991, no.70, pp.228–9.
2 Hind 1923, no.54, p.67.
3 *ODNB* 2004, vol.53, pp.159–61, entry on James Stuart, 4th Duke of Lennox and 1st Duke of Richmond by David L. Smith .

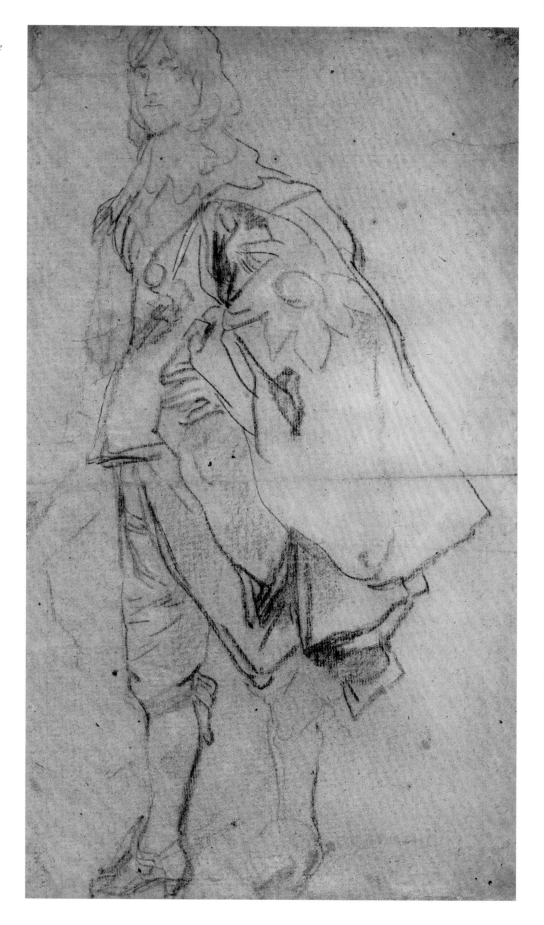

81

Two Studies of a Greyhound c.1633
Black chalk with white chalk highlights on
light brown paper
47.0 x 32.8
The British Museum, London

Like no.80, this is a study towards van
Dyck's full-length painted portrait of *James
Stuart, 4th Duke of Lennox* (no.31).

This sheet comprises two preparatory
drawings of the greyhound that appears
in the painting, where the duke rests his
hand on its head.[1] To the right is a more
finished study of the dog, wearing a collar,
sitting on its haunches and looking upwards;
the rapid drawing line seems to reflect the
animal's quivering alertness. To the left is a
less complete study, depicting the animal's
body and its front legs, both of which are
placed on the ground. The greyhound in
the finished painting is clearly based on the
right-hand study, except that its front legs
are both on the ground and almost crossed,
as in the left-hand study here.

A greyhound is also included in another
of van Dyck's portraits of the duke, the
half-length at Kenwood House (The Iveagh
Bequest) in London. It has been suggested
that the dog had saved the duke's life during
his travels on the Continent.[2] KH

Notes
1 Vey 1962, no.215, p.288, and fig. 264; Brown 1991, no.71,
pp.230–1.
2 Barnes et al. 2004, no.IV.201, p.586.

82
Studies of a Horse 1633
Black chalk, with white chalk highlights, on
blue paper (the sheet is composed of three
overlapping pieces of paper)
42.9 x 36.6
The British Museum, London

The two preparatory studies on this sheet
show a horse in a similar position to the one
depicted in van Dyck's immense equestrian
painting of Charles I with his equerry, the
Seigneur de St Antoine, also included here
(no.21).[1] A third preparatory drawing for
the same portrait, of the horse's left foreleg,
is also in the collection of the British
Museum.[2] KH

Notes
1 Vey 1962, no.208, pp.281–2; Millar 1982, no 69, p.105;
Brown 1991, no.68, pp.224–5.
2 Vey 1962, no.209, p.282.

83
Endymion Porter and his Son Philip c.1632–3
Black chalk, with some white chalk
highlights, on light brown paper
31.8 x 24.2
The British Museum, London

Endymion Porter had been a friend of
van Dyck since the artist's first brief visit
to London in 1620–1, and was the subject of
a number of portraits by him (see nos.15
and 65).[1]

This is a study from life for the
group portrait *The Family of Endymion Porter*
(private collection), which shows Porter, his
wife Olive Boteler, and their three sons.[2] In
this rapid sketch Endymion Porter grasps
a sword in his left hand; in the finished
painting, however, his hand is empty and
gestures towards a sculpture of the classical
goddess Pallas Athena placed behind the
head of his wife.[3] His son Philip (1628–55),
depicted here, was the youngest of the
three boys. Unfortunately he grew up to
be a delinquent who died young while
on bail on a charge of high treason. The
Porters had twelve children in all, of whom
five died in infancy.

This sketch was to belong successively
to the painters Jonathan Richardson the
Elder and Thomas Hudson (see nos.113,
122), both of whom greatly admired van
Dyck's work. KH

Notes
1 *ODNB* 2004, vol.44, pp. 947–50, entry on Endymion
Porter by Ronald G. Asch; see also Gervas Huxley, *Endymion
Porter, the Life of a Courtier 1587–1649*, London 1959.
2 Repr. Barnes et al. 2004, as no.iv.190, p.577, where it
is noted that George Vertue reported in 1751 that it was
already 'decay'd and damaged'.
3 Vey 1962, no.210; Brown 1991, no.64, pp.216–17.

Van Dyck's London Studio

84

Anne Cecil, Countess of Northumberland c.1635
Black chalk, heightened with white, on
greenish-grey paper
35.1 x 23.9
The British Museum, London

Van Dyck's drawing of Anne Cecil (1612–
37), the wife of Algernon Percy, 10th Earl of
Northumberland – one of the artist's keenest
patrons (see no.51) – gives a clear indication
of the sitter's costume.[1] In particular, the
white heightenings indicate the sheen on the
countess's satin bodice.

This may be an early sketch for the
portrait of the earl and countess with their
young daughter Katherine, painted in 1635
(Petworth House), although in that work the
countess's arms are differently positioned
and her attire is significantly changed.[2]

The countess died on 6 December 1637,
greatly mourned by her husband. She was
described as a 'Vertuous and Religious young
woman, so apted and fitted for him'.[3] KH

Notes
1 Vey 1962, no.211, pp.284–5 and fig.258.
2 Barnes et al. 2004, no.IV.175, pp.565–6.
3 Ibid.

85
Lucy Percy, Countess of Carlisle c.1637
Black chalk heightened with white on
greenish-grey paper
49.8 x 25.8
The British Museum, London

This is a preliminary drawing made by van
Dyck for his full-length portrait of Lucy
Percy, sister of his patron, Algernon Percy,
10th Earl of Northumberland (see no.51),
and widow of James Hay, 1st Earl
of Carlisle.[1]

 In this rapid and expressive sketch van
Dyck records the sitter's lively glance and
the position of her head and upper body.[2]
At this stage he is not concerned with the
details of her attire: her dress is merely
sketched in, but appears to be simpler than
that depicted in the eventual painting itself
(no.43), in which, for instance, the countess
wears a remarkable broad, pinned-back, gold-
brocade-lined sleeve.[3] The final costume,
in which the rich fabrics are rendered with
great freedom, must have been agreed after
discussion between artist and sitter: the
shape of the bodice is different from that
in the sketch, the countess's décolletage is
lower, and she wears large pieces of jewellery
at her shoulder and in her sleeve. Similar
jewels can be seen in van Dyck's portraits
of other women painted at around this date.

 This sketch subsequently belonged to
the painters Jonathan Richardson the Elder
(see no.113) and Thomas Hudson
(see no.122). KH

Notes
1 *ODNB* 2004, vol.25, pp.1026–8, entry on Lucy Hay,
Countess of Carlisle by Roy E. Schreiber. See also Lita-
Rose Betcherman, *Court Lady and Country Wife: Two Noble
Sisters in Seventeenth-Century England*, New York 2005.
2 Millar 1982, no.74, pp.108–9.
3 Gordenker 2001, p.55.

86
A Woman, presumed to be Margaret Lemon c.1637
Black, red and white chalks on paper
Octagonal 19.2 x 24.5
Inscribed at bottom: 'Mrs Lemon Sr. A Vandyck' and 'PHL' [conjoined]
The Syndics of the Fitzwilliam Museum, Cambridge, acquired with the assistance of The Art Fund (with a contribution from the Wolfson Foundation) and Re:source/V&A Purchase Grant Fund, 2001

Prior to its acquisition by the Fitzwilliam Museum in 2001, this beautiful drawing was unknown.[1] In addition to the inscription it bears the conjoined letters 'PHL', the monogram of the London-based painter and collector Prosper Henricus Lankrink (1628–92).[2] It is laid down on an eighteenth-century washed mount.

The inscription identifies the subject as van Dyck's mistress in London, Margaret Lemon. Van Dyck not only painted portraits of her, but also used her features in narrative compositions (see no.69). For instance, she is thought to be the model for the sleeping Psyche in his outstandingly beautiful painting *Cupid and Psyche* of about 1638–9 (no.29).

The remarkable intimacy and sensual warmth of the present image, which depicts the sitter lying on a pillow or cushion, suggests that the identification is correct. Few facts are known about Margaret Lemon's life, and recent writings on her have introduced confusion rather than clarification.[3] KH

Notes
1 *NACF Quarterly*, Autumn 2001, p.23 and NACF 2001 *Review*, p.78, entries by David Scrase.
2 See the entry on the Fitzwilliam Museum website (www.fitzmuseum.cam.ac.uk), accessed 9 January 2008. This drawing is thought originally to have been owned by Nicholas Lanier (nos.14, 78) and subsequently by Jonathan Richardson the Elder (see no.113), both keen admirers of van Dyck's work.
3 Susan E. James, 'The Model as Catalyst: Nicholas Lanier and Margaret Lemon', in the *Antwerp Royal Museum Annual*, 1999, pp.70–89; *ODNB* 2004, vol.18, pp.770–5, entry on Margaret Lemon by Susan E. James.

87
A Study of Plants c. mid-1630s
Pen and brown ink with brown wash on paper
21.3 x 32.7
Inscribed: 'on bord cron semel. Soufissels, nettels. gras. trile gras. / nyghtyngale on dasy / foernen'; signed 'A vandijck'
The British Museum, London

This is a rare example of van Dyck making close study of the natural world, finding beauty in the ordinary overlooked plants of the English countryside. Whilst he commonly depicted vegetation in the foreground of many of his portraits, especially in his second Flemish and English periods, the precise form of this study cannot be found in any of them. Similar groups of vegetation can be seen in the portrait of *Lord George Stuart, Seigneur d'Aubigny* (no.46), which has a thistle in the foreground, and the portrait of *Robert Rich, 2nd Earl of Warwick* (no.35). His portrait of *Charles I in the Hunting-Field* (fig.21, p.65) contains a large plant, probably a common burdock, which is similar to that in his

portrait of *James Hamilton, later 1st Duke of Hamilton* (c.1640; Prince of Liechtenstein, Vaduz Castle), suggesting that the artist may have referred to a pattern book of plants.[1]

The inscription at the top of this sheet, a mixture of seventeenth-century English and Flemish, is probably in the hand of van Dyck. The first part of it reads, 'on the edge' or 'on the cartoon', and then gives a list of the names of the plants which have been drawn. They can be identified as: on the extreme left, greater celandine (*Chelidonium majus*), also known as tetterwort, a yellow-flowering member of the poppy family; in the centre the large and prickly leaves of the corn sow-thistle (*Sonchus arvensis*), with behind it the stinging nettle (*Urtica dioica*); in the foreground is common quaking grass (*Briza media*); top right is a daisy (*Bellis perennis*), and below this, on the right-hand edge, lady fern (*Athyrium filix-femina*). The inscribed name 'nyghtyngale' (an early spelling for nightingale) may refer to herb robert (*Geranium robertianum*), greater stitchwort (*Stellaria holostea*) or other less precise cuckoo flowers, though none of these is drawn here.[2] TJB

Notes
1 Millar 1982, no.84, p.115.
2 Royalton-Kisch 1999, no.19, p.100.

88
A Study of Trees c. mid-1630s
Pen and brown ink with brown wash and
watercolour on paper
19.5 x 23.6
The British Museum, London

The date of this delicate study of trees is
uncertain, but it was probably produced in
around 1635, following the artist's return to
London from Flanders. The loose handling
and quick brush strokes suggest that it was
painted outside, direct from nature. There
are a number of other loose sketches of trees
by van Dyck, mainly in pen and ink, but
this is the most closely observed, accurate
and finished. The species is not indicated
by the artist, but they have the appearance

of English Elm (*Ulmus procera*). The tree in
the centre left is almost exactly the same
as that in the background of his portrait
of *Charles I on Horseback* (fig.7, p.18).[1] Trees
of a similar nature, though less accurate
and more generalised and romanticised,
feature prominently in the background of his
portraits of *Venetia Stanley, Lady Digby* (no.36)
and *Sir William Killigrew* (no.49). TJB

Note
1 Royalton-Kisch 1999, no.20, p.102; and Vey 1962, vol.2,
no.303, p.359.

89

A Hilly Landscape with Trees and a Distant Tower c. mid- to late 1630s
Pen and brown ink with grey wash and blue and green watercolours with some gum arabic on paper
22.8 x 33
The Trustees of the Chatsworth Settlement

Through the trees in the distance of this sensitive landscape study emerges a plain, square tower. To the right of this, against the blue watercolour of the hills beyond, can be seen the pencil outlines of two triangular rooftops of buildings and another tower, probably a church. Due to the lack of detail, the location depicted is unknown. Unlike other landscape studies or more detailed studies from nature, this does not appear to have been produced for use in portrait painting, but was drawn by van Dyck for its own sake: it is not so fragmentary and is centred on the page, with space allowed for open grassland, rolling hills and expansive sky with clouds. The swift handling and impromptu nature of the finish suggest that it was produced outdoors – *en plein air*.[1]

There is a note on the verso of the paper which reads: '16 lanschappen van van Dyck' ('16 landscapes by van Dyck'), probably added by N.A. Flinck, whose collection was acquired by the 2nd Duke of Devonshire in 1723/4. The annotation suggests that this is one of sixteen landscapes by van Dyck, though only five of this type are known today.[2] His watercolour landscapes are the earliest produced in England, and anticipate the great British landscape watercolourists of the eighteenth and nineteenth centuries such as Thomas Sandby (1721–98), Thomas Girtin (1775–1802), J.M.W. Turner (1775–1851) and John Sell Cotman (1782–1842).[3] TJB

Notes
1 Millar 1982, no.85, p.116.
2 Brown 1991, no.90, p.280.
3 Royalton-Kisch 1999, no.23, p.108.

Van Dyck's Impact during the Seventeenth Century

Fig.44
Cornelius Johnson
Diana Cecil, Lady Bruce c.1638
Oil on canvas
The Suffolk Collection, English Heritage, Kenwood

Fig.45
Peter Lely
Portrait of Everhard Jabach early 1650s
Oil on canvas
124 x 105
Rheinisches Bildarchiv, Cologne

Van Dyck's impact on other painters working in Britain was immediate and considerable. Some, such as the king's former principal painter Daniel Mytens (see nos.3, 12), were effectively displaced, while van Dyck's compositions were blatantly borrowed by his English-born contemporaries such as Cornelius Johnson and Edward Bower. Johnson's earliest attempts at full-length portraiture had been awkward and unsatisfactory but, always pragmatic, once he had adopted the van Dyck model (see fig.44) he clearly found greater success in this format, which had long been so popular with court clients.

Van Dyck died in London on 9 December 1641 at the age of forty-two, probably partly as a result of overwork. The political situation was deteriorating fast, and the following year Charles I was forced to escape from Parliamentarian-held London and set up a court in exile in Oxford. There William Dobson, by now the leading painter to Charles and to his Royalist supporters, produced a series of remarkable, vivid portraits of these internal exiles, including one of van Dyck's friend Endymion Porter (see no.97).

After years of civil war and Charles I's execution in January 1649, England was ruled by a Commonwealth government until 1653, and subsequently by the Protector, Oliver Cromwell. During the 1650s Robert Walker portrayed Parliamentarian generals – and Cromwell himself (no.99) – in poses that had earlier been used by van Dyck to depict Charles I and his Royalist subjects. There seem to have been no ideological objections from Walker's sitters to this practice. A portrait head of Oliver Cromwell from a painting by Walker was copied on to an engraving after van Dyck's equestrian portrait of the late Charles I (no.100). A curious double half-length image of the Protector and his wife Elizabeth (fig.48, p.173), which echoes van Dyck's celebrated early double portrait of Charles I and Henrietta Maria (fig.26, p.71, and no.18), which in turn copied a work by Mytens, also survives, although the context in which it was produced is unclear.[1]

John Hayls, who later painted the diarist Samuel Pepys (1638–1708), borrowed elements wholesale from van Dyck, and became known as a copyist of his work (no.103). Cornelius Johnson emigrated to the Northern Netherlands in 1643, where, like Adrian Hanneman at The Hague, he adapted van Dyckian compositions to meet the requirements of his Dutch clients. Later in the seventeenth century van Dyck's work continued to be viewed as the measure against which other artists were compared. As James Elsum observed in verse on 'A Portrait of K. Charles I. by Dobson':

> Tell me what modern Picture can compare
> With this for Sweetness and *majestick Air*.
> What lively *tints* and *touches* strike the Eye,
> And a *Vandykish Manner* do descry.
> Nothing's more nicely follow'd, or more like,
> In ev'ry *stroke* you see the great *Vandyke*.[2]

Van Dyck's compositions became widely available to both artists and their clients through the prints made after them (see, for example, nos.92 and 105). As a result, his poses and his approach to costume could be copied even by painters who had not seen his paintings at first hand.

The Haarlem-trained Sir Peter Lely, a pupil of Pieter de Grebber (1600–1653), arrived in London at the beginning of the 1640s.[3] Initially he painted slightly erotic pastoral scenes, Dutch Caravaggist figures of musicians, and sombre, dark-toned

Van Dyck's Impact during the Seventeenth Century

Fig.46
Godfrey Kneller
Self-portrait 1675
Oil on canvas
73 x 61
Whereabouts unknown

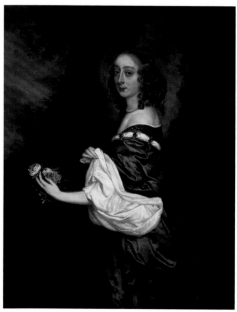

Fig.47
Peter Lely
Portrait of Elizabeth Capel c.1653
Oil on canvas
125.7 x 100.3
Collection of the Duke of Northumberland, Syon House

portraits.[4] Nothing is known of his work before he came to England, but during the 1640s he was employed by a number of van Dyck's former clients who were active Parliamentarians. They included Philip Herbert, 4th Earl of Pembroke (see fig.33, p.108), and Algernon Percy, 10th Earl of Northumberland, and this gave him the opportunity of seeing the works by van Dyck that they owned, and thus to absorb the older artist's style, palette and compositions. In 1647 Northumberland commissioned from Lely a double portrait of the captive Charles I with his second son, the Duke of York, which resonates with van Dyckian echoes. Lely's 1653 portrait of Northumberland's daughter Elizabeth, who married Arthur Capel, later Earl of Essex, borrowed the composition used by van Dyck for her cousin, Dorothy Sidney (fig.35, p.118, and no.52). Another (fig.47) echoed *Frances, Lady Buckhurst* (no.39). When van Dyck's former client Everhard Jabach visited London during the early 1650s, probably to purchase at the dispersal of the late Charles I's collection (from which Jabach acquired a number of works), he apparently took the opportunity to have his portrait painted by Lely (fig.45).[5]

Like van Dyck, Lely too collected works of art by earlier international artists, including van Dyck himself. At the Restoration of the Stuart monarchy in 1660 Lely, among others, was pressurised to return to the Royal Collection works that had been sold under the Commonwealth. Among Lely's collection were van Dyck's *The Three Eldest Children of Charles I* and *Cupid and Psyche* (no.29). At his death twenty years later, Lely still possessed twenty-five paintings by van Dyck, including the double portrait of Elizabeth Thimbleby and her sister (no.56).[6] Echoes of some of the van Dycks in his collection can be seen in his own portraits.

At the Restoration, Lely – in spite of having worked for Cromwell and the Republic during the 1650s – was able to position himself as the successor to van Dyck, re-shaping the imagery that van Dyck had used before the Civil War. He became official portraitist to Charles I's son, Charles II, who appointed him his Principal Painter, and on 30 October 1661 granted him a pension of £200 a year 'as formerly to van Dyck'. It has been suggested that Charles II and his court deliberately sought continuity through the imagery that van Dyck had used more than twenty years earlier. Like van Dyck, Lely ran a busy and productive studio, employing assistants and specialist contributors.[7] His female portraits, although owing a compositional debt to van Dyck, increasingly conveyed a deeper sensuality that reflected the laxity of Charles II's court, far removed from the strong morality of Charles I.

Perhaps confirming that desire for continuity – to go back to images of the first Caroline court, before the outbreak of the Civil War – a surviving print of Charles II and his queen, Catherine of Braganza, depicted the couple side by side in a further echo of van Dyck's double image of Charles's parents (see fig.49).[8]

Despite the circumstances of Civil War, Republic and Restoration, following van Dyck's death British painters chose to depict themselves in compositions that echoed his self-portraits, particularly his comparatively plain late self-portrait of 1640–1. These included William Dobson (no.96), Robert Walker (no.98), Lely himself and Sir Godfrey Kneller (fig.46). Samuel Cooper, too, emulated van Dyck's self-imagery (no.95), in miniature format. Evidently these *homages* expressed the artists' own aspirations to the reputation and respect previously accorded to van Dyck – and, as the next chapter will demonstrate, self-portraits by artists of the eighteenth and nineteenth centuries, such as Thomas Barker of Bath and Richard Cosway (fig.54, p.205) – and even of amateurs, such as Oldfield Bowles (no.129) – continued to reference van Dyck's self-imagery.

Fig.48
Unknown artist
Elizabeth and Oliver Cromwell
The James Marshall and Marie-Louise Osborn
Collection, Beinecke Rare Book and Manuscript
Library, Yale University

Fig.49
Peter Williamson
Charles II and Catherine of Braganza 1662
Engraving
The Huntington Library, San Merino

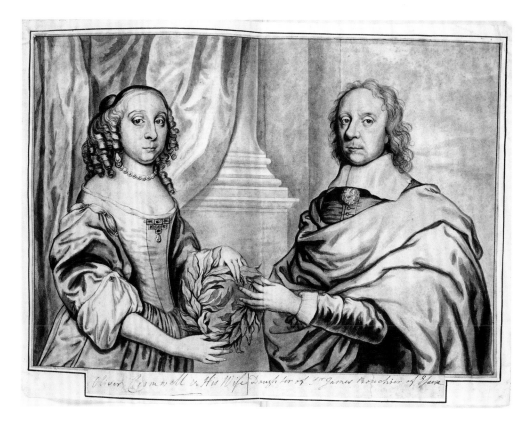

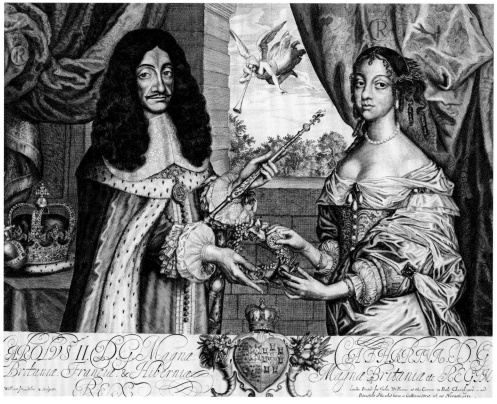

Notes
1 See Knoppers 1998, pp.1283–4, 1287–9.
2 James Elsum, *A Description of the Celebrated Pieces of
Paintings* ..., 1704, Epigram 79, p.60 (I am grateful to Kevin
Sharpe for this reference, also noted in Rogers 1983, p.65).
3 The early eighteenth-century engraver George Vertue
was told that when Lely first arrived in London he had
'wrought for Geldorp [van Dyck's former associate] in his
house'.

4 Millar 1978; *ODNB* 2004, vol.33, pp.305–8, entry on Sir
Peter Lely by Diana Dethloff.
5 Friso Lammertse and Jaap van der Veen, *Uylenburgh &
Son*, Zwolle 2006, pp.270–4.
6 For Lely's collection, which included more than five
hundred paintings, see no.111.
7 See MacLeod and Alexander 2001, pp.50–61.
8 See Knoppers 1998, pp.1314–16.

Van Dyck's Impact during the Seventeenth Century

90
Cornelius Johnson (1593–1661)
Portrait of an Unknown Gentleman 1632
Oil on canvas
76.2 x 60.9
Signed: 'C.J. 1632'
The Huntington Library, Art Collections,
and Botanical Gardens, San Marino,
California. Gift of the Art Collectors
Council

Notes
1 See *Tudor & Stuart Portraits 1530–1660*, exh. cat.,
Weiss Gallery, London, 1995, no.21; Asleson 2001, no.42,
pp.212–15.
2 Asleson 2001, pp.214–15; Barnes et al. 2004, no.IV.201,
p.586 and IV.A33, p.640.
3 Hearn in Roding 2003, pp.113–29.

Both the identity of the sitter and
the history of this painting prior to
the twentieth century are unknown.[1]
Nevertheless, it is an important work in
Johnson's oeuvre. He has here abandoned
his usual static presentation in favour of
one of baroque ebullience, and depicts the
unidentified gentleman as if he has just
turned to gaze directly at the viewer. Unlike
Johnson's earlier sitters (no.16), this man
is informally dressed, wearing only a shirt
and a dark cloak, which are rendered in bold
sweeps of fabric. A long section of his hair
has been drawn into a 'lovelock', a court
fashion of the 1630s. His fine lace collar is,
however, conveyed with Johnson's customary
attention to detail.

This remarkably direct and sympathetic
portrait is unlike any of Johnson's previous
work, and was painted at a significant
moment. Johnson customarily signed and
dated his works, and this one is dated 1632.
In seventeenth-century England a year was
deemed to run from the former religious
feast of Lady Day to the following Lady Day:
'1632 Old Style' ran from 25 March 1632 to
24 March 1633. According to its inscription,
therefore, this portrait was painted between
those dates. Van Dyck arrived in London in
the spring of 1632 and immediately began to
work for Charles I, who knighted him on 5
July of the same year. This painting may be
Johnson's response to the new, more dashing,
style of portraiture introduced by van
Dyck. It has been suggested that it may in
turn have influenced van Dyck's comparable
half-length portrayals of James Stuart, 4th
Duke of Lennox, with his hound, of about
1636 (Kenwood, London), and a workshop
derivation, without the dog (Louvre,
Paris).[2] The unusual approach of the present
portrait may also have been prompted
by the sitter, which makes it particularly
disappointing that it has not proved possible
to identify him.

In December 1632 Johnson was himself
appointed Charles's 'servant in ye quality
of picture maker', although he seems to
have been asked to paint very few works for
him.[3] KH

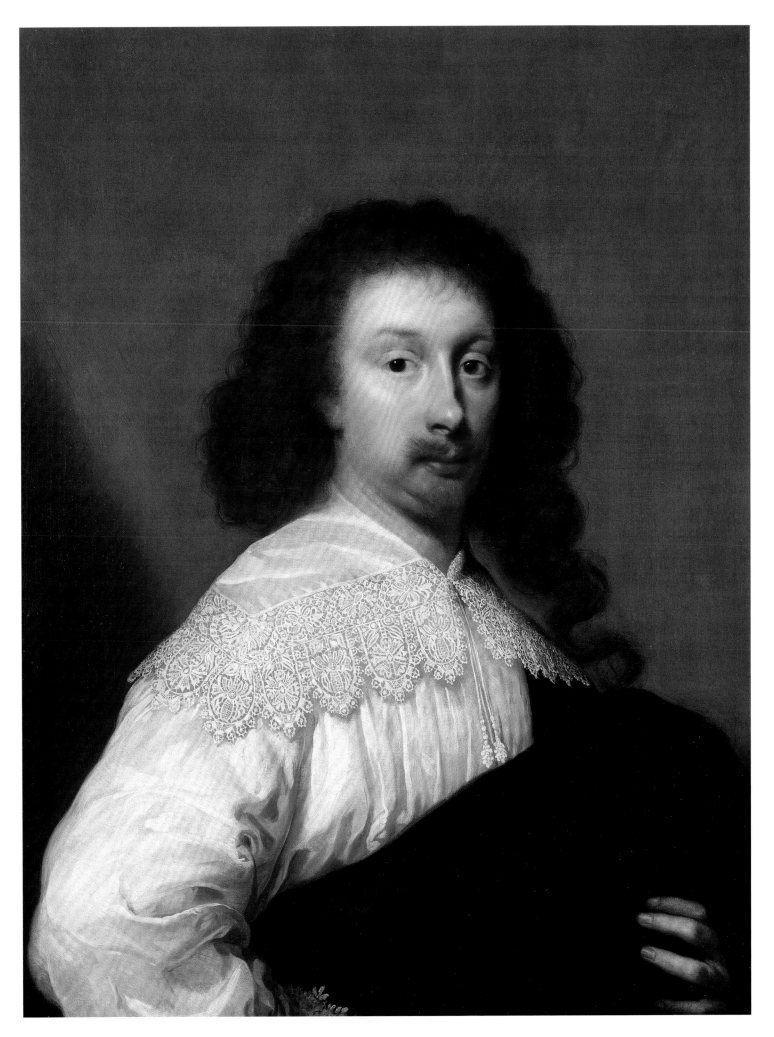

Van Dyck's Impact during the Seventeenth Century

91
Seventeenth-century British School, after
Anthony van Dyck
Elizabeth Howard, Countess Peterborough
mid-seventeenth century
Oil on panel
37.5 x 29
Inscribed: 'Elizabeth Countes͞. of
peterbororgh'
Private collection

There seems to have been a substantial
contemporary market for sets of small-
scale head-and-shoulders copies of original
portraits by van Dyck. These were generally
groups of female portraits, suggesting
that they may have been intended to act as
'galleries of Beauties'.[1] They are often still
framed in fine carved and gilded seventeenth-
century frames.

This example comes from a set of small
head-and-shoulders images on wooden
panel that were originally owned by, and
had presumably been commissioned by,
van Dyck's assiduous patron Philip, Lord
Wharton (see no.30). These paintings,
which have descended in an English private
collection, are almost all inscribed across
the top in the characteristic lettering found
on other works from Wharton's collection,
and many are of members of his family.[2]
The present work is clearly painted after
van Dyck's full-length portrait of the
countess of about 1638, in the collection
of her descendants in a private collection
in England (fig.50).[3] The countess was
the daughter of William, Lord Howard
of Effingham, and the wife of John, Lord
Mordaunt, later 1st Earl of Peterborough.

The portrait sets seem to be by a
number of hands. Examples survive in
various British private collections, including
those at Woburn Abbey, Darnaway, Berkeley
Castle, Warwick Castle and, formerly, the
Craven collection (which was dispersed at
Sotheby's, London, 27 November 1968, lots
25–7). Another important set, comprising
twelve images of ladies associated with
the English court, of which all but two are
based on portraits by van Dyck, is now in
the Museum Schloss Mosigkau in Dessau-
Mosigkau, Germany (fig.51). This group,
thought to have been painted in 1638–9, was
in the collection of the Dutch stadtholder
Frederick Henry and his wife Amalia van
Solms in The Hague by the mid-seventeenth
century. The group may have been given to
them at the time of the marriage of Charles
I's daughter Princess Mary (see no.22) to
their son, subsequently William II, in 1641.[4]
A further substantial set survives in the
Royal Collection. This seems to fall into

three different groups in terms of size, and
some pieces are copied after portraits by Sir
Peter Lely as well as after originals by van
Dyck.[5] As early as the first decade of the
eighteenth century these were described
as '14 … Ladies heads Copys by Remy',
hanging at Windsor Castle, indicating that
they were then thought to be by Remigius
[or 'Remy'] van Leemput.[6] Born and trained
in Antwerp, Remy had settled in London by
October 1635. There are a number of early
documentary references to him as a copyist,
and it has also been suggested that he was
a member of van Dyck's studio in London
(see pp.153–5 in the present volume).[7]
The set at Woburn Abbey has traditionally
been attributed to Theodore Russell, or
Roussel, nephew and probably also pupil
of Cornelius Johnson (see nos.16, 20, 90).
Like Johnson and van Dyck, Roussel lived at
Blackfriars; his son Anthony was later to tell
the engraver and antiquarian George Vertue
that Theodore had spent a year with van
Dyck, and also that he had copied van Dyck's
'pictures on small pannells'.[8] KH

Notes
1 Christopher Rowell, 'Reigning toasts: Portraits of
beauties by Van Dyck and Dahl at Petworth', *Apollo*,
vol.157, 2003, pp.39–47.
2 Oliver Millar, 'Philip, Lord Wharton, and his collection
of portraits', *Burlington Magazine*, vol.136, July 1994,
pp.517–30.
3 Barnes et al. 2004, no.IV.189, pp.575–6.
4 See Peter van der Ploeg and Carola Vermeeren, *Princely
Patrons: The Collection of Frederick Henry of Orange and Amalia
of Solms in The Hague*, exh. cat., Mauritshuis, The Hague,
1997, pp.164–8. I am also grateful to Alastair Laing for his
comments.
5 Millar 1963, pp.117–19, nos 218–30.
6 Ibid., p.117.
7 *ODNB* 2004, vol.33, pp.140–1, entry on Remigius van
Leemput by L.H. Cust, rev. by Ann Sumner.
8 *ODNB* 2004, vol.48, pp.340–1, entry on Theodore
Russell by L.H. Cust, revised by Ann Sumner.

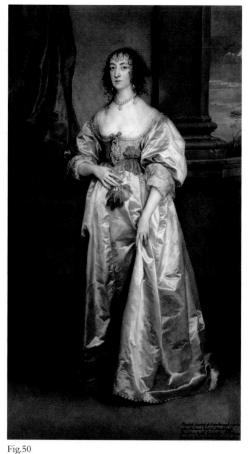

Fig.50
Van Dyck
Elizabeth Countess of Peterborough c.1638
Oil on canvas
232 x 125
Private collection, England

Fig.51
The 'Brown Cabinet', 1997
Museum Schloss Mosigkau

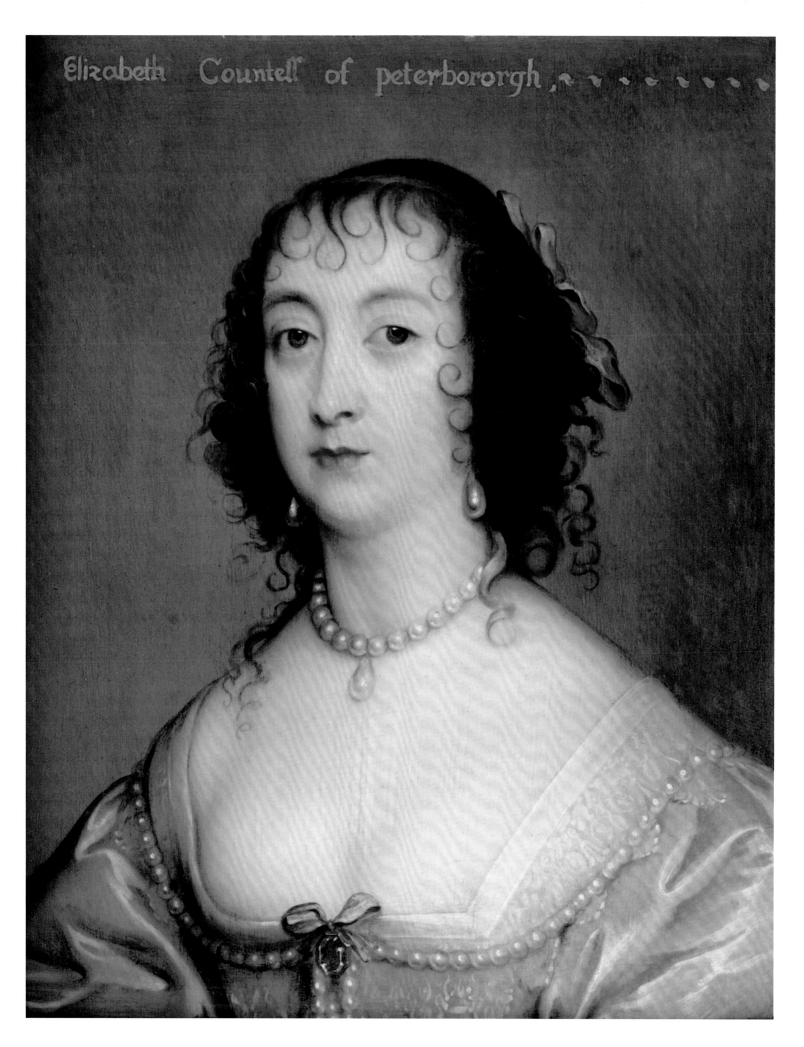

Elizabeth Countess of peterbororgh

Van Dyck's Impact during the Seventeenth Century

92

Pieter de Jode the Younger (1606–1674) after
Anthony van Dyck
Henrietta Maria c.1660
Engraving
48.2 x 33.7
Lettered at top right in the design: 'HMR
/ 1632.'; in the margin four lines in Latin:
'SERENISS.[MA] …. HENRICA-MARIA
BORBONIA … REGIS FIL'; below a three
line dedication to 'CAROLO VANDEN
BOSCH' by 'Math. Antonius, Ciuis
Antverp'; below left the production details:
'Antonius van Dijck Eques pinxit'; towards
right: 'Petr. de Iode sculpsit'; and at right:
'Math. Antonius excudit Antuerpiæ.'
The British Museum, London

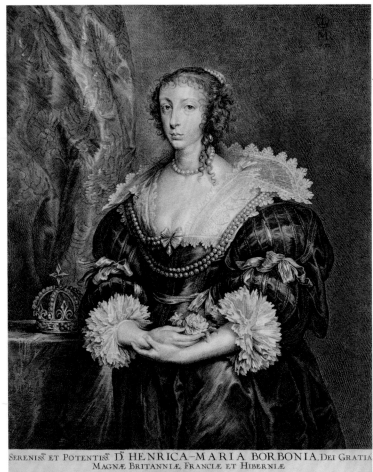

When van Dyck arrived in England in 1632,
he was knighted and appointed 'principall
Paynter in Ordinary to their Majesties'; he
was immediately sent to work on numerous
royal commissions, including the portrait
of the royal family known as the 'Greate
Peece' (no.17).[1] Among the commissions
were separate portraits, of which one of the
first to be executed must have been a three-
quarter length of the queen (no.19), which
served as the model for the present print.[2]
Emilie Gordenker[3] has described the dress in
this painting in some technical detail:

> The Queen wears a basqued bodice with
> a square neckline, over which lies a lace
> collar. A standing fan-shaped collar rises
> behind her head, and her décolletage
> is covered with a partlet. The virago
> sleeves end in richly tiered cuffs.
> Henrietta Maria wears her hair bound up
> at the back of the head with a strand of
> pearls, with ringlets at the sides of her
> temples, and a single lock of hair, like
> the men's love-lock dangling down to her
> bosom.

However, this official and rather sombre
portrait was in a mode of dress and idiom
from which van Dyck was to depart, and
subsequent portraits of the queen differ
from this one in many regards. This portrait
has a much more continental feel and recalls
van Dyck's portraits of Henrietta Maria's
mother Marie de' Medici[4] or Amalia van
Solms, Princess of Orange (1602–75),[5] the
wife of the Stadtholder Frederick Henry
(1584–1647), prominently decorated with
orange rosettes to signal her allegiance.
 This impressive, large-scale print of
Henrietta Maria is closely related to the
painting and even reproduces the queen's
initials, 'HMR', in monogram with the
date, '1632', all under a crown at the top

right corner. This is a companion to another
engraving by De Jode of Charles I,[6] again
accurately reproducing a painting by van Dyck.[7]
Both were published in Antwerp, and the Latin
lettering records the importance of the sitters,
their pedigree and full titles. They are dedicated
by the publisher of the prints, 'Math. Antonius'
(Matthijs Antheunis, c.1600/10–1664), to
the owner of the paintings, the avid collector
Bishop Karel van den Bosch (1597–1665). A
number of other good versions of the painting
are recorded, and it is likely that these official
likenesses were sent first as diplomatic gifts and
subsequently dispersed. ST

Literature
Hollstein Dutch & Flemish, vol. IX, no.61; Deepauw and
Luijten 1999, no.44b; New Hollstein, pt V, no.391.

Notes
1 O. Millar in Barnes et al. 2004, no.IV.45.
2 Ibid., no.IV.113.
3 Gordenker 2001, p.35.
4 H. Vey in Barnes et al. 2004, no.III.105.
5 Ibid., no.III.113.
6 Hollstein Dutch & Flemish, vol.IX, no.60; Depauw and
Luijten 1999, no.744a; New Hollstein 390.
7 O. Millar in Barnes et al. 2004, no.IV.56 (private collection).

93
British School
Portrait of Eleanor Evelyn c.1633–5
Oil on canvas
111.8 x 83.8
Private collection, Boston, USA

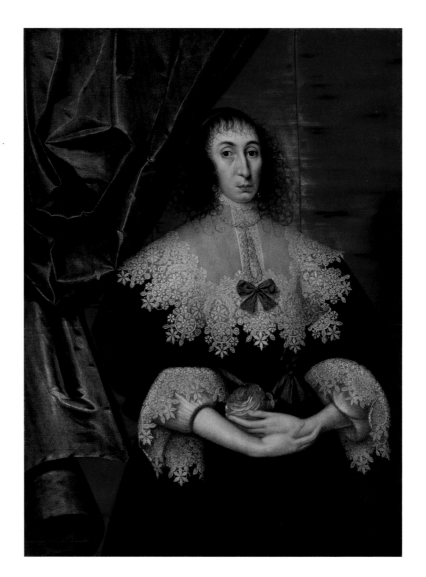

Although the painter of this remarkable portrait is unknown, he or she was clearly aware of van Dyck's 1632 three-quarter-length portrait of Queen Henrietta Maria attired in black (no.19) – or more probably of an engraving made after that painting. The posture of the figure, with crossed hands cradling a red rose, closely echoes that portrait, in reverse. At the same time, however, the green silk curtain looped up to one side is a device that can be seen in English and Scottish portraiture stretching back into the sixteenth century, an introduction by Netherlandish-trained painters.[1]

This likeness must have been painted before Eleanor Evelyn's death in 1635, which indicates a rapid assimilation of the van Dyck's composition by an English artist and/or client. Eleanor (1599–1635) was the wife of Richard Evelyn of Wotton in Surrey (d.1640) and mother of the celebrated diarist and writer John Evelyn. Her parents were John Stansfield (d.1627) and Elianor (*sic*), née Comber (d.1613). Richard Evelyn, who was worth £4,000 a year, became Sheriff of Sussex and Surrey.[2]

In 1634 Eleanor's daughter Elizabeth died; according to her son, John, it was grief at this loss, as well as at the memory of her earlier deceased children, that precipitated his mother's own death while still only in her mid-thirties. Although she wears black in the present portrait, Eleanor does not, however, appear to be wearing mourning, which may suggest that the work pre-dates Elizabeth's death. If Eleanor had chosen to be portrayed in mourning she would not have worn such a sumptuous display of lace, her ribbons would have been black rather than green, and she would have some form of black head-covering.[3]

When Sir Oliver Millar included this striking work in his 1972 exhibition 'The Age of Charles I' at the Tate Gallery, he followed David Piper in attributing it to the little-known painter J[ohn?] Parker.[4] More recently Malcolm Rogers has proposed that it may be a very early work by Robert Walker (for whose self-portrait see no.98).[5] In 1648 Walker was commissioned by John Evelyn to paint his portrait in a 'melancholy' posture, with his left hand resting on a skull (National Portrait Gallery, London). It is evident from that and the present work

that there was a strong facial family likeness between mother and son. KH

Notes
1 See, for example, the portrait of *George Seton, 5th Lord Seton*, 157[?], by an unknown artist (National Gallery of Scotland, Edinburgh, repr. in *Dynasty: The Royal House of Stewart*, ed. R.K. Marshall, Edinburgh 1990, p.29, fig.29) and the portraits of *Lady Diana Cecil* and *Lady Anne Cecil*, both attributed to William Larkin (Kenwood House, repr. in Roy Strong, *William Larkin*, Milan 1995, pp.86–7).
2 *ODNB* 2004, vol.18, pp.770–5, entry on John Evelyn by Douglas D.C. Chambers.
3 Opinion kindly supplied by Susan North, June 2008.
4 Millar 1972, no.142, p.90. For Parker, see Waterhouse 1988, p.211, where he is described as active between 1637 and 1658.
5 I am grateful to Dr Malcolm Rogers for discussing this work with me.

94

David des Granges (baptised 1611, died
c.1672)
*Katherine, Countess Antrim, formerly Duchess of
Buckingham* 1639
Water-bound pigment on vellum laid on card
Oval, 5.8 x 4.8
Signed on the right, in gold: 'D / D.G: /
1639:'
Her Majesty The Queen (The Royal
Collection Trust)

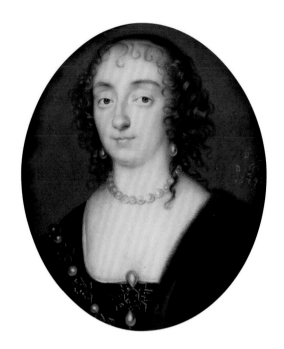

Lady Katherine Manners (d.1649) had
married George Villiers, 1st Duke of
Buckingham, at the age of seventeen,
in 1620. On his death in 1628 Katherine
inherited a considerable fortune, and she
and her children became great favourites
of Charles I.[1] In 1635 she married Randall
MacDonnell, 2nd Earl and 1st Marquess of
Antrim (1609–83), and in 1638 the couple
moved to Ireland where Dunluce Castle
became their principal residence.

Katherine was portrayed at least three
times by van Dyck, dressed in black and thus
as Buckingham's widow (see no.32). In the
present miniature her head is very similar
to van Dyck's representations of her; it was,
however, made four years after her second
marriage and des Granges has updated her
costume accordingly.

Des Granges's family was of French
origin, but he grew up in Blackfriars, an area
of London at that time inhabited largely by
foreign-born craftspeople – including van
Dyck himself. In 1636 he married a Judith
Hoskins, whose surname suggests a link
with the miniaturist John Hoskins (nos.18,
27) and thus also with his nephew Samuel
Cooper (nos.95, 101).[2]

This is the earliest dated miniature by
des Granges, although other works by him
survive from the late 1620s.[3] He painted a
number of other miniatures after portraits
by van Dyck as well as a handful of paintings
in oil on canvas.[4] He is traditionally said
to be the author of the very large group
portrait *The Saltonstall Family* of c.1640
(fig.52), in which the figures of the two
children on the left are clearly echoes of van
Dyck's group portraits of the royal children,
particularly *The Five Eldest Children of Charles
I*, 1637 (see fig.23, p.66).[5] KH

Notes
1 *ODNB* 2004, vol.35, pp.304–5, entry on Katherine
MacDonnell, Duchess of Buckingham and Marchioness of
Antrim by Jane Ohlmeyer.
2 *ODNB* 2004, vol.15, pp.897–8, entry on Samuel Cooper
by John Murdoch.
3 Reynolds 1999, pp.123–4, no.97.
4 Examples were with Lane Fine Art Ltd, London, in 1983;
see Waterhouse 1988, pp.71–2.
5 Barnes et al. 2004, no.ɪᴠ.62, pp.479–80.

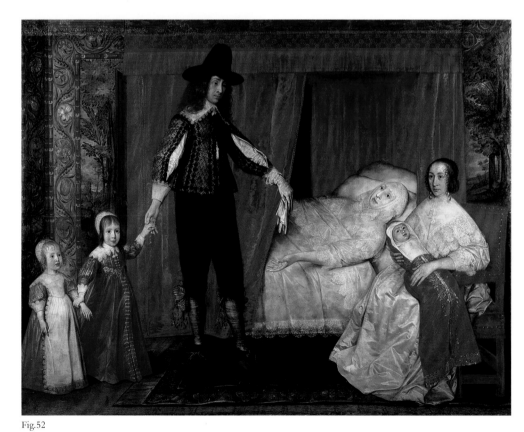

Fig.52
David des Granges
The Saltonstall Family c.1640
Oil on canvas
214 x 276.2
Tate. Purchased with assistance from the Friends of the
Tate Gallery, The Art Fund and the Pilgrim Trust 1976

95
Samuel Cooper (1607/8–1672)
Self-portrait 1645
Water-bound pigment on vellum laid on
card, with a gessoed back
Oval, 7.2 x 5.5
Inscribed: 'S: Cooper / fe: 1645'
Her Majesty The Queen (The Royal
Collection Trust)

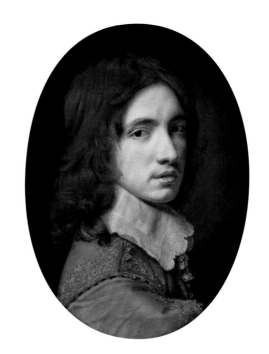

In this eloquent self-portrait, Samuel
Cooper – like William Dobson and Robert
Walker at around the same date – echoes
van Dyck's manner of self-representation
(see nos.67, 96).

It has been observed that the full
signature at lower right on the front of
the miniature is unusual in Cooper's work,
indicating that he intended it to be a
particular display of his powers, and perhaps
a special gift.[1] His slightly parted lips give
the illusion that he is about to speak. His
apparently plain light brown jacket is, on
closer inspection, embellished with delicate
silver embroidery, evidence of his already
lucrative professional success.

Cooper was probably born in the London
area of Blackfriars, where he and his brother
Alexander (also a miniature-painter) were
raised and trained by their artist uncle,
John Hoskins (see no.18).[2] There, as his
earliest biographer Richard Graham records,
Cooper 'derived the most considerable
Advantages, from the *Observations* which he
made on the Works of *Van Dyck*'[3] – indeed,
Cooper's earliest signed miniature, of
about 1635, depicts van Dyck's mistress,
Margaret Lemon. An accomplished linguist
and musician, Cooper had a reputation for
personal charm and gentlemanly behaviour
which made him, like van Dyck, particularly
agreeable for an aristocratic individual to
sit to.

During the Civil War and interregnum
period Cooper continued to prosper,
depicting a number of Parliamentarians;
during the early 1650s these included Oliver
Cromwell himself.[4] Following the Restoration
in 1660, Charles II sat to Cooper, which
resulted in the production of a number of
miniatures of the new king, as well as his
profile image for the new coinage.

Cooper was acquainted with 'most
of the intellectual and artistic elite of the
period'[5] and, according to Richard Graham,
with 'the greatest Men of *France, Holland*,
and his *own country*, and by his *Works* more
universally known in all parts of *Christendom*'.
On Cooper's death in May 1672, the artist
Charles Beale (1632–1705) wrote that he had
been 'the most famous limner [miniature-
painter] in the world for a face'.[6] KH

Notes
1 Reynolds 1999, pp.129–30, no.106, where it is also noted
that the gesso back was incised by the artist: 'Samuel
Cooper fecit feberuaris 1644 ould stile'.
2 *ODNB* 2004, vol.13, pp.267–70, entry on Samuel Cooper
by John Murdoch.
3 [R.Graham], 'A short account of the most eminent
painters, both ancient and modern', in C.A. du Fresnoy, *De
arte graphica / The art of painting*, trans. J. Dryden, London
1695, p.340.
4 See Graham Reynolds, *English Portrait Miniatures*,
Cambridge, rev. edn 1988, pp.50–3.
5 See note 2.
6 Ibid.

96
William Dobson (1611–1646)
Self-portrait c.1645
Oil on canvas
Oval, 57.3 x 44.3
Private collection

After van Dyck's early death in December 1641, the leading artist at the increasingly beleaguered court of Charles I was the British-born William Dobson (for whose portrait of van Dyck's friend Endymion Porter see no.97). Comparatively little is known about this artist, who was of gentleman status and trained in London first with William Peake (son of Robert Peake, see nos.1, 2) and then with the Baltic-German-born incomer Francis Cleyn (1582–1658).[1] The earliest known surviving portraits by Dobson probably date from the late 1630s.[2]

Dobson is said to have had 'the advantage of copying many excellent Pictures, especially some of Titian and van Dyck'.[3] His painting technique was, however, very different from van Dyck's, although some of his compositions do echo those employed by the senior court painter.It was said that Dobson gained the favour of the king with van Dyck's encouragement.[4] He subsequently portrayed not only Charles I himself, but also his sons – Charles, Prince of Wales and James, Duke of York – and his nephews, the Palatine Princes Rupert and Maurice, sons of Charles's exiled sister Elizabeth, the 'Winter Queen'.

When Charles I left London and set up his court in Oxford, Dobson went too, setting up a workshop with an assistant, a priest called Hesketh, and painting portraits of Royalist sitters. He returned to London in 1646, where he died unexpectedly in October of that year. He was subsequently described as 'a fair middle-sized man, of ready wit, and a pleasing conversation, yet being somewhat loose and irregular in his way of living, he … died poor at his house in St Martin's Lane …'.[5]

In this self-portrait Dobson can be seen consciously emulating van Dyck's elegant late self-portrait of 1640–1 (no.67).[6] The two works, both oval in format, are close in date. Like van Dyck, Dobson turns his head to glance intently over his right shoulder at the viewer. He is plainly but richly attired in a black satin mantle and white satin collar. Both self-portraits were owned by the writer and art enthusiast Richard Graham, Dobson's first biographer, and were later bought at Graham's sale on 6 March 1712 by a 'Mr Child'. Both remain in richly carved and gilded seventeenth-century auricular frames. KH

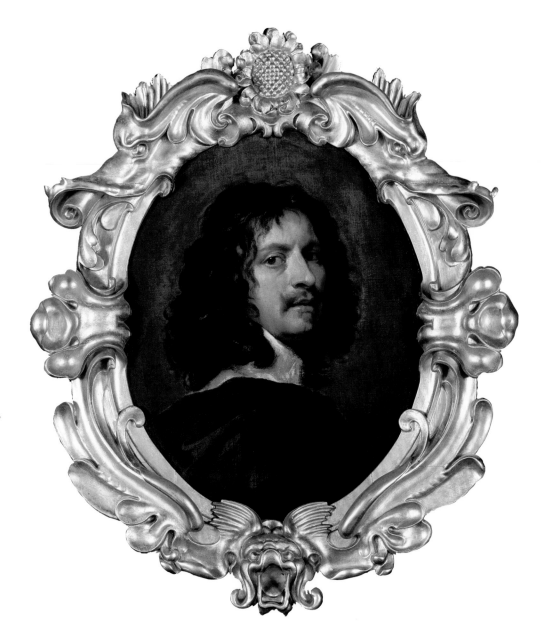

Notes
1 *ODNB* 2004, vol.16, pp.366–9, entry on William Dobson by Katharine Gibson.
2 Rogers 1983, nos.1 and 2, pp.22–3.
3 B. Buckeridge, 'An essay towards an English school', in R. de Piles, *The art of painting, with the lives and characters of about 300 of the most eminent painters*, 3rd edn, London 1754, p.369.
4 [R.Graham], 'A short account of the most eminent painters, both ancient and modern', in C.A. du Fresnoy, *De arte graphica / The art of painting*, trans. J. Dryden, London 1695, p.340.
5 Buckeridge 1754.
6 Rogers 1983, no.15, p.45, and repr. on back cover.

97
William Dobson (1611–1646)
Portrait of Endymion Porter c.1642–5
Oil on canvas
149.9 x 127
Tate. Purchased 1888

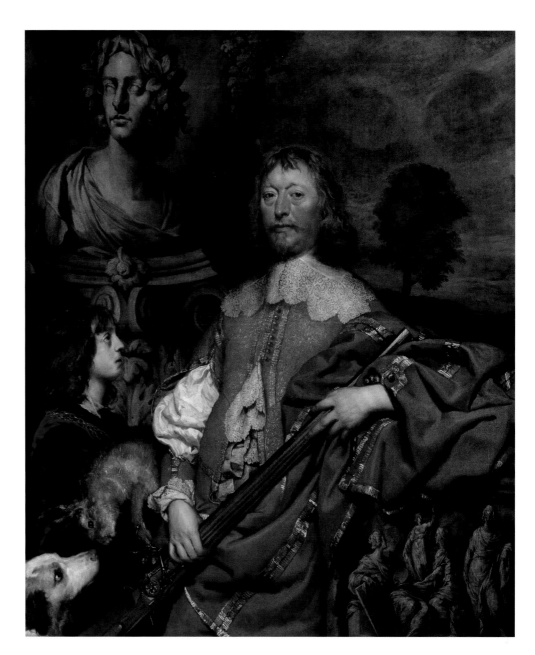

Endymion Porter had been a close friend
of van Dyck, who had painted his portrait
four times (see nos.15, 65, 83), in one case
including his own self-portrait alongside that
of his friend. A Groom of the Bedchamber
to Charles I, Porter was a patron of painters
and writers, and acted as an artistic adviser
to the king.

William Dobson depicts Porter standing
out of doors, against a sunset sky, holding
a German-made wheel-lock sporting rifle.
His left arm rests on a stone carved with a
relief representing the arts: the female figure
of Painting holds a palette and brushes and
supports a canvas on which she has painted
the image of Minerva, goddess of the arts;
Sculpture sits in the middle, having carved
the figure of Minerva that Painting has
copied; to the right is Poetry, a quill-pen
in her hand. To the left of Porter, a young
attendant holds a dead hare, which is being
sniffed at by a dog. Behind the boy, on a
stone Corinthian capital, is a large carved
bust of Apollo, patron god of the arts.

By the early 1640s, as Porter's various
grants ceased with the deteriorating political
situation, he began to experience financial
problems. When Charles I was forced to move
his court to Oxford, Porter accompanied
him and was a member of the parliament
there. During the Civil War he 'belonged
to the king's personal entourage but did
not command a regiment himself although
nominally a colonel'.[1] In July 1645 he left for
exile in France and the Low Countries. He
returned to England, destitute, early in 1649
and died in London in August the same year.
His own art collection had been dispersed,
and no inventory of it survives.

The present painting is among Dobson's
very finest works. He based the composition
on that of Titian's *Vespasian*, one of the
twelve paintings of Caesars that Charles
I had acquired from the collection of the
Dukes of Mantua in 1628, and which hung in
the Gallery at St James's Palace in London.[2]

Some scholars consider that this work
was painted while both sitter and artist
were resident in Oxford. However, Rogers
has argued that as it appears to represent
a celebration of the arts of peace (in the
context of a country landowner's sporting
pursuits), the portrait is likely to have been
conceived earlier, in about 1642, when both
Dobson and Porter were still in London.[3]

It is possible that the artist followed his
grand patron to Oxford with the work only
partially completed.

This painting was engraved by William
Faithorne in 1646, its caption giving the
names of the sitter and the artist and the
printseller Thomas Rowlett. After 1649 the
plate was altered by Thomas Hinde, another
printseller, who darkened the subject's
moustache and altered the title to 'the true
and lively Pourtraicture of Robert Earle
of Essex', the commander-in-chief of the
Parliamentary army.[4] KH

Notes
1 *ODNB* 2004, vol.44, p.950, entry on Endymion Porter by
Ronald G. Asch.
2 Vaughan 1970, pp.30–1.
3 Rogers 1983, no.8, pp.33–5, and col. pl.III.
4 Robert Devereux, 3rd Earl of Essex (1591–1646); see
Griffiths 1998, no.78, p.128.

98
Robert Walker (1595/1610–1658)
Self-portrait c.1640–5
Oil on canvas
73.7 x 70
Inscribed bottom right: 'R.Walker: pict^or et
pinx[…]'
The Ashmolean Museum, Oxford

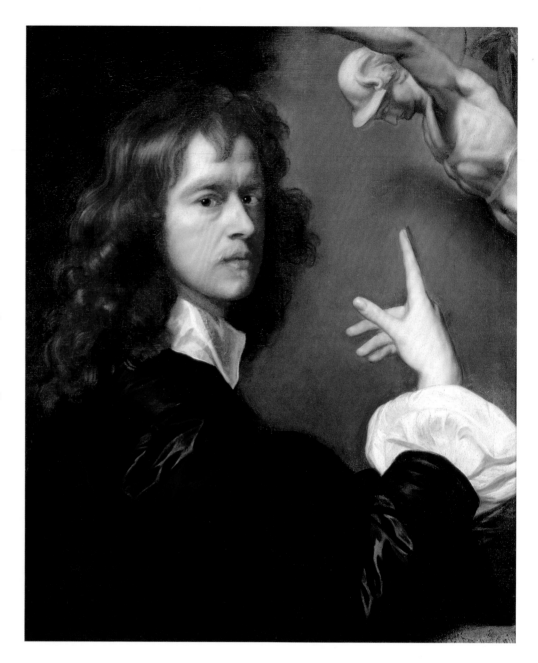

This is the most complex of a number of
variant self-portraits by Robert Walker.[1]
It is most closely based on one painted
by van Dyck in c.1633, showing himself
pointing at a great sunflower (fig.6, p.17),
and simultaneously drawing attention to a
substantial gold chain round his neck.[2] An
engraving by Wenceslaus Hollar after van
Dyck's painting is included here (no.64). The
present self-portrait has been described as
an 'ironic reworking' of van Dyck's original.
Instead of the sunflower, symbolic of a
subject's devotion to his or her monarch –
and in this case of the painter's loyalty to the
king who was his special patron[3] – Walker
depicts himself pointing at a sculpture
of the Roman god Mercury. As well as
being associated with the art of painting,
Mercury was also recognised as the god of
thieves: here Walker appropriates van Dyck's
composition, turning to look over his right
shoulder to gaze boldly at the viewer.[4] The
painting is signed in the bottom right corner
(running under the frame). It was in the
collection of the Bodleian Library, Oxford
by 1679.[5]

Little biographical information about
Walker has survived,[6] but it is clear that
he acted as principal portrait painter to
Oliver Cromwell and his circle, often using
a van Dyck composition for the figure and
substituting the head of the parliamentarian
sitter (see his portrait of Cromwell, no.99).
It was said of Walker that when asked 'why
he did [not] make some of his own Postures,
says he if I could get better I would not do
Vandikes. He [Walker] would not bend his
mind to make any postures of his own'.[7]
He is also known to have made copies of
Italian paintings in Charles I's collection,
particularly those by Titian.[8]

Walker's portraits were popularised
by the engravings produced after them by
William Faithorne, and included images
of the Parliamentarians John Lambert and
Thomas Fairfax, of which the originals are
now lost. KH

Notes
1 Other versions are in the Royal Collection, the National
Portrait Gallery and at Belvoir Castle; see *Ashmolean
Museum, Complete Illustrated Catalogue of Paintings*, Oxford
2004, p.x .
2 Barnes et al. 2004, no.IV.4, pp.431–2.
3 For a study of van Dyck's portrait see Peacock 2006,
with an account of Walker's self-portrait on pp.269–71.
4 Chaney and Worsdale 2001, no. 11, pp. 28–9.
5 Mrs R. Lane Poole, *Catalogue of Portraits in … Oxford*,
Oxford 1912, vol.1, p.175, no.424. I am grateful to Colin
Harrison, Ashmolean Museum, for sending photographs of
the signature area (August 2008).
6 *ODNB* 2004, vol.56, p.885, entry on Robert Walker by
Ann Sumner.
7 British Library, Add. MSS 22950, anon., f.41v, cited
in David Piper, 'The Contemporary Portraits of Oliver
Cromwell', *Walpole Society*, vol.34, 1952–4, Glasgow 1958,
p.28.
8 C.H Collins Baker, *Lely and the Stuart Portrait Painters*,
London 1912, vol.1, pp.106–10.

99

Robert Walker (1595/1610–1658)
Oliver Cromwell 1649
Oil on canvas
127.7 x 102.9
Leeds Museums & Galleries (Temple
Newsam House)

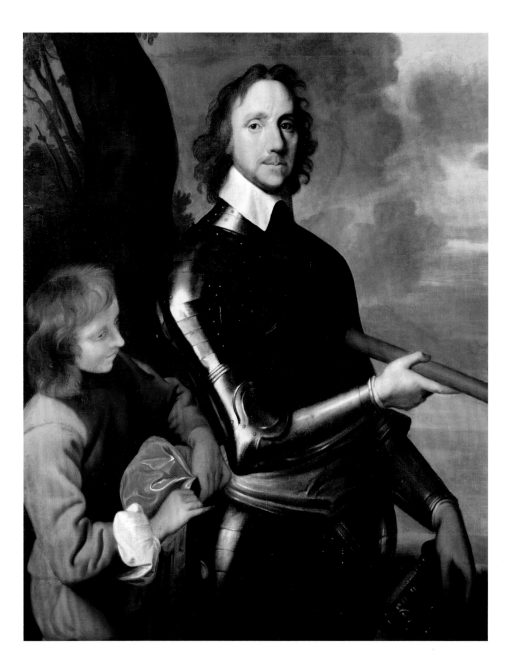

Robert Walker became, in effect, the
principal painter to the new regime under
Oliver Cromwell and the Parliamentarians
in the late 1640s and early 1650s. However,
the radical change that had occurred in the
politics of the country was not mirrored
in its portraiture. Indeed, Walker was not
merely influenced by the paintings of van
Dyck; he actively recycled his compositions,
continuing the visual language that van
Dyck had introduced.[1] His debt to van
Dyck is acknowledged in his own *Self-portrait*
(no.98).

Walker painted several portraits of
Oliver Cromwell (1599–1658), but this is his
most common composition. Several other
versions were completed at around the same
time,[2] but this is the only one dated. In a
display of military power and authority,
the victorious Parliamentarian general is
shown holding a baton and wearing full
black plate armour more akin to the early
sixteenth century, rather than the backplate
and breastplate with buff leather coat that
he would in reality have worn.[3] Cromwell's
face in Walker's portrait lacks the roughness
and the famous warts that can be seen in the
miniature by Samuel Cooper (c.1650; private
collection) and the portrait by Sir Peter
Lely (1653–4; Birmingham Museum & Art
Gallery):[4] Walker's rendition is of a much
smoother visage without any imperfections.[5]

The composition is an amalgamation
of several elements from paintings by van
Dyck. Cromwell's pose is taken from van
Dyck's half-length portrait of Charles
I's closest adviser, *Thomas Wentworth, 1st
Earl of Strafford* (c.1636; National Trust,
Petworth House).[6] In hindsight there is
a certain amount of irony in the leading
Parliamentarian being portrayed in the
manner of the king's most formidable
minister. The page tying the sash at his side
also appears in van Dyck's double portrait,
*Mountjoy Blount, 1st Earl of Newport, and
George, Lord Goring* (no.58). Walker used the
same composition and pose in his portrait
of *Colonel John Hutchinson and his Son* (late
1640s – early 1650s; private collection).[7] Yet
despite his overwhelming debt to van Dyck,
it has been argued that Walker's portraits
show subtle changes and developments
compared with those of the Flemish master:
the glamour and splendour of van Dyck's

portraits is not found in Walker's work,
which is plainer and much more appropriate
for a figure such as Oliver Cromwell.[8]

Another half-length portrait of
Cromwell by Walker, his right hand holding
a baton and his left hand resting on a helmet
(c.1649; Cromwell Museum, Huntingdon),
is derived from van Dyck's portraits of
Sir Kenelm Digby (c.1638; National Portrait
Gallery) and *Sir Edmund Verney* (c.1639–40;
private collection),[9] whilst a full-length
portrait of Cromwell in cavalry uniform
attributed to Walker (Cromwell Museum,
Huntingdon) bears a strong resemblance to
van Dyck's full-length portrait of *Henry Rich,
Earl of Holland* (c.1639; private collection).[10]
TJB

Notes
1 D. Piper, *The English Face*, ed. M. Rogers, National
Portrait Gallery, London [1978] 1992, p.88.

2 Other notable versions are in the National Portrait
Gallery (NPG 1665); collection of Earl Spencer, Althorp;
Justitsministeriet, Copenhagen.
3 L.L. Knoppers, *Constructing Cromwell – Ceremony, Portrait
and Print 1645–1661*, Cambridge 2000, pp.32–3.
4 J. Cooper, *Oliver the First – Contemporary Images of Oliver
Cromwell*, National Portrait Gallery, London, 1999, no.14,
pp.29–31 and no.17, pp.32–3.
5 Piper 1992, p.89.
6 Cooper 1999, no.11, pp.26–7.
7 Waterhouse 1994, p.88 .
8 Knoppers 2000, pp.34–5; L.L. Knoppers, 'The Politics
of Portraiture: Oliver Cromwell and the Plain Style',
Renaissance Quarterly, vol.51, no.4, winter 1998, pp.1282–
1319.
9 Cooper 1999, no.12, pp.27–8; D. Piper, 'The
Contemporary Portraits of Oliver Cromwell', *Walpole
Society Journal*, vol.34, 1952–4, pp.27–41.
10 Barnes et al. 2004, no.IV.135, p.534; Knoppers suggests
that a copy of van Dyck's portrait of *Frederick Hendrick,
Prince of Orange* (c.1631–2; Baltimore Museum of Art;
Barnes et al. 2004, no.III.112, p.338) owned by Charles I
might have been the inspiration for the full-length portrait
of Cromwell in L.L. Knoppers, *Constructing Cromwell*,
Cambridge 2000, p.43 (the portrait of Cromwell is
illustrated as fig.8, p.44).

100
Pierre Lombart (1612–1682) and another
engraver? after Anthony van Dyck and
Robert Walker (1595/1610–1658)
Oliver Cromwell on Horseback, with a Page,
1st state, c.1655, converted to *Charles I on
Horseback with a Page,* 6th state
Engraving
55.0 x 35.3
Lettered in margin in three lines Latin in
open capitals: 'OLIVERIVS MAGNAE
BRITANNIA … CONSILIO D.D.D
PETRVS LOMBARDVS.'; below horse's
hoof in design: 'P.Lombart sculpsit.'; in
the later state re-lettered: 'CAROLVS I.
DEI GRATIA / MAGNAE BRITANNIAE,
FRANCIAE ET HIBERNIAE REX.'; below
left: 'Wandijck Pinxit' and at right: 'P.
Lombart sculpsit'
Nicholas Stogdon

Pierre Lombart was a highly skilled French
engraver working in London from 1650 for
about ten years, during the Interregnum
(1649–60), then returning to Paris where he
continued to make fine portrait engravings.
He is best known for the present engraving
popularly called 'The Headless Horseman',
and for his series known as 'The Countesses'
(no.105).

A precursor to the print described
here is a three-quarter-length painted
portrait of Oliver Cromwell with a page
by Robert Walker,[1] the favoured painter
of the Parliamentarians, which has been
dated between 1651 and 1653. Cromwell
is shown in his martial capacity, holding a
baton of command with his accumulation
of titles: General of the Army of the
English Republic, Governor of Scotland and
Chancellor of Oxford University. In this
grander equestrian portrait of Cromwell
dated 1655 he is depicted as Lord Protector.
The politically charged image, blatantly
usurping van Dyck's original painting *Charles
I on Horseback with M. de St Antoine* (no.21)
in the Royal Collection, shows Cromwell as
His Highness 'Oliverius Magnae Britanniae
Hiberniae'.

The present famous print is renowned
for the subsequent series of radical
state changes or alterations to the plate,
particularly around the head. In the first
state, shown here, Oliver Cromwell is
depicted; his head was later erased and
there is a curious impression in the British
Museum showing a large, cleared area or
white space (hence 'headless'; fig.53).[2] This
was done on Cromwell's death and the
collapse of the Commonwealth republic in
1660. A new, more topical head was then
added, of the French king, Louis XIV; this

head was replaced with Cromwell's once
more, then with Charles I's, and remarkably,
Oliver Cromwell's reinstated. These changes
seem to have been made not out of political
imperative but in order to satisfy a demand
amongst print collectors. The question
of who precisely made the alterations and
when, or who acted as the publisher, remains
a mystery. The plate still survives (Nicholas
Stogdon collection).

Altering a printing plate in order to
change the sitter was frequently done to
avoid the expense of making a new plate,
and there are numerous examples of this
practice. Another good comparable example
of an altered plate is Hollar's print of the
Earl of Arundel on horseback, made in 1639.[3]
In subsequent states the head was replaced
by that of the more newsworthy Sir Thomas
Fairfax, and then by 'The Right Honourable
and undaunted warrior Oliver Cromwell,
Lo[rd] Governour of Ireland'. Similarly, the
equestrian portrait of Algernon Percy, 10th
Earl of Northumberland,[4] made by Hollar
in 1640 and published by Thomas Jenner
(d.1673), quickly became untopical and was
once again transformed into the New Model
Army 'warts and all' General Cromwell. ST

Literature
Griffiths 1998, no.117; New Hollstein, pt v, no.392.

Notes
1 Griffiths 1998, no.116.
2 Inv.P,2.249. In 1922 G.S. Layard's book *The Headless
Horseman* was published on the subject of this print; he
subsequently also wrote *A Catalogue Raisonné of Engraved
British Portraits from Altered Plates* (1927), based on a
collection of altered plates that he had formed for the 6th
Marquess of Sligo. The collection was presented to the
British Museum in 1935 and comprises about two hundred
items (inv.1935,0413.12 … 219.).
3 Pennington 1982, no.1352; Godfrey 1994, no.53.
4 Pennington, 1982, no.1474.

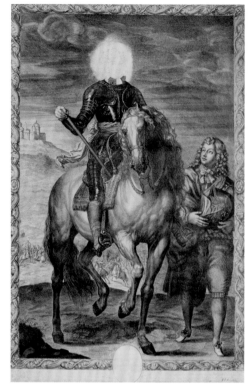

Fig.53
Pierre Lombart, after Anthony van Dyck
The Headless Horseman
Engraving
The British Museum, London

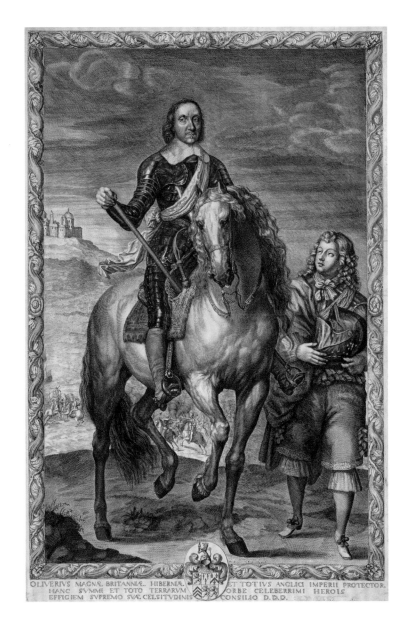

OLIVERIVS MAGNÆ BRITANNIÆ. HIBERNIÆ. ET TOTIVS ANGLICI IMPERII PROTECTOR.
HANC SVMMI ET TOTO TERRARVM ORBE CELEBERRIMI HEROIS
EFFIGIEM SVPREMO SVÆ CELSITVDINIS CONSILIO D.D.D.

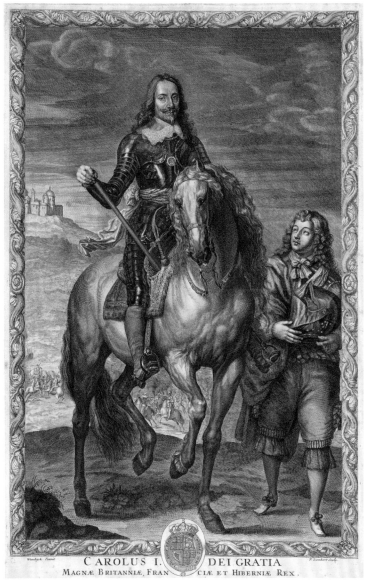

CAROLUS I. DEI GRATIA
MAGNÆ BRITANNIÆ, FRAN CIÆ ET HIBERNIÆ REX.

101
Samuel Cooper (1607/8–1672)
Portrait of Hugh May 1653
Water-bound pigment on vellum laid on card
with a gessoed back
Oval, 6.7 x 5.3
Inscribed on right in gold: 'S C / 1653'
Her Majesty The Queen (The Royal
Collection Trust)

Cooper here borrows, for a male sitter, a
posture that van Dyck had often employed
for female subjects (see nos.39, 69), as well
as in his self-portrait with Endymion Porter
(no.65). He turns to gaze over his shoulder,
at the same time fingering the fabric of the
blue satin cloak at his breast with his far
hand. The simultaneous movement of the
head and the hand introduces a compelling
dynamism to the portrait.[1]

The Royalist Hugh May (1621–84) was
an architect. During the 1650s he visited the
Stuart court in exile in the Low Countries
and helped George Villiers, 2nd Duke of
Buckingham (no.33), to transfer his late
father's works of art there in order for them
to be sold. May became a close friend of the
Dutch incomer painter Lely – a relationship
that was later, in about 1675, recorded in
Lely's fine double portrait of himself and the
architect (no.107). In 1656 May accompanied
Lely, as his 'servant', on another visit to the
exiled court in the Netherlands.[2]

Details of May's architectural career
prior to the Restoration are few, but he was
to become 'one of the outstanding English
architects of the seventeenth century'.[3] In
1660, he became Paymaster of the Royal
Works, responsible for the funding of the
restoration of the rundown royal palaces.
In 1665–6, with Sir Roger Pratt (1620–84)
and Sir Christopher Wren (1632–1723),
May advised on the repair of old St Paul's
Cathedral, and after the Great Fire in
1666 he was appointed a supervisor of the
rebuilding of the City of London.

May's principal architectural work for
Charles II was the remodelling of the upper
ward of Windsor Castle, carried out between
1674 and 1684. Although it has since been
either lost or altered, his work at Windsor
was highly innovative. He also designed
buildings for various courtiers, of which
few now survive: a rare example is Eltham
Lodge in Kent, designed for Sir John Shaw in
1664. KH

Notes
1 Reynolds 1999, p.131, no.108.
2 *ODNB* 2004, vol.37, pp.548–50, entry on Hugh May by
John Bold.
3 Ibid.

102
Peter Lely (1618–1680)
Portrait of a Young Boy, believed to be the 2nd Earl of Carnarvon c.1647/8
Oil on canvas
132 x 112
Private collection
[not exhibited]

This portrait of an aristocratic young man is an early work by Lely and clearly strongly influenced by van Dyck. The sitter is thought to be Charles Dormer, the 2nd Earl of Carnarvon (1632–1709), eldest son of Robert Dormer, the 1st Earl, a Royalist commander killed during the early Civil War at the Battle of Newbury in 1643, and Anna Sophia Herbert, daughter of the 4th Earl of Pembroke. We know from John Evelyn's *Diary* that Charles Dormer was in Genoa in 1646, when Evelyn records meeting 'Monsieur Saladine with his little pupil the Earle of *Carnarvon*'. Given the painting's stylistic and technical treatment, the portrait was probably painted c.1647/8.

Dressed in exquisite silk with a lace-trimmed linen collar and cuffs, his hat and cane signifying courtly elegance, Charles Dormer is the epitome of refined ease, although his youthful face and small stature (but note Evelyn's comments) seem almost too child-like and fragile for his confident adult demeanour. His pose, with one foot raised as if mounting a step, allowing us to admire his soft buckskin boots, is used by van Dyck in some of his English male portraits: for example, it is reminiscent of (but in reverse) that of the sitter's grandfather, the 4th Earl of Pembroke (Barnes et al. 2004, no.IV.81). This provides a link, as perhaps Lely intended, between his work and that of van Dyck, and also helps support the possible identity of the sitter.

Although the present portrait owes a strong compositional debt to van Dyck, the treatment of the atmospheric background landscape, the rich but subtle colour contrast of purple curtain and red costume and the strong accents of light picking up Dormer's head and right hand are all distinctive characteristics of Lely's own work at this period. DD

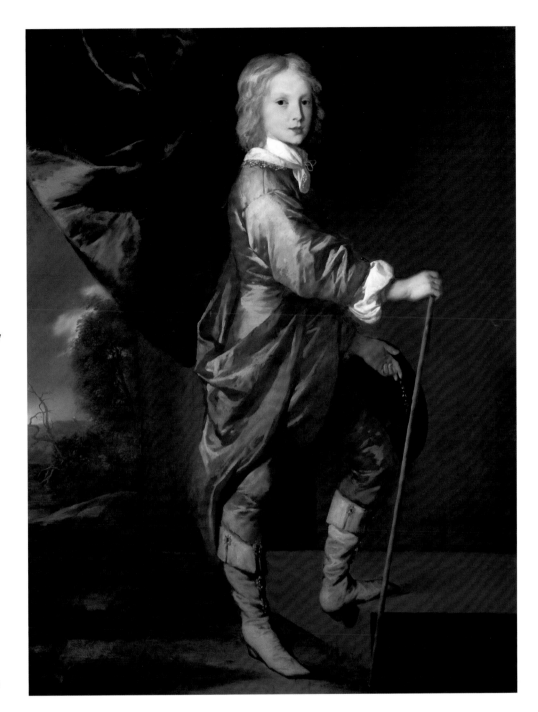

Van Dyck's Impact during the Seventeenth Century

103
John Hayls (d.1679)
Portrait of a Lady and a Boy, with Pan
c.1655–9
Oil on canvas
173 x 160
Tate. Presented by the Patrons of British Art
through the Tate Gallery Foundation, 1995

A label on the back of this painting, probably from the nineteenth-century, names the sitters as 'Mrs Dalison & her son Thomas Dalison. She was the wife of Thomas Dalison Esq of West Peckham Kent – and daughter of Sir Thomas Style 2nd Baronet of Wateringbury. Her Christian name was Susannah'. However, the lady in this portrait wears a dress fashionable in the late 1650s, and neither Susan Style (as she was more commonly known) nor her husband Thomas Dalison were born until around 1658; their son Thomas was not born until 1684. If this portrait does, nevertheless, relate to the Dalison family, the sitters must be of the previous generation. In this case, the lady could be Frances (1635–84), only daughter and heiress of Thomas Stanley of West Peckham and the wife of Maximilian Dalison (1632–71); this couple's son Maximilian was born in 1655, and could be the boy depicted here. He died in 1665.

Mythologising portraits of this kind were more commonly found on the Continent than in Britain. To the left is a figure from Roman mythology, either a satyr or the god Pan, identifiable by his horns and goat's legs and by the pipes in his left hand. Presumably symbolic of the sin of lust, he is here a rather humorous figure being kept in his place both by the classically attired little boy with bow and arrow (probably representing Cupid), and the small dog, a symbol of faithfulness. Pan is also being resolutely ignored by the lady herself, in the role of the goddess Venus, leaning against a rock entwined with ivy representing marital happiness and being pelted with roses by one of the putti over her head, while the other one holds a laurel wreath.

The theme of a female sitter with a young male relative dressed as Cupid was introduced to English art by van Dyck; John Hayls was said to have worked as a copyist of his works.[1] The lady here appears to be based on van Dyck's portrait of *Mary Villiers as St Agnes* (no.34) while the putti above her head echo the angels in van Dyck's allegorical portrait of *Venetia Digby* (no.36). Little else is known about Hayls: although sometimes described as a rival to Sir Peter Lely, he seems to have attracted rather less exalted clients. Between 1666 and 1668 the diarist Samuel

Pepys (1638–1708) commissioned him to paint a number of portraits, describing their progress in his *Diary*. Unfortunately the only one of these to have survived is that of Pepys himself (National Portrait Gallery, London). Hayls was probably related to both John Hoskins and Samuel Cooper.[2]

After Tate had acquired this work, infra-red photography revealed that some areas had been overpainted. The large stringed instrument on the right – called a theorbo – had been covered by a later layer of paint, as had the putti in the sky above. It is not certain when the theorbo and putti were painted over, but the latter seem still to have been visible in 1929 when a sale catalogue description of the painting referred to 'cupids'. Whether they were overpainted due to early twentieth-century prudery, or to conceal a change of colour in the pigments used for the sky, is unclear. Careful cleaning and restoration by Tate Paintings Conservator Helen Brett has revealed these elements again,[3] along with the meaning of the composition, which can be seen as a celebration of love and faithfulness within marriage, presumably commissioned by the sitter's husband.

Surviving works by John Hayls or Hales are extremely rare, and as he did not sign his paintings his style has had to be established by comparison with a handful of documented portraits. The painting most comparable with the present work is his double portrait of *Lady Anne and Lady Diana Russell*, c.1658 (Woburn Abbey); common elements of handling between the two confirm the attribution of the Tate work to Hayls. KH

Notes
1 B. Buckeridge, *The Art of Painting*, London 1706, pp.382–3, where stated that Hayls 'was so excellent a copist, that many of the portraits which he did after Vandyck, pass at this day for originals'.
2 *ODNB* 2004, vol.26, pp.512, entry on John Hayls by Karen Hearn.
3 See 'The Rediscovery of John Hayls's A Portrait of a Lady and a Boy with Pan' by Helen Brett, Paintings Conservator, Tate, on the Tate website (www.tate.org.uk).

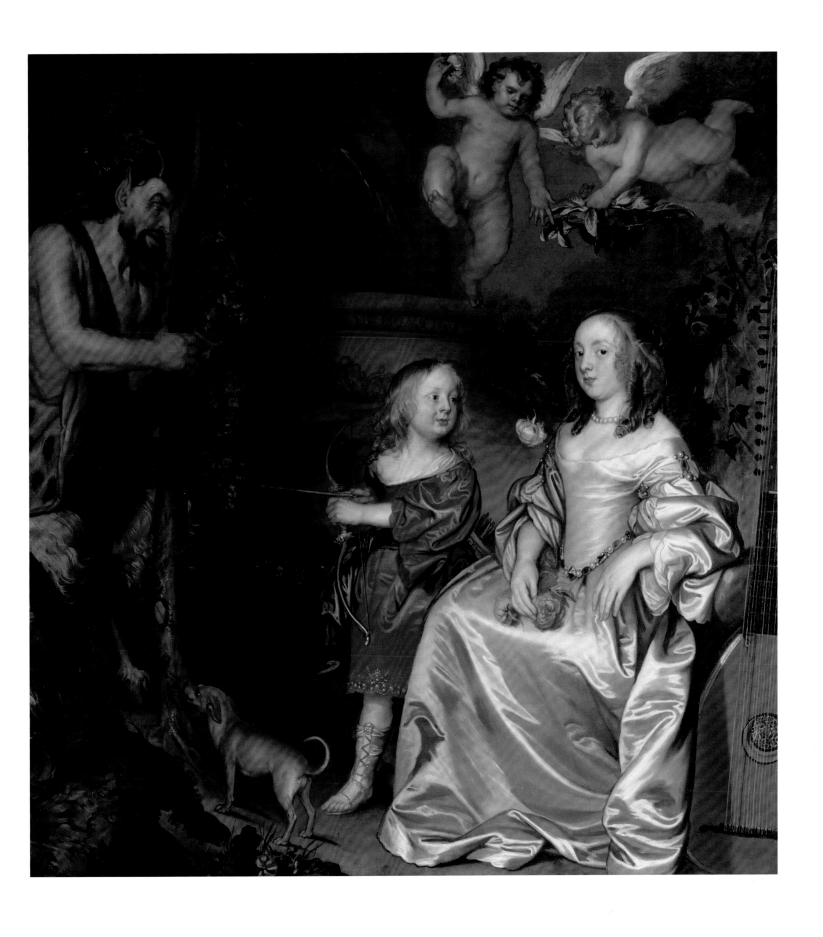

Van Dyck's Impact during the Seventeenth Century

104
John Michael Wright (1617–1694)
Colonel John Russell 1659
Oil on canvas
128.9 x 107.3
Signed and dated left (above drum): 'Io.
MRitus / P.1659' [the 'MR' in ligature]
Ham House (The National Trust); acquired
by HM Government in lieu of death-duties
in 1948 and transferred to the National
Trust in 2002

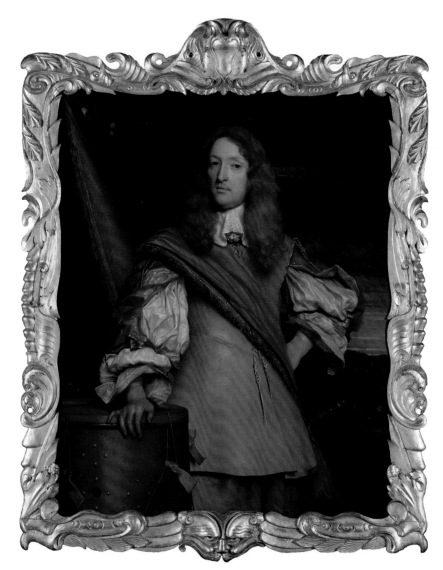

It has sometimes been said that Wright's
work 'owes little to van Dyck',[1] but the
elegance and poised confidence of the sitter
in this painting are reminiscent of such
portraits by van Dyck as *Philip, 4th Lord
Wharton* (no.30) or even *Sir Thomas
Hanmer* (no.54).

John Russell (1620–81) was a younger
brother of the 4th Earl of Bedford and
a colonel in the Royalist army. After the
execution of Charles I in 1649, Russell
became a leader of the Sealed Knot, a secret
group who worked for the restoration of
Charles II to the throne. Another member of
the group was Elizabeth Murray, Countess of
Dysart (d.1698), who was the owner of this
portrait by 1683.

This portrait is considered to be
one of Wright's finest works. Although
painted as late as 1659, it harks back to the
Civil War period of a decade previously,
presenting Russell in a buff coat of the type
worn on the battlefield. It has therefore
been described as 'an aggressive political
gesture'.[2] The billowing shirt and long hair
are characteristic of the late 1650s, and
Russell's crimson sash indicates his Royalist
sympathies.[3] Russell was evidently very
interested in his own image and a number
of other portraits of him by various artists,
including William Dobson and John Hayls,
also survive.

Wright was one of the most interesting
painters in seventeenth-century Britain, with
a very individual style. Born in London but
trained in Edinburgh by George Jamesone
(1590–1644), he was in Rome by 1642, where
in 1648 he became a member of the Academy
of St Luke (other foreign members included
Velásquez and Nicolas Poussin). In Rome,
Wright amassed an extensive collection
of books, prints, drawings and paintings.
According to Richard Symonds, an English
art enthusiast who knew him in Rome,
Wright there made a copy of van Dyck's
triple portrait of Charles I, which had been
sent out to aid Bernini to sculpt a bust of the
king.[4] During the early 1650s he carried out
antiquarian duties for the collector Archduke
Leopold Wilhelm (1614–62), the Governor
of the Spanish Netherlands, who was based
in Brussels. Having also apparently worked
in France, Wright returned to Britain in 1656
where in 1658 he painted Oliver Cromwell's
daughter, Elizabeth Claypole (d.1658).
During the 1660s Wright conducted a busy
career in London, although he was always
outshone by Sir Peter Lely, Charles II's
principal painter. In 1673 he was appointed
Picture Drawer in Ordinary to Charles II,
and from then on often signed his paintings
'Pictor Regius' ('painter to the king').[5] KH

Notes
1 Sara Stevenson and Duncan Thomson, *John Michael
Wright. The King's Painter*, exh. cat., Scottish National
Portrait Gallery, Edinburgh, 1982, p.60.
2 Ibid.
3 Ribeiro 2005, pp.195–6.
4 Mary Beal, *A Study of Richard Symonds*, New York and
London 1984, p.39.
5 *ODNB* 2004, vol.60, pp.456–8, entry on John Michael
Wright by Duncan Thomson.

Pierre Lombart (1612–1682) after Anthony
van Dyck
Anne, Countess of Morton c.1661–2
Engraving
34.8 x 25.3
Lettered: 'ANNA DE MORTON
COMITISSA'; below left: 'Antonius Van
Dyck Eques pinxit' and at right: 'P Lombart
sculpsit [] londini auec Priuileige du Roy /
et ex. parisis..'
The British Museum, London

ANNA DE MORTON COMITISSA

The print is from a series of twelve showing
three-quarter-length figures, ten women
and two men, known popularly as 'The
Countesses', after the Latin word *Comitissa*,
which appears in the margins of the plates
(there is also one *Domina* or Lady).[1] The
series is distinctive for the individual
decorative borders imitating frames around
each portrait, similar to those employed
by the French printmaker Abraham Bosse
(c.1604–76), which increases the uniformity
and grandeur of the set. The prints must
have been conceived to be framed and hung
as an ensemble of 'Beauties': indeed, they
were later advertised in the *London Gazette*
newspaper on 22 November 1708 as being
'very proper to adorn rooms, closets etc'.
They were engraved around 1660, shortly
after the Restoration of Charles II (lettered
'Londini avec privileige du Roy') and,
unusually, were also issued in Paris (see the
insertion in smaller lettering 'et ex. Parisis').
The plates were eventually acquired by the
publisher John Boydell and were advertised
in his catalogue in 1767 as 'Twelve Portraits
after the Original Pictures, by Vandike,
Engraved by P. Lombart, 9 ¾ by 13 ¾ in
Height. Price 1 s. each, or 8 s. the twelve'.

 The ambitious enterprise must have
posed logistical difficulties for Lombart, not
least gaining access to the original paintings
and permission to engrave them; the
provenances suggest that he must have made
arrangements with Algernon Percy, 10th
Earl of Northumberland, although the plates
carry no dedications or acknowledgement.

 Anne (née Villiers; d.1654) was the
daughter of Sir Edward Villiers and sister
of William Villiers, 2nd Viscount Grandison
(1614–43), who fought on the Royalist side
in the Civil War. William was also portrayed
by van Dyck,[2] and his portrait was later
engraved and included in a comparably
impressive series of prints after full-length-
portraits by the Dutch engraver Pieter van
Gunst (1659–1724) after drawn copies made
by Arnold Houbraken (1660–1719); these
were published in Amsterdam under the title
Decem Pictas Effigies in 1716 (the majority

from paintings belonging to the Duke of
Wharton and originally assembled by Philip,
4th Lord of Wharton). In 1627 Anne married
Robert Douglas, Lord Dalkeith and later Earl
of Morton. The whereabouts of the original
version of her portrait is not known, but a
copy is at Dalmahoy House, Midlothian.[3]
Although van Dyck seldom used exactly the
same posture for more than one sitter, it is
interesting to note that the composition
here recalls his portrait of Mary, Lady
Killigrew (no.50).

 Lombart's fine reproductions of so many
beautifully and inventively posed portraits
by van Dyck effectively served as a model
book for other portraitists and ensured
further, later borrowings and echoes. ST

Literature
Griffiths 1998, no.120; New Hollstein, pt IV, no.259.

Notes
1 The other women in the series were Anne, Countess
of Bedford (1615–84; O. Millar in Barnes et al. 2004,
no.IV.22), Lucy, Countess of Carlisle (c.1600–60; ibid.,
no.IV.38), Margaret, Countess of Carlisle (d.1676; ibid.,
no.IV.39), Anne Sophia, Countess of Carnarvon (d.1695;
ibid., no.IV.41), Elizabeth, Countess of Castlehaven
(d.1679; ibid., no.IV.42), Elizabeth, Countess of

Devonshire (c.1620–89; ibid., no.IV.90), Rachel, Countess
of Middlesex (1613–80; ibid., no.IV.A4), Penelope, Lady
Herbert (1620–?1647; ibid., no.IV.A28) and Dorothy,
Countess of Sunderland (1617–84; ibid., no.IV.223). The
two men were Henry Frederick Howard, Earl of Arundel
(1608–52; ibid., no.IV.12) and Philip, Lord Herbert, later
5th Earl of Pembroke (1621–69; ibid., no.IV.185). See New
Hollstein 250–61.
2 O. Millar in Barnes et al., no.IV.108.
3 Ibid., no.IV.A24.

106
Peter Lely (1618–1680)
Two Ladies of the Lake Family c.1660
Oil on canvas
127 x 181
Signed in monogram centre left: 'PL'
Tate. Purchased with assistance from The
Art Fund, 1955

Two fashionably dressed ladies, contrasted both in age and by the colours of their rich silk dresses, are seated on a stone bench, behind which extends a landscaped park. The elder, to the right, in a bronze satin dress, looks directly at the viewer while her younger companion, in blue, plays a guitar.

From the women's hairstyles, and from the texture and handling of Lely's paint here, the portrait can be dated to about 1660, when guitar playing was newly fashionable at the English court. A decade earlier Lely, expressing a traditional Dutch interest in music-making, had painted a series of individual images of musicians, giving careful attention to the details of their instruments. Here he depicts the guitar with similar precision, enabling it to be identified as probably a French example, made in Paris in about 1660 by the Voboam family.[1]

In the tradition of seventeenth-century double portraits, it is very likely that the two ladies were either related or close friends. From the mid-1650s onwards Lely produced several three-quarter-length double portraits, often of married or betrothed couples, but also of women. It is probable that the concept of his female friendship portraits derived from prototypes by van Dyck, in particular his *Dorothy Savage and her sister Elizabeth, Lady Thimbleby* (?) (no.56), a work that Lely himself owned.[2]

The sitters cannot be firmly identified, although a reference in a 1725 inventory of the property of James Brydges, 1st Duke of Chandos (1673–1744) – to a portrait of 'Sr. Lanc Lake of Cannon's Lady & Lady Essex Check by Sr Peter Lilly', which was valued at £80 – may be to this work.[3] But as Frances Cheke [*sic*] (d.1678) was already the wife of Sir Lancelot Lake (d.1680), by 1638, she would have been too old to be the lady on the left.[4] Sir Lancelot and his wife had a daughter, Essex Lake (b.1638), who was to become Lady Drax: she could be one of the ladies portrayed here. Sir Lancelot's estate of Canons in Middlesex had been taken on in 1713 by the Duke of Chandos, who had married a member of the Lake family in 1696, and could have acquired the present picture with the house. The portrait seems later to have been sold in 1747, with other Chandos property, under the title 'Lady Drax, and Mrs. Francklin playing on a Guitar'.[5]

Both the painting and its fine late-seventeenth-century carved and silvered frame were conserved during the 1990s at Tate.[6] KH/DD

Notes
1 Information supplied by Peter Forrester, letter of 28 September 1992.
2 As with so many items in Lely's collection, there is no record of when he might have acquired it.
3 Letter from Miss Haydee Noya, Cataloguer, Huntington Library and Art Gallery, San Marino, California, dated 31 January 1956; subsequently, Susan Jenkins, '"An Inventory of his Grace the Duke of Chandos's Seat att Cannons Taken June the 19th 1725" by John Gilbert', *Walpole Society*, vol.LXVII, Oxford 2005, p.135 and p.191, note 24.
4 Moreover, her mother Essex Rich, wife of Sir Thomas Cheke, had died in August 1658.
5 Correspondence with Sir Oliver Millar, 1956, in Tate files; see also Susan Jenkins, *Portrait of a Patron: The Patronage and Collecting of James Brydges, 1st Duke of Chandos (1674–1744)*, Aldershot 2007, pp.186–7.
6 Conservation of the painting was carried out by Christopher Holden, and of the frame by the late John Anderson.

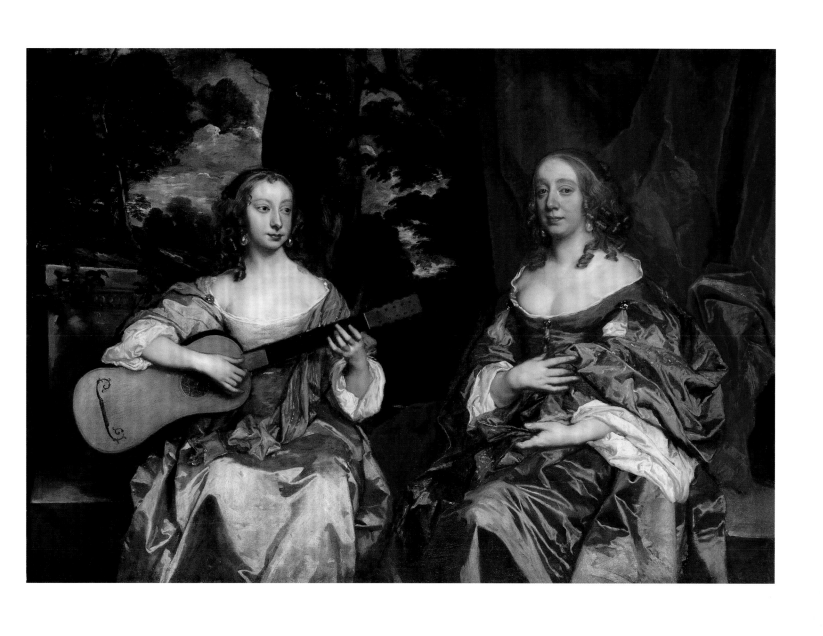

Van Dyck's Impact during the Seventeenth Century

107
Peter Lely (1618–1680)
Portrait of the Artist with Hugh May c.1675–6
Oil on canvas
143.5 x 182.2
The private collection of Lord Braybrooke,
on display at Audley End House, Essex

As van Dyck did in his self-portrait with his
close friend Endymion Porter (no.65), Lely
here confers a similar honour on his architect
friend Hugh May (1621–84) by including
him in this double portrait, painted in the
later 1670s, very probably for May himself.
The work is usually read as a friendship
portrait, celebrating some twenty-five years
of personal and professional friendship
between the two artists: they had known
each other since at least the early 1650s,
when May had lodged at Lely's Covent
Garden house. In 1656 they travelled
together to the Low Countries and spent
several months at the Hague, where Lely
had family property, developing strategic
contacts with members of the exiled Royalist
court. After Lely's death in November 1680
May was appointed as one of three executors
of his will.

By the time this work was painted,
both men had established reputations. Lely
was Charles II's Principal Painter and the
most fashionable portrait painter of the
day, running a large and well-organised
studio. He was a recognised authority on
artistic matters, and owned an impressive
collection of paintings, prints and drawings.
May had recently been appointed to the
post of Comptroller of Works at Windsor
Castle. Before that he had served as one of
the surveyors for the rebuilding of the City
of London following the Great Fire of 1666,
and had been responsible for work at Eltham
Lodge and Cornbury House.

Lely, the elder by a few years and
materially and professionally more
successful, stands on the left, traditionally
the superior side of a painting. Adopting a
pose used by the artist in a number other
male portraits of this period, he holds the
viewer at a distance with his rather heavy
presence and commanding gaze. By contrast,
May, who is seated on the right and wears an
informal Indian gown, seems to be including
the viewer in this 'pictorial conversation',
pointing his left hand in a gesture of
invitation to examine the architectural
drawing in his lap. This and the bundle
of papers on the table beside him refer to
the rebuilding and redecoration work he
supervised between 1674 and 1684 (none of
which survives) at Windsor Castle, whose
Round Tower can be seen in the distance.

Between the two figures Lely has
inserted a sculpted bust, traditionally
thought to represent the sculptor Grinling
Gibbons (1648–1721) who had worked with
May on a number of projects, including
Windsor Castle. The two had met through
Lely who, according to some sources, had
recommended Gibbons to the king, and who,
in his will, commissioned him to design his
commemorative monument (destroyed by
fire in 1795) for his neighbourhood church,
St Paul's, Covent Garden. The bust is not
now thought to be an accurate likeness of
Gibbons, but until it is correctly identified,
a reading of this image as a commemoration
of friendship between three key artistic
figures in Restoration England seems very
persuasive. DD

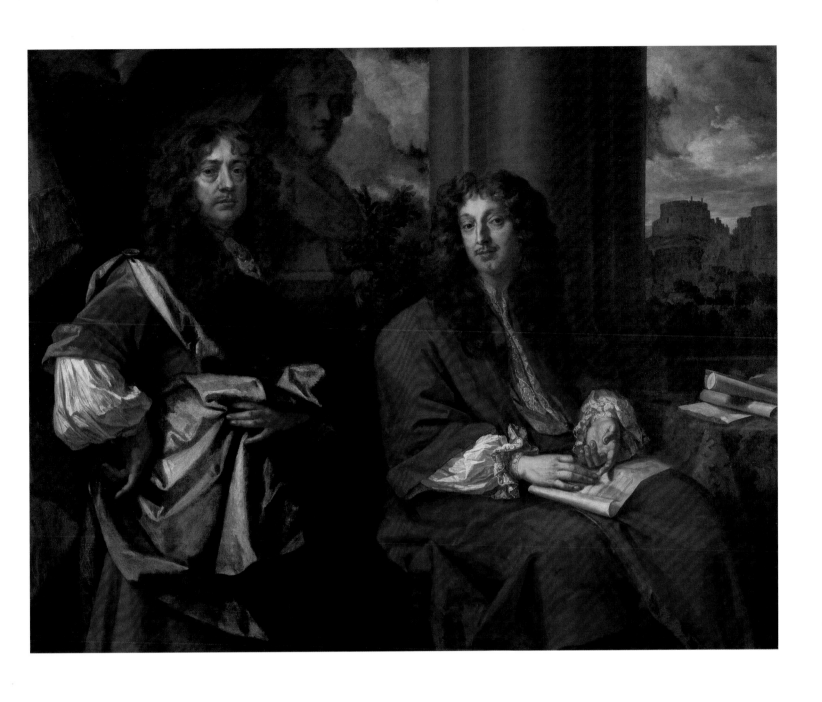

Van Dyck's Impact during the Seventeenth Century

108
Peter Lely (1618–1680)
Arabella Bankes, Mrs Gilly c.1660
Oil on canvas
127 x 103
Kingston Lacy, The Bankes Collection (The National Trust)

This portrait was painted c.1660, shortly before Lely's appointment to the post of Principal Painter to Charles II, for which he was to receive 'a pension of £200 … as formerly to Sr Vandyke'. From this period onwards Lely began to use particular poses and compositional types, which he would repeat for different sitters, to help cope with an increasing number of commissions. The sitter in this three-quarter-length portrait – a format confusingly referred to as half-length in contemporary inventories – adopts a pose that Lely seems to have favoured for other female portraits of the early 1660s.

The painting was very probably commissioned by Sir Ralph Bankes, the owner and builder of Kingston Lacy, who was a lawyer at Gray's Inn and a close friend and patron of Lely. The identity of the sitter has a confused history, but has now been established after a careful reading of the Kingston Lacy inventories.[1] The sitter is Arabella Bankes, one of Sir Ralph's eight sisters, who was born in 1642 and married a Mr Samuel Gilly. Staring intently and seriously at the viewer, she is seated beside a scallop-shell fountain, a motif found in many other female portraits by both Lely and van Dyck. It may be no more than a reference to a feature commonly found in aristocratic parkland, but the association of the fountain with water and water's purifying qualities may reflect Arabella's suitability as a potential young bride. She holds in her right hand a glass jar and in her left its lid. A jar was an attribute of Mary Magdalene, a sinner who repented. This association seems curiously inappropriate for a young woman about to get married, although it may, of course, have had a quite different and very particular relevance to the sitter, its original meaning now lost. Behind her is a beautiful landscape, perhaps a compliment to her own natural beauty, so unlike the painted artificiality of fashionable court women, although the cut and quality of her silvery-grey gown indicate wealth and social privilege.

This richly foliated landscape background is also used in other three-quarter-length portraits produced by Lely for Sir Ralph Bankes, including Bankes's own portrait. Lely may have been specifically asked to produce a collection of portraits of family and friends, all of the same size, format and with comparable backgrounds, which could be displayed in Bankes's recently refurbished family seat as a testament to dynastic ties and friendship.

Lely began increasingly to use studio assistants in the early 1660s, very often skilful artists in their own right. But the consistently high quality and uniformity of the handling and application of paint in this work would seem to suggest it is by Lely himself. This may be an indication of how seriously Lely took the commission, or of the sitter's closeness to Sir Ralph Bankes. DD

Note
1 See Alastair Laing 'Sir Peter Lely and Sir Ralph Bankes', in Howarth 1993, pp.107–31.

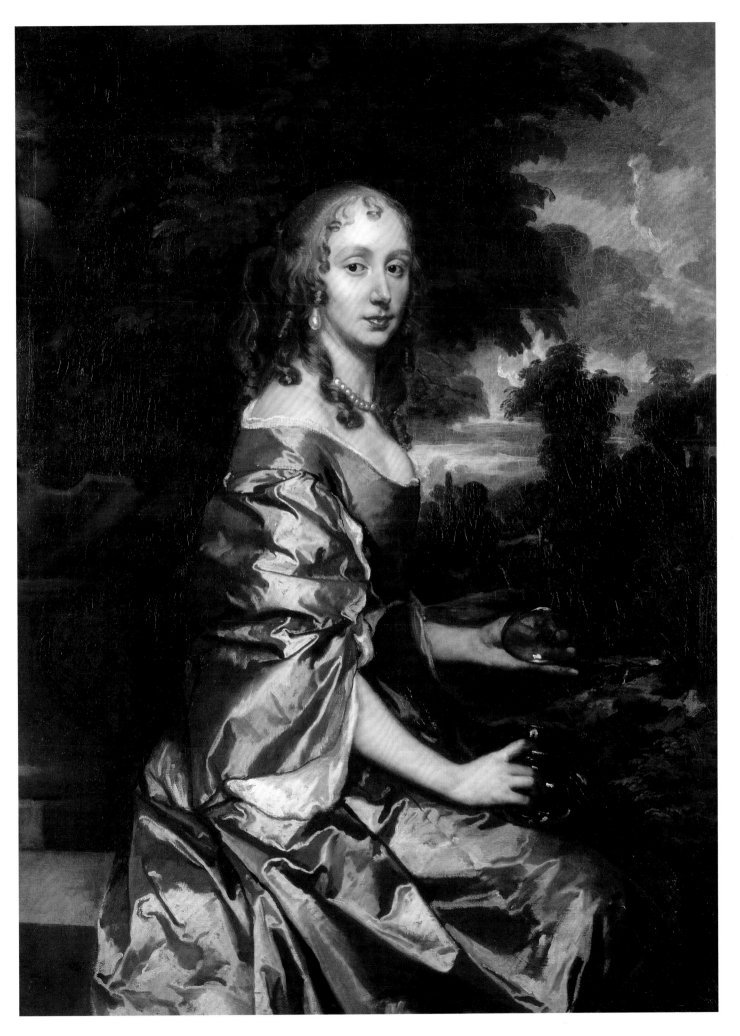

Van Dyck's Impact during the Seventeenth Century

109
Peter Lely (1618–1680)
Mary of Modena c.1674–5
Oil on canvas
126 x 102.2
English Heritage, Kenwood, London

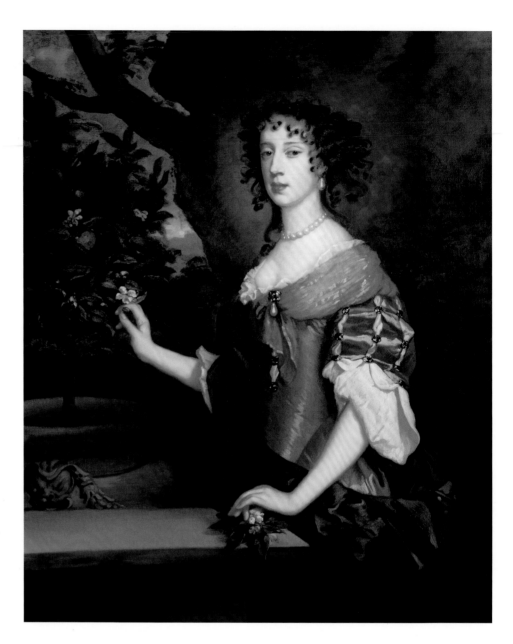

Maria Beatrice Anna Margherita Isabella d'Este (1658–1718) was born at the Palazzo Ducale in Modena in Italy, the elder of the two surviving children of Alfonso IV d'Este, Duke of Modena and Reggio. Educated at a Carmelite convent, Maria (henceforth Mary) became the second wife of James, Duke of York, late in 1673. The duke, a Catholic convert, had been determined to choose a Catholic bride, which made the marriage unpopular in Britain: as the duke's brother Charles II (see no. 112) was childless, any son of James's new union would in due course inherit the throne.[1]

Mary landed at Dover on 21 November 1673, where she met her new husband for the first time. She was not generally considered a great beauty: visiting Cambridge in 1680, she was described as: 'a very handsome, gracious-looking person, pretty tall, not very big, black-eyed, something pale-faced and a little outlandish-like swarthy colour'.[2] Her numerous pregnancies initially produced no long-lived heir. She had a miscarriage in May 1674, a short-lived daughter in January 1675, further miscarriages in May and October 1675, a short-lived son in November 1677 and another short-lived daughter in August 1678. She eventually gave birth to a son, James Francis Edward (later the Old Pretender), in 1688.

Soon after her arrival in London Mary sat to the leading court painter Sir Peter Lely, and a number of portraits of her by Lely and his studio survive.[3] Her hairstyle and dress in the present portrait suggest that it was painted soon after she arrived in England. By this time Lely's streamlined studio production process meant that poses were being repeated.[4] He had previously already borrowed the composition devised by van Dyck for his portrait of *Dorothy Sidney, Lady Spencer, later Countess of Sunderland* of c.1637–9 (no.53),[5] and he has broadly done so again here. Mary picks blossom from an orange tree with her right hand; her left hand rests on a ledge in the foreground and grasps another sprig of blossom.[6] Orange blossom was symbolic of marriage, and appropriate for a portrait of a recently married woman – one who may, indeed, have been pregnant at the time it was painted.

Nothing is known of the circumstances in which it was made, although the Duke of York regularly commissioned works from Lely. Mary herself seems not to have established links with any one particular portraitist: she was also to be painted by Simon Verelst (c.1644–1721), John Riley (1646–91), Sir Godfrey Kneller and Willem Wissing. A mezzotint after the present portrait, naming the sitter as the Duchess of York, was produced by Abraham Blooteling (1640–90, arrived in Britain around 1673) and copied by subsequent engravers.[7]

When Mary became Queen Consort on the death of Charles II on 6 February 1685 she had no living children. The birth of her son James Francis Edward on 10 June 1688 precipitated the decision of the Protestant William of Orange to invade Britain in order to restore Protestant rule. Mary and her husband, by then James II, escaped with their infant son to exile in France, while William took the British throne with his wife, James's daughter by his first marriage, to rule as William and Mary. KH

Notes
1 *ODNB* 2004, vol.37, pp.97–103, entry on Mary [Mary of Modena] by Andrew Barclay; Andrew Barclay, 'Mary Beatrice of Modena: the "Second Bless'd of Woman-kind"', in *Queenship in Britain 1660–1837*, ed. Clarissa Campbell Orr, Manchester 2002, pp.74–93.
2 *ODNB* 2004, loc. cit.
3 See MacLeod and Alexander 2001, nos.61–2, pp.158–61. A broader approach is taken in Sandra Jean Sullivan, 'Representations of Mary of Modena, Duchess, Queen Consort and Exile: Images and Texts', Ph.D. thesis, University of London 2008; the present portrait is discussed in vol.1, pp.66–8.
4 See MacLeod and Alexander 2001, pp.56–7.
5 For instance, in his portrait of *Elizabeth Percy, Countess of Essex*, c.1650 (fig.35, p.118).
6 John Jacob, *The Suffolk Collection Catalogue of Paintings*, London 1974, no.39 (unpaginated); also Anna Keay, 'The Later Stuart Portraits in the Suffolk Collection', in *English Heritage Historical Review*, vol.1, 2006, pp.62–73. I am grateful to Laura Houliston for making her unpublished catalogue entry available.
7 F. O'Donohue, *Catalogue of Engraved British Portraits … in the British Museum*, London 1912, vol.3, p.189, no.9; repr. Sullivan 2008 (see note 3), vol.2, fig.23a (unpaginated).

110
Richard Gaywood (active 1644–1668) copy
after Wenceslaus Hollar (1607–1677) after
Anthony van Dyck
Nell Gwynn c.1662–72
Etching
25.6 x 17.3
Lettered: 'Madam Gwin'
Her Majesty The Queen (The Royal
Collection Trust)

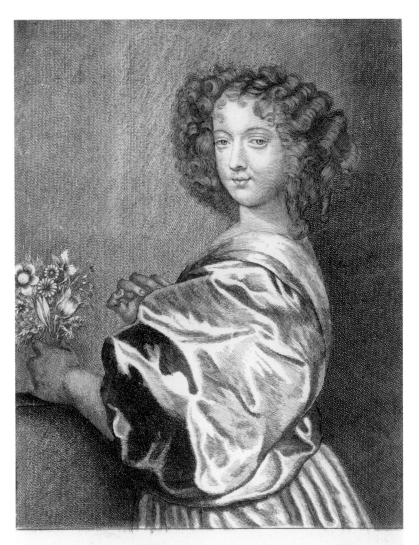

Richard Gaywood, whose oeuvre remains
to be reconstructed, was a prolific etcher
working in the manner of Hollar. He mainly
worked for the printseller Peter Stent
(active 1642–65), notable for buying up
old plates and reissuing them (including
Hollar's famous print of *Greenwich*), and
also for being the first English publisher to
issue stocklists.[1] These catalogues, issued
over a number of years, are extraordinarily
revealing and show the changing range of
his stock, including books and maps, and
of course his prices. Stent's prints are far
removed from the high-quality Antwerp
products of Martinus van den Enden and
Gillis Hendricx who issued van Dyck's
Iconography prints, which is precisely why
they are so interesting.[2]

Gaywood's print in the first state is an
exact copy, albeit in reverse, of Hollar's print
of 1646 of Margaret Lemon, van Dyck's
mistress (see no.68). It was published by
Stent and advertised in his catalogue of
1662. In this state the head has been erased
and re-engraved and the title changed,
updated to a portrait of Eleanor 'Nell'
Gwynn, Charles II's most famous mistress.
The engraved head is unconvincing and
jars with the surrounding etched lines. It is
derived from another engraving by Gerard
Valck (1651/2–1726) after a portrait by Sir
Peter Lely,[3] the principal court painter and
successor of van Dyck, and brings us up
to the licentious milieu of the Restoration
court. Unfortunately the impression is
cut and it is likely that there was further
lettering revealing the name of the publisher.
Stent died in 1665 during the Plague and
his stock was taken over by John Overton
(1640–1713). It is very likely to be Overton
who issued the revised plate, as well as
another copy by Gaywood of a Hollar print
of Mary Villiers, Duchess of Lennox and
Richmond after van Dyck,[4] reworked as
Mary of Modena, Duchess of York, who
married James, Duke of York, Charles II's
brother, in 1673. ST

Literature
Globe 1985, no.206; Griffiths 1998, p.169; New Hollstein,
pt VI, no.468 (copy).

Notes
1 His first is *A Catalogue of Plates and Pictures that are printed
and sould by Peter Stent dwelling at the Signe of the White Horse
in Guilt-Spurr Street betwixt Newgate and Pye-corner* [London
1654]. See A. Griffiths, 'A Checklist of Catalogues of
British Print Publishers c.1650–1830', *Print Quarterly*, vol.1,
no.1, 1984, pp.4–22, and Peter Fuhring, 'Bibliography of
Print Publishers' Stocklists', http://bingweb.binghamton.
edu/~gmckee/Fuhring/List.html. For a detailed analysis
of Stent's career, see Globe 1985.
2 Sheila O'Connell, *The Popular Print in England, 1550–
1850*, London 1999, pp.48–50.
3 MacLeod and Alexander 2001, no.67.
4 Pennington 1982, no.1457.

111
A list of Peter Lely's collection of paintings
sold on 18 April 1682
Wiltshire & Swindon Archives

This is a list recording the buyers, the prices they paid and the works, complete with measurements, that were sold at the sale of Sir Peter Lely's collection of paintings.[1] The sale took place on 18 April 1682 (OS), shortly after Lely's death, at his former house in the Great Piazza, Covent Garden. He may have begun to collect paintings, and in all likelihood prints and drawings also, before he arrived in London in the early 1640s. It is interesting that during these early London years he worked briefly for George Geldorp, a fellow painter and noted picture dealer. By the time of his death in 1680 Lely owned over five hundred paintings. He seems to have put the collection together for a variety of reasons, such as to confirm his status as a connoisseur and man of taste, for pedagogic benefit to himself and his studio and, very probably, to provide potential dealing stock. Together with large numbers of his own work and studio copies, the collection had to be sold in order to settle his sizeable debts and to honour the various legacies he had bequeathed to his two surviving children in London and other relatives in Holland.

The actual catalogue for this sale[2] was compiled by one of Lely's executors, the lawyer and fellow collector Roger North, most probably with the help of the still-life painter Parry Walton (Keeper of the King's Pictures from 1679 to 1690), and John Baptist Gaspars (d.1692), Lely's posture painter, who together valued the collection. Artists' names and titles and dimensions of works were clearly recorded, and notices advertising the sale and the two-week preview period were placed in the *London Gazette*. The sale itself was organised by Walton and two of Lely's studio assistants, Frederick Sonnius and Prosper Henry Lankrink, with the print dealer Richard Tompson acting as auctioneer.

Over two hundred of the paintings listed in the catalogue are by sixteenth- and early seventeenth-century Italian artists such as Veronese, Tintoretto and Jacopo Bassano. But the greater proportion were by Dutch and Flemish painters including Rubens, Antonio Mor and, as this record of the sale clearly shows, there were a large number by van Dyck. Most of these were portraits, such as a self-portrait, two large family groups and the double portrait of Elizabeth Lady Thimbelby and her sister (see no.56). But there was also 'A Crucifix with Angels' and 'A Madonna and Child' (although this may have been a copy by Lely after van Dyck which the appraisers did not recognise) and some thirty-seven preparatory grisaille sketches for the 'Iconography' series.

Some of the twenty-five works by van Dyck in Lely's collection may of course have been dealer's stock, but a number, particularly the portraits of women, may have been acquired as a direct inspiration for his own work, which they clearly influenced. According to one contemporary, the writer Bainbridge Buckeridge (1668–1733), Lely's 'wonderful stile in painting' was 'acquired by his daily conversing with the works [i.e. in his collection] of those great men'. Lely also owned a number of figurative and drapery drawings by van Dyck, and also his Italian sketchbook, which were sold in two subsequent sales in 1688 and 1694. The catalogues of these sales no longer survive. DD

Notes
1 For a detailed discussion of Lely's collection and this sale and an annotated transcription of his executors' account book, see Dethloff 1996.
2 See 'Editorial: Sir Peter Lely's Collection', *Burlington Magazine*, vol.83, no.485, August 1943.

112
Godfrey Kneller (1646–1723)
Charles II 1685
Oil on canvas
224.5 x 143
Signed and dated: 'Gotfred Kneller /
ad vivum fecit / Ao 1685'
National Museums, Liverpool, Walker Art
Gallery
[not exhibited]

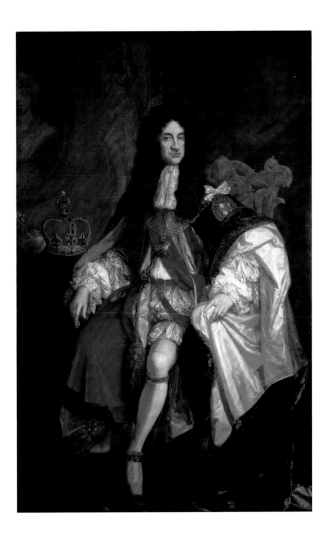

In 1689 the German-born artist Sir Godfrey Kneller was appointed William III and Mary II's Principal Painter, the prominent court office previously held by van Dyck under Charles I and by Lely under Charles II. Kneller retained the position until his death in 1723, and thus served not only William and Mary but also Queen Anne, George I and George II. The Principal Painter was responsible for creating the official likeness of the Sovereign, used for the visual presentation of the monarch to his subjects and to foreign governments overseas. As his predecessors had been, Kneller was amply rewarded for his services. As well as an annual pension of £200 (in fact, rarely paid), an entitlement to New Year gifts of silver, and payment for each portrait commission, the office brought other honours: on 3 March 1692 was knighted; in 1699 he was presented with a valuable gold chain and medal; and, a step further than any other artist, on 24 May 1715 he was created a baronet.

Following the death of Lely in 1680 the vacant Principal Paintership was given in 1681 to John Riley rather than to Kneller. But, despite never holding an official appointment under Charles II, Kneller was said to have been the king's favourite painter, who used to 'come and sit ... at the house where Sir Godfrey dwelt in the Piazza Covent-Garden'.[1] Kneller painted the king from life at least three times, in 1677/8, 1681 and 1685, and from these sittings created four distinct portrait types.[2] This powerful, penetrating image of the ageing king must have been started just a month before the king's death in February 1685. Commissioned by Charles II's brother the Duke of York, later James II, it was recorded in the King's Bedchamber at Whitehall Palace in 1693, and at St James's Palace in 1713, but how or why it broke away from the Royal Collection is not known.[3] The seated pose was used again by Kneller for his 1716 state portrait of George I.

Kneller's earliest English biographer, Marshall Smith, claimed that Kneller came to England in 1676 'longing to see *Sir Antony Van Dyck's Works*, being most ambitious of imitating that great Master'.[4] One direct copy after van Dyck is known (*Charles, Prince of Wales, later King Charles II*, Christie's New York, 17 October 2006, cat.264),[5] and it is also documented that he wished to make copies after Lord Wharton's van Dycks (see no.30); but, unlike some artists, Kneller adapted rather than slavishly utilised van Dyck's compositions for his own works. Van Dyck's images of Charles I and his family set powerful precedents, however, and in Kneller's royal works the influence was perhaps unavoidable and, in some cases, quite deliberate. The pose, elegance and commanding majesty of van Dyck's *Charles I in Robes of State*, 1636 (Royal Collection), for example, served as the model not only for Kneller's full length of Charles II, produced for the Privy Council Chamber at Holyroodhouse in 1684, but also for his full lengths of James II as well as his 1690 state portrait of William III. The use of van Dyck's pattern for the latter would have been approved of, if not deliberately requested, by the king, whose court was self-consciously traditional. Van Dyck's images of the Stuart dynasty were hung in prominent positions in William III's palaces, and William's own image in the guise of Charles I would have been a powerful visual reinforcement of his Stuart ancestry and legitimacy to the throne.[6] TB

Notes
1 Bainbridge Buckeridge, 'An essay towards an English School of painting', in R. de Piles, *The Art of Painting*, 3rd edn, 1754, p.394.
2 Gibson 1997, vol.1, pp.138–40.
3 Millar 1963, pp.141 (Millar supposes the 1685 portrait recorded in the Royal Collection to be a version of the Walker Art Gallery picture but Gibson disagrees); Douglas Stewart 1983, p.27; Gibson 1997, vol.1, p.140, and vol.2, p.354.
4 Quoted in Douglas Stewart 1983, p.11.
5 A late work, probably painted in 1641, of which numerous versions exist. Kneller's copy is claimed to be taken from the best version, now in the Newport Restoration Foundation, Rhode Island, but in the latter the Prince wears shoes with silk bows whereas Kneller paints him with boots. Kneller's copy is signed *Gottfried Kneller*, which has prompted suggestions that it was painted before his arrival in England in 1676. Kneller, however, signed his name in a variety of ways before arriving at the anglicised Godfrey Kneller, and it seems more likely that it was painted in England.
6 William III's conscious emulation of Charles I was discussed by Andrew Barclay in his paper 'William III's Royal Court' at the conference *William III: Politics and Culture in an international context*, University of Utrecht, 12–15 December 2002, and in his paper 'A Very English Court: William III and the British monarchy 1689–1702', Society for Court Studies seminar, 9 June 2003.

Van Dyck's Continuing Influence

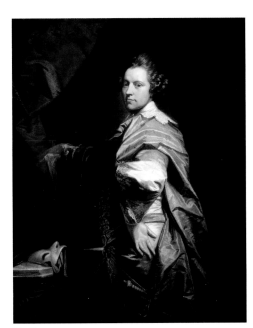

Fig.54
Richard Cosway
Self-portrait in Vandyke Dress c.1770
Oil on canvas
130 x 102
National Trust, Attingham Park

'English Art had no childhood, it did not pass through the infant stages observable in that of Italy, it sprang at once from a highly organised basis, from Van Dyck and the Venetians'. This was John Evan Hodgson (1831–95), Professor of Painting at London's Royal Academy, in the 1890s, looking back at the art of the eighteenth and nineteenth centuries. Henry Fuseli (1741–1825), who became Professor of Painting at the Academy in 1799, was equally convinced that the art of his own era owed everything to lessons learnt during the age of Charles I. As he put it, 'Charles indeed called Rubens and his scholars to provoke the latent English spark….'. Almost every writer from the second half of the eighteenth century traced the origins of English painting to the influence of Titian and Rubens as translated by van Dyck. Not only had van Dyck spent a significant proportion of his working life in London and left behind many works that could be studied at first hand, but his art formed a bridge between the Italian Old Masters and a modern way of interpreting the world.

Eighteenth-century attitudes to van Dyck were, to a surprising degree, shaped by the writings of the painter Jonathan Richardson the Elder (no.113). Sir Joshua Reynolds, first President of the Royal Academy, set great store by Richardson, and even claimed that it was reading his essays that had inspired him to become a painter. Reynolds's rival Thomas Gainsborough, a supposedly un-bookish painter, quoted from Richardson in a letter to a friend written in the 1760s. Richardson's *Essay on the Theory of Painting*, first published in 1715, praised the grace and expression of van Dyck's portraits and (importantly for Gainsborough) the artist's handling of paint; he also advised painters to use 'Van-Dyck's Heads', or the collection of prints now commonly referred to as the *Iconography* (see no.73), as a source book. Richardson's practice as a portrait painter had an effect as long-lasting as that of his writings. He was master to Thomas Hudson (see no.122), who became one of the busiest English artists of the mid-century and was in turn tutor to Reynolds (nos.118, 122), Joseph Wright of Derby (1734–97) and, for a short spell, Richard Cosway (fig.54). Throughout his career Richardson had amassed a fine collection of drawings; these too served to educate and inform succeeding generations of painters. Thomas Hudson purchased eight drawings by Rubens and thrity-one by van Dyck from Richardson's sale. Van Dyck's drawing *Endymion Porter with his Son* (no.83) belonged to Richardson, to Hudson and then to Gainsborough's friend Uvedale Price (1747–1829), writer on the Picturesque; the drawing *Lucy Percy, Countess of Carlisle* (no.85) passed from Richardson via Hudson to Reynolds.

Jonathan Richardson's son, also Jonathan, is responsible for one of the most moving tributes to van Dyck ever written by a painter. He is recording his impression of the full length of Cardinal Bentivoglio, which he saw at the Pitti Palace in Florence:

> Cardinal *Bentivoglio* (the same of which *Morin* has finely Etch'd the Head) I never saw any thing like it. I look'd upon it two Hours, and came back twenty times to look upon it again. He sits in an Elbow Chair, with his Elbows upon the Arm of the Chair, and his Hand (the most Beautiful and Graceful in the World) falls carelessly in his Lap by the other, which most unaffectedly gathers up his Rochet … His Face has a Force beyond any thing I ever saw, and a Wisdom, and Solidity as great as *Raffaele*'s, but vastly more Gentle….[1]

Richardson's parenthetical reference to Jean Morin's etching, which he evidently knew well, reminds us that it was largely through prints that van Dyck's

Van Dyck's Continuing Influence

images were dispersed. Gainsborough owned a copy of the *Iconography*, and almost every artist's studio sale of the period contained bundles of prints after van Dyck. Some of these were reissues of old plates, others modern, and it is possible to identify waves of interest in van Dyck following the publication of certain collections of prints. In 1708 the Huguenot Simon Gribelin (1661–1733) republished a set of twelve half-length van Dyck 'Countesses' by Peter Lombart (see no.105) as 'one of the best performances in Graving and very proper to adorn any rooms'. These were complemented in 1713 by a series of full-lengths drawn by Arnold Houbraken, engraved in Amsterdam and distributed in England. Line engravings, as Richardson pointed out, could only convey the composition of a painting, and it took James MacArdell and a number of other mezzotint engravers of the mid-eighteenth century to bring a sense of van Dyck's softness of touch and tonality to a wide public. *The Houghton Gallery*, a set of modern reproductive prints of Sir Robert Walpole's collection at Houghton Hall in Norfolk, was one of the last great series to include a large group of van Dycks. Since the project coincided with the sale of the collection to Catherine the Great of Russia in 1779, it attracted a great deal of interest. At no other time had such a group of van Dyck canvases been lost to this country.

The Richardsons were concerned with van Dyck's way of painting, or as another theorist, Roger de Piles (1635–1709), expressed it, the ability to 'see with Vandyke's eyes'. Alongside this artistic preoccupation there developed a fashion for what became known as 'Vandyke dress'. This was a form of fancy dress, often designed for use at masquerade balls, and popularly worn for portraits. Aileen Ribeiro has pointed out that Vandyke dress was deemed particularly appropriate for portraits of sitters with specialist antiquarian and aesthetic interests. Sometimes sitters wore Vandyke suits or dresses that are known to have been their personal property; on occasion they were painted in artists' studio costumes or clothes of the artist's invention. A sitter to the miniature painter Sykes of Yarmouth noted that after he had his portrait painted in a grey Vandyke suit two other gentlemen asked to be painted in the same dress. Confusingly, one of the most familiar forms of so-called Vandyke costume is derived from a painting now known to be by Rubens (no.120). The portrait, known as 'Rubens's Wife', or 'Helena Fourment', was purchased around 1730 by Sir Robert Walpole (1676–1745) as the work of van Dyck, and created a sensation. English artists produced a rash of imitations, even before the portrait had been reproduced in mezzotint in the mid-1740s.

One of the picture's most skilled interpreters was the drapery painter Joseph van Aken, a Fleming who had settled in England around 1720 (no.121). Van Aken worked for Jeremiah Davison (c.1695–1745), Henry Pickering (active 1740–71), Isaac Whood (1688–1752), Hudson and Allan Ramsay, taking over their canvases once the heads had been painted. Some provincial artists even sent to van Aken heads painted on small pieces of cloth which he then let in to full-length canvases. In 1743, spurred on by the success of his association with Rubens and van Dyck, van Aken and his London-based compatriot Michael Rysbrack came up with a scheme to 'publish', as sets of plaster casts, sculptural portraits of Rubens, van Dyck and the sculptor François Duquesnoy (1597–1643). These elegant small full-length figures by Rysbrack were also a response to the popularity of the memorial sculpture of Shakespeare by Peter Scheemakers (1691–1781), carved in 1740 for Westminster Abbey, a Shakespeare romantically dressed in Vandyke costume.

Painters had clear reasons for associating themselves with van Dyck, and many did so by painting themselves as van Dyck, or in Vandyke costume, at the outset of their careers (no.129). Patrons had a range of motives for commissioning portraits in van Dyck mode and looked to a variety of models, one of the most famous of which was the *Pembroke Family* (fig.32, p.108), then, as now, at Wilton, near Salisbury. The picture was well-known through prints and was copied on a small scale by a number of painters including Gainsborough and his nephew and pupil, Gainsborough Dupont (1754–97). The central figure in the *Pembroke Family*, Charles, Lord Herbert, heir to the family title and fortune, was picked out by Thomas Jefferys in his *Collection of Dresses of Different Nations* for a plate entitled 'Habit of an English Gentleman, in 1640' (no.120). Jefferys' costume book, the first of its kind to be published in England, appeared in 1757. At exactly the same date John Astley (1724–87), a former pupil of Hudson, and (briefly) of Batoni, was creating the largest of all British derivations of the *Pembroke Family*. This was a group portrait of *The Family of Marcus Beresford, Earl of Tyrone* (fig.55), a *tour de force* containing eleven life-sized figures in Vandyke dress, arranged with the heir, George de la Poer Beresford, the future 1st Marquess of Waterford occupying the position of the eldest son in the *Pembroke Family*. Astley's is, like van Dyck's original, a dynastic portrait, celebrating the bringing together of two important families, in this case the De la Poers and the Beresfords, and dates from the year of George de la Poer Beresford's coming of age.

Other families commissioned portraits in Vandyke costume or van Dyck style to complement 'real' examples in their collections. Descendants of the sitters in van Dyck's *Pembroke Family* had the young 10th Earl of Pembroke painted in Vandyke dress in 1748 (Fitzwilliam Museum, Cambridge); the Digby family, owners of several important van Dyck portraits, employed the eighteenth-century van Dyck specialist John Giles Eccardt (d.1779) to paint Edward, the 6th Lord Digby and Henry, the 7th Lord (Sherborne Castle). For the Marquess of Rockingham, who owned van Dyck's famous *Thomas Wentworth, 1st Earl of Strafford, with Sir Philip Mainwaring* (no.57), Sir Joshua Reynolds painted Rockingham with Edmund Burke (Fitzwilliam Museum, Cambridge), a modern version of van Dyck's composition that was unfortunately never completed. The Spencer family of Althorp, owners of the splendid double portrait of Lords Digby and Russell by van Dyck (fig.29, p.86), employed Angelica Kauffmann to paint George John, Lord Althorp (the future 2nd Earl Spencer) in a white Vandyke suit and had Reynolds paint him in a slate-grey Vandyke suit: both these portraits belong to the mid-1770s. Lord Althorp had blue eyes and striking red hair which, in both portraits, he still wears at shoulder-length, making him a handsome and credible companion for Lords Digby and Russell. Reynolds's *Lord Althorp* was, in fact, designed to hang alongside the van Dyck. In 1743 the Spencers had also purchased a bust of van Dyck from Rysbrack. In 1786 Gainsborough was asked by Thomas Coke (1754–1842) to paint an equestrian portrait of the Prince of Wales (the future George IV) to hang at Holkham Hall as a pendant to van Dyck's *Albert de Ligne, Prince of Arenberg and Barbançon* (see no.127).

Some eighteenth-century van Dyck-inspired portraits were designed to mark the restoration of family prestige, others were made for the newly rich who wished to create instant portrait galleries. It was again in the 1780s that Gainsborough painted portraits of the 11th and 12th Dukes of Norfolk in black Vandyke suits, the older duke being supported (like the Pembrokes in van Dyck's group portrait) by an armorial plaque drawing attention to his lineage and his felicitous marriage

Fig.55
John Astley
The Family of Marcus Beresford, Earl of Tyrone 1757
Oil on canvas
263 x 411.5
Private collection

Van Dyck's Continuing Influence

to an heiress. Charles Howard, the 11th Duke, was, of course, descended from one of van Dyck's most important English patrons (see nos.7, 38). He was devoted to the restoration of Arundel Castle and its picture collection and had already commissioned portraits of himself in Vandyke dress from Nathaniel Hone (1718–84) and Nathaniel Dance (1735–1811).

The family of the 1st Lord Berwick had a more tenuous link with van Dyck and the age of Charles I, but one that they were equally keen to exploit in their new country seat, Attingham Park, in Shropshire. Lord Berwick, builder of Attingham, married, in 1768, Ann Vernon, a collateral descendant of van Dyck's patron Thomas Wentworth, 1st Earl of Strafford (no.42). The Berwicks named their eldest daughter Henrietta Maria; their son Thomas Noel Hill, 2nd Lord Berwick, commissioned a portrait of himself in Vandyke dress from Angelica Kauffmann. The younger Lord Berwick also acquired for Attingham copies of van Dyck's *1st Earl of Strafford* and of the double portrait of Strafford with his Secretary, Sir Philip Mainwaring. At Attingham he also hung Richard Cosway's *Self-portrait* in Vandyke dress (fig.54, p.205). The 1st and 2nd Lord Berwicks' extravagant building and collecting could not be sustained and most of the contents of Attingham had to be auctioned in 1827.

Although the Noel Hills were, by comparison with the Howards of Arundel, *nouveau riche*, they were of 'good' breeding. Sitters of the period with few or no claims to family wealth or rank could use portraits of themselves in Vandyke dress to add sophistication and, perhaps, a feeling of age, to their drawing rooms. Henry Pickering painted a number of such portraits of mayors of north country towns, often pairing them with portraits of their wives, also in Vandyke costume. These are charming and often rather touching portraits, but they are probably the kind of pictures that Reynolds had in mind when he complained in 1776 in his *Seventh Discourse* that through the use of this 'fantastick' costume, 'very ordinary pictures acquired something of the air and effect of Vandyck, and appeared therefore at first sight to be better pictures than they really were'.

In England, at the end of the eighteenth century, Vandyke dress remained popular for theatrical subjects, but it was less used for society portraiture. In 1795 the Academician Martin Archer Shee (1769–1850) completed a portrait which, he told a correspondent, he had painted in Vandyke dress, 'to have it a little out of the common way'. Enthusiasm for van Dyck's way of painting had not waned. A visitor to Petworth in 1798 saw in the Great Hall, 'several of the pictures of Vandyke standing, and Collins the Miniature painter, Philips the Portrait Painter, and a Clergyman from Cambridge copying them'. Sir Thomas Lawrence (1769–1830), the painter who guided British art into the new century, was, like Reynolds and Gainsborough, often compared to van Dyck – not because Lawrence favoured Vandyke dress, but because the easy elegance of his figures, his seemingly effortless brushwork and glowing colours were recognised as belonging to the van Dyck tradition. The artist James Ward (1769–1859) thought Lawrence's great triple portrait of the directors of Barings bank, exhibited at the Academy in 1807, 'equal to the works of Vandyke or Rubens'. Such was van Dyck's enduring reputation that this was still the highest compliment one painter could pay to another. SS

The Nineteenth and Twentieth Centuries

In the nineteenth century van Dyck continued to be a source of inspiration, principally in the work of Sir Thomas Lawrence. But after his death, and the end

of the Georgian monarchy, interest in the flamboyance and panache of van Dyck waned. The reign of Queen Victoria witnessed a new-found earnestness and seriousness in British culture, at odds with what was perhaps perceived as the sensuousness of seventeenth-century court painting. Coinciding with the institutionalisation of the British Empire, there was an additional new imperative to define the national school of painting and protect it from alien influences: French tendencies were viewed with suspicion, although the precision of German art found moral approval and imitation. However, in the last two decades of Victoria's reign there was a revival of historical interest in all things seventeenth-century and this found expression variously in genre paintings of the English Civil War; the popularity of 'Jacobethan' furniture and architecture; and historical romances such as Richard Blackmore's novel *Lorna Doone* (1869) or Captain Maryat's *Children of the New Forest* (1847), both of which sold in record-breaking numbers. At the International Exhibition in Paris in 1900, to celebrate the birth of the new century, the French presented a spectacular display of cutting-edge Art Nouveau design under the guidance of innovative art dealer Siegfried Bing (1838–1905). But the British Pavilion looked backwards. Designed by Edwin Lutyens (1869–1944), it was a replica of a seventeenth-century manor – Kingston House in Bradford on Avon. Inside, the house was filled with Jacobethan furniture and fittings. 'There is nothing to surpass it', commented *Country Life*, 'because there is nothing more artistically charming' (20 October 1900, p.488). Further expression of these interests was found in the fashion for dressing up in so-called 'Vandyck' costume at fancy-dress balls, most famously the Marlborough House Ball in 1874 and Devonshire House Ball in 1897, events that recreated the aristocratic grandeur of a lost age.

For a new generation of young British artists who were rediscovering the interests of seventeenth-century painters van Dyck came to be a particular inspiration, along with Velásquez (1599–1660) and Rembrandt (1606–69). This was represented and encouraged by major surveys at the Royal Academy of Rembrandt and van Dyck in 1898 and 1900 respectively, and by the willingness of art teachers at the progressive Slade School to expose students to the Old Masters and have them copy seventeenth-century drawings at the British Museum and elsewhere.

Much of the artistic following can be ascribed to a revival of van Dyck's visibility, especially towards the end of the nineteenth century. Publishing played an important role, but more central was the appearance of works in Royal Academy Winter Exhibitions. Paintings became available on the open market due to an economic crisis facing the landed aristocracy from the 1880s. After the American Civil War cheap grain flooded Britain and aristocratic landowners found their estates economically unviable; a social group that had prided itself on the power that land brought, now saw it evaporate in a new economy.

The principal beneficiary of van Dyck's artistic legacy was the Florence-born American painter John Singer Sargent. Initially based in Paris, Sargent settled in London in 1886. When he first arrived in England he was viewed with suspicion as an 'Impressionist' painter; but by acknowledging modern French ways of painting while associating them with seventeenth-century prototypes Sargent assured his own success. Furthermore, his 'new money' sitters were flattered to be given the appearance of 'old money' aristocrats into whose houses they had moved. RU

Notes
1 Jonathan Richardson the Elder and Jonathan Richardson the Younger, *An Account of some of the Statues, Bas-reliefs, Drawings and Pictures in Italy, etc with Remarks*, London 1722, pp.72–3.

Van Dyck's Continuing Influence

113
Jonathan Richardson the Elder (1667–1745)
Two Discourses: I, An Essay on the whole
Art of Criticism as it relates to Painting; II,
An Argument on behalf of the Science of a
Connoisseur
London 1725
Printed book
The British Library, London

Jonathan Richardson was a pupil of the
painter John Riley (1646–91) who, in
turn, had been taught by Gerard Soest
(c.1600–81). Although he was himself a
busy portrait painter, it was as a writer that
Richardson had more influence over the
course of eighteenth-century British art.
His essays, in shortened versions under the
general title of the *Works of Mr. Jonathan*
Richardson, were republished long after his
death, in 1773 and 1792. In 1715, in the *Essay*
on the Theory of Painting, Richardson had
declared that 'when *Van-Dyck* came Hither, he
brought *Face-Painting* to Us: ever since which
time … *England* has excell'd all the World in
that great Master Branch of Art'.[1] As Carol
Gibson-Wood has shown, Richardson wished
to 'alter the way in which people thought
about painters and painting' so that native
artists could enjoy a higher level of self-
esteem and set their sights on new heights
of achievement.[2]

In his *Art of Criticism* Richardson
suggests methods for appraising works
of art. He acknowledges that prints are
a useful introduction to the work of the
best artists, but reminds readers that
engravings can only convey the composition
of a painting. He recommends a scale of
excellence based on that devised by the
Frenchman Roger de Piles in the previous
century, and advises connoisseurs to
carry a small pocketbook marked up with
this scale, so that they could record their
impressions when standing in front of
original paintings. Richardson's scale
offered marks for each of the various
qualities of a picture: composition,
colouring, handling, drawing, invention,
expression, grace and greatness, advantage
and pleasure. As an exemplar Richardson
records his own assessment of van Dyck's
Frances Brydges, Dowager Countess of Exeter,
a picture that is now lost, but whose
appearance is known through a copy at
Burghley House, van Dyck's compositional
sketch (fig.56), and Faithorne's engraving
(no.114).

Unsurprisingly, van Dyck scored highly
in Richardson's analysis. Richardson, like
his son, was particularly impressed by van
Dyck's ability to convey emotion. In the eyes

of the Countess of Exeter he perceived the
sorrow of widowhood:

> Never was a Calm becoming Sorrow
> better Express'd than in this face chiefly
> there where 'tis most conspicuous, that
> is in the Eyes: Not *Guido Reni*, no, nor
> *Raffaelle* himself could have Conceiv'd
> a Passion with more Delicacy, or more
> Strongly Express'd it![3]

The use of a scale, or 'balance' as it was
termed by De Piles, to evaluate artists or
works of art, was imitated by others and
applied to poets and orators. In 1776 the
Gentleman's Magazine published a similar table
of marks for musicians, awarding marks to
Arne, Handel, Boyce and others for qualities
such as 'original melody' and 'expression'.[4]
Popular newspapers carried things even
further and marked fashionable ladies of the
day on such niceties as their complexions and
their deportment. SS

Notes
1 Jonathan Richardson, *An Essay on the Theory of Painting*,
London 1715, p.41.
2 Gibson-Wood 2000, p.88.
3 Richardson 1725, pp. 63–4.
4 *Gentleman's Magazine*, vol.46, December 1776, pp.543–4.

Fig. 56
Anthony van Dyck
Frances, Countess of Exeter, seated
Chalk on paper
34.7 x 27.4
The British Museum, London

114
William Faithorne (1621–1691) after
Anthony van Dyck
Frances, Countess of Exeter date unknown
Engraving
28.6 x 21.2
Lettered: 'Francesca Bridges Filia Domini
Cavendish / et Dotissa Exoniæ Comitisa';
below left: 'Ant: van Dyck pinx:'; and at
right: 'Guil: Faithorne excud:'
The British Museum, London

William Faithorne was the most talented
native English engraver of his era. He was
apprenticed to the printseller William Peake
and then to his son Robert Peake, who
published his first prints between about
1640 and 1642. Among these early prints
there are a number after portraits by van
Dyck, and these inevitably include saleable
royal portraits of Charles I and Henrietta
Maria, 'The most Mightie and Illustrious
Prince Charles' – the future Charles II – and
also 'The most Excellent and High Borne
Princess Mary' and 'The most Renowned and
Hopefull Prince William', made in 1641 to
coincide with their dynastic marriage. There
are also notable portrait heads after portraits
by van Dyck of James, 3rd Marquess and
1st Duke of Hamilton (1606–49) and Henry
Rich, 1st Earl of Holland, both beheaded
as royalist casualties of the Civil War, and
also of James Stuart, 4th Duke of Lennox
and 1st Duke of Richmond (1612–55),
and Prince Rupert (1619–82). Faithorne
later also engraved some striking portraits
after William Dobson and Robert Walker
published by Thomas Rowlett.

Around 1646–7 Faithorne spent some
time in Paris, where he mingled with the
advanced community of printmakers and
publishers around the rue St Jacques. He
was back in London in 1652, when he
was made a Freeman of the Goldsmiths'
Company. Although he specialised in
portrait engravings, he was also an able
draughtsman and had the ability to draw
ad vivum likenesses, such as the portrait of
John Aubrey (1626–97) aged forty made in
1666 (Ashmolean Museum, Oxford).[1] He
became a well-established publisher and
printseller and notably issued a translation
of Abraham Bosse's treatise *The art of
graveing and etching, wherein is exprest the true
way of graveing in copper. Allso the manner
and method of ... Callot and Mr. Bosse in their
severall ways of etching ... And sold at his shop
next to ye. signe of ye: Drake, without Temple
Barr* (1662). With the Restoration, Faithorne
was given a royal appointment and produced
a very finely engraved print of the new
Queen Catherine of Braganza (1638–1705)

after Dirk Stoop (c.1610–c.1685) in 1662.[2]
Another masterpiece of engraving is his
portrait print of Barbara Villiers, Countess
of Castlemaine (1640–1709), after Sir Peter
Lely,[3] particularly admired by Samuel Pepys
and actually recorded in his *Diary* in 1666.

The calligraphy beneath the present
print helps identify the sitter as Frances,
Countess of Exeter (1580–1663), whose
maiden name was Bridges (or Brydges).
Unfortunately it is not clear when the print
was made and published. The sitter was
the daughter of the 4th Baron Chandos;
she was twice married and widowed, first
to Sir Thomas Smith (d.1609) and then
Thomas Cecil, 1st Earl of Exeter (d.1623).
The original painting of the sitter, seated
in widow's apparel, is untraced and the
composition is only known in copies,[4] but
there is an original related compositional
sketch by van Dyck in the British Museum
(see fig.56).[5] The painting was greatly
admired by Jonathan Richardson the Elder
(see no.113). ST

Literature
Louis Fagan, *A descriptive catalogue of the engraved works
of William Faithorne*, London 1888, p.24; Griffiths 1998,
pp.125–8; New Hollstein, pt v, no.431.

Notes
1 David Blayney Brown, *Catalogue of the Collection of
Drawings in the Ashmolean Museum*, vol.4, *The Earlier British
Drawings: British Artists and Foreigners working in Britain
before c.1775*, Oxford 1982, no.123.
2 Griffiths 1998, no.132; MacLeod and Alexander 2001,
no.7.
3 O. Millar in MacLeod and Alexander 2001, no.34.
4 Barnes et al. 2004, no.IV.A14. 'The presumed original,
now lost, was probably the portrait in the possession of
Jonathan Richardson by whom it was described at length,
in 1717, and extravagantly praised (*An Essay on the whole
Art of Criticism*).'
5 Inv.Gg,1.423; Vey 1962, no.226.

115
Sarah Churchill, Duchess of Marlborough
(1660–1744)
Letter of 13 June 1734 to Diana Spencer,
Duchess of Bedford
The Duke of Bedford and the Trustees of the
Bedford Estates

A week before this letter was written the
Duchess of Marlborough reported that
nearly all the pictures she had commissioned
to decorate her house at Wimbledon were
finished, but she lacked portraits of her
granddaughter Diana, Duchess of Bedford
and Diana's husband the Duke of Bedford.
She proposed sending Isaac Whood to
Woburn with very specific instructions for
pictures of these two treasured members
of her family. She wanted Whood to
paint her granddaughter in the guise of
van Dyck's full-length portrait of Anne
Russell, Countess of Bedford, then, as
now, at Woburn. She particularly admired
the white satin clothes of the *Countess of
Bedford*, and thought that 'the Neck may
be Copy'd by the Countess of Bedford's'.
The duke, she suggested, should be painted
in Coronation robes. Her granddaughter
responded with the thought that it might
look odd for her and her husband to be
painted in clothes of different ages, but the
Duchess of Marlborough was undeterred,
noting that 'many Women are now drawn in
Vandyke's Manner, tho' Vandyke I suppose
has been Dead these Hundred Years'. If her
granddaughter was still uneasy about the
old-fashioned dress, she should ask Whood to
alter the sleeves and waistline according to
contemporary fashion. Things were resolved
by the young Diana's counterproposal
that her husband should, like her, be in a
Vandyke costume, this time taken from van
Dyck's famous double portrait of the duke's
ancestors George, Lord Digby and William,
Lord Russell, at Althorp.

One of the most interesting points
about this exchange is the Duchess of
Marlborough's lack of confidence in Isaac
Whood's ability to compose a portrait. Even
the best modern painters cannot give 'a
good Air in the dress', or 'make a Picture
stand well', in her opinion, although she is
anxious that Whood should not get wind
of her feelings. She also suggests that if
Whood copies the neck of van Dyck's *Countess
of Bedford* 'it will be more like yours than
any he will draw for you', implying that
she considers him incapable of catching
a likeness. At the same time she expects
Whood to be able to update the Vandyke
dress rather than copy it slavishly. She shows
no awareness of the fact that this part of the
picture would not necessarily be painted by
Whood himself, since he was one of those
who regularly used the drapery-painting
services of Joseph van Aken (no.121).

Unfortunately Isaac Whood's companion
portraits of the Duke and Duchess
of Bedford in Vandyke mode are now
untraced. SS

116
Francis Hayman (1708–1776)
*The Wrestling Scene from 'As You Like
It'* c.1740–2
Oil on canvas
52.7 x 92.1
Tate. Purchased 1953

In the early years of the eighteenth
century historical dramas were played in
contemporary dress, regardless of the period
in which they were set. 'Historical' or 'old
English dress', as introduced on stage, was a
romantic form of Vandyke dress.[1] So closely
was this associated with Shakespearean
drama that the playwright himself was
depicted in Vandyke costume in Peter
Scheemakers's celebrated memorial statue
of 1740 for Westminster Abbey. (Interestingly,
Scheemakers was commissioned by the 9th
Earl of Pembroke to make a version of this
Shakespeare for Wilton House in 1743.)

Hayman's *Wrestling Scene* was developed
from an illustration he provided for a six-
volume edition of Shakespeare's works,
commissioned by Sir Thomas Hanmer
in 1740–1 and published in 1743–4.
Hanmer gave Hayman instructions for the
compositions and the characterisation of
the figures in these illustrations. For the
Wrestling Scene he specified that the women

(Celia and Rosalind) 'should show greater
joy than all the rest', at the throwing of
Charles, Duke Frederick's wrestler, and that
'their figures must be set off to all possible
advantage as young beautifull and of the
highest rank'.[2] Hayman's painted version
is even clearer than the illustration in
showing that he chose Vandyke costume for
the women as a means of conveying their
elevated social status. Several of the male
actors are also given an early seventeenth-
century appearance. Again, this seems to
have been for the purposes of conferring
rank rather than for reasons of historical
accuracy.

The *Wrestling Scene* is related, in terms
of format, to a series of paintings Hayman
made to decorate the supper-boxes at
Vauxhall Gardens, a pleasure ground
somewhat like Ranelagh (see no.122). The
canvas is considerably smaller than the set
of four Shakespearean subjects designed by
the artist to decorate the Prince of Wales's
pavilion, but may have made to demonstrate
the artist's abilities to Jonathan Tyers (1702–
67), proprietor of the Gardens. SS

Notes
1 Ribeiro 1984, pp.308–12.
2 Allen 1987, p.153, no.82.

117
Thomas Bardwell (1704–1767)
The Practice of Painting and Perspective made Easy London 1756
Printed book
The British Library, London
[not exhibited]

Thomas Bardwell's *Practice of Painting* was one of the clearest technical guides for aspiring artists. Like any other book of its kind it was partly based on earlier texts, but it contained a higher proportion of genuine practical advice than most. Bardwell spoke from personal experience as a portrait painter, and from his observation of the painting methods of some of his contemporaries. Among those he apparently saw at work was Joseph van Aken (no.121), whom he described as 'the best Drapery-painter we ever had in England'.[1] Bardwell acknowledged the overriding influence of Sir Godfrey Kneller (see fig.46, no.112) on painters of his own generation. He believed that Kneller was, in his time, 'the best Face-painter in Europe', and that most English artists followed Kneller's example in terms of technique and studio practice. Kneller was much admired for the vigour of his brushwork, even by painters of the next generation such as Gainsborough, whom we more readily associate with van Dyck. In 1758 Gainsborough wrote to a client in response to a criticism of his own visible brush strokes. Sir Godfrey Kneller, he said, had shown that 'pictures were not made to smell of; and what made his pictures more valuable than others with the connoisseurs was his pencil or touch...'.[2] Nevertheless, for Bardwell and Richardson, and subsequently for Reynolds and Gainsborough, the colour, grace and expression of van Dyck's portraits put Kneller's work in the shade, and it was to van Dyck that they returned for inspiration.

At a time when it was *de rigueur* for any self-respecting young gentleman to make a Grand Tour to Italy, Thomas Bardwell suggested that, for students of art 'and other mistaken men', such an excursion was a waste of time. Instead, he proposed that they would do well to stay at home, study the works of van Dyck and observe the beauties of English ladies. As a painter, Bardwell practised what he preached. His *Francis, Earl of Dalkeith* (private collection), for example, is, in terms of pose and dress, a mirror image of van Dyck's *William Villiers, 2nd Viscount Grandison* (Duke of Grafton, Euston Hall, Suffolk).[3]

In fact, some of the young artists who trod the traditional route to Italy did not set their sights exclusively on the Italian Old Masters, or antique sculpture, but included visits to collections containing works by van Dyck in their itineraries. The younger Jonathan Richardson could hardly tear himself away from van Dyck's *Cardinal Bentivoglio* in Florence. The Scottish painter Katharine Read (1723–78), once darkly accused of being involved in a 'propagandist trade in Jacobite icons', made a copy of van Dyck's *Three Children of Charles I* on her arrival in Rome in 1751.[4] Her model was presumably an early version or copy of that subject then in the ownership of someone associated with the exiled Stuart court. Another Scot, George Willison (1741–97), displayed in his studio in Rome in 1764 his copy of the same van Dyck royal group portrait.[5] Batoni and then Angelica Kauffmann kept the spirit of van Dyck alive among English travellers to Italy until the end of the century (no.127). SS

Notes
1 Kirby Talley 1978, p.103.
2 *The Letters of Thomas Gainsborough*, ed. John Hayes, New Haven and London 2001, p.11, no.5.
3 Ribeiro 1984, p.194 and plates 25, 26.
4 Margery Morgan, 'Katharine Read: A Woman Painter in Romney's London', *Transactions of the Romney Society*, vol.4, 1999, pp.14–15.
5 Ingamells 1997, p.1005.

118
Joshua Reynolds (1723–1792)
Susannah Beckford 1756
Oil on canvas
127 x 102.2
Tate. Purchased 1947

Susannah Love (d.1803) married Francis Beckford, son of Peter Beckford, Governor of Jamaica, in 1755. She and her husband celebrated their union by sitting to Reynolds for portraits during that year. The plantation-owning Beckfords were famously wealthy, and Susannah herself already had a private fortune of £20,000.[1] Reynolds adopted the unusual device of using a male van Dyck pose for Susannah Beckford and a female one for Francis Beckford. *Susannah Beckford* is derived from van Dyck's Lord Russell in the well-known full-length of Lords Digby and Russell at Althorp. Reynolds had used the same Lord Russell pose for another female portrait, *Mrs Hugh Bonfoy*, a year earlier (Trustees of the St Germans Estate, Port Eliot, Cornwall). That picture was one of the first of Reynolds's works to be engraved and thereby made available to a public beyond the immediate family of the sitter: it was reproduced in mezzotint by James MacArdell in 1755.

In 1755 Reynolds copied van Dyck's Lord Russell in a more straightforward way for his half-length of John Proby, 1st Baron Carysfort, in Vandyke dress (Elton Hall Collection, Cambridgeshire). Although Mrs Beckford's pose recalls Lord Russell, her dress is a modern gown of the 1750s, with no hint of Vandyke or masquerade style. The Beckfords were probably unaware of the source of Reynolds's composition and simply chose an attitude based on MacArdell's mezzotint of the elegant Mrs Hugh Bonfoy.

Reynolds's work regularly invited comparison with van Dyck. His knighthood, which resulted from his appointment as first president of the Royal Academy in 1769 and placed him in a position of social privilege, further encouraged the view that he was van Dyck's natural successor. His *Earl of Cholmondeley* (Marquess of Cholmondeley, Houghton Hall), exhibited at the Academy in 1780, was described at the time in the *Candid Review* of the exhibition as depicting the earl

in his robes, with his Coronet in his hand, and walking in an agreeable landscape, which is finely contrived to relieve the figure. The drapery is graceful, and richly coloured, and it altogether forms a picture equal to a *Vandyke*.[2]

Critics sympathetic to Reynolds's artistic rivals were not above turning the comparison with van Dyck to his disadvantage. The huge group portrait, *The Marlborough Family*, painted in 1777–8 for Blenheim Palace, was held by some to be a modern masterpiece. When it was exhibited at the Academy in 1778, the *Morning Post*, under the editorship of Gainsborough's friend Henry Bate, thought otherwise and invoked the name of van Dyck to make the point:

Nothing could equal my astonishment as well as disappointment on seeing the picture of the *Marlborough* family, which has been puffed to that degree, as superior to the famous one of the Pembroke family, painted by Van Dyck; – in every respect I think it one of the worst performances I ever saw.[3]

Bate's criticism makes it clear that by 1778 the link between Reynolds and Van Dyck was firmly established in the public mind; the conscious process of building that link had been set in train by Reynolds himself in the 1750s with such portraits as *Susanna Beckford*. SS

Notes
1 Mannings 2000, 1, p.82, no.147.
2 Anon., *A Candid Review of the Exhibition (Being the Twelfth) of the Royal Academy … By an Artist*, London 1780, pp.16–17, no.xxxii.
3 *Morning Post*, 4 May 1778.

119

Thomas Jefferys (1719–1771)
A Collection of the Dresses of Different Nations,
Antient and Modern, and more particularly Old
English Dresses after the Designs of Holbein,
Vandyke, Hollar
London 1757
Printed book
The British Library, London

This, the first history of costume in
English, acted as a guide for the makers
of masquerade costumes and for painters.
Jefferys was a print and map seller and
geographer to the Prince of Wales. An
ingenious and entrepreneurial businessman,
he also turned a map of Europe into a board
game and inspired his apprentice John
Spilsbury (1739–69) to create 'dissected
maps', the first jigsaw puzzles.

Richard Cosway owned a copy of
Jefferys's *Collection of Dresses* and made
drawings after several of the illustrations,
including *The Habit of a Nobleman of England*
in 1640, a plate derived from van Dyck's
William Villiers, 2nd Viscount Grandison (Duke
of Grafton, Euston Hall, Suffolk).[1] Cosway
then adapted this figure for his *William,*
3rd Viscount Courtenay (Lord Courtenay), a
portrait that marked Courtenay's coming of
age and shows him in the Vandyke costume
he wore for the celebrations. SS

Note
1 Jefferys 1757, II, p. 217.

120
James MacArdell (c.1729–1765) after Peter
Paul Rubens (1577–1640)
Rubens's Wife undated
Mezzotint
Inscribed: 'Sr Ant Van Dyke pinxit' and'
Rubens' 2d Wife'
The British Museum, London

The painting after which MacArdell's
mezzotint is engraved was commonly known
in the first half of the eighteenth century
as 'Rubens's Wife', and was thought to
have been painted by van Dyck; it is now
in the Gulbenkian Museum, Lisbon, and
correctly identified as the work of Rubens.
However, it may be a portrait of Rubens's
sister-in-law Susanna Fourment. Sir
Robert Walpole, who acquired the painting
around 1730, gave it pride of place above
the mantelpiece in the Corner Drawing
Room at Houghton, his Norfolk country
seat.[1] Its impact on British art was instant,
astonishingly widespread, and enduring. Its
most subtle interpretation, and, in a sense,
its apotheosis, is Gainsborough's great full-
length of Queen Charlotte, painted in 1781
(Royal Collection). Gainsborough's portrait
does not use archaic costume, but updates
the pose, showing the queen with her hands
lightly resting above a full skirt, holding a
fan, not now an ostrich feather, but a folded
fan of her own period.

Between the third and sixth decades
of the century 'Rubens's Wife' was the
model for countless Vandyke dresses worn
at masquerades and balls, and in portraits.
The first such portrait may have been John
Vanderbank's (1694–1739) now lost half-
length of his wife, which was said to have
been painted 'in a habit somewhat like
a picture of Rubens wife' in 1732.[2] The
fashion was taken up by John Robinson
(1715–45), a pupil of Vanderbank who
was successful enough to take over Charles
Jervais's premises opposite St James's Palace
on Jervais's death in 1739, but died suddenly
in 1745, before realising his potential.[3] In
1744–5 Allan Ramsay painted a clutch of five
female portraits based on 'Rubens's Wife'.
Sir Joshua Reynolds painted *Miss Sarah Stanley*
(private collection) in this mode in 1754, and
the model was also used by Henry Pickering
and George Knapton (1698–1778).

MacArdell's mezzotint is undated, but
it cannot have been made before 1746 as it
was only in that year that the printmaker
moved to England from Dublin. In 1783 a
fresh reproduction of 'Rubens's Wife', a
stipple engraving, was made by Louis Sailliar
(1748–95) for the set of prints known
as the *Houghton Gallery*. It is probably no
coincidence that in 1784 Richard Cosway
painted a portrait of Elizabeth Milbanke,
Viscountess Melbourne (Royal Collection),
in a pose and costume adapted from
'Rubens's Wife'. SS

Notes
1 *Houghton Hall: The Prime Minister, the Empress and the
Hermitage*, ed. Andrew Moore, exh. cat., Norwich Castle
Museum and Iveagh Bequest 1996, p.138, under no.56; *A
Capital Collection: Houghton Hall and the Hermitage*, ed. Larissa
Dukelskaya and Andrew Moore, exh. cat., Somerset House
2002, pp.216–17, no.117.
2 'The Note-Books of George Vertue relating to Artists
and Collections in England', *Walpole Society*, vol.22, 1934,
pp.57–8.
3 Ibid., pp.124–5.

121
Joseph van Aken (c.1699–1749)
A Lady in Vandyke Costume undated
Black chalk, heightened with white, on blue
paper
464 x 302
National Gallery of Scotland, Edinburgh
[not exhibited]

At first sight it is difficult to determine the
authorship of many British portraits of
the 1740s. Examples by Jeremiah Davison,
Thomas Hudson, Henry Pickering and
Allan Ramsay look very alike, for the simple
reason that the same drapery painter, the
highly accomplished Joseph van Aken, was
employed by all these artists. Van Aken
arrived in England from Antwerp in about
1720, together with his artist brothers
Arnold and Alexander. By the time of his
death Joseph had earned a handsome fortune,
and won the friendship of major English
artists. In 1748 he and William Hogarth,
Hudson and Francis Hayman (see no.116)
enjoyed a Continental tour together. Certain
artists, notably Hogarth, Stephen Slaughter
(1697–1765) and Joseph Highmore (1692–
1780), claimed not to use a drapery painter,
but throughout the eighteenth century
the busiest portrait studios were sustained
by assistants, among whom van Aken was
probably the most highly respected. He
seems to have done more than just paint
costumes. The antiquary and printmaker
George Vertue (1684–1756) described him
as 'a man of good compleaxon a good round
fatt face and shortish stature', and says that
for many artists van Aken 'composed their
disposition of pictures in a much better and
more Ellegant Manner then they coud'.[1]

This chalk drawing shows how elegantly
van Aken could convert a seventeenth-
century model, *Rubens's Wife*, into a
modern portrait. This is achieved almost
imperceptibly by a subtle slimming-down of
the figure, a gentle turn of the head and the
addition of background features suggestive
of an English garden. The painting belonged
to the statesman Sir Robert Walpole, and
was believed to be by van Dyck (see no.120).
Its popularity, expressed in the form of a
host of imitative portraits and innumerable
masquerade costumes, owed a great deal to
van Aken's skilful reinvention of the work
of one of his own countrymen. In 1743–4
he collaborated with Michael Rysbrack
to produce sets of small-scale full-length
sculptures of famous Flemish artists,
Rubens, van Dyck and François Duquesnoy.[2]
Bearing in mind George Vertue's claims
about van Aken's ability to compose as well
as to paint costume, it is possible that he

advised Rysbrack on the attitudes of these
figures as well as the marketing of them.

Sitters were largely ignorant of the
role of drapery painters. William Pulteney,
Earl of Bath, sitting to Reynolds for his
portrait in 1761, reported to a friend, 'I have
discovered a secret by being often at Mr
Reynolds, that I fancy he is sorry I should
know. I find that none of these great Painters
finish any of their Pictures themselves. The
same Person, (but who he is, I know not)

works for Ramsay, Reynolds, and another,
calld Hudson'.[3] SS

Notes
1 'The Note-Books of George Vertue relating to Artists
and Collections in England', *Walpole Society*, vol.22, 1934,
pp.150–1.
2 Eustace 1982, pp.56–7, under no.57.
3 Derek Hudson, *Sir Joshua Reynolds: A Personal Study*,
London 1958, pp.53–4.

122
Thomas Hudson (1701–1779)
Mary Panton, Duchess of Ancaster 1757
Oil on canvas
239 x 137
Private collection

Mary, Duchess of Ancaster (1730–93), became a senior member of the royal household in the reign of George III. In her portrait by Hudson she wears a variety of Vandyke costume based on Sir Robert Walpole's painting *Rubens's Wife* (no.120). She is portrayed at Ranelagh Gardens, Chelsea, near the Rotunda, which opened in 1742. Ranelagh was, like Vauxhall (see no.116), a fashionable venue for concerts and masquerades. It is likely that the duchess's costume is one she wore to a ball. During the intervals of the indoor entertainments at Ranelagh the company walked in the gardens, which were lit by lamps. Not only is the duchess's dress of Vandyke style, but the rock on which she leans, which has every appearance of being based on a theatre wing, is inspired by the example of van Dyck.

Mary Panton married Peregrine Bertie, 3rd Duke of Ancaster (1714–78), in 1750. He was described by a contemporary as 'a very egregious blockhead … mulish and intractable'.[1] A noted beauty, she was a natural daughter of a royal servant, Thomas Panton (1697–1782), Master of the King's Running Horses (or royal racehorse trainer) at Newmarket. In 1761, shortly in advance of the marriage of George III, she was appointed Mistress of the Robes to the future Queen Charlotte. Despite being pregnant with her third child, and suffering from 'hysteric fits', she travelled to Mecklenburg-Strelitz to bring Princess Charlotte to England. Sir Joshua Reynolds's full-length portrait of the duchess of c.1763 (Houghton Hall, Norfolk) depicts her standing, leaning on an ermine-lined cloak, near the sea. The storm-blown ships in the background refer to the difficult passage endured by the royal party on their return to England. The duchess had her portrait painted again in 1770, in miniature, by Ozias Humphry (1742–1810), an artist then in favour with the queen (private collection). A miniature of her dating from around 1780 is set into the famous 'Ancaster Box' that also features portraits of her son, the 4th Duke, and her two daughters, the latter double portrait being the work of Richard Cosway (private collection). The duchess remained at court until her death in 1793.

James MacArdell (see no.120) scraped a fine mezzotint after Hudson's full-length of the duchess in 1757, the year the picture was painted. This print was no doubt the

source for a number of portraits by other artists that reflect the pose and costume of Hudson's picture, but Joseph Wright of Derby's remarkably similar *Mrs Ann Carver* of 1760 could be based on first-hand knowledge of the original since Wright underwent his second period of training in Hudson's studio in 1756–7. It is conceivable that Wright had a hand in the painting of the *Duchess of Ancaster*. Hudson signed the picture, but by this stage of his career he is

not likely to have undertaken a costume as complex as this unaided: in the 1730s and 1740s his most demanding draperies were deputed to Joseph van Aken (no.121). By 1757 van Aken was dead and Hudson had to look elsewhere. Wright, an experienced pupil, would have been an obvious candidate for the task. SS

Note
1 Mannings 2000, p.87, no.168.

123
Johan Zoffany (1733–1810)
*John, Lord Mountstuart, later 1st Marquess of
Bute* 1765–6
Oil on canvas
91.5 x 71
Private collection, Great Britain, lent by a
descendant of the subject

Lord Mountstuart (1744–1814) was the
eldest son of the courtier and politician
the 3rd Earl of Bute. His mother, Mary
Wortley Montagu, was the only daughter
of the famous 'bluestocking' of the same
name. Mountstuart had his portrait painted
by Allan Ramsay, Jean-Etienne Liotard
(1702–89), Pompeo Batoni, Sir Joshua
Reynolds, Nathaniel Hone, George Romney
(1734–1802), Gainsborough and Zoffany, a
remarkable record for any one man. One of
his sisters, Lady Carlow, writing to another
sister in 1781, seems to be referring to yet
another portrait, painted in Italy, when she
reports, 'the picture he sent over to my
mother, ridiculous as it is, is more like him
than I could have thought'.[1] Mountstuart
was at that time British Envoy in Turin.
Zoffany's small full-length probably dates
from the mid-1760s. In 1763–4 the artist
painted two group portraits of the sitter's
six brothers and sisters, but Mountstuart
was away on a Grand Tour from early in 1761
until 1765. His sittings must have taken
place on his return to England.

Mountstuart's elegant pose is
reminiscent of van Dyck's William,
Lord Russell, in the double portrait of
Lords Digby and Russell in the Spencer
collection (Althorp), but the costume is
an eighteenth-century confection. Aileen
Ribeiro has described it as having all
the 'fussy theatricality of a real dress', a
dress, that is, that he would have worn
to a masquerade.[2] The sword he wears is
genuinely old, an Italian seventeenth-century
cup-hilt rapier. The sumptuous painting
of the costume and confident stance of the
figure show how far Zoffany had come as
a painter since his arrival in London from
Germany in 1760. The portrait exudes an
air of self-satisfaction; from what we know
of the sitter, it is an accurate measure of his
character. James Boswell, on finding himself
in a room that Mountstuart had recently
occupied, speculated that the mirrors
round the wall had been placed there by
his friend 'who loved to look at himself,
like another Narcissus'.[3]

It may have been Mountstuart's father
the Earl of Bute who recommended Zoffany
to the king, thereby setting in train a
series of commissions that were to secure

the painter's reputation in England (see
no.124). In the 1750s the 3rd Earl had played
a key role in the education of the future
George III, and in the years immediately
following George's accession in 1760, his
influence was unchallenged. German was
still regularly spoken at court, and so, once
an introduction had been effected, Zoffany
would have been at ease in the company of
the king and queen. The *Mountstuart*
portrait illustrates, in the clearest possible way,
courtly van Dyckian style updated in line
with eighteenth-century taste. SS

Notes
1 *Gleanings from an Old Portfolio containing some Correspondence
between Lady Louisa Stuart and her Sister Caroline, Countess of
Portarlington*, ed. Mrs Godfrey Clark, I, Edinburgh 1895,
p.126.

2 Ribeiro 1995, p.208.

3 Francis Russell, *John, 3rd Earl of Bute, Patron and
Collector*, London 2004, p.73.

124
Richard Earlom (1743–1822) after Johan
Zoffany (1733–1810)
*George III, Queen Charlotte and their Six Eldest
Children* 1770
Mezzotint engraving
58.5 x 50.8
Hunterian Museum and Art Gallery,
University of Glasgow

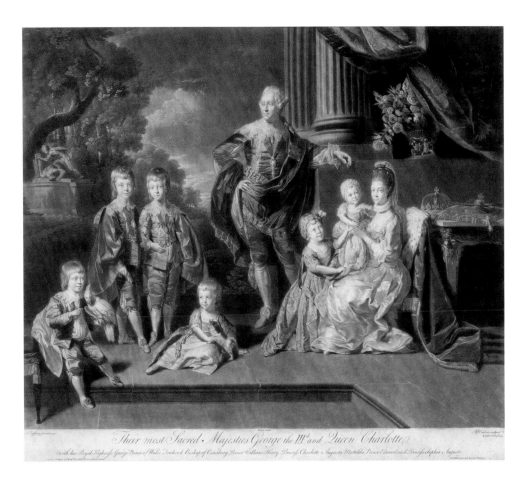

Earlom's mezzotint, engraved in October
1770 and published in January 1771,
reproduces Zoffany's royal group portrait
of 1770. In the 1760s George III brought
together at Buckingham House (later
Buckingham Palace) many of the finest van
Dycks in the Royal Collection. In 1765 he
purchased van Dyck's *Five Eldest Children of
Charles I*. This was probably the year in which
Zoffany painted the first of his eventual
twenty-one royal portraits, a remarkable
series, seventeen of which are still in the
Royal Collection.

This large group portrait by Zoffany
shows the king and the young princes in
Vandyke suits and Queen Charlotte in a
white dress that is reminiscent of those worn
by Queen Henrietta Maria in portraits by
van Dyck. The two eldest princes are posed
in the manner of van Dyck's *George Villiers,
2nd Duke of Buckingham and Lord Francis
Villiers*, a picture that hung in the royal
apartments, and beneath which the same two
princes play in another portrait by Zoffany.

In the painting the king's Vandyke
costume is of a vivid blue. Since the
canvas was painted at precisely the time
Gainsborough exhibited his *Blue Boy* at the
Royal Academy, Zoffany may have been
responding to that modern masterpiece as
well as to originals by van Dyck. The *Blue
Boy*, a poignant portrayal of a solitary youth
in a stormy landscape, was much admired,
but Zoffany's more literal updating of van
Dyck was not to everyone's taste. When
the *King, Queen and Six Eldest Children* was
exhibited at the Academy in 1771 Horace
Walpole marked his catalogue 'in Vandyck
dresses, ridiculous'.[1] Zoffany remained
faithful to the rococo style of painting he had
learned in Germany, meticulously recording
and differentiating every inch of lace and
silk; Gainsborough, by contrast, attempted
to do as Roger de Piles had advocated, to 'see
with Vandyck's eyes', creating unity of form
through the use of dramatic effects of light
and brushstrokes that blurred the outlines
between figure and background.[2]

Richard Earlom was a skilled interpreter
of contemporary portraits and of the
works of Old Masters including van Dyck.
Unusually for an engraver, he was a man

of means. This allowed him to experiment
and devise techniques appropriate to the
different styles of paintings he strove to
reproduce. He was one of the engravers
employed by the publisher John Boydell on
the *Houghton Gallery*, a set of reproductions
of the paintings from the Walpole collection
at Houghton Hall (see no.119): one of his
contributions to this project was a mezzotint
of van Dyck's *James Stuart, 1st Duke of
Richmond*, a print dating from 1773. SS

Notes
1 Quoted in Roberts 2004, p.31, no.7.
2 Roger de Piles, *The Art of Painting*, London 3rd English
edn, n.d., p.267 (1st published 1673, 1st English edn 1706).

Van Dyck's Continuing Influence

125
Thomas Gainsborough (1727–1788)
Edward Richard Gardiner c.1772–4
Oil on canvas
62.2 x 50.2
Tate. Presented by Miss Marjorie
Gainsborough Gardiner, 1965

Gainsborough's nephew Edward Richard Gardiner (b.1764) appears about eight or ten years old in this portrait. His blue Vandyke suit is very like the one that gives its name to the *Blue Boy*, a full-length portrait exhibited at the Royal Academy in 1770 (Huntington Art Collections, California). The costume appears again in an exquisite small oval portrait of another of the artist's nephews, Gainsborough Dupont, a picture dating from 1773 (Rothschild Collection, Rothschild Family Trust, Waddesdon Manor).[1] Gainsborough also painted two adult portraits featuring this suit (or one very like it), *Paul Cobb Methuen* of 1775–6 (private collection) and *Sir Charles Holte* of c. 1770 (Birmingham City Art Gallery). Paul Methuen is a young man, painted at around the time of his marriage; Holte is much older, about fifty years of age. The same suit is found again in an unfinished full-length of a youth usually dated to around 1770 (private collection).[2]

It is possible that the blue Vandyke suit was a single studio costume that Gainsborough adapted in the course of painting these six different portraits. He, like van Dyck himself, was born into a family associated with the cloth trade, and had a particular sensitivity to the cut and textures of clothing. The correspondence of Sarah, Duchess of Marlborough, concerning a portrait by Isaac Whood (no.115) proves that much lesser artists were required to make creative adjustments to costumes. (The duchess asked Whood to copy a painting of a relative by van Dyck in order to compose a portrait of her niece, but to alter the sleeves and waist in order to bring the dress into line with contemporary fashion.) It is also possible that the person who modelled the blue Vandyke suit in every case was Gainsborough Dupont, who lived with the artist's family from an early age and became officially apprenticed to him in 1772. The leap of imagination required to unite the head of a sitter with the body of a studio model or inanimate lay figure was certainly within Gainsborough's grasp; those earlier artists who had employed van Aken as a drapery painter had worked in this way as a matter of course (no.121).

The lively brushwork that characterises this affectionate portrait of Edward Gardiner bears witness to the fact that Gainsborough was not only interested in Vandyke costume, or in poses taken from van Dyck, but wanted to paint in an old-masterly manner. Fluidity of hand was perceived to be the mark of Titian's, Rubens's and van Dyck's genius. Gainsborough's copies of Titian's *Vendramin Family* and van Dyck's *Lords John and Bernard Stuart* show how carefully he observed and continued to learn from these models throughout his life. (The *Vendramin Family* (fig.40, p.134) had once belonged to van Dyck, which gave it an added significance for van Dyck admirers of the eighteenth century.) Gainsborough had clearly read Jonathan Richardson's *Theory of Painting* (1715), and had taken special note of his appreciation of van Dyck's 'handling' or brushwork. Richardson considered van Dyck's touch to be bold but never 'impudent', or bold for its own sake. Gainsborough, echoing Richardson, said of the modern art on show at the Society of Artists' exhibition in 1766 that 'there is certainly a false taste and an impudent stile prevailing, which if Vandyke was living would put him out of countenance'.[3] SS

Notes
1 Susan Sloman, '"A Divine Countenance": Gainsborough's portrait of his nephew rediscovered', *Burlington Magazine*, vol.146, May 2004, pp.319–22.
2 Rosenthal and Myrone 2002, p.34, fig.28.
3 *The Letters of Thomas Gainsborough*, ed. John Hayes, New Haven and London 2001, p.38, no.21.

Van Dyck's Continuing Influence

126
Thomas Gainsborough (1727–1788)
Commodore Augustus Hervey, later 3rd Earl of Bristol 1767–8
Oil on canvas
232.5 x 152.5
Ickworth, The Bristol Collection (The National Trust); accepted by HM Treasury in lieu of death-duties and transferred to the National Trust in 1956

Thomas Gainsborough's attachment to the works of van Dyck was legendary. His friend the musician William Jackson of Exeter (1730–1803) claimed that his last words were 'We are all going to Heaven and Vandyke is of the party'.[1] This was disputed by William Pearce, an Admiralty Clerk who was an intimate friend of the painter in his last years. Pearce, who sat at Gainsborough's deathbed, reported that he actually said only three words, 'Vandyke was right'.[2]

It was during Gainsborough's residence in Bath between 1759 and 1774 that he developed an increasingly confident style of portraiture based on the model of van Dyck. Living in the west of England gave him the opportunity to visit Wilton, where he saw the *Pembroke Family*, and other van Dyck portraits, and Longford Castle, where he would have seen one of van Dyck's portraits of Queen Henrietta Maria (no.19). *Commodore Hervey* is essentially a mirror image of another of Gainsborough's naval portraits, *Commodore Richard Howe, 1st Earl Howe* (private collection), a picture of three or four years earlier. In both paintings Gainsborough made use of the ubiquitous eighteenth-century cross-legged pose, an attitude that had been famously employed by the sculptor Peter Scheemakers (1691–1781) for his *Shakespeare* for Westminster Abbey (see no.116). In both *Hervey* and *Howe* Gainsborough painted the details of the sitters' uniforms with meticulous care and set the figures against soft, warmly lit coastal landscapes. *Commodore Hervey* is, however, a much more imposing portrait than its predecessor. A mature understanding of van Dyck brought Gainsborough to this point in his career.

Commodore Hervey takes its inspiration from van Dyck's *Algernon Percy, 10th Earl of Northumberland* (no.51), a picture Gainsborough might have seen at Cassiobury in Essex, where it hung in the eighteenth century, or known through a copy. Hervey leans on an anchor in the manner of Percy and holds a telescope that ingeniously replaces Percy's baton. Much more significantly, Hervey is, like Percy, seen from a low viewpoint, and it is this that distinguishes Hervey from Howe and raises Gainsborough's status in the competitive world of English portraiture of the 1760s. The horizon is sharply lowered from the position it occupied in the portrait of Commodore Howe. It is clear that Gainsborough, under the influence of van Dyck, added a few inches to the height of the dais on which he placed the sitters' chair in his studio, a relatively small practical adjustment that had a dramatic effect on his portraits.

Reynolds had painted a more literal interpretation of van Dyck's *Algernon Percy, 10th Earl of Northumberland* in the form of *Philip Gell* (1760–1; private collection). Throughout their competing careers both Gainsborough and Reynolds quoted from van Dyck. Gainsborough was the more intent upon painting in van Dyck's manner, and was generally recognised to be a better colourist than Reynolds. Of his copies of van Dyck originals even Reynolds said that they could be mistaken, at first sight, for the work of the master himself.[3] SS

Notes
1 William Jackson, *The Four Ages; together with Essays on various Subjects*, London 1798, p.161.
2 Farington 1978–98 edn, x, p. 3799.
3 Reynolds 1959 edn, p.253.

Van Dyck's Continuing Influence

127
Pompeo Batoni (1708–1787)
Thomas William Coke, later 1st Earl of Leicester (of the second creation) 1774
Oil on canvas
241.9 x 167.5
Signed lower right: 'P. BATONI PINXIT ROMAE AN. 1774' and inscribed: 'THIS PORTRAIT FOR / THE COUNTESS OF ALBANY, WIFE / OF PRINCE CHARLIE WAS / PRESENTED BY HER TO / MR T.W. COKE, AFTERWARDS / VISCOUNT COKE AND EARL OF LEICESTER' and on the base of the column, left: 'THOMAS WILL. COKE.'
Viscount Coke and the Trustees of the Holkham Estate

Thomas William Coke (1754–1842) inherited Holkham Hall, Norfolk, already a great repository of works of art, from his father in 1776. As a youth he took a close interest in the exiled Stuart court in Rome and in April 1772 was a witness at the marriage of the 51-year-old Bonnie Prince Charlie, known officially as the Count of Albany, but to Jacobites as Charles III. Coke's portrait by Batoni was painted in Rome in 1774, by which time the Prince's wife, the young Countess of Albany, was disillusioned and lonely, seeking solace from a group of visiting connoisseurs, artists and poets. Coke was apparently one of those young men. The inscription on Batoni's portrait asserts that the picture was a gift to the sitter from the countess.

Coke's seventeenth-century-style dress and the King Charles spaniel at his feet may be read as symbols of his links with the Jacobites, but his clothing is masquerade costume rather than something that might have been seen during van Dyck's lifetime. The suit is probably the one mentioned by the painter Joseph Wright of Derby in a letter from Rome of 10 August 1774:

> It is now Carnival time; the Romans seem to me all going mad. The gent[ln] & ladies parade in their carriages up & down a long street whimsically dressed in masques, the most beautiful of w[ch] was young Mr Coke, our Member's son. You know he is very handsome, and his dress, w[ch] was chiefly white, made him appear charming indeed[1]

White 'Vandyke' suits with pink accessories were popular in the mid-1770s and early 1780s. An outfit remarkably similar to Coke's is worn by George John, Lord Althorp, in a group portrait of him with his sisters, painted by Angelica Kauffmann (Althorp):

that picture also dates from the mid-1770s. In 1781 the Prince of Wales was asked by his brother Prince Frederic, then in Hanover, to order for him a white satin Vandyke costume trimmed with pink puffs and knots.[2]

Coke's pose is adapted from van Dyck's *Robert Rich, Earl of Warwick* (no.35). Batoni had established himself as '*the* painter of the Grand Tourist' in 1758 through a portrait of another Englishman in Vandyke costume, Sir Wyndham Knatchbull-Wyndham, a young man acutely conscious of his ancient lineage and considerable estates in the county of Kent.[3]

At home Thomas Coke was the inheritor of an equestrian portrait by van Dyck, *Albert de Ligne, Prince of Arenberg and Barbançon*, which had been acquired by his ancestor, another Thomas Coke, in Paris in 1718. The painting was engraved in mezzotint by Richard Earlom in 1783 and three or four years later Coke, the subject of Batoni's portrait, asked Gainsborough to paint an equestrian portrait of the Prince of Wales, the future George IV, to hang as its pendant. In preparation for this Gainsborough painted a scaled-down copy (now lost) of van Dyck's Arenberg picture. His *Prince of Wales* was reported by the *Morning Chronicle* to have been started about eighteen months before the artist's death in August 1788, but it was never delivered.[4] SS

Notes
1 Anthony M. Clark, *Pompeo Batoni: A Complete Catalogue of his Works with an introductory Text*, Oxford 1985, p.333, no.377.
2 Ribeiro 1995, p.208.
3 Clark 1985, p.76, no. 218; pp.275–6.
4 *Morning Chronicle*, 15 August 1788.

Van Dyck's Continuing Influence

128
Joshua Reynolds (1723–1792)
George Huddesford and John Bampfylde c.1778
Oil on canvas
125.1 x 99.7
Tate. Presented by Mrs Plenge in accordance with the wishes of her mother, Mrs Martha Beaumont, 1886

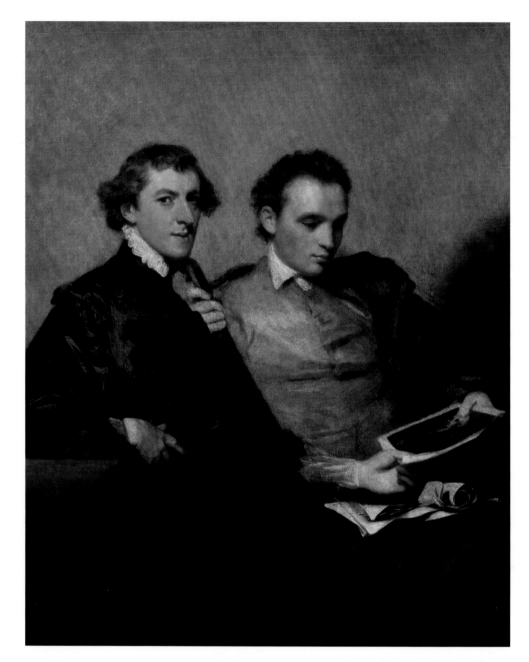

Reynolds's later interpretations of van Dyck are less literal than those of the 1750s (no.118), but no less important. Despite his criticism of artists who used Vandyke dress to give a false veneer of quality to their works, he continued to paint sitters in this way when the occasion demanded. This portrait recalls several double portraits by van Dyck, notably *Thomas Wentworth, Earl of Strafford, with Sir Philip Mainwaring* (no.57), a canvas much copied in the eighteenth century.

Huddesford and Bampfylde was no run-of-the-mill commission, but a picture full of personal significance for Reynolds, and one which he evidently planned with particular care. It was painted for George Huddesford (1749–1809) (on the left), who wears a black Vandyke suit, fitting attire for a young painter who had attended the Royal Academy Schools and was, for a short time, one of Reynolds's own pupils. He was the son of the President of Trinity College, Oxford. Huddesford's companion, John Codrington Warwick Bampfylde (1754–c.1796), a keen amateur musician and poet, was in love with Reynolds's niece Mary Palmer, and dedicated his *Sixteen Sonnets* to her in 1778. The sitters are linked by their attention to a print. This is an engraving dating from 1777 after Reynolds's portrait of Joseph Warton (1722–1800), a literary friend and member of the club to which Reynolds and Dr Johnson belonged. In 1777 Warton was instrumental in awarding to Reynolds the important commission to design the west window of New College, Oxford, a project that occupied the artist for several years.

In the emerging critical press of the 1770s and 1780s the model of van Dyck was held up as a standard of excellence against which contemporary painters could be judged. One of the weaknesses for which Reynolds was regularly chided was his careless use of fugitive colours, especially in the skin tones of his portraits. A spoof letter to the *St James's Chronicle* (16–19 August 1788) uses the example of van Dyck to emphasise the case against Reynolds. The correspondent claims to be puzzled by the 'lingua technica' of the arts as spoken by the younger generation. According to his children, he writes, 'If I look pleasant, and come in with a cheerful Countenance, they tell me I have the Air and Grace of a Vandyke; if I have a bad Night, I am told I am like a *faded* Reynolds, and have a *sombre* Hue; but, if a good one, I have the Colouring of a Titian …'. This facetious notice makes no mention of Gainsborough, but it dates from within a month of that artist's death in August 1788 and follows hard on the heels of a number of obituaries which hailed him as van Dyck's principal artistic descendant in England. The *Huddesford and Bampfylde* portrait is a reminder that throughout their rivalry in the 1770s and 1780s both Reynolds and Gainsborough played on their indebtedness to van Dyck, knowing that their artistic quotations would be appreciated by the most discerning of their clients and by an increasingly well-educated exhibition-going public. SS

129
Oldfield Bowles (1740–1810)
Self-portrait in Vandyke Dress at his Easel c.1770
Oil on canvas
71 x 50.8
Clevedon Court, The Elton Collection (The National Trust); accepted by HM Treasury in lieu of tax and transferred to the National Trust in 1998

Oldfield Bowles was a significant patron, amateur artist and musician. Reynolds's celebrated *Miss Bowles* (Wallace Collection) is a portrait of his eldest daughter Jane. Bowles's first wife was the sister of John Bampfylde, who was also painted by Reynolds. Bowles himself took lessons from the Welsh painter Thomas Jones (1742–1803), who, in turn, had been a pupil of Richard Wilson (1714–82), the most important British landscape artist of the mid-eighteenth century. The *Self-portrait* shows him standing at his easel in front of one of his own paintings, a landscape in the Wilson tradition.

A large number of British eighteenth-century artists depicted themselves as van Dyck or in Vandyke dress. Among them are Joseph Wright of Derby, who painted two such self-portraits as a young man; Nathaniel Hone, who painted himself this way in miniature; William Doughty (1757–80/82), a pupil of Reynolds who made a mezzotint after his own van Dyckian self-portrait; and Thomas Barker (1769–1847), who portrayed himself as a romantic young van Dyck (Tate Britain). Richard Cosway painted and drew several self-portraits in this mode (fig.54). It is noticeable that all these are of artists at the outset of their careers, when they were at their most idealistic and ambitious. It is less common to find an amateur painter depicted in this way, but one of Bowles's other interests was in amateur theatricals, and, as Hayman's *Wrestling Scene* (no.116) shows, Vandyke dress was commonly associated with the stage and 'old English' dress. It was also used for portraits of men who, like Bowles, were respected connoisseurs: John Julius Angerstein (1735–1823), for example, whose collection formed the basis of the National Gallery, was painted in Vandyke dress by Sir Joshua Reynolds in 1765.

Gainsborough was one of Bowles's friends, and, like Bowles, was as interested in music as he was in painting,. At some point in the 1780s Gainsborough was apparently so keen to possess a particular violin that belonged to Bowles that he allowed the amateur to select any picture from his studio in exchange for the instrument. The canvas

that Bowles chose, an oval of cattle crossing a bridge, an Academy exhibit of 1781, is one of Gainsborough's most romantic late landscapes. Bowles does seem to have led a charmed life: the diarist and landscape painter Joseph Farington (1747–1821), another Wilson pupil, said, 'I have seldom seen a life passed with so much felicity as that of Mr. Bowles now deceased. He had generally speaking, high health a fortune to live in a very handsome manner; a cheerful & easy temper; a genteel & good, & amiable wife'.[1] SS

Note
1 Farington 1978–98 edn, x, p. 3775, entry for 25 October 1810.

130
Exhibition of Works by van Dyck 1599–1641
Exhibition catalogue
Royal Academy, Winter Exhibition 1900
Private collection

From 1870 the Royal Academy mounted a programme of Winter Exhibitions focusing on works in British collections. These generally consisted of selections of Old Master pictures with the addition of 'deceased members of the British School'. However, with the death of its President, Lord Frederic Leighton, in 1896, the Academy staged its first large full-scale monographic survey, with a special exhibition of Leighton's work. The following year the same memorial review was undertaken for Millais, the President who succeeded him. In 1898 the principle was extended to hold one of the largest exhibitions ever of the work of Rembrandt; this success was followed in 1900 by a survey of the work of van Dyck. It is easy to underestimate the effect of these Old Master surveys upon artists who had never before seen large groups of pictures brought together with the intention of giving a definitive overview of an individual painter's career. The number of Old Master painters covered by authoritative monographs was extremely small; furthermore, these publications were much less freely available than they are today and they were illustrated only in monochrome. So the impact the Royal Academy van Dyck and Rembrandt surveys made was significant. Van Dyck in particular was a revelation because his works were lent principally from private collections, often from houses that were not accessible to public visitors: at this time very few of van Dyck's pictures were in any British museum collections, so this was the first opportunity to reappraise his art. John Singer Sargent appears to have been particularly struck by the painterly brilliance of van Dyck's portraits, and absorbed some of the nuances of his style into his own work around this time (see nos.131, 132).

The van Dyck exhibition was held at the Royal Academy from 1 January to 10 March 1900 and occupied the western half of the principal galleries; admission was one shilling. The show was extensive and consisted of 129 principal oils in the main rooms and then a further 105 smaller drawings, watercolours and oil studies in the watercolour room, including the series of 40 grisaille portraits belonging to the Duke of Buccleuch. Works were exhibited from all the principal British collections, with seven paintings loaned by Queen Victoria. Other works came from abroad: Tsar Nicholas lent one painting from the Hermitage, the portrait of Lord Wharton (here no.30, now National Gallery of Art, Washington), and both the King of Italy and the French painter Léon Bonnat (1833–1922) sent extensive groups of drawings. Iconic works that were exhibited included the image of *Thomas Howard, Earl of Arundel with his Grandson*, the great full-length of *Thomas, Viscount Wentworth, later Earl of Strafford, with Dog*, the double portrait of *Thomas Killigrew and another Gentleman* (at that time thought to be Thomas Carew),[1] and the full-length of *Lucy Percy, Countess of Carlisle* (then erroneously identified as 'Lady Wentworth')[2] (nos.38, 42, 47 and 86 respectively). These works are also included in the present exhibition.

Not every item in the 1900 show would today be considered to be by van Dyck. Many of the works that were lent to it by the old families in which they had descended were subsequently sold during the twentieth century. RU

Notes
1 *Exhibition of Works by van Dyck*, no.58, p.58, and nos.63 and 65, p.28.
2 Ibid., no.21, p.16.

131
John Singer Sargent (1856–1925)
The Earl of Dalhousie 1900
Oil on canvas
154 x 111
The Earl of Dalhousie

There is a Dalhousie family tradition that Sargent was commissioned by the earl to make this portrait after the two met in the Sultan's Palace at Khartoum; the sitter's tropical suit and tanned features may lend this story credibility. There is even a white line across Dalhousie's forehead where he has been protected from the sun by his hat. However, the portrait itself was painted in Sargent's Chelsea studio: the twin columns and base appear in a number of his pictures and it has been suggested that for painting them he worked from some sort of architectural model.[1]

Sargent's portrait of Dalhousie is an adventurous essay in harmonising various tones of the same colour – columns, base, sitter's suit and shirt are all painted in different tones of white, which Sargent alleviates with the dramatic red splash of Dalhousie's tie. His unbuttoned jacket, tanned features and raffish pose lend the portrait a sense of relaxed grandeur, and for all the strictures of Edwardian male dress, his colourful tie is deliberately flamboyant and bohemian. But Dalhousie's direct, steady gaze also gives him an edge of aristocratic hauteur. His pose, resting on the columns, suggests a direct connection with or particular sensibility for the antique, possibly even that the columns are part of some grand historical building that belongs to him. This was a pose familiar from Grand Manner portraits by such painters as Pompeo Batoni and Sir Joshua Reynolds, who were themselves quoting van Dyck. Sargent was greatly stimulated by study of Old Master portraits, and works by van Dyck and Velásquez were particular sources of enjoyment and inspiration – albeit never to be simply copied but always synthesised, developed and made wholly original. Dalhousie's gentlemanly ease, the background columns and the sitter's crooked elbow and hand on hip all find greater or lesser expression in a number of pictures by van Dyck, for example his *Portrait of Lord John Stuart and his Brother, Lord Bernard Stuart* (no.40), where aspects of both figures are repeated in Sargent's painting. The portrait was included in the large survey of van Dyck's work held at the Royal Academy in 1900, the year in which Sargent painted Lord Dalhousie, so he would have been able to study van Dyck's picture closely. Some of van Dyck's half-length male portraits, such as those of Sir Thomas Hanmer (no.54) and Sir William Killigrew (no.49) also have elements that find a certain echo in Sargent's *Dalhousie*. RU

Notes
1 See Richard Ormond and Elaine Kilmurray, *John Singer Sargent: The Later Portraits*, New Haven and London 2003, p.xxix, no.21.

132
John Singer Sargent (1856–1925)
Almina, Daughter of Asher Wertheimer 1908
Oil on canvas
134 x 98.5
Tate. Presented by the widow and family of Asher Wertheimer in accordance with his wishes, 1922

Generally known as Alna, Almina (1886–c.1928) was the fifth daughter of Asher Wertheimer, a prominent London dealer in Old Master pictures and antiques. This was the last in a decade-long sequence of a dozen portraits Sargent made of the Wertheimer family. He reportedly first met Asher Wertheimer in 1896 or 1897,[1] who commissioned from him a pair of portraits of himself and his wife to mark their silver wedding anniversary; these were exhibited at the Royal Academy in 1898. In the same year Wertheimer famously acquired the Hope Collection of Dutch pictures for £121,550. Over subsequent years Sargent painted a number of single and group portraits of the Wertheimers' ten children, of which ten from the series were bequeathed to the nation by Asher Wertheimer in 1922. There are certain suggestions that Wertheimer helped Sargent acquire a number of important commissions, and that Sargent reciprocated by painting the pictures of his family. Despite Sargent's complaint at one stage that he was suffering from 'chronic Wertheimerism', in fact he was extremely fond of the family, dining with them weekly at their house in Connaught Place and greatly enjoying time at their country house in Henley.

For Wertheimer, Sargent was an ideal choice of painter for the series because of his dazzling recapitulations of historical portrait prototypes. Wertheimer was a celebrated dealer in Grand Manner portraits which he sold to clients such as the Rothschilds. He was particularly known for handling works by seventeenth-century painters, most notably van Dyck. Looking to history, Sargent elevated the Wertheimer family to a dynasty. Emulating the poses and sometimes the opulent settings of aristocratic sitters of the past, Sargent appropriated their status for a new elite whose power was founded on commerce and business rather than the outmoded holding of land. Many of the old landed families now found Sargent's pictures too expensive or lacking suitable patrician discretion; but his approach suited perfectly the demands of a new class commemorating its ascendancy, which was prepared to invest in portraits that gave its members the élan of an established ruling order.

For his portrait of Almina Wertheimer, Sargent appears to have looked closely at van Dyck's *Teresa, Lady Shirley* (no.10), echoing the sitter's seated pose, oriental costume and amused expression. However, his viewpoint is considerably lower: we actually look up at Almina rather than down as in the van Dyck. Sargent's handling of paint is entirely his own, a skilful synthesis of French and academic practice that was wholly original and owed nothing to the past. As an Academician, Sargent saw the large van Dyck Winter Exhibition at the Royal Academy in 1900, and it may have been this experience that after this date stimulated his interest in using van Dyck as a source of inspiration. However, *Lady Shirley* was not included in this survey and remained unexhibited, suggesting that Sargent may have known it only through reproduction unless he was a visitor to Petworth.

The Wertheimers were prominent members of London's Jewish community, and Sargent's use of an Eastern costume for Almina plays on associations of exoticism and otherness. In his lush treatment and Almina's playfully upturned head, there are also certain undertones of sensuality in this characterisation. The sense of dressing up reinforces this, as does the element of cross-dressing: Almina's long Turkish paisley jacket is a man's, one of Sargent's studio props. Sargent's friend the artist Jane de Glehn wrote that he 'has stacks of lovely Oriental clothes and dresses anyone he can get in them'.[2] Almina holds a sharod from northern India, which should correctly be played in an upright position. Sargent would never have intended such colourful attributes to be construed in a negative context. But nonetheless, the exotic nature and sexual temperament of his portrait of Almina echoes and reinforces negative contemporary stereotypes. RU

Notes
1 Mount 1957, p.187.
2 Letter from Jane de Glehn to her mother, dated 13 August 1907, Archives of American Art, Smithsonian Museum, Washington, DC, quoted in R. Ormond and E. Kilmurray, *John Singer Sargent: The Later Portraits*, New Haven and London 2003, no.549, p.202.

Van Dyck's Continuing Influence

133
Philip de László (1869–1937)
Mrs George Sandys 1915
Oil on canvas
241.3 x 125.7
Mr and Mrs Sandys

In 1907 John Singer Sargent retired from painting portraits and officially closed his studio, citing as his principal motives boredom with his sitters and a desire to focus on landscape. That same year Philip de László arrived in London. He was a young Hungarian painter who had trained in Budapest, Munich and Paris and who now sought to carve a career in Britain. As an artist de László had enormous facility and panache, and a feeling for the sensuousness of paint that matched Sargent's own. He had painted many of the new and old elite of Continental Europe and in London he quickly established himself as Sargent's successor for society portraits. Like Sargent, de László's approach to his sitters combined the traditions of depicting their social status and wealth with a more modern concern to represent their underlying character and psychology. With a commission from Edward VII in 1907, de László's success in Britain was quickly established, and a long sequence of commissions flowed in from aristocrats and plutocrats alike that maintained his status as the leading society portraitist for over three decades.

De László's customers were delighted by his European origins, and believed they saw them reflected in the mixture of sophistication and flamboyance that characterised his painting style. It was a school of portraiture that Walter Sickert (1860–1942) aptly described as 'chiffon and wriggle'. The manner in which de László approached his portraits was spirited but methodical, and it was a process he later documented in his book *Painting a Portrait* published in 1937, which gave extensive detail about his technique. He mixed his colours using poppy oil, which dried slowly, and allowed him to paint 'wet on wet' without the colours drying too quickly. This produced a smooth and sleek appearance. He might produce preparatory studies or drawings to help originate his design, but the final work was drawn with the brush onto the canvas directly before his subject. De László focused on getting the head painted correctly first, then moved on to the background and surroundings to ensure that the head rested harmoniously, and finally came the hands and the body.

Dulcie Sandys was painted by de László when he was at the height of his fame. She was the daughter of Sir Edward Redford and grew up in Edinburgh, where in 1914 she married George Sandys. The following year the couple moved into Greythwaite Hall in Lancashire. The portrait was, their descendents believe, painted as a celebration of the birth of their first child in June 1915, when Mrs Sandys was twenty-two. The picture would have also formed an impressive addition to the interior at Greythwaite: it is a sophisticated design that skilfully sets the figure in a pose that has her both stepping forward and turning towards the viewer, subtly animating the composition. De László has greatly elongated Mrs Sandys's body like the *Venus de Milo*, and this is accentuated further by the added length of her foot pointing out. The long swathe of purple silk flowing off to the left unites the figure with its setting and similarly emphasises her soaring, slim poise. Evidently de László used as his prototype for the picture van Dyck's *Lucy Percy, Countess of Carlisle* (no.43). This has the same half-turned pose, gentle smile and soft touch of the hand that de László clearly copied for his own picture. There is the same fall of fabric in the background, and there is close resonance too in the contrast of the sitters' rich silk dresses and the bare flesh of their shoulders and breast. De László's picture is a reversal of van Dyck's composition, and there are such close similarities between them as to raise the question of whether some form of tracing may have played a part in the initial planning of the Sandys portrait. RU

234

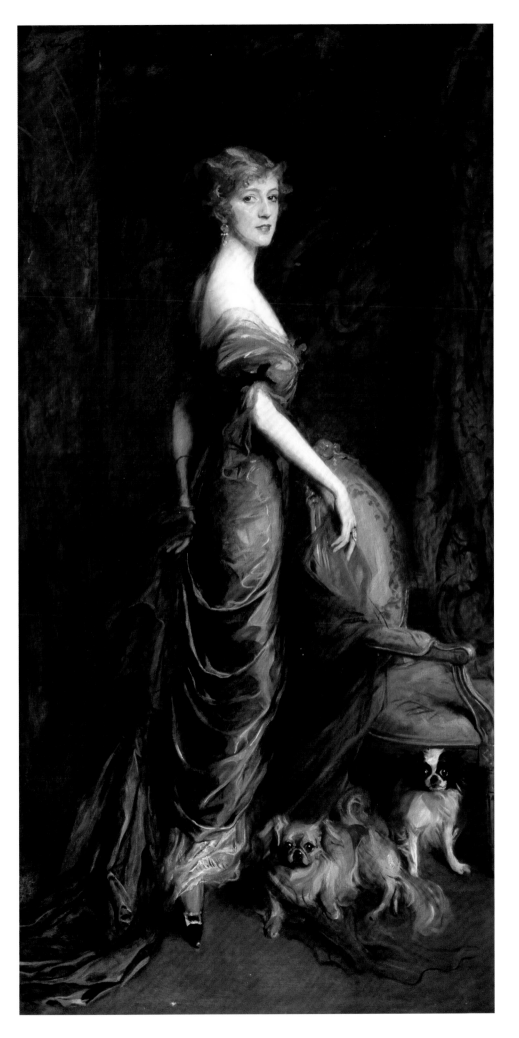

Van Dyck's Continuing Influence

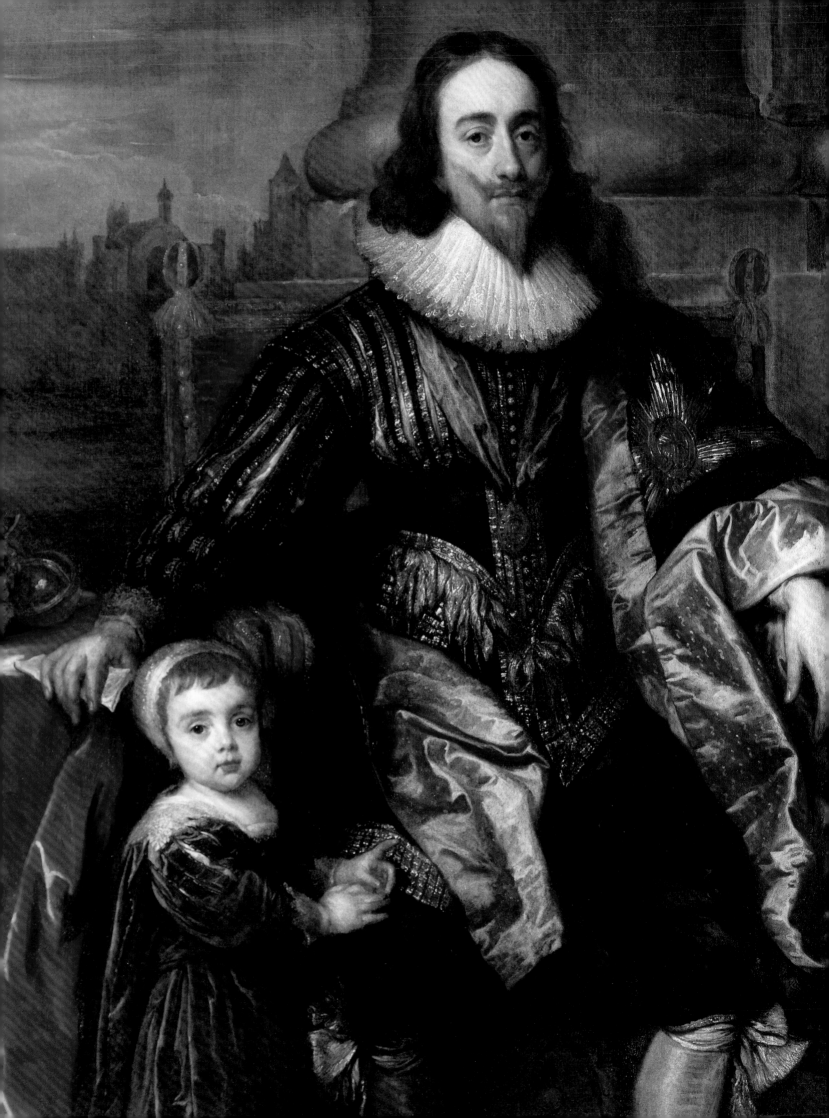

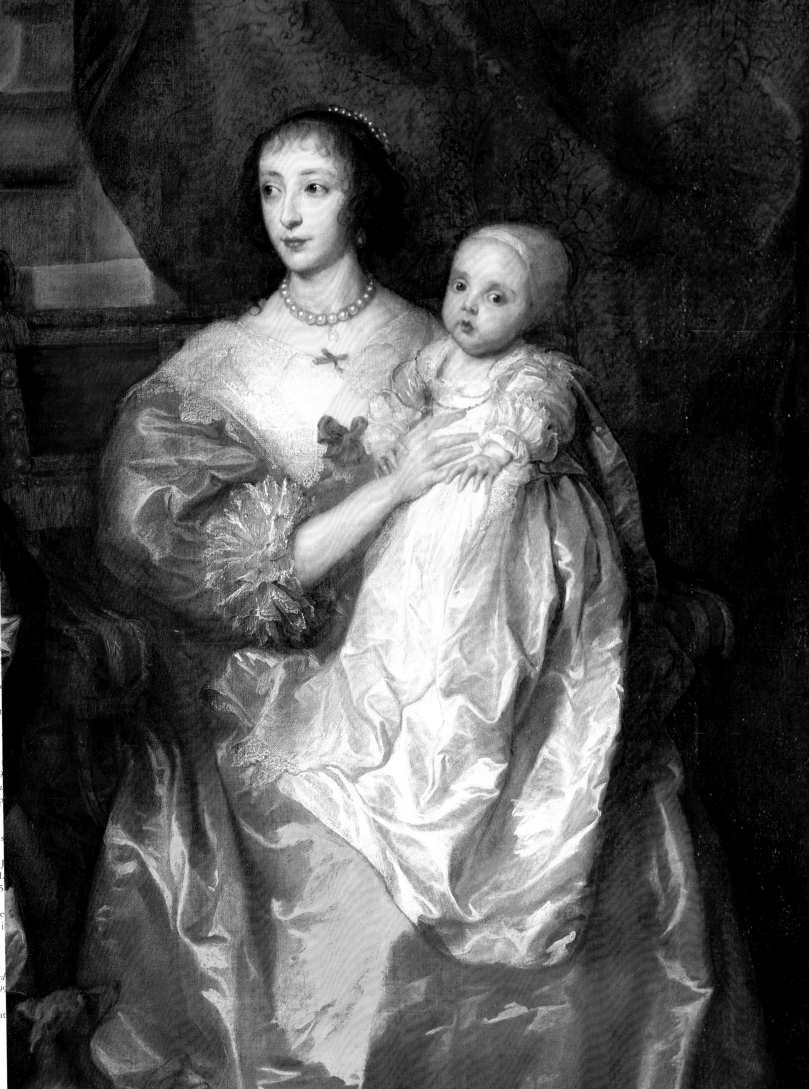

Fashioning the Mode[...]
Clothing, cavaliers a[...]
in van Dyck's Londo[...]
Christopher Breward

Acknowledgements
I am grateful to Glenn Adamso[...]
James Brook, Clare Browne, St[...]
Ehrman, Christine Guth, Kare[...]
Llewellyn, Peter McNeill, Ange[...]
Liz Miller, Susan North, Angus[...]
Carolyn Sargentson, Michael Sm[...]
Welch and Oliver Winchester fo[...]
writing of this essay.

1 Jerome de Groot, *Royalist Iden[...]*
2 Millar 1972, p.96.
3 Roy Porter, *London: A Social [...]*
4 Rosemary Weinstein, 'Londo[...]
War', in Stephen Porter (ed.), *L[...]*
London 1996, pp.31–2.
5 Porter 1994, p.66.
6 A.L. Beier, 'Engine of Manufa[...]
London', in A.L. Beier and Roge[...]
1500–1700: The Making of the M[...]
p.155.
7 Weinstein 1996, p.40.
8 Ibid., p.33.
9 Smuts 1999, p.58.
10 Weinstein 1996, pp.34, 38.
11 Ibid., p.33.
12 Stephen Porter, 'The Econom[...]
the Civil War upon London', in [...]
13 Ibid., p.188. See also Beier a[...]
14 Smuts 1999, pp.58–60. See al[...]
15 Sharpe 1992, p.209.
16 Ibid., pp.223–5.
17 Susan Vincent, *Dressing the E[...]
England*, Oxford 2003, p.166.
18 Sharpe 1992, pp.230–3.
19 Ribeiro 2005, p.94.
20 Christopher Breward, *The Cu[...]
Manchester 1995, pp.66–7.
21 George Kirke, 'The perticula[...]
of George Kirke ... of the receip[...]
disbursem[en]ts for and concerni[...]
and other necessaries belonging t[...]
s owne person ... A[nno] D[omi][...]
[etc.]', National Art Library (Gre[...]
MSL/1939/638. I am grateful to [...]
use of her notes on these account[...]
p.353.
22 V&A: 348&A–1905; T.372–1[...]
23 Vincent 2003, pp.40–1.
24 Kevin Sharpe and Peter Lake [...]
in Early Stuart England, London 19[...]
25 Christopher Breward, *Fashion[...]
Modern Metropolis*, Oxford 2004, p[...]
26 Sharpe and Lake 1994, p.167.[...]
27 Ibid., p.174.
28 Gordenker 2001, p.38. See als[...]
pp.259–61.
29 Ribeiro 2005, p.110. See also [...]
Head, Charles I: King and Martyr, L[...]
30 Sharpe and Lake 1994, pp.175[...]
31 Ibid., p.182.
32 Margaret Pelling, 'Appearance[...]
surgeons, the body and disease', i[...]
pp.91–2.
33 Godfrey 1994, pp.79–80.
34 Sharpe 1992, p.233.
35 Thomas N. Corns, *Uncloistered[...]
Literature, 1640–1660*, Oxford 199[...]
36 Vincent 2003, p.84.
37 Caroline Hibberd, 'The Theat[...]
1996, pp.161–2.

Van Dyck in Brita[in]

Karen Hearn

1 *ODNB* 2004, vol.17, pp.[...]
Jeremy Wood.
2 Leading recent scholars [...]
British work have included [...]
Zaremba Filipczak, Emilie [...]
John Peacock, Malcolm Ro[...]
R.Malcolm Smuts, Arthur [...]
White, Jeremy Wood and, [...]
Millar.
3 *Portrait of a Man Aged 7[...]
Arts, Brussels; see Barnes e[...]
4 Millar 1982, p.17.
5 *ODNB* 2004 (see note 1), [...]
6 On the fashion for these, [...]
length Portrait in Britain', [...]
Suffolk Collection, English He[...]
7 Brown and Vlieghe 1999, [...]
8 Millar 1986, pp.109–23.
9 Millar 1982, p.22.
10 See Millar 1963, no.43, [...]
Christopher Lloyd, *The Que[...]
Gallery, London, 1991, no.8[...]
11 Millar 1982, p.20.
12 See I. McClure, 'Henry, [...]
in *The Art of the Conservator*, [...]
pp.59–72; T.V. Wilks, 'The [...]
and his Circle', unpublished [...]
pp.98–9.
13 Millar 1982, p.22; Wheel[...]
14 Barnes et al. 2004, no.IV[...]
15 John Hopkins ('"Such a [...]
in the Pair": An Investigatio[...]
Cholmodeley Sisters', in *Tra[...]
of Lancashire and Cheshire, vo[...]
that the sitters may be Letti[...]
and Mary Calveley (d.1616) [...]
Cholmondeley (1552–1601), [...]
not conclusive.